After the Hunt

CALIFORNIA STUDIES IN THE HISTORY OF ART

Walter Horn, General Editor
Advisory Board: H. W. Janson, Bates Lowry, Wolfgang Stechow

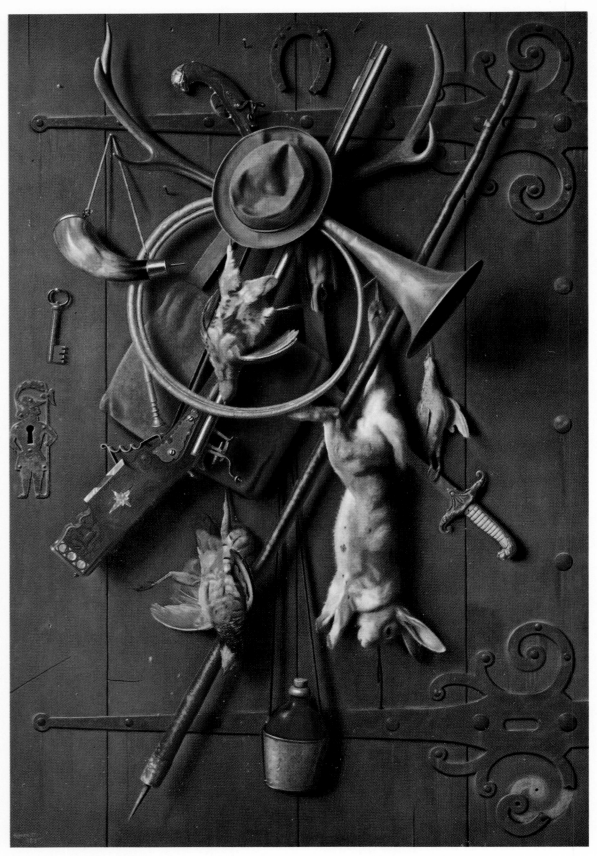

W. M. Harnett, *After the Hunt,* fourth version, 1885 (70½ x 47½)
Mildred Anna Williams Collection,
California Palace of the Legion of Honor, San Francisco

After the Hunt

WILLIAM HARNETT AND OTHER AMERICAN

STILL LIFE PAINTERS 1870–1900

ALFRED FRANKENSTEIN

REVISED EDITION

UNIVERSITY OF CALIFORNIA PRESS

BERKELEY AND LOS ANGELES 1969

UNIVERSITY OF CALIFORNIA PRESS

BERKELEY AND LOS ANGELES, CALIFORNIA

UNIVERSITY OF CALIFORNIA PRESS, LTD.

LONDON, ENGLAND

COPYRIGHT, 1953, 1969, BY

THE REGENTS OF THE UNIVERSITY OF CALIFORNIA

LIBRARY OF CONGRESS CARD CATALOG

NUMBER: 68-31417

PRINTED IN THE UNITED STATES OF AMERICA

DESIGNED BY JOHN B. GOETZ

TO THE MEMORY OF
MY MOTHER AND FATHER

Preface to the First Edition

A BOOK of this kind is, by its very nature, a coöperative effort, and I have had innumerable collaborators. Scattered through the text are thanks and acknowledgments for help in specific instances. More general acknowledgments are in order here.

First and foremost, to Edith Gregor Halpert, director of the Downtown Gallery, without whose interest this book could not have been written at all.

To Henry Allen Moe and the John Simon Guggenheim Memorial Foundation, for financial assistance and moral support.

To Lawrence S. Fanning, former managing editor, and Paul C. Smith, former editor, of the San Francisco *Chronicle,* for more of the same.

To Lloyd Goodrich, Sheldon Keck, Dorothy C. Miller, and Alfred H. Barr, Jr., for invaluable advice and technical collaboration.

To Thomas Carr Howe, Jr., Jermayne MacAgy, Henry-Russell Hitchcock, Bartlett Cowdrey, and John I. H. Baur, who provided the opportunity for various exhibitions which grew out of my work and for the publications connected with them; and to Mr. Howe and the trustees of the California Palace of the Legion of Honor for the color plate of Harnett's *After the Hunt* used as frontispiece.

To John Gildersleeve and John Jennings of the University of California Press, for editorial assistance far beyond the line of duty, and to John Goetz of the same organization, for his brilliant solution to the complicated problems involved in the design and production of this book.

To Mrs. Henry Howell, Jr., and her staff at the Frick Art Reference Library, all of them unfailingly coöperative participants in the search for the wild goose on the hunting-cabin door.

To my wife, Sylvia Lent Frankenstein, for her patience, her encouragement, and her innumerable shrewd suggestions.

To R. H. Hagan, Roy A. Boe, James Roland Kantor, Barbara Sellers, Virginia Fanning, Phyllis Lang, Victor Chapman, Ferdinand Isserman, Jr., Martine Gilchrist, and Hy Hirsch, for detail work of many sorts.

To all the museum directors, librarians, owners of paintings, art dealers, and curators of historical societies whose names crowd out of memory so thick and fast that I cannot begin to list them.

To the San Francisco Art Association, for use of the facilities of the Villa Montalvo, at Saratoga, California, where parts of this book were written, and to Arlene Loofborouw, former director of the Villa Montalvo.

Finally, to John H. Powell, for his conversation.

* * *

Parts of this book have previously appeared in the *Art Bulletin, Art News,* the *Magazine of Art, The Magazine Antiques,* the San Francisco *Chronicle;* the catalogue of the John Frederick Peto exhibition held at the Smith College Art Gallery, the Brooklyn Museum, and the California Palace of the Legion of Honor in the spring of 1950; and in two publications of the last-named museum—its monthly *Bulletin* and the catalogue of its exhibition, *Illusionism and Trompe l'Oeil,* held in the spring of 1949. Thanks are due for permission to employ this material, all of which has been thoroughly revised and reworked.

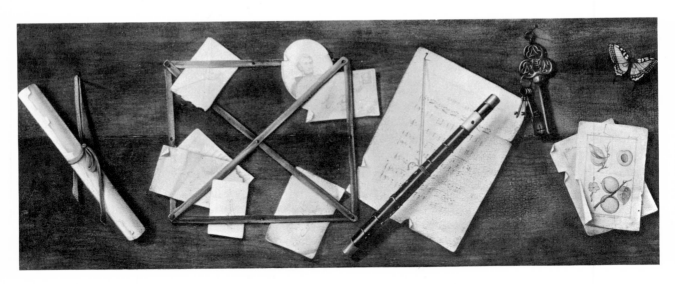

A. Bianchi
Picture A (19 x 51¾)
Private collection, Hollywood

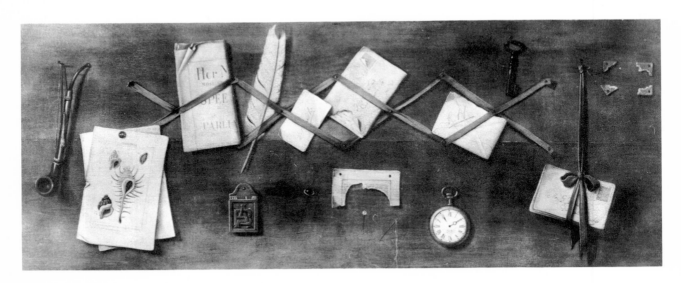

A. Bianchi
Picture B (19 x 51¾)
Private collection, Hollywood

Preface
to the Revised Edition

SUNDAY is a poor day for news in any town, and eighty years ago the Minneapolis *Tribune* took to filling its Monday columns with the texts of sermons which had been preached on the previous day in the city's churches. In September of 1887 there was a state fair in Minneapolis; a large art show formed part of it, and Harnett's *Old Violin* (plate 60) was on display. The Reverend Doctor F. T. Gates of Central Baptist Church chose the art show as his sermon topic for September 11, and this is what he had to say about *The Old Violin:*

> You will have to look long and closely and from different angles to assure yourself that this is a painting at all, and not a real violin hung on a pair of old wooden shutters with a broken hinge. In Philadelphia they employed a policeman to keep people from trying to settle the matter by putting their hands on it. Here the frame is set in a glass case. The delineation is perfect, the deception complete. And yet that picture is a specimen of the humblest function of the art of painting. The picture conveys no worthy thought or emotion. It is simply a trick. The thought in the mind of the artist is simply "Only see how I can deceive you." "Just see me do it." There is nothing whatever in the picture to please or instruct or elevate you. It is nothing but an anonymous old fiddle. The purpose of the painting is just nothing else in the world than to make you admire the man who could depict so vividly. All the accessories of the picture—the rusty hinges, the cracks in the board, the ring and staple, the tacks, the printed slip, the crumpled envelope—are arranged with the single design of rendering the ocular deception perfect. The picture is unworthy, because its purpose is low and selfish. It is a mere piece of legerdemain.

This is the only contemporary document relating to William Michael Harnett which has come to light since the publication of the present volume fifteen years ago,* and it explains why *all* the contemporary documents relating to William Michael Harnett are so scanty and imperfect. The Reverend Doctor Gates's attitude toward "mere legerdemain"

is even echoed by the historians of still life, Arthur Edwin Bye and Herbert Furst, who published the first books on this subject forty years later (see below, p. 93). The collectors and the middle class thought Harnett's style was sinful because his subject matter did not elevate the soul; the saloon class loved him, but the saloon class does not keep the records of the history of art.

The documents remain, then, meager and unsatisfactory, but the search for the works of Harnett inaugurated by Edith Gregor Halpert in 1935 has continued unslackened, and, as is demonstrated in the new Harnett catalogue at the end of the present volume, forty-five paintings, two drawings, and a piece of sculpture have been added to the Harnett canon since this book was first published, in 1953; ten additional forged or misattributed Harnetts have also floated to the surface in recent years.

Harnett's reputation was high in 1953, and it has remained so. The first edition of this book served to create major reputations for John Frederick Peto and John Haberle as well. Both artists are now represented in the permanent collection at the Metropolitan and in other first-line American museums; in 1966 Peto was listed among the twenty artists whose work was most wanted to provide the White House with a representative collection of American painting; and dealers who formerly scorned them both are now only too happy to buy and sell them. But because Peto and Haberle worked in so precipitous and unsystematic a fashion, one cannot even attempt to assemble a catalogue of their pictures.

The new catalogue of Harnett, however, underlines the completely systematic manner in which he painted. As the corpus of his known work enlarges, we can see with increasing clarity his manner of ringing changes on a single group of models. All manner of compositional variations on the same few objects will follow each other in swift succession, and then the objects, drained of their pictorial possibilities, will be abandoned. It is now possible to

* It was discovered by the art historian, Roy A. Boe, who was stalking quite different game through the pages of the Minneapolis newspapers.

Preface
to the Revised Edition

date a Harnett, with a fair degree of accuracy, by a model alone, like the bright red lobster which appears in five pictures painted late in 1881 and early in 1882, only one of which was known to exist when this book first appeared in 1953. To be sure, one does not need to rely on the models for the dating of Harnetts, since the artist always provided dates in Arabic numerals.

The best finds always turn up on the day after books go to press. The truth of this bitter maxim was never more devastatingly exemplified than in the case of *After the Hunt,* the Harnettian subject from which the present volume takes its name.

The first edition of this book was published on September 15, 1953. At that time, two versions of *After the Hunt* were known to exist, one at the Columbus Gallery of Fine Arts and the other at the California Palace of the Legion of Honor. It was also known that Harnett had painted another version of the same subject; the canvas was lost, but a photograph of it had been preserved by the painter's friend, William Ignatius Blemly, in a scrapbook which is discussed at length elsewhere in these pages.

On October 10, 1953, less than a month after the first edition came out, the Philadelphia art dealer, Robert Carlen, discovered still another *After the Hunt* in an old house where it had hung unknown for nearly seventy years. It now forms part of the collection at the Butler Institute of American Art in Youngstown, Ohio.

Fate was kinder in the case of the painting known through Blemly's photograph; it came to light in Munich in July, 1968, just as the revised edition of this book was going to press, and was sold to a private collector in New York.

The four versions of *After the Hunt,* then, are as follows:

1. Munich, 1883; Columbus, Ohio, Gallery of Fine Arts.
2. Munich, 1883; private collection, New York.
3. Munich, 1884; Butler Institute of American Art, Youngstown.
4. Paris, 1885; California Palace of the Legion of Honor.

These four paintings have many motifs in common—the hat, the powder horn, the hunting horn, the antique gun, the sword, the game bag, the dead birds, the fancy hinges and key plates—but they fall together as two pairs, not as a quartet.

The first two paintings of the series are much simpler in composition than the last two. In the versions of 1883, the long barrel of the gun provides a kind of diagonal axis around which all the other objects swing; the relief of the objects is strong and their formal relations are straightforward and easily read. In the last two paintings of the series, however, the composition is highly complex. Antlers appear to provide a great X-form against which circular and diagonal movements are counterpointed; the objects are somewhat flattened against the door, and in the Paris version, by far the largest of the series, the composition is stretched to heroic proportions between the horseshoe at the top and the canteen at the bottom. It is worth noting, also, that in the versions of 1883 the key plate is merely that, but in 1884 and 1885 it takes the shape of a halberdier—a different halberdier in each instance. All four of these paintings, as is demonstrated on pages 66 and 67 and in plate 58, are deeply beholden to photographs taken about 1860 by Adolphe Braun. More detailed discussion of *After the Hunt* will be found at the appropriate chronological point in the main body of this book.

II

THE HARNETT forgery department was greatly enlivened by a dramatic happening which took place on August 30, 1967. On that day, Miss Jean Volkmar, Conservator at the Museum of Modern Art, removed a lining canvas from the back of *Old Scraps,* which the museum had acquired as a Harnett and which is shown to be a Peto in the present volume, and uncovered the following inscription on the back of the original canvas:

OLD TIME LETTER RACK
11.94
John F. Peto
Artist

ISLAND HEIGHTS
N. J.

Preface
to the Revised Edition

This, of course, completely confirms what is demonstrated with regard to that painting on pages 11–13 of this book. For a lining canvas to be placed over an inscription on the back of a painting without transferring the inscription to the new canvas is, of course, a violation of the ethics of the conservator's profession; Miss Volkmar believes that the lining canvas was placed on the back of the picture solely to conceal that inscription, and that this was done by the same persons who adorned the front of the painting with the faked Harnett signature and faked clues pointing to Harnett which are analyzed below on the pages indicated.

A most entertaining addendum to the literature of scallawaggery connected with American still life came to light in the fall of 1966 when the collection of a prominent Hollywoodian was exhibited at the art gallery of the University of California in Santa Barbara. This involves two paintings, similar in subject matter and identical in size (19 x 51¾), which had been purchased from a prominent New York dealer as "American, anonymous, 19th century." Both pictures are reproduced herewith. We shall call the one with the rack and the portrait of Lincoln Picture A and the other Picture B.

At the extreme left of Picture A is a scroll hanging on a ribbon. Next right is a rack composed of tapes or ribbons in an X form within a square. At the lower left of this rack is an envelope addressed "Egr. Sig. Mar . . .", and emerging from that envelope is a corner of a letter on which one may read ". . . enze 1896." (The implication, of course, is that the picture was painted in Florence in the year mentioned.) Below this envelope is a card inscribed "A. Bianchi."

At the lower right corner of the rack in Picture A is a white envelope inscribed "Per M . . ./Gio. Cor . . . M/SPM." At the top right of the rack, under the portrait of Lincoln, is an envelope with an Italian stamp and a cancellation mark of which only "ZE" is legible; this envelope is addressed, however, to "Mr. Tom Carol/36 L . . . Str/ New York."

To the right of the rack in Picture A is a piece of music headed "St. Kevin," from which a piccolo hangs on a string. Next is a large key with three small keys hanging from it, and, finally, a botanical plate and a butterfly.

The rack, the picture of Lincoln, the "Tom Carol" envelope below it, and the envelope at the extreme upper left corner of the rack all come from plate 4 of the present book, a painting by Peto in the Phillips Memorial Gallery in Washington, D.C. The music entitled "St. Kevin" and the piccolo are from plate 79, a painting by Harnett now in the Metropolitan.

Picture B begins at its left with a long pipe, then a botanical plate. There is a long, narrow rack containing, in order, a pamphlet headed "Her M . . ./ Most Gra . . ./Speech/Parlia . . ."; a feather; a card inscribed "A. Bianchi"; an envelope with a ten-cent stamp addressed to "Mister Smit . . ./. . . ncoln Str./New York," and the back of an envelope inscribed "R.M."

Below the rack in Picture B are, left to right, a metal match container formed in the initials "A.B."; two jewel-headed pins and a threaded needle; part of a label which had been tacked to the board but was torn off roughly in an inverted U shape; and a large watch. Above the rack, at the right, are a key and a torn-off label which had been tacked at its four corners. Finally, between the key and the four-corner label, is a long ribbon from which hangs a thin stack of envelopes.

The pipe at the extreme left in Picture B comes from our plate 103 (Haberle); the rack and the key from plate 42 (anonymous); the pamphlet about Her Majesty's most gracious speech from plate 41 (Collier); the feather from plate 40 (Vaillant); the match container from plate 79 (Harnett); the tacked label torn in the shape of an inverted U from plate 92 (Peto); the watch from plate 104 (Haberle); and the four-corner torn label at the extreme upper right from plate 4 or plate 92 or some other plate wherein that very common Peto device appears.

Of thirteen objects represented in Picture A, six were taken from plates in this book. Of the sixteen objects in B, nine are from this book. That they have no other source is proven, among other things, by their juxtaposition. The feather from plate 40, the pamphlet from plate 41, and the rack and key

from plate 42 are all in separate pictures, of different nationalities and periods, brought together on a single page of the present volume for a special illustrational purpose. It is quite beyond the range of possibility that these same objects could have been brought together elsewhere or in any other way.

These paintings are not fakes in the ordinary sense of that word. Each is signed by one A. Bianchi, who obviously had connections in Florence and New York. No other signature is attached to them, and no effort was made to represent the pictures as the work of anyone in particular. The false date, 1896, and the artificially induced crackle are part of the fun. I sincerely hope that A. Bianchi, who studied the first edition of this book so carefully, will read the second edition, too, and communicate with its author. Few art historians have been so flattered by the attentions of an unknown painter.

III

AMONG THE newly discovered Harnetts are some rather curious youthful works which represent tentative moves in this direction and that before the artist had settled on the path he was ultimately to follow. Most interesting of these are the two studies of Dante, both produced in 1873.

One is Harnett's only known work of sculpture, a bronze profile portrait in relief; the clarity of its technique and its extremely small size (less than three inches high) obviously relate it to Harnett's early activity as an engraver of fancy table silver. Harnett's other *Dante* is a rather crude watercolor of the poet reading a huge book at a window; astonishingly, it turns out to be a copy of a fresco by Luca Signorelli painted in 1499 in the Cathedral of Orvieto. Harnett's color and Signorelli's are nearly identical; in other words, Harnett had access to a color reproduction or a painted copy of the Orvieto picture. Painters like Harnett are traditionally assumed not to know anything about old masters like Signorelli; the Dante picture demonstrates, however, as do many other bits of evidence,

that the conventional view of American art history is oversimplified, and that American artists of the nineteenth century were far more aware of the traditions from which they came than they have usually been credited with being.

The mysterious V. Dubreuil, whose tantalizing personality and mocking, satirical art are discussed on page 151, was rendered a little less mysterious in 1964 when Mrs. William H. Roach of Miami, Florida, came forward with ten or a dozen paintings by him which her husband had inherited from his father and which were sold to the Kennedy Galleries in New York. According to an article by Kay Murphy in the Miami *Herald* for February 2, 1964, Mrs. Roach's father-in-law was the proprietor of a tavern called Dickens House at 38th Street and Seventh Avenue in New York of which Dubreuil was a devotee and for which he painted many things; this was in the 1890's. Miss Murphy's material is rather vague and Mrs. Roach failed to respond to my inquiries. But the pictures at the Kennedy Galleries considerably enrich our understanding of Dubreuil.

They show him to be obsessed with the image of money, but our statement on page 151 that he seems to have painted nothing but money must now be revised. The newly discovered pictures include still lifes of artist's equipment, of food and drink, and of Presidential portraits. Among the latter is a painting of a photograph of Grover Cleveland on the cardboard mount of which, lettered in the style of the commercial photographers of the time, is the artist's name and an address, "110 West 44 N.Y." My friend, Miriam Godofsky, to whom I am indebted for the Miami *Herald* article, once owned a painting representing, among other things, a letter addressed to the artist as Victor Dubreuil, with the 44th Street address crossed out and a forwarding address, "107 West 43," pencilled in. So Dubreuil did frequent the Times Square neighborhood, but there seem to be no other records of him in New York.

His work is interesting for its vein of stark brutality, which reaches a climax in *Don't Make a Move,* the painting of a bank robbery which we reproduce. The same brutality runs through his relatively crude studies of paper currency and his

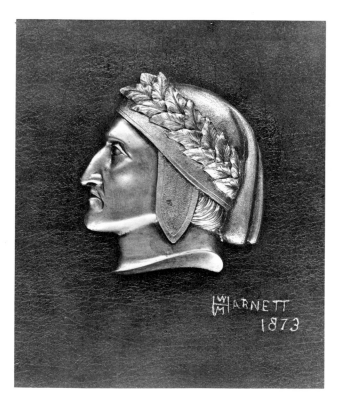

W. M. Harnett
Head of Dante 1873 (7½ x 5)
Bronze on wood panel
Harold Hays, Philadelphia

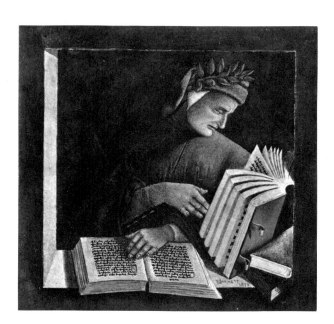

W. M. Harnett
Dante in His Study 1873 (7¾ x 7¾)
Watercolor
Kennedy Galleries, New York

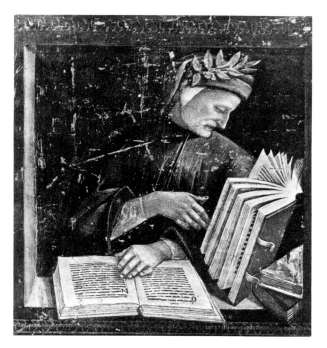

Luca Signorelli
Dante
Photograph from R. T. Holbrook,
Portraits of Dante from Giotto to Raffael

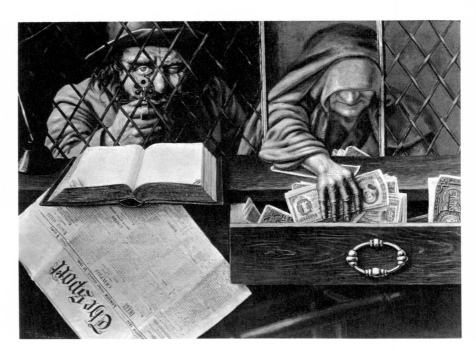

V. Dubreuil
Don't Make A Move c. 1900 (24 x 32)
Kennedy Galleries, New York

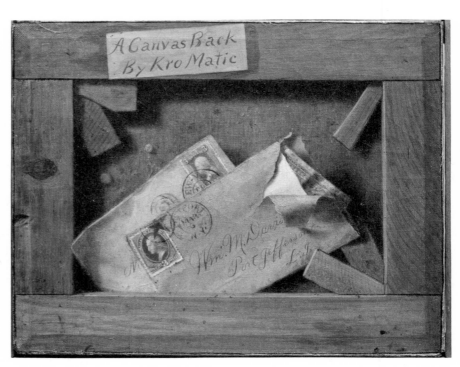

William M. Davis
A Canvas Back c. 1870 (8 x 10)
Suffolk Museum, Stony Brook, Long Island

Preface
to the Revised Edition

variations on the *Barrels of Money* theme one of which, from Dickens House, is signed and dated "N.Y. 1893." But *Don't Make a Move* is his masterpiece.

Another of our mystery men, B. J. Harnett (see page 158) turns out to have been an amateur painter, mostly of seascapes, who was in the shipping business, on both the east and west coasts, until his death in New York in 1914. He was an Englishman who came to the United States about 1875. He seems to have been a prolific painter of landscapes and marines, and the likelihood of his work's being confused with that of William Michael Harnett is extremely remote, but any painting signed "Harnett" is bound to attract attention, perhaps more attention than it merits.

William M. Davis (1829–1920) was a most interesting "third circle" artist of whose existence I was not aware when the first edition of this book was written. He seems to have lived all his life in the village of Port Jefferson, Long Island, and to have painted landscapes, genre, and a few *trompe l'oeil* still lifes of a remarkably prophetic kind.

The most famous of these works was called *The Neglected Picture*. As described in *The Home Journal* for February 22, 1862, it represented "an old, dirty, stained lithograph" of Jefferson Davis "in a dilapidated mahogany frame, with the glass broken. The edges and points of the broken glass look remarkably keen, appearing as if ready to fall from the picture. The frame, one corner covered partially with cobwebs, in which several flies have become imprisoned, seems ready to drop apart, and the torn paper and the business cards of 'Justice and Co.' and 'B. Happy' in the corners are so accurately delineated, that it seems almost impossible that the representation is on a piece of canvas."

The painting of prints under broken glass is, of course, an old, old device of European *trompe l'oeil,* but this appears to be the earliest known instance of it in American art. Where did a provincial Long Island painter become acquainted with that theme?

Davis had some contact with the celebrated Long Island artist, William Sidney Mount, who, on December 28, 1865, recorded in his diary the fact that he had attended a sale of Davis's paintings at

Port Jefferson; thirty works were sold and brought about $320. Mount wrote an article about Davis "which was read by Mr. Thos. S. Strong before the sale commenced"; regrettably it has disappeared.

Two other entries concerning Davis are worth quoting from Mount's diary.

April 9, 1862:

"Mr. Davis selected a head stone and printed on it 'Hic jacet secesh' and arranged about it the various accompaniments of the rebel soldier. Every thing [the incidents of the war] he could think of to tell his story was placed about the grave stone on the table and imitated as close as was desirable. A very ingenius [sic] way to tell a story by a still life arrangement. The different objects were well painted. The painting is on exhibition at Messrs. Ball, Black and Co.'s show window, in Broadway."

We learn from Mount's diary and other sources that *The Neglected Picture* was also displayed in the show window at Ball, Black and Company—the same Ball, Black and Company which, according to the reminiscences of James E. Kelly, gave Harnett his first public exposure in the same show window some fifteen years later. (See below, page 36.)

On the day after his diary entry about *Hic Jacet Secesh,* Mount adds the following, apparently with reference to the current annual exhibition at the National Academy of Design:

"Mr. William M. Davis ordered Mrs. Croker [door keeper] to alter 475 marked Fruit to read 4 apples and a pare [sic] when the painting represents four oranges and a lemon. It looks like courting notoriety at the expense of truth."

Only one *trompe l'oeil* painting by Davis seems to survive. (Stony Brook, Long Island, Suffolk Museum.) It is a picture of a canvas stretcher startlingly like the Peto reproduced as plate 87. The trick, obviously, is to make one think it *is* a stretcher and that the real picture is on the other side; but when one turns it over, one sees only the real stretcher. On the top bar of Davis's painted stretcher is the somewhat painful label, "A Canvas Back/By Kro Matic." Tucked behind the bottom bar are two letters; the one on top is addressed to Davis at Port Jefferson, is postmarked "Westport, N.Y. Mar. 6," and reveals paper money at its

slashed-open right end. The bottom letter bears a brown-rose three-cent stamp issued on August 18, 1861. The top letter has a green three-cent stamp (at the wrong end of the envelope) which appeared on April 12, 1870. The picture may well have been produced in 1870; if so, it antedates Peto's handling of the same subject by eighteen years. In general, Davis seems like an artist of the Harnett-Peto generation rather than the generation of their fathers; but the few fragments of his work which we possess really indicate how little we know about the history of still life in America.

Another third circle artist of less interest is Levi Wells Prentice (1851–1935); he deserves a few lines here, however, because a still life of his bearing a forged Harnett signature has been added to our catalogue. (See below, p. 187, No. 28.) Prentice was primarily a landscape painter and was particularly fond of the Adirondacks; the prime source of information about him is the Adirondack Museum at Blue Mountain Lake, New York, one of whose research assistants, William K. Verner, is preparing a detailed study of his work. Prentice's still lifes are mostly of fruit and fruit baskets; the forms are heavy, bold, and staring; they lack both elegance and realism, but chromolithographs of them were widely circulated when they were new and some of these have been resurrected by the antique trade of our own time.

IV

BRINGING OUT a new edition of a book enables one to correct errors, restore material previously omitted for one reason or another, and, above all, redefine one's evaluation of the subject after the passage of time.

The most serious error committed in preparing the first edition of this book lay in overlooking a photograph, in the Blemly scrapbook, of a version of *After the Hunt* probably painted in 1883 and now listed in our catalogue as No. 81A. With the newly discovered version of 1884 (catalogue No. 94A), four versions of this picture are now accounted for, and the famous one of 1885, the most celebrated work of Harnett's life (frontispiece) is the fourth and last of them, not the second, as it was consistently called throughout our earlier edition.

A minor error worth confessing was my reference, in describing Harnett's *Music and Good Luck,* to "an enigmatic shuttle hanging by an equally enigmatic hook which curves to the left." As the late Albert Ten Eyck Gardner gently pointed out, this "enigmatic shuttle" is actually nothing but an old-fashioned hasp with which to secure the door. In locked position it would swing to the right, the staple on the door frame at the extreme right would go through it, and the padlock would go through the staple (plate 79). Other minor errors have been corrected without the necessity of confession here.

Two things omitted from the edition of 1953 in order not to offend the sensibilities of friends need no longer be suppressed. The first of these is the probable identity of Artist X, the only deliberate forger involved in the Harnett forgery story. His identity is suggested in the note on his work in the catalogue.

The second thing omitted from the edition of 1953 was a paragraph which had actually been published in my first report on the Harnett forgery problem in the *Art Bulletin* for March, 1949; it was left out of the book in 1953 at the urgent request of a New York dealer. This paragraph told how, in August, 1947, I took a small painting by Peto from Island Heights to Philadelphia and floated it in the art market there. At that time it bore no signature or identifying mark of any kind except a small check mark which I myself placed on its back in the presence of witnesses on the night before the sale was made. In December of 1947 this painting was in a New York dealer's gallery. It had been cleaned and framed, and on its back, in addition to the check mark, was a rubbed, old-looking inscription in pencil: "Painting by Harnett/Property of Mrs. A. Lovell (?)/Chestnut Hill, Pa." No owner was mentioned at the time this painting went into the Philadelphia market, and nothing was said about Chestnut Hill. Most of the Harnett forgeries, it is clear, were made around 1905; but not all of them were.

Preface
to the Revised Edition

What should I have seen in 1953 that I did not see, or see sufficiently? Mostly, I think, the baroque restlessness of Peto's composition. Harnett's objects are by no means invariably at ease, but the whole effect of his work is eminently reposeful compared to the acrobatics of Peto. Except in his small table-top pictures, nothing is ever at rest in Peto's work; everything slides, falls, dangles, or balances in the most precarious and alarming fashion. His lighting, also, is intensely dramatic, picks up bits of this and spots of that, and casts the rest in deep shadow. The objects he chooses to paint are frequently torn, burned, ripped, or otherwise violated; there is a strong undercurrent of violence in his still life. In a sense, he is a forerunner of Robert Rauschenberg and other moderns who treasure the wasted and derelict objects of modern life. Like his contemporaries, Winslow Homer, Albert Ryder, and Thomas Eakins, he was an isolated American out of tune with the Gilded Age. But by the same token he was also in the mainstream of American art in his time—and he is the only artist considered in this book of whom that can be said.

In 1953 one could not perceive that John Haberle was the forerunner of pop art because pop art did not exist at that time. But Haberle affirms, in the idiom of his own moment, a vernacularistic streak in American art which rose to its highest prominence during the pop-art era. A detailed look at a picture like Haberle's *Bachelor's Drawer* (plates 98, 99, and 100) will reveal some astonishing parallels to the work of the pop performers.

In the center of the painting is the lid of a cigar box, painted with the most fanatical detail in every curlicue of its engraved labels and revenue stamps. This is held to the drawer by means of a yellow ribbon looped around a nail at the top and two little leather hinges along the bottom edge. This hinged cigar-box lid is a crude container behind which are held a corncob pipe, an old comb, a small corked bottle, an envelope torn open at its right-hand end, a label or baggage check of some sort with a tasseled cord attached to it, and, at the extreme left, a loop of shoelace. Why does an artist paint a conglomeration like that? He is, I think, debunking the high falutin'-ness of art, the notion that art must confine itself to a limited, "noble"

subject matter and precious materials. This is precisely the kind of debunking of cultural pretension that fills Mark Twain's books about his travels abroad; and both Haberle and Twain would have understood Alan Kaprow when, in predicting where art would go after the death of Jackson Pollock, he said, "Objects of every sort are materials for the new art: paint, chairs, electric and neon lights, smoke, water, old socks, a dog, movies, a thousand other things which will be discovered by the present generation of artists."

A Bachelor's Drawer is full of paper money, which Haberle and others of his time painted not so much because it was valuable as because it was flat. Haberle's kind of illusionism cannot abide deep space, for reasons suggested below on page 54; Haberle never painted a table-top still life in his entire career but devoted himself to two-dimensional or, at the most, extremely shallow objects. This predilection of his drives him into some very curious inconsistencies: all the objects in *A Bachelor's Drawer* are represented with the highest degree of "realism," but these objects are displayed as if pasted to the front of the drawer in a highly fantastic manner. Pop artists like Andy Warhol loved to paint paper money and the postage stamps and playing cards beloved of Haberle, and for the same reason: they are totally two-dimensional things and therefore capable of complete, illusionistic representation.

The largest thing in *A Bachelor's Drawer* is a cheap, colored engraving of a dandy with fancy whiskers and hairdo; the analogy with Roy Lichtenstein and his pop-art emphasis on comic-book illustration is obvious enough. Haberle's bachelor liked cheap nudity, as witness the photograph so modestly draped with a band from a package of envelopes; the parallel to Mel Ramos and his pop-art cuties is clear. Setting *A Bachelor's Drawer* aside, one may note that Haberle painted pictures of his own palette; so did the pop artist, Jim Dine. Haberle painted street signs; so do pop artists as diverse as Robert Indiana and James Rosenquist. And it is scarcely news that a palette is about as flat as a five-dollar bill and that, like Warhol's stamps and bank notes, practically everything painted by the pop artists is two-dimensional; even the land-

Preface
to the Revised Edition

scapes of Lichtenstein lack any indication of depth.

Haberle, like the pop artists, had a keenly satiric mind and a fine sense of the absurd. The parallels one can draw between his work and that of the present or recent past confer a sense of historic continuity on the newer painting and reveal fresh, contemporary meanings in the old. In his book, *Object and Idea,* Brian O'Doherty speaks of the throwing of such bridges between past and present as evidence of a conservative turn of mind. So be it. But both Haberle and the pop artists are enriched by the linkage.

Two small Harnetts came to light at the last minute and full descriptions of them could not be inserted at the proper places in the Harnett catalogue. These paintings are as follows:

27C. *Alas, Poor Yorick.* Nearly identical with 27B. This picture is slightly wider than 27B, however, and uses its extra width to set off its modest *dramatis personae* with more empty table space at the extreme left; it also shows us more of the folded poster at the extreme right. The phrase "two ounces" is not legible on the revenue stamp here. The signature on this painting is unnaturally large and was probably not placed there by the artist himself; like No. 23, this is an authentic Harnett with a signature of dubious authenticity. L. 7⅜ x 9⅝.
Ansonia, Connecticut, Robert Paul Weiman.
(*Note:* On the back of the stretcher of No. 27C is a printed slip, apparently cut from an old exhibition catalogue, giving the picture the title *Materials for a Leisure Hour.* Whether correctly or not, this title has long been applied to our No. 49, and since No. 49 has repeatedly been exhibited, catalogued, and mentioned in the literature under that name, we leave it as it is.)

76D. *Still Life with Two Signatures.* A second paraphrase of No. 76B. The paneled cabinet is nearly identical with the one in 76B except that it exhibits no hinge and its veined marble top is black. On the table top are the same apple and peach as in 76B and nearly the same bunch of grapes hanging over the edge. Between the apple and the peach, however, are a second apple, a wineglass, and a pear, and behind the fruit is a large glass carafe two-thirds filled with red wine; it has a Greek meander pattern etched around its belly and a bright gold neck, handle, and spout. In the background, at the left, is a flowered drape, behind the carafe is a paneled wall, and, at the extreme right, a deep, dark niche. The painting is signed and dated twice, both times vertically, as in 76B, once at the extreme upper left and once at the extreme lower left. The upper left signature is very small and a frame-rub indicates that it was at one time covered by the frame; hence, apparently, the second and larger signature at the bottom. The panel also bears Harnett's monogram on its back. 6¼ x 4¼.
Los Angeles, Mr. and Mrs. Barry Taper.

The total tally of the works of Harnett given in the introduction to the catalogue includes these additions.

A conscientious effort has been made to determine the current ownership of the paintings reproduced on the following pages, but in some instances current ownership data could not be obtained. In these cases, the phrase "formerly collection of" is employed, referring to the owners of record in 1953.

Finally, I should like to offer thanks to Thomas Albright for his assistance in preparing this revision.

July, 1968

Contents

Illustrations

Illustrations

AS OUR TASTE EXPANDS THE PAST GROWS WITH IT, SOMEHOW ALWAYS AHEAD.
 —*James Thrall Soby*

The Problem and Its Solution

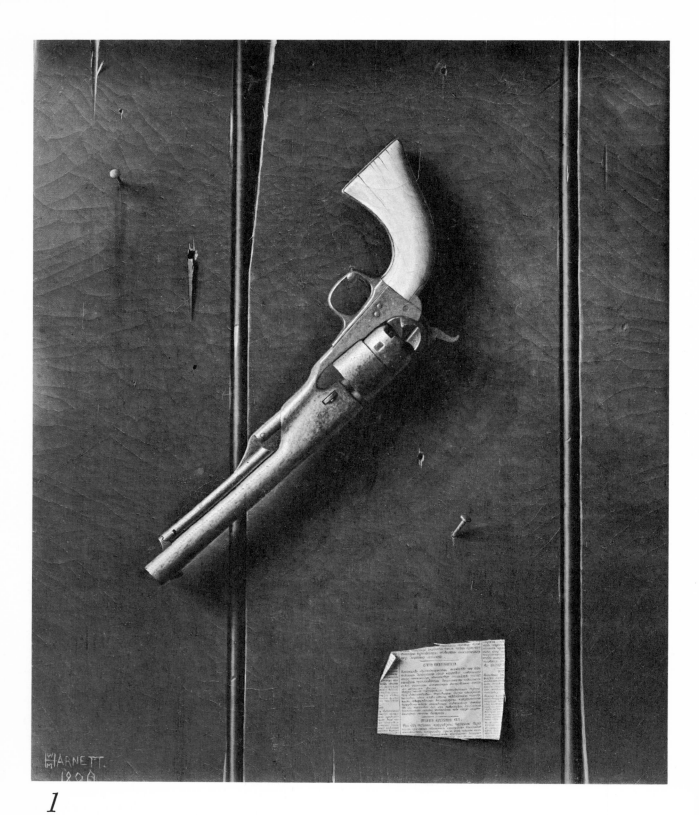

1

W. M. Harnett
The Faithful Colt 1890 (23 x 19)
Wadsworth Atheneum, Hartford, Connecticut

A T THE VERY LEAST, it was a magnificent example of pictorial Americana. A "runner" from Philadelphia had brought it to the Downtown Gallery in New York, for the Downtown Gallery was deeply interested in American folk art, and American folk art was then—in the spring of 1935—experiencing a decided bull market.

But this new find was very different from the rhapsodically disproportionate still lifes, "theorem pictures" and female-seminary art then being sold under the American rubric. There was a hint of Wild Western savagery in its subject—an old pistol hanging against a weathered door—and the man who had created it possessed a cool assurance in drawing and a precision in formal arrangement quite foreign to the work of the folk artists. He also had a cunning control of paint and a wizardly knowledge of its descriptive uses—witness the hammered, rust-flecked steel of the pistol barrel, the more finely grained brass of its frame, and the creamy but stained and cracked ivory of the stock. The door, with its long grooves and minor splinters, was a rich dark green relieved from monotony by its cracks, its energetic rusty nails, and its suddenly explosive craters where nails had been removed. The newspaper clipping at the bottom was a little masterpiece of eye-fooling; a corner of the clipping was creased forward, and one's hand went out almost automatically to pull it off. Above and beyond its realism, the picture was remarkable for its values of placement, organization, and the suggestion of space within its extremely shallow depth. Move that dangling gun or a nail or the newspaper clipping ever so slightly and the whole thing would fall apart. Its balance was both perfect and alarmingly precarious; and there was something mocking and strange about its fusion of literal rendition and pictorial artifice that reminded one of the contemporary surrealists.

At the lower left corner of the picture, painted as if whittled into the door, were a signature and date: "W. M. Harnett 1890." On the back of the canvas-stretcher was an old printed slip, apparently cut from an exhibition catalogue, which read as follows:

W. H. [*sic*] Harnett, deceased (1848–1892). Acknowledged Head of Still Life Paintings. Pupil Pennsylvania Academy of Fine Arts; National Academy of Design, New York; Institute of New York. Exhibited in the Paris Salon, Royal Academy of London, also in Frankfort and Munich.
No. 1731: A Faithful Colt.

That title, *A Faithful Colt,* made the thing complete. If one were thumbing through the catalogue of an exhibition held at the National Academy of Design in the 1890's and ran across the listing, *A Faithful Colt,* one's mind would instantly conjure up some sentimental horse-and-farm-boy picture in the style of Eastman Johnson's followers, but this *Faithful Colt* came out of the past with force and virility; it conveyed a wide range of subtle implications, and it suggested that back there in the dark was a virtuoso to be investigated.

None of this was lost on Edith Gregor Halpert, director of the Downtown Gallery. She bought *A Faithful Colt* from the Philadelphian on April 12, 1935, and sold it on the following June 22 to the Wadsworth Atheneum in Hartford, Connecticut, where it remains today. Meanwhile, runners were alerted, libraries were consulted, and the pilot-picture, *A Faithful Colt,* went on tour—first with an exhibition of historic American paintings that made a circuit of New England galleries,[1] and later with a more general show of American art that went to Paris.[2] Returns from the runners came in rather slowly, but in four years' time they turned up ten more still lifes bearing Harnett's name. Mrs. Halpert also discovered his *Emblems of Peace* in the Springfield Museum of Fine Arts, his *Old Violin* in the collection of Charles Finn Williams in Cincinnati, and a fine chromo of the latter at the Whitney Museum of American Art. These fourteen pictures (the ever-faithful *Colt* was, of course, included) formed the first Harnett exhibition of modern times, held at the Downtown Gallery from April 18 to May 6, 1939, under the amusing, provocative, and ungrammatical title, *Nature-Vivre.*

[1] *Thirty Paintings of Early America,* organized by the College Art Association and exhibited in various cities of New Hampshire, Massachusetts, and Connecticut between October 20, 1935, and January 26, 1936.
[2] *Trois siècles d'art aux États-Unis,* organized by the Museum of Modern Art in New York at the invitation of the French government and shown at the Musée du Jeu de Paume in the summer of 1938.

*The Problem
and Its Solution*

II

THE INTRODUCTION to the catalogue of the *Nature-Vivre* show provided such information about Harnett as Mrs. Halpert had been able to gather. Most of it was taken up with a brief biographical sketch of the artist by his friend, E. Taylor Snow, which had appeared originally in the catalogue of the sale of Harnett's effects held in Philadelphia shortly after his death;[3] a copy of this catalogue was in the New York Public Library.

Snow states that William Michael Harnett was born in Clonakilty, County Cork, Ireland, on August 10, 1848, and was brought to Philadelphia when he was one year old. As a young man he learned the trade of engraving on silver, and, while engaged in this work, studied art at the Pennsylvania Academy of the Fine Arts and at the National Academy of Design and Cooper Union in New York. According to Snow, he gave up his trade and began his career as a painter in 1875, had a studio in Philadelphia from 1876 to 1878, and then went to Europe, where he remained for seven years.[4] He was especially active in Munich, but he also lived, worked, and sold paintings in Frankfurt, London, and Paris. He had great success at the Paris Salon of 1885 with a large picture entitled *After the Hunt*.

Harnett lived in New York from 1886 to his death on October 29, 1892. Snow has little to say about these later years, but in his summary account of them he does tell a story which was widely circulated in the early days of the Harnett revival—that Harnett had painted a picture of a five-dollar bill which was promptly seized by agents of the Treasury Department and confiscated under the laws against counterfeiting. Harnett was not prosecuted for this, but he was warned not to do anything of the sort again.

Snow concludes his sketch with these words:

Mr. Harnett always grouped his models so as to make an artistic composition—he endeavored to make his composition tell a story. Before painting he would make a finished lead-pencil drawing, with minute details. Through hard study and years of toil, he achieved the highest fame in his line of painting, being recognized the most realistic painter of his age.

To Snow's sketch Mrs. Halpert added some information about Harnett's exhibition record at the National Academy of Design and in various European galleries, this material having come from the catalogues of the National Academy itself and from the few lines given to Harnett in the standard biographical dictionaries of artists. She observed that in his time Harnett had commanded high prices, but that his reputation declined rapidly after his death and he was being introduced as a rediscovery. Mrs. Halpert concluded:

While his recognition in the nineteenth century may have been due to his "artistic composition" and his reputation as "the most realistic painter of his age," our present interest in Harnett is based on more contemporary considerations. We marvel at the fact that he anticipated a style practised today by the vanguard in France and in this country. His color is brilliant, the painting flawless, and the composition organized in abstract pattern. But it is Harnett's combination of meticulous realism with an arbitrary juxtaposition of unrelated objects that may be said to provide a link between Dutch art of the seventeenth century and surrealism of the twentieth. The contemporary school of imaginative realism is enriched by another American ancestor presented in this exhibition.

The critics underscored the modern parallel; some of them, in fact, appropriated phrases from the paragraph just cited without credit or indication of source. And, as often happens when a new work or a new artist is brought forth, certain exceptional details were so appealing that these alone were dwelt upon and the rest was overlooked. No one perceived, for example, that Mrs. Halpert's remark about brilliant color was not true of all the paintings in the show, many of which were actually rather somber and dark. No one observed that most of Harnett's compositions—a mug, a pipe, and a newspaper; books on a table; a violin and a sheet of music; a melon, an apple, a vase, and a knife—could not properly be described as "arbitrary juxta-

[3] *Executrix's Sale: Catalogue of Exquisite Examples in Still Life, Being Oil Paintings by the Late William Michael Harnett, Including the Furnishings of His Studio* . . . The sale was conducted in the Philadelphia auction rooms of Thomas Birch's Sons on February 23 and 24, 1893.

[4] Snow's date for Harnett's departure is two years too early; Harnett went to Europe in 1880 and returned in 1886.

positions of unrelated objects," nor did anyone point out the curious discrepancy between this phrase and Snow's "endeavoring to make his composition tell a story."

There were, to be sure, three paintings in the show to which the phrase did apply. All three (plates 4, 6, and 19) followed the very old but not very common card-rack formula: strips of tape tacked to a door, with books, letters, quill pens, photographs, cards, and tickets of various kinds suspended from or tucked behind them in a mysterious clutter. On one of these paintings (plate 4), painted as if carved into the door, was the date, "1900," eight years after Harnett's death, although the same picture also bore, inscribed on one of its envelopes, Harnett's name and the address of the studio at 400 Locust Street, Philadelphia, which, according to the National Academy record, he had occupied in 1879. The picture was accordingly dated in that year, and the *Nature-Vivre* catalogue made no effort to explain the "1900." It was later explained as an instance of Harnett's surrealism; that he had practiced an even more extraordinary prolepsis in another rack picture of the *Nature-Vivre* show was not noticed then, nor for eight years afterward.

So the Harnett revival was launched—with a small group of paintings and an assemblage of biographical data which, although it represented all that the libraries would yield, was nevertheless meager—in an atmosphere of critical appreciation concerned almost solely with the artist's predictions of modern trends.

The launching was a great success. On April 23 the New York *Times* reported that "the little box of red stars had at once to be opened," and that one of the sales was to the Smith College Museum, which had purchased a picture entitled *Discarded Treasures* (plate 17). According to the *Art Digest* for May 1, 1939:

Before the [*Nature-Vivre*] exhibition had been open two days, Nelson Rockefeller, treasurer of the Museum of Modern Art, had acquired two Harnetts for his private collection; Alfred Barr, director of the Modern museum, bought one; a benefactor donated another to the Modern's collection; and several museum directors took options on other exhibits.

One wonders if the editors of the *Art Digest,* as they prepared this material for publication, remembered a story they had printed exactly two years before. The Gallery of Fine Arts in Columbus, Ohio, sinking a depth bomb into its dead-storage vaults, had come up with a show entitled *Painting as Our Grandfathers Knew It.* In reviewing this, the *Art Digest* had observed:

A few [of the artists represented], like Bonheur, Keith, Knight, Schreyer, and Bierstadt, are still mentioned by the present generation; a majority have long since passed into the limbo of forgotten men. Who, might ask a gallery visitor under forty were: Gustave Egide, Charles Wappers, John Jay Barber, William de Leftwich Dodge, William M. Harnett, or Victor Nehlig?

Gallery visitors of all ages now had the beginnings of an answer so far as one of those dwellers in limbo was concerned; an answer which was to grow louder and more explicit with the coming years.

III

BY 1947, more than a hundred paintings ascribed to Harnett had found their way into museums and private collections. Many dealers had taken up the search for his works, although the Downtown Gallery remained the principal outlet. The public museums of Boston, New Britain, New York, Brooklyn, Philadelphia, Pittsburgh, Buffalo, Detroit, Chicago, St. Louis, Wichita, and San Francisco had all acquired Harnetts as a result of the success of the *Nature-Vivre* show. Columbus again dusted off the two Harnetts it had always had and placed them permanently on view. Springfield did likewise with *Emblems of Peace,* while Hartford, as we have seen, led the procession of the modern revival. The privately owned Phillips Gallery in Washington, the Fogg Museum at Harvard University, and the Addison Gallery of American Art at Phillips Academy in Andover, Massachusetts, followed the lead of Smith College and the Museum of Modern Art in acquiring Harnetts, and the list of private

owners, headed by the late President Franklin D. Roosevelt, included many of the country's most perspicacious collectors. Nelson Rockefeller's collection was the largest, for in the eight years since the *Nature-Vivre* exhibition he had acquired five more Harnetts, bringing his total for this artist to seven works.

Harnett, it would seem, had been definitely established. An augmented version of the *Nature-Vivre* show had toured the country in 1940, making his name known from coast to coast. His works were being included in all the American historical exhibitions and in most of the exhibitions which dealt with the forerunners of modern art, and reproductions of them were appearing in all the books: Wolfgang Born's *Still-Life Painting in America* contained no less than sixteen. The final proof of Harnett's triumph as an American old master was manifested when contemporary painters, like Hananiah Harari, began to imitate his subjects and his mannerisms.

The time had come for a searching study of William Michael Harnett's life and his achievement as an artist. No real research had as yet been done on him. Born's book, published in 1947, presented nothing new about Harnett and contented itself largely with speculation; for the rest, the literature contained only news reports concerned with the acquisition of Harnett's canvases by museums and private collectors and a scattering of articles having to do with the esthetic and psychological character of his paintings.

That an immensely important collection of Harnettiana had reposed unexplored since 1939 in the safe at the Downtown Gallery was known to very few. This collection had come to Mrs. Halpert as a result of the *Nature-Vivre* show. The publicity connected with that event eventually reached a gentleman named William Aloysius Blemly, who sat in a black alpaca coat in an old, Dickensian real-estate office on Ninth Avenue. As a child, William Aloysius Blemly had known William Michael Harnett. His father, William Ignatius Blemly, had worked at the same bench with him in the New York silver-engraving shop of Wood and Hughes; twenty years later Ignatius Blemly had been one of the pallbearers at Harnett's funeral, and from the middle

'eighties until 1895 he had carefully kept all the clippings, photographs, and other memorabilia relating to his friend which he was able to find. All this material had been pasted, at some unspecified time, into a scrapbook of 106 small pages, which Aloysius Blemly sold to Mrs. Halpert. The scrapbook contains, among many other things, two crucially important catalogues—one devoted to an exhibition of Harnett's paintings held at Earle's Galleries in Philadelphia immediately after his death, in November, 1892, and the other, previously known and mentioned above, concerned with the sale of his effects at Birch's auction rooms in the same city in February of the following year.

The Earle catalogue, several more copies of which have since come to light, is a four-page folder listing thirty-eight of Harnett's works, by title only; the fourteen lenders of these works are also listed, but separately, and there is nothing to indicate who lent what. The Earle catalogue also contains a biographical sketch by E. Taylor Snow, practically identical with the one in the Birch catalogue, and on its front cover is a drawing, signed by Snow, employing Harnettian motifs—a "card rack," the big horseshoe which Harnett had used as a model in a known painting, the flute and books and candlestick which appear in many of his pictures, and the artist's big palette framed in a shadow box, just as I eventually found it in the home of Snow's daughter.

The Birch catalogue is a much more involved affair than the Earle. It runs to thirty pages and includes detailed listings and many supplementary descriptions of everything Harnett left behind at his death—twenty-five drawings, thirteen paintings, and nearly four hundred objects, or lots of objects, which he had used as models. The catalogue also provides photographs of many of these objects and of some of the paintings as well. Four of the paintings had been recovered by 1946; everything else seemed lost for good.

For the rest, the Blemly scrapbook contains all manner of clippings relating to Harnett, photographs of paintings by him both known and unknown, and a complicated miscellany of other things, including calling-cards, patterns for engraving on silver, even a receipted bill for shipping a

The Problem
and Its Solution

painting on the German state railroads. The material had been pasted into the book according to no perceptible plan or chronology, and most of the clippings are devoid of notation as to their date or source.

It was apparent, even at a casual glance, that the Blemly scrapbook was crammed with clues whereby "new" Harnetts might be discovered. There was, for example, the list of fourteen gentlemen who had contributed to the Earle show. This show, the catalogue clearly stated, was primarily a loan exhibition held to honor the artist's memory, and twenty-four of the thirty-eight canvases it contained were not for sale. It therefore seemed very likely that the descendants of at least a few of the fourteen lenders might still possess the Harnetts their fathers or grandfathers had owned, and that some of these descendants might be found. This supposition proved to be correct; and the newspaper clippings in the scrapbook were equally helpful. One example might well be cited now.

On page 65 of the scrapbook is the following clipping:

A FINE PICTURE

In the drug store of I. N. Reed may be seen an oil painting that will bear inspection. It is from the brush of Wm. M. Harnett of New York, whose paintings rank among the best in the world, some of them selling for fabulous prices. This picture is not large. It represents a table on which is a violin, a few books, a candle, a copy of the Blade, etc. It is not a picture that would attract the unappreciative eye, but to the man of intelligence it will increase in interest the more he studies it, while the artist would be charmed at first sight. The subject is a plain one, but the artist has made it so perfect—so like the real—that in looking upon it you are likely to forget that it is a picture and feel that you are looking upon a true violin, a genuine candle, etc. The highest triumph of artistic genius is in approaching the actual—in the perfect reproduction of the subject presented. This is a picture well worth seeing, and those who can appreciate the true and the good will no doubt find pleasure in looking upon it.

Blemly, as usual, had not given the source or date of this clipping, but a famous old journal called the *Blade* has been published for years in Toledo, Ohio. I accordingly visited Toledo, went to the court house, and called for the will of I. N. Reed. It was there, and it showed that when Isaac N. Reed died

on October 3, 1891, he had left all his property, including his drugstore, to his wife. Mrs. Reed died on December 25, 1914: her heirs were her son, Oliver Clayton Reed, and her daughters, Marion Reed Kirtland, Edna Reed Montgomery, and Mabel Reed Smith. The current Toledo telephone book revealed no Oliver Clayton Reed and no one named Montgomery, while to look for a Mrs. Smith in a city of 300,000 was obviously a hopeless task. But the Toledo directory did contain the name of Harry B. Kirtland, attorney at law. A quarter of an hour after my call on Mr. Kirtland I added a beautiful "new" Harnett to my bag (plate 66), for the late Marion Reed had been Harry Kirtland's first wife. Total elapsed time in Toledo: forty minutes. But it was not all as easy as that; some of the clues in the Blemly scrapbook led for years through thickets and jungles of research, only to fizzle out in the end. And the hunt for hitherto unknown Harnetts had to be dropped entirely for a time because of startling and unexpected developments which were forthcoming as soon as I took up another phase of the work.

IV

SEEING PHOTOGRAPHS of paintings is one thing; seeing the paintings themselves is quite another. Similarly, obtaining a general impression of a show in order to write an article about it for a newspaper is not in the least like studying pictures individually and in minute detail. It soon became apparent that establishing criteria for Harnett's style, which had at first seemed a simple matter, was going to be an exceedingly difficult task and one which might never be accomplished at all. The Harnetts shown me by collectors, dealers, and museum directors were in at least a dozen different styles, some of them exceedingly crude, inexpert, and tasteless. Mrs. Halpert had warned me about Harnett forgeries, but although a dealer is privileged to reject a painting for any reason that appeals to him, an art historian has to prove his rejections (to say nothing of his acceptances), and I could find no ground for elimi-

*The Problem
and Its Solution*

nating anything as provable forgery. All the pictures were obviously fifty to eighty years old: there was always the argument that the poorer ones were early efforts, and I could neither establish nor contradict this on the basis of the information which I then possessed. I could not even talk intelligently about "early Harnett" because I did not know for sure when he had begun to paint. In one of the two versions of his biographical sketch E. Taylor Snow stated that Harnett did his first oils in 1874,[5] yet there were two well-known pictures (*Off to the Opera* and *Raspberries and Ice Cream*), both indubitably oils, which bore Harnett's signature and the date 1870.

As I traveled about the country, seeing more and more Harnetts and finding more and more pieces of the puzzle that did not fit together, I worked out a program for tackling the stylistic problem in several successive stages. The poorest pictures had all come to light after the Harnett revival was well under way. They had passed through the hands of people who had had no experience with Harnett and so had no basis of comparison for their attributions: furthermore, with one or two exceptions, very little had been made of them; they had not been exhibited or reproduced to any appreciable degree, and many of their owners did not regard them as works of any particular importance. It seemed to me, therefore, that this group of about thirty pictures could

well be left for later study, and that, although I obviously had to see and make note of everything offered as Harnett, I should be on the safest ground if I approached the formulation of my criteria through those works which had been known from the earlier years of the Harnett revival and had been generally accepted by the art world. Meanwhile, biographical research would continue, and, I hoped, enough material would finally be collected to fill out the entire picture and provide sound reasons for placing the dubious canvases in or out of the Harnett canon.

I also came to realize that one could approach a definition of Harnett's style only through the unfashionable esthetics of his own patrons. In the beginning of the revival much was made of the parallel between Harnett and Pierre Roy and other contemporary painters; later it was the smart thing to psychoanalyze him on the basis of his iconography. I was, and remain, sympathetic to the first attitude, although the second seems to me no more than a pretentious, pseudoscientific effort to cater to the make-the-picture-tell-a-story trade;[6] at all events, regardless of one's opinion of these modern points of view, they were clearly catastrophic pitfalls on the road toward criteria for Harnett's way of working. One had to adopt the attitude of the village half-wit who found a lost cow when everyone else had failed and who, when asked how he had done it, replied, "I just figured out where I would go if I was a cow, and I went there and there she was." In other words, it was necessary to think of these paintings with the minds of people for whom "the highest triumph of artistic genius is in approaching

[5] The only important discrepancy—if discrepancy it can be called—between the two editions of Snow's brief biography is on this point. It is in the Earle catalogue that Snow makes the assertion cited here; in the Birch he merely says that in 1875 Harnett abandoned the silver-engraver's trade to devote himself entirely to painting. The Birch statement does not rule out the possibility that Harnett might have been working in oil for a decade before he became a full-time painter, and this possibility seemed, in the nature of things, altogether credible. If the Earle statement was to be believed, Harnett fought shy of oil throughout seven years of instruction in three different art schools, did not take up this medium until he was twenty-six years old, and then, with only one year's experience, set up shop as a professional oil painter. It seemed far more likely that Harnett had been working with oil as a student and amateur long before 1874, and this view was apparently corroborated by an interview he had given a reporter for the New York *News* in 1889 or thereabouts. This article, a copy of which is in the Blemly scrapbook, is clearly the source for much of the information about Harnett which Snow provides; in it the artist himself gives no specific date for the start of his career as an oil painter, but simply says he embarked on his full-time professional activity in 1875. Later research has shown, however, that Snow had excellent reason for saying what he did say in the Earle catalogue. Curious as its implications may be, we now possess proof—to be adduced at the proper place—that Harnett actually did not paint a single oil before 1874.

[6] "In 1881 he (Harnett) painted *Old Souvenirs* . . . Assembled on a wooden wall are booklets, a newspaper, the photograph of a little girl, some prints, a poster, and the ubiquitous letter, which arouses our curiosity but does not give us the full story of the souvenirs. They are his own souvenirs, hinting at the more profound aspects of his thought. The miscellaneous souvenirs on the letter rack conceal rather than disclose the experiences for which they stand, but the fact that the poster in the center advertises fire insurance suggests that 'inside' there is danger of a conflagration . . . [Ellipses in the original text.]

". . . The slips of paper . . . may betray something the painter chose not to reveal directly. If the fire insurance poster really suggests a smoldering desire, the photograph of the little girl might suggest that the actual content of the old souvenir is the restrained lament of a solitary man who longs without hope for the return of a childhood love." Wolfgang Born, *op. cit.*, pp. 32–33. (The little girl in the photograph has been identified. She is still alive and plays an exceedingly important part in our proceedings.)

The Problem
and Its Solution

the actual—in the perfect reproduction of the subject presented." In these lines the *Blade* neatly set forth the esthetic principles of those who bought the paintings of Harnett when they were new—not, be it well noted, the general esthetic orientation of Harnett's time—and these principles, I felt, provided the only safe guide for the historic approach to Harnett's work. If the story told by this or that canvas should seem mysterious, one might rest assured that the mystery arose not from some subconscious revelation of personal secrets, but from the simple fact that we had lost the key to a juxtaposition of objects which might today seem arbitrary or unrelated but which in its own time, and to the proper person, was perfectly logical and overtly significant. Consequently every book, every inscription, every postage stamp represented in these pictures had to be scrupulously noted down. Finding the keys would, to be sure, rob the mysterious works, especially the card racks, of their enigmatic appeal; I therefore rejoice in the fact that such partial keys as I have been able to discover have only increased the mysteries rather than dispelled them. I am also glad that my theory regarding these paintings proved to be wrong in certain instances—some of the card racks to be discussed in this book do seem intended as "arbitrary juxtapositions of unrelated objects"—although the method of research evolved on the basis of the theory proved altogether correct when it came to placing the pictures in their proper historic perspective.

An excellent example is the painting to which was given the title, *To Edwin Booth* (plate 119). This floated to the surface fairly early in the revival years, was acquired as a work of Harnett by A. Conger Goodyear, who was then the president of the Museum of Modern Art, and was widely exhibited and reproduced. The picture represents an eighteenth-century Philadelphia playbill across which is a five-dollar note and a letter addressed to Edwin Booth at the Players Club in New York; jutting out from behind the playbill is the first page of the catalogue prepared for the sale of an art collection which had belonged to a man named Leaming. This work is signed "W. M. Harnett, 1879." No one observed, however, that the five-dollar bill is clearly inscribed, "Series of 1880." No one picked

up the telephone to ask when the Players Club was founded (1888), nor went to the library to find out when the Leaming sale was held (April 4, 5, and 6, 1893, following the death of Dr. James Rosebrugh Leaming of New York on December 5, 1892, five weeks after the death of Harnett himself). These data do not explain why the picture was painted or what it "means" in a literary sense but they do establish very clearly that Harnett, far from having created this work, could never even have seen it. There is good reason for believing that *To Edwin Booth* was actually painted by a very obscure New York artist named Nicholas A. Brooks. This reason, and a little more data on the Goodyear picture, will be found in the paragraphs devoted to Brooks in a later chapter; the point of telling the story now is simply to bring out the fact that this Brooksian goat could not have been separated from the Harnettian sheep by a critical method based on the philosophy that subject matter doesn't count.

V

TEMPORARILY REDUCING the number of pictures to be studied likewise reduced the number of stylistic questions to be answered, but did not by any means eliminate them. After intensive inspection of all the paintings which formed the accepted Harnett canon as it existed in 1947, and disregarding unessentials and minor issues, I formulated three basic, crucial questions, all of which had to be answered before one could say one really knew anything about Harnett at all. The first of these was why Harnett had apparently painted in two quite different manners interchangeably throughout his career. The second was why, although he had signed everything, he had failed to affix dates to certain works. The third was why he had dated two canvases after his death.

The first problem, that of the two styles, is difficult to illustrate by means of photographic reproductions. For the sake of a simple terminology, I called one the "hard" style and the other the "soft."

Examples of the "hard" style outnumbered the "soft" by at least four to one. The foremost char-

The Problem
and Its Solution

acteristic of the "hard" [7] style (plate 3) was its fanatical concern with differentiated textures. As Snow had said in the Birch catalogue, quoting a previous writer, Harnett's "brass is brass, his wood, wood," and every other texture—those of paper, porcelain, stoneware, fur, cloth, leather, ivory, iron, the skins of fruits, the petals of flowers, and so on—was set forth with equally convincing realism. For this reason, these pictures had an extraordinary tactile appeal. People were always fingering them, giving as their excuse a desire to test whether or not actual objects had been glued to the canvas, but their real reason was that the painted textures aroused such strong tactile associations as to invite appreciation through touch as well as through sight.

No matter how close one came, the surfaces of these paintings never lost their brittle, crystalline effect; furthermore, they continued to yield details even when one reached the nose-on level of examination by low-powered microscopes, which sometimes brought forth painted minutiae, like splinters or shavings in the groove of a door, which were not visible to the naked eye. It was only when high-powered microscopes were used that the pictures began to dissolve into their components and ceased to speak in descriptive terms; and it was only then that one perceived the individual brushstrokes of which they were composed.

Compositions in the "hard" style seldom employed much depth. Very often the eye was almost immediately stopped in its backward progress by a door or wall against which the represented objects were hung. Even when the objects were disposed on table tops, they had a way of crowding forward toward the front, and frequently a matchstick, a knife handle, or the corner of a newspaper seemed to cut right through the foremost plane of the picture and enter the spectator's own space. The light also was deployed toward the front; in its illumina-

tion, the edges and contours of all objects were represented with razorlike sharpness, and the spatial placement of each object was indicated with the utmost clarity. If the top or fore edge of a book figured in the first plane of a painting in the "hard" style, each individual page would be indicated; book titles and every last curlicue of tooling or gold stamping on a binding would also be there. As objects receded from the front plane and from the light, their edges would soften somewhat and they would be less meticulously described, but their placement and their spatial relationship to every other object in the painting was always carefully considered; one always knew where a thing *was* if it figured in a "hard" style picture.

Except for the tendency to use little depth, the "soft" style (plate 2) was almost the exact reverse of this. In the vast majority of instances there was no effort to differentiate textures at all. Everything was set forth in terms of precisely the same texture —a soft, muted, radiant, powdery surface that had caused more than one critic to invoke a parallel with Vermeer of Delft. Occasionally, however, only the principal objects in a "soft" style painting were done in the Vermeer-like manner, while the backgrounds were roughly stippled.

The lack of textural differentiation was compensated for by much stronger contrasts of light and shade and a more brilliantly contrasted use of color. There was no tactile appeal; consequently no one stepped up to touch these paintings, and in none did any object cut through the picture-plane into the spectator's space. Edges and outlines were soft, woolly, or feathery throughout, details like the pages, titles, and ornamentation of books were completely absent, and spatial relations were often quite ambiguous: whereas in the "hard" style the air between a beer stein and the wall behind it was always clearly perceptible, in the "soft" style the stein often seemed to merge with the wall or press into it. In general, the "soft" style involved considerably less realism than the "hard" and no eye-fooling artifice at all; on the other hand, thanks to the refinement of its texture and the power of its color, it was more satisfying from a purely esthetic point of view.

The problem of the undated pictures can be some-

[7] These terms have been criticized by some of my friends in the art world on the ground that they convey invidiously critical and even moral implications. I admit that they are far from satisfactory, but all the substitutes for them which have been proposed are even less desirable. I can only go on using these words, making it clear that they are intended in a strictly descriptive sense, without any honorific overtones whatever. If you must, in place of "hard style" and "soft style" read "Style A" and "Style B."

The Problem
and Its Solution

what more briefly set forth. Harnett had signed all his paintings and had dated the vast majority of them. There were Harnetts dated in every year of the artist's career from 1876 to its close with his death in 1892, but there was also a small group of pictures which were not dated at all, and these resisted every effort to place them at a given point or points in the procession of Harnett's work.

Some of the undated pictures had been assigned to the late 1870's because they were on pieces of academy board bearing the label of F. Weber and Company, the Philadelphia firm of dealers in artists' materials; it was known that Harnett had worked in Philadelphia until 1880, when he went to Europe, and it was assumed that a picture of his on a piece of academy board purchased from a Philadelphia supply house was probably created in that city. Investigation showed, however, that F. Weber and Company did not assume this name until 1887, by which time Harnett was well established in New York. To be sure, Harnett might have purchased materials from Weber no matter where he lived, but the paintings on F. Weber and Company's board had, obviously, to be reassigned to a considerably later period than that originally suggested.

A study of the dated pictures established the fact that Harnett had, at various stages of his career, shown special preference for certain models, but the undated works dealt with an entirely different set of models, and so the iconographic approach proved useless so far as dating the undated was concerned.

The problem of the two posthumously dated pictures was, in all its ramifications, the most complex of all. As is pointed out above, there was a rack picture entitled *Old Reminiscences* (plate 4), originally exhibited at the *Nature-Vivre* show of 1939 and later sold to the Phillips Gallery in Washington, D.C., in which, painted as if whittled into the door, was the date, "1900," eight years after Harnett's death. This had been spotted when the painting came to light, since the numerals were at least an inch high; it had been explained as a little surrealistic *jeu d'esprit* on Harnett's part. That another rack picture of the *Nature-Vivre* show, *Old Scraps* (plate 6), now the property of the Museum of Modern Art in New York, was also posthumously

dated was apparently not observed until 1947.

In fact, a detailed examination of *Old Scraps* disclosed several quite astonishing things. At the top right corner of the rack (plate 8) were two painted envelopes (or what I took to be envelopes; one of them was actually a Government penny postcard), bearing the painted postmarks, "Lerado, Ohio, Nov. 8, 1894," "Cincinnati, Ohio, Nov. 7" (no year), and "Milford, Ohio, Nov. '94" (no day). At the lower left of the rack (plate 10) was another envelope, also with a postmark, but someone had removed the name of the town from this with a knife, scraping off the first layer of the paint at that point but leaving undisturbed the date—"Dec. 7, '94"—and the first initial, "N," of a state abbreviation.

There was a fourth envelope in the painting, at the lower right corner of the rack (plate 9), postmarked "Newark, N.J. Oct. 20" (no year). The inscription on this envelope was rather strange. It was partly covered by the tape of the rack itself, but one could read "Mr. . . . Harnett . . . 15th Str / Phila. Pa." Now, I had been over city directories and other documents and had worked out an apparently complete record of Harnett's addresses for every year of his life in the United States; there was no evidence to show that he had ever lived on Fifteenth Street in Philadelphia, ever had a studio there, or was ever connected with that thoroughfare in any way.

One of the envelopes at the top of the rack (plate 8) bore the address, ". . . lings / & Wharton St. / Philadelphia, Penn." The envelope with the scraped postmark (plate 10) also bore an address, but it was pushed so far under the tape that one could read only a capital "M," below it the figure #, often used as a symbol for the word "number," and, in one corner, the words, "In haste."

The Blemly scrapbook contained a clipping, taken from the Philadelphia *Evening Item* for June 11, 1895, wherein George Hulings of Fourth and Wharton Streets, Philadelphia, told several stories about his friend, the late William Harnett; this interview also stated that Mr. Hulings then owned several of Harnett's paintings, including one which represented "a home made card and letter rack made of tape in which has been placed a number of cards and letters from his friends." It seemed logical to

assume, because of the first of the two inscriptions just mentioned, that *Old Scraps* was the rack painting which had once belonged to Hulings, but there was no way of explaining why it was dated in three places two years after Harnett's death. And when the handwriting of the addresses on this painting was studied, still more mysteries presented themselves.

Each of the addresses was clearly in a different hand. Furthermore, each was in a different medium. The ". . . lings / & Wharton St." inscription was in a small, fine script. It had been placed on the paint film in ink, with a pen; below the first layer of the pigment in the same area there seemed to be another inscription which had been painted over before the pen-and-ink inscription was applied. The "Harnett / 15th Str." address was in a bold hand and in a mixture of ink and paint; the paint was underneath the ink at certain spots, while at others no paint was perceptible. The third inscription, "M / #" and "In haste," was in a relatively large, flowing, and elegant style and was entirely in paint; it showed no evidence of tampering or overwriting of any sort.

Comparison of the inscriptions on *Old Reminiscences,* the Phillips Gallery picture with its unexplained "1900," with those on the Museum of Modern Art's *Old Scraps* proved most interesting, to say the least. Like *Old Scraps, Old Reminiscences* (plate 4) had three inscribed envelopes. One of these read "Mr. W . . . Harnett / . . . Locust St. / Philadelphia." (As pointed out above, Harnett occupied a studio at 400 Locust Street, Philadelphia, from 1877 to 1879.) This address was in the same small, fine script as the ". . . lings / & Wharton St." of the Museum of Modern Art picture, and it, too, had been applied in ink, with a pen, and over another, preëxisting inscription. The address on another envelope of the Phillips Gallery picture was almost completely covered, and only a single capital "M" could be read. The third envelope bore the word "Proprietor." Both these inscriptions were in the same large, elegant handwriting as the "M / #" and "In haste" of *Old Scraps,* and, like them, were in paint, untampered with.

Tabulating this information will make it a little clearer.

OLD SCRAPS	OLD REMINISCENCES
Handwriting 1: ". . . lings / & Wharton St." in ink, over a preëxisting inscription now illegible.	*Handwriting 1:* "Harnett/Locust St." In ink, over a preëxisting inscription now illegible.
Handwriting 2: "Harnett / 15th Str." In ink and paint, the ink over the paint.	*Handwriting 2:* Not present.
Handwriting 3: "M / #" and "In haste." In paint alone. No evidence of tampering or overwriting.	*Handwriting 3:* "M" and "Proprietor." In paint alone. No evidence of tampering or overwriting.

It seemed probable after inspection with the naked eye that only Handwriting 3 had been present on these two pictures at the time they were painted, and this opinion has since been confirmed by laboratory analysis. Handwritings 1 and 2 were later additions, placed on the canvases by persons unknown.

None of these three hands was that of William Michael Harnett; this has been corroborated by two of the country's leading experts on handwriting, Clark Sellers of Los Angeles and Albert Osborn of New York, who were given proven samples of Harnett's handwriting and who were consulted on every phase of this research coming within their special field.

Handwriting 3, the one in paint and the one which shows no evidence of tampering or overwriting, occurs over and over again in other pictures. Handwritings 1 and 2 occur nowhere else, and cannot be associated with any known person, living or dead, nor does the ink medium in which they appear ever show up again. All three writers, however, left tell-tale traces of themselves.

The author of Handwriting 3, whose inscriptions are part of the original paint-film and were on the canvases from the day they were completed, conveys no information about Harnett and makes no effort to do so: he merely provides such cryptic words as "Proprietor" and "In haste." But the perpetrators of Handwritings 1 and 2, which are later additions placed on the canvases after they were finished, concern themselves exclusively with information about Harnett: in other words, these inscriptions were added to the paintings in order to emphasize Harnett's name in connection with them. Whoever was responsible for Handwriting 1 possessed correct information about Harnett—his Lo-

cust Street studio and his relations with George Hulings. The author of Handwriting 2 seems to have had no real information about Harnett at all and either gave him an imaginary address in the right town, or else—as seems more likely—inked over the entire preëxisting inscription in paint, changing the name to that of Harnett but leaving the address as it was.

Last of all, *Old Scraps* and *Old Reminiscences* are both on canvas-stretchers of light blond wood, with a ridge or beading all around its outer edge, and stamped "The Pfleger Patent, Patented Feb. 2, 1886." I had seen this stretcher on other paintings, all of them in the "soft" style; original stretchers on paintings in the "hard" style were invariably of brown wood, beveled rather than beaded on the outer edge, and bore no maker's mark.

VI

WITH THE three big unsolved problems in mind (two separate Harnett styles; a small group of undated and apparently undatable Harnetts; and two Harnetts, full of mysterious inscriptions, dated after the artist's death) I left New York on the afternoon of July 21, 1947, intending to drive to Philadelphia by way of a small town on the New Jersey shore called Island Heights. I went to Island Heights because Wolfgang Born [8] had told me that John Frederick Peto's daughter lived there, in her father's old studio, and there were two interesting references to Peto in the Blemly scrapbook.

Nothing was known about John Frederick Peto beyond the fact that a number of still lifes bearing his name had for some years been kicking around the galleries of various New York dealers. Two of them had found their way into permanent museum collections, those of the Minneapolis Institute of

Arts and the Wadsworth Atheneum in Hartford, Connecticut, but neither Minneapolis nor Hartford possessed any information about this artist; even his dates of birth and death were absent from their files. Peto was, in short, one of a large, completely unexplored group of painters whom the art world casually accepted and casually dismissed as "Harnett imitators."

One of the Blemly scrapbook references to Peto was a monogram, a capital "O" bisected by a capital "J," and in the free space within the circle of the "O" and to the right and left of the shaft of the "J" a peapod and a human toe. Next to this was the inscription "Monogram / of / Joseph Peto / 1872 / by / W. M. Harnett / W. I. B." A person named Joseph Peto may have existed, but to judge from all available evidence, it seems far more likely that the monogram was made for John Frederick Peto, and that William Ignatius Blemly, (the "W. I. B." of the inscription) was not sure of his first name.

The other reference was in a newspaper clipping:

HARNETT'S NAME FORGED

*It is Attached to a Painting by Another Man.
The Former Owner Surprised to Find It in "the Late
William Culp's" Collection.*

Among the collection of bric-a-brac, furniture, old prints, engravings and paintings, constituting that portion of the estate of the mysterious and undiscoverable "late William Culp," sold at Freeman's auction rooms a few days ago, was a still life painting representing a violin and bow hanging against a door, entitled "Hang Up the Fiddle and the Bow," and said to have been from the brush of the late William M. Harnett, whose autograph it bore in one corner.

And now the story leaks out that this picture was never painted by Harnett, but owes its origin to a young artist named Peto, but little known to fame, who is a modest follower of Harnett's style and who would consider himself lucky to realize one-fourth the amount brought by his picture at the sale referred to; a price that was low for a Harnett but large for a Peto.

The history of "Hang Up the Fiddle and the Bow" is simply this: The picture was purchased a number of years ago by a well-known Philadelphia newspaper publisher, who is a patron of the fine arts, and in course of time was relegated to the lumber room above his office, whence it was cleared out with a lot of other articles and sold at auction for what they would bring.

[8] I should like here to emphasize my indebtedness to Professor Born (who declined to accompany me to Island Heights) for the many courtesies he showed me before his sudden and untimely death in 1949. His *Still-Life Painting in America* performed an exceedingly valuable function: it brought together all that could be discovered about its subject by means of research in libraries. It is scarcely Professor Born's fault that the information obtainable in libraries was extremely slim, fragmentary, and ninety per cent wrong.

The Problem
and Its Solution

Discovered By The Former Owner

To its old owner's surprise it was discovered by him in "the late William Culp's" collection, hanging in a place of honor with colored draperies surrounding it, and Harnett's signature very much in evidence. What its journey had been since leaving its original owner it is impossible to state. It was probably resold several times, and it is but justice to the auctioneers to say that they acted with perfect good faith in the matter, and sold the picture for what it was represented to be. That the forgery of signatures on and the imitation of the work of foreign masters has been carried on to a great extent is a well known fact. Imitation Corots are a drug on the market, and the other French painters are copied to a greater or less extent, but it is a new departure to use this method in the case of American artists, where the fraud is bound to be discovered sooner or later.

This newspaper story is, of course, cast in a deliberately mysterious and provocative tone, and it remains largely unexplained.[9] Explained or not, it indicated that a visit to Island Heights might prove interesting.

Born did not know the name of Peto's daughter, but some boys in a soda fountain on the main street of Island Heights said she was called Mrs. George Smiley. Armed with this information, I soon found

a large, pleasant, red-roofed house before which stood a small sign in the form of a palette bearing the legend, "The Studio / John Frederick Peto."

Mrs. Smiley was there. She patiently examined my credentials, patiently listened to my story, and led me into the studio proper. Up to this point, it was clear that she thought me rather strange; as soon as I stepped into Peto's painting room, however, she must have thought me violently insane. For on ledges, shelves, and wall-brackets in Peto's workshop were the very candlesticks, pistols, lamps and other objects represented, over and over again, in paintings by William Michael Harnett (plates 12 and 13). There were also many paintings by John Frederick Peto in that studio, but I paid relatively little attention to them until later; at first I had eyes only for the models, which, it seemed obvious, Peto must have purchased at the Birch sale of Harnett's effects.

I asked Mrs. Smiley if her father had ever mentioned Harnett. She replied that he had spoken of him constantly—Harnett had, in fact, been Peto's ideal of perfection in still life painting. She told me that Harnett and Peto had known each other as young men in Philadelphia but had lost contact after her father had come to Island Heights in the 1880's. Peto, said Mrs. Smiley, had died in Island Heights in 1907. After his death, she and her mother had kept the house as it had been during his lifetime, partly out of respect to his memory and partly because it provided a picturesque, distinctive setting for their summer-boarder business. Mrs. Peto had died some years before my visit, but George and Helen Smiley remained proprietors of the Studio. Mr. Smiley also had business connections in New York, and in the summer of 1947 they were raising mink in their back yard.

It was obvious that the Harnett models in Peto's studio had at once to be photographed and otherwise recorded, and as I set about taking notes on them, Mrs. Smiley went off to find some clippings about Harnett she thought her father had left. Gradually I began to notice the innumerable paintings by Peto that were perched on the ledges, hung on the walls, and stacked in odd corners of the studio. Peto, it would seem, had not only possessed some of the Harnett models; he had also painted them himself. I picked up one of the Peto academy-board

9 Harold Lancour's *Catalogue of American Art Auction Catalogues, 1795–1942*, showed that the Culp sale had been held at Freeman's on March 17, 1893. The date of the sale having been established, it was not difficult to trace the story just given to the Philadelphia *Times* for March 23 of that year. I also discovered that on March 18, the day after the sale took place, the *Times* had published a long, lamely satirical account of it, mentioning the bad weather, the small crowd, the slow bidding, and so on, but saying nothing about Harnett or Peto. The *Times* reporter who wrote the story of March 18 had clearly received orders from above regarding the manner in which he was to handle it, and he had done his best with an unpromising subject. In 1950, while collating all the newspaper material on Harnett in preparation for the writing of this book, I observed an interesting and suggestive fact: the *Times* had given Harnett much more space than any other Philadelphia daily, was the only one to carry the news of his death on the front page, and the only one to cover his funeral and the sale of his effects at Birch's. In other words, it seems very likely that the publisher of the Philadelphia *Times* was a friend of Harnett's; in all probability, it was he who had originally owned Peto's *Hang Up the Fiddle and the Bow*, had discovered it, with the forged Harnett signature, in the Culp sale, and had therefore directed that the sale be covered in his newspaper as it was. (If he had exposed the forgery before the sale was completed, he might well have stirred up trouble with Freeman's; exposing it afterward was a much safer procedure.) The publisher of the Philadelphia *Times* in 1893 was a man named Frank McLaughlin, who, like Harnett, had been born in Ireland and raised in the Pennsylvania city. McLaughlin, however, was twenty years older than Harnett. He was a man of considerable wealth and prominence and he had a large family, but I have had no luck in my effort to locate his descendants and through them, perhaps, discover more specific evidence of his relations with Harnett. No doubt children and grandchildren of Frank McLaughlin are living in Philadelphia today, but the only descendant of his I could find was a grandson, Samuel Preston Moore, who has spent much of his life in Tahiti and has never been in touch with the McLaughlin side of his family.

The Problem
and Its Solution

pictures on which a Harnett lamp was represented. On its back was a label: "F. Weber and Company. . . ."

The Smileys fed me, listened to me, and observed with quiet interest when I produced photographs of pictures by Harnett and showed them how this candlestick across the room figured in that painting, and how that pistol was represented in this work. When I arrived at the rack picture owned by the Museum of Modern Art, I pointed out the Cincinnati, Lerado, and Milford postmarks, but before I could speak of their odd, posthumous dating, Mrs. Smiley interrupted, most diffidently, as if she did not wish to intrude with a silly remark, "Lerado, Ohio, is where my mother was born."

That night, the light in the Smiley's guest room went out only when the sun rose. I started a letter to my wife: "This house is full of William Michael Harnett's models. It is also full of paintings by John Frederick Peto. There is a connection between them, but I don't know what it is." And then something hit me, and all the mysteries began to solve themselves, and by morning there were no problems any more.

First of all, it dawned on me that if Peto *had* obtained any of the objects in his house at the Birch auction of Harnett's effects, they would undoubtedly be listed in the catalogue of that event, which, it will be remembered, is exceedingly detailed and runs to nearly four hundred items. I therefore went over the catalogue with microscopic attention. Only one of the models in Peto's studio corresponded to a listing in that pamphlet. This was a small stoneware ink bottle with the label of the London firm of F. and J. Arnold; this type of ink bottle is to be found in pictures by all the "Harnett imitators," and Harnett and Peto might easily have secured examples of it independently. So far as the other objects were concerned—the pistols, the candlesticks, the gate latch, and so on—there was no evidence, at least in the Birch catalogue, that Harnett had ever possessed them. To be sure, Peto might have obtained these things by gift or purchase directly from Harnett before the older artist's death, in which case they would not have formed part of the Birch sale, but this possibility was soon ruled out of consideration by subsequent discoveries.

Sometimes it requires the stress of special circumstances to make one aware of the significance of material which has long been in one's possession. I had realized, in a vague, unfocused way that certain paintings could be proven, from external evidence, to be works of Harnett. Some, like the Boston Museum's *Old Models* and the Farnsworth Museum's *Professor's Old Friends,* were reproduced in the Birch catalogue. Reproductions of others, like *My Gems,* at the National Gallery, and *Music and Literature* at the Albright-Knox were also included in the Blemly scrapbook. For still others, such as the Springfield's Museum's *Emblems of Peace,* the Wadsworth's *Faithful Colt* (plate 1), William Williams' *Old Violin* (plate 60), and *After the Hunt* (frontispiece), in the collection of the California Palace of the Legion of Honor, there were detailed contemporary descriptions which established Harnett's authorship beyond question. I had made no effort to segregate these externally provable Harnetts as a special group. I now did so. There were seventeen of them (today there are more than fifty), and not one of them involved any of the objects in Peto's house, the Arnold ink bottle alone excepted.

A second glance at the photographs of the externally provable Harnetts brought forth something considerably more important. Without exception, all were in the "hard" style. I then added the photographs of the seventy-odd paintings which were in the same style but had no pedigrees or other external proof of Harnett's authorship: the models in Peto's house still remained completely absent from view, save, of course, for that annoying ink bottle.

The next step was obvious. I assembled the photographs of all those paintings which represented the models in Peto's house, including those reproduced in plates 2 and 14. Inevitably and predictably, all proved to be in the "soft" style. But then I saw something I had not expected, even though it was something I ought to have seen weeks earlier: all the *undated* pictures were in this pile, too. I had utterly failed to make the elementary observation that the undated pictures, without exception, fell within one of my two stylistic categories. I had failed to make this observation because two "soft" style pictures did bear dates, and these had been just enough to con-

fuse the issue. But now I understood why I had not been able to date the undated works through their iconographic resemblance to works of Harnett whose dates were known: they all involved models which Harnett had never used.

Last of all, comparing my two stacks of photographs, I perceived the final, clinching fact. The externally provable Harnetts and the paintings which were stylistically consistent with them—nearly ninety canvases, all told—all exhibited signatures which were modest in scale and in the same type of lettering. The signatures on the majority of the "soft" style pictures, on the other hand, were enormous; furthermore, all were inconsistent, from a chirographic point of view, with those on the "hard" style paintings and were even inconsistent with each other: at least four radically different types of lettering were involved.

A careful check of the paintings in Peto's studio and in the homes of his neighbors, Howard and Cheston Keyser of Island Heights, confirmed the conclusion to which my work with the photographs inevitably pointed. Place one of these Petos alongside a "soft" style Harnett, especially one involving the same models, and it was impossible to see any stylistic difference between them (plates 4, 5, 6, and 7; 14 and 15; 17 and 18). Moreover, the Petos at Island Heights brought forth innumerable examples of Handwriting 3—the one hand which had been present on *Old Scraps* and *Old Reminiscences* from the beginning and the only one in which no information about Harnett was provided—as well as many Pfleger stretchers and Weber academy boards; these, my notes clearly showed, were not associated with a single provable Harnett nor with a single painting stylistically consistent with the provable Harnetts.

With this work, then, all the Harnettian problems had been solved and the long-sought stylistic criteria had been established. The "hard" style, and the "hard" style alone, was Harnett; the "soft" style was Peto concealed under forged Harnett signatures. Finally, a comparison of the signatures on the genuine and suspect paintings provided criteria by which true and false Harnett signatures might be differentiated.

All this seemed clear enough to me, however astonishing in its first, incredible revelation; proving it to others would, I realized, be a considerable job. Going back over the *Nature-Vivre* catalogue, I saw that seven of the fourteen works which that show had contained were Peto forgeries.[10] Confused standards for Harnett's style had been implanted in the minds of the art world from the very beginning, and although in later years many more genuine Harnetts than Peto forgeries had floated to the surface, the Peto forgeries had attracted an immense amount of notice and were in some of the country's most important public and private collections. And when, for nearly a decade, you have been told in authoritative tones that a certain thing is a certain thing, it may take an earthquake to convince you that it is something else. Even I found it difficult completely to accept my own findings, and I kept going back over my evidence and reasoning to see if they were watertight.

I had gone to Island Heights expecting to stay, perhaps, two hours; I remained five days, photographing, cataloguing, and digging through such documents as Mrs. Smiley had preserved. Among these was a Government penny postcard (plate 11) which Peto's father, who was in Philadelphia, had sent to the artist in Lerado, Ohio, on September 7, 1894. I was interested in this at first because it proved that Peto was in that Middlewestern village at about the time when *Old Scraps,* with its Lerado postmark of November 8, 1894, was presumably painted, but a second look revealed that the card was even more significant. For this card, or one of the same issue, had been used as a model in *Old Scraps* itself (plate 8): the Jefferson-head stamp and the legend "United States of America" in shaded letters were unmistakable, even though, beside the stamp, only part of the "c," the "a," and the period of the legend had been copied onto the canvas, the remainder of the card being covered by the envelope with the Lerado postmark. I took the card to the

[10] Here, and throughout this book, unless otherwise specified, the word "forgery" is used in a special sense, to imply paintings innocently and legitimately created by contemporaries of Harnett to which false Harnett signatures have been added by persons unknown. Ordinarily the word is used in art criticism to signify works made by one artist in the style of another with deliberate intent to deceive the purchaser. Harnett forgeries of this type are rare. All those known to me seem to have been produced by one person, Artist X, whose work is discussed in the Harnett catalogue on pages 174–175.

The Problem
and Its Solution

library of the Post Office Department in Washington: this design, replacing a completely different one, had been adopted on October 1, 1893 (nearly a year after Harnett's death), and had been put in circulation on January 2, 1894.[11] If, therefore, the representation of the postcard on *Old Scraps* could be proven to be part of the original paint film, then Harnett could not possibly have painted this picture and Peto's authorship of it could be regarded as certain. If, on the other hand, the card proved to be a late addition to the painting, there was still room to argue that Harnett might have done the rest.

I returned to New York and explained the situation to Alfred H. Barr, Jr., at the Museum of Modern Art. Mr. Barr immediately sent *Old Scraps* to Sheldon Keck, head of the laboratory at the Brooklyn Museum. Mr. Keck reported that the postcard was indeed part of the original paint film, and then, being Mr. Keck, he went over the entire canvas with a high-powered microscope. He discovered a smudgy, overpainted spot toward the bottom and to the right on the painting and requested permission to remove the overpaint at this point. This request was granted. The removal of the overpaint was done piecemeal and required several days. After the first day's work was over, Mr. Keck reported that he had found a signature: the first name, clearly, was "John." A few days later he had progressed to "John F. Pe . . . ," and finally he phoned Mr. Barr to inquire if he had ever heard of an artist named John F. Peto. (A date, "94," was also uncovered.) Peto's signature, similarly overpainted, has since been found on more than half of the "soft" style pictures which have been submitted to the laboratory for examination.

VII

TWENTY-ONE PAINTINGS formerly ascribed to Harnett must now, in my opinion, be given to Peto. These are as follows: [12]

1. *Old Books* (New York: Nelson A. Rockefeller)
2. *The Old Cremona* (New York: Metropolitan Museum of Art)
3. *Old Scraps* (New York: Museum of Modern Art) (plate 6)
4. *Box of Books* (New York: Alfred H. Barr, Jr.)
5. *Career's End* (Pittsburgh: Edgar Kaufmann)
6. *The Marked Passage* (New York: Alfred H. Barr, Jr.)
7. *Breakfast* (New York: Mrs. C. N. Bliss)
8. *Old Reminiscences* (Washington, D.C.: Phillips Gallery) (plate 4)
9. *Discarded Treasures* (Northampton, Massachusetts: Smith College Museum of Art) (plate 17)
10. *Old Souvenirs* (New York: Oliver B. Jennings) (plate 19)
11. *Old Friends* (New York: Alfred H. Barr, Jr.) (plate 2)
12. *Nine Books* (Chicago: Earle Ludgin)
13. *After Night's Study* (Detroit: Robert A. Tannahill)
14. *Protection* (Haverford, Pennsylvania: Mrs. H. Gates Lloyd) (plate 14)
15. *Research* (New York: Downtown Gallery)
16. *Sustenance* (New York: Julian Levy)
17. *For Sunday Dinner* (New York: Downtown Gallery)
18. *The Gray Jug* (New York: Morris Kantor)
19. *The Writer's Table* (New York: Edith Gregor Halpert)
20. *Mug, Pipe, Newspaper, and Biscuits* (Bel Air, California: Walter Reisch)
21. *Mug, Pipe, Newspaper, Book, and Candlestick* (Merion, Pennsylvania: Mrs. David Tendler)

These reascriptions do not depend upon any trick of circumstantial evidence or upon any kind of magical formula. They depend, in the last analysis, upon the fact that each of the reascribed pictures is in a style which is demonstrably Peto's and not Harnett's. Although iconography provided the first clues through which the forgeries were discovered, iconography slips down to a secondary, confirmatory role in the reascription once the entire matter has been studied in detail; in fact, Peto's authorship can be and has been proven without any iconographic evidence at all. The various chirographic factors also play a secondary role, but one which is rather more important than that of the iconography. A third confirming factor, although the least important in the chain, is that of the materials employed.

[11] See *A Description of United States Postage Stamps and Postal Cards*, Washington, 1927, pp. 45–46. (The "G" card.)

[12] The names of the owners in the accompanying list are as of 1953. A few of the paintings in private collections have since changed hands and cannot be traced today.

The Problem
and Its Solution

The manner of painting which has previously been described as the "soft" style is the manner of Peto's full maturity and was not completely developed until the late 1880's. His earlier work is rather loose and stringy; drawing is often inaccurate and the paint is laid on in rather slapdash fashion, without the rich refinement of the Vermeer-like surface. The contrast between early and late Peto is very marked; it is, in fact, so striking that it was at one time used as an argument against my views on this entire subject. Early, signed, incontrovertible Petos were compared with "soft" style pictures bearing Harnett's presumed signature, and since the difference between them was obvious, it was claimed that they could not be by the same hand. This argument can be maintained, however, only when early Petos are used as the standard of comparison, and it falls to the ground as soon as one becomes acquainted with Peto's work as a whole. As a matter of fact, two paintings in Peto's early manner—numbers 4 and 10 (plate 19) in the list above—bear forged Harnett signatures and passed for his work quite as easily as the pictures in Peto's later style. Both these early Petos with forged Harnett signatures can be specifically dated. Laboratory examination of number 4 brought out not only Peto's signature but a date indicated in a manner which Peto often employed: "11.84." (In other words, November, 1884.) Number 10 is a rack picture which includes, among other things, a newspaper dated ". . . ober 10, 1881," but, as we shall see, Peto made a rather significant change in this painting about twenty years later.

In order that the stylistic question might be answered as fully as possible, ten unquestioned Petos, ten unquestioned Harnetts, and eleven of the suspected pictures (numbers 3 to 7 and 10 to 15 of the above list) were submitted to Mr. Keck for examination by X ray; an X ray of number 8 taken in Washington was also available. Mr. Keck stated that in his opinion the radiographs of all the suspected pictures "reveal structure and technique which are closer to those found in radiographs of paintings by Peto than those found in Harnett."

The differences revealed by X ray are set forth as follows in Mr. Keck's report:

1. Harnett invariably used a fresh canvas, planned his composition and carried it through with no changes; Peto frequently used a canvas on which he had started or finished another picture and often changed his composition to a major or minor degree as he progressed in his painting.

2. Harnett used an indirect method of painting in that he first painted his objects in their local color over which he did his modeling or shadows in thin, glazelike paint; as a result, completely modeled objects often appear as flat, even densities in the radiographs, particularly objects which are made up of paints containing lead. Peto modeled his paintings directly, and the modeling is shown by different densities in the radiographs.

3. Harnett's backgrounds are usually painted thinly and do not visualize in the radiographs. Peto's backgrounds are generally more opaque and show density in the radiographs. Often they were painted after the objects were completed and are thinner as they approach the outlines of the objects. In the radiographs, a dark outline appears around Peto's objects as a result of this technique.

4. Harnett's lines, highlights, and edges are very sharp and definite; Peto's are fuzzy by comparison.

5. Harnett's brushwork is less distinct in the radiographs, areas of the same color on the surface showing an even, equal density in the radiograph. Peto's brushwork is broader and more broken, so that areas of the same color appear uneven in density in the radiographs.

At Mr. Keck's suggestion, numerous macrophotographs of details in Harnetts, Petos, and suspected paintings were taken. These "intensify their differences in style and technique. This is to be seen in the microscopic treatment used by Harnett as opposed to the broader, more heavily brushed technique of Peto. These confirm the already observed differences in style to be seen in the paintings themselves."

The chirographic question breaks down into three parts—inacceptable Harnett signatures, buried Peto signatures, and the handwriting of inscriptions other than signatures.

The standard Harnett signature (plate 16, right-hand column), one which he used throughout his career and practically without variation after 1880, can be analyzed as follows: It begins with a monogram; a "W" and an "M" are enclosed within a considerably larger "H," the "W" above the crossbar of the "H" and the "M" below it. The sidebars of the "H" are curved inward. The "ARNETT" is in printed capitals. The diagonal stroke of the "R" usually protrudes under the first vertical stroke of the "N," and the "R" often has a little flourish like a cockatoo's crest at its upper left corner. The first

2

John Frederick Peto (attributed to W. M. Harnett)
Old Friends (6 x 9)
Mr. and Mrs. Alfred H. Barr, Jr., New York

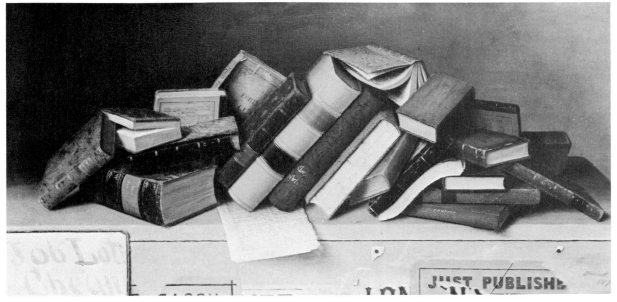

3

W. M. Harnett
Job Lot, Cheap 1878 (18 x 36)
Reynolda House, Winston-Salem, North Carolina

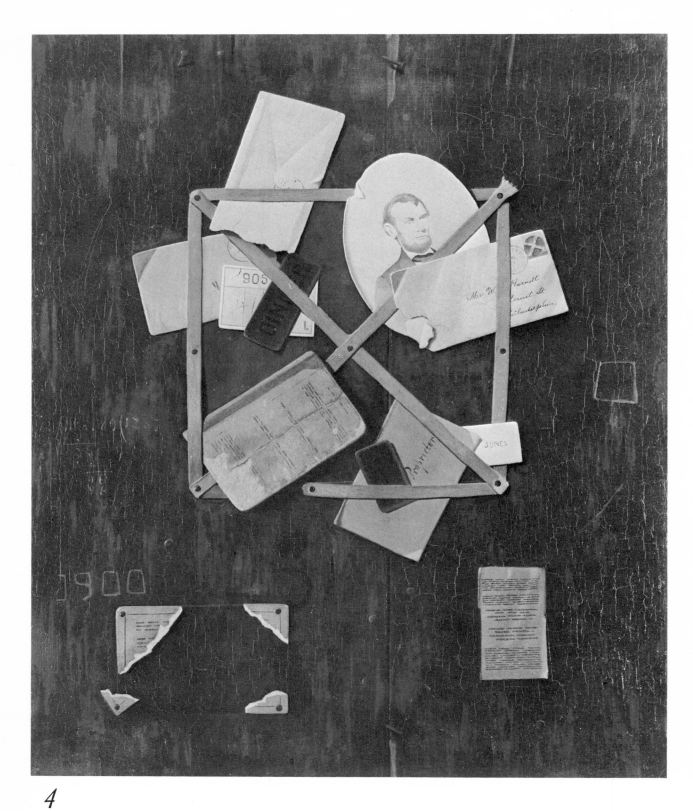

4

John Frederick Peto (attributed to W. M. Harnett)
Old Reminiscences (30 x 25)
Phillips Memorial Gallery, Washington, D.C.

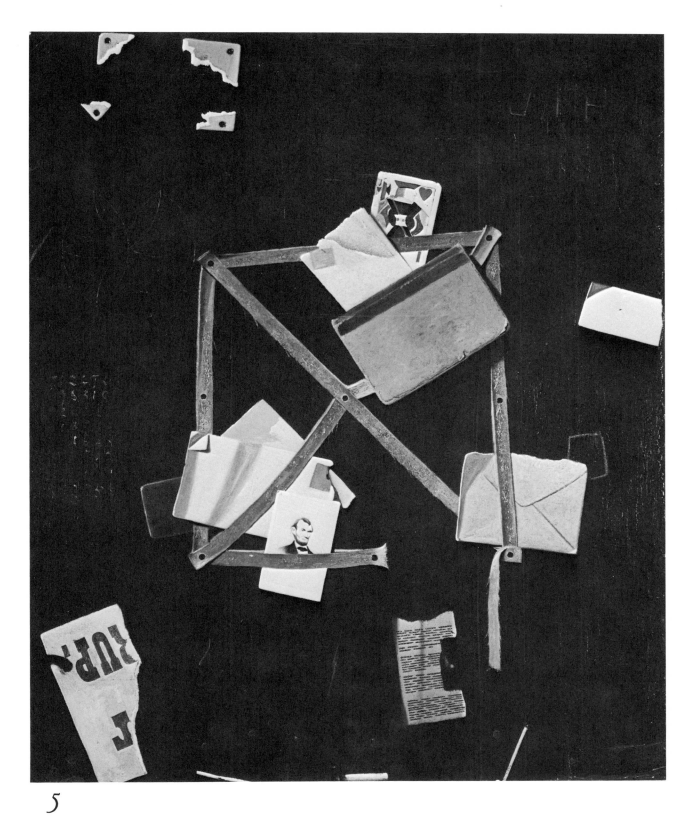

5

John Frederick Peto
Letter Rack with Jack of Hearts (30 x 25)
Mrs. Jacob Kaplan, New York

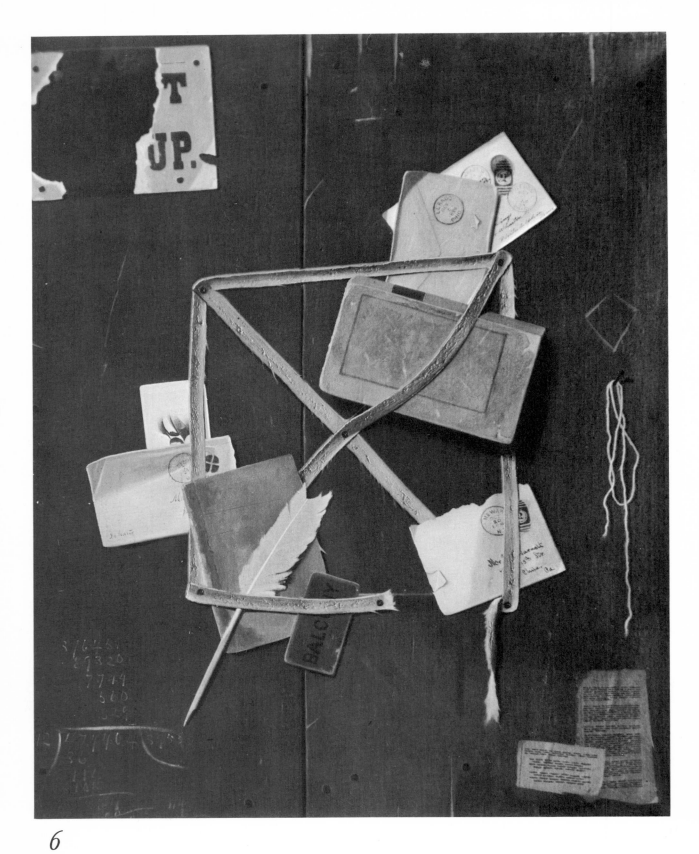

6

John Frederick Peto (attributed to W. M. Harnett)
Old Scraps (30 x 25)
Museum of Modern Art, New York, gift of Nelson A. Rockefeller

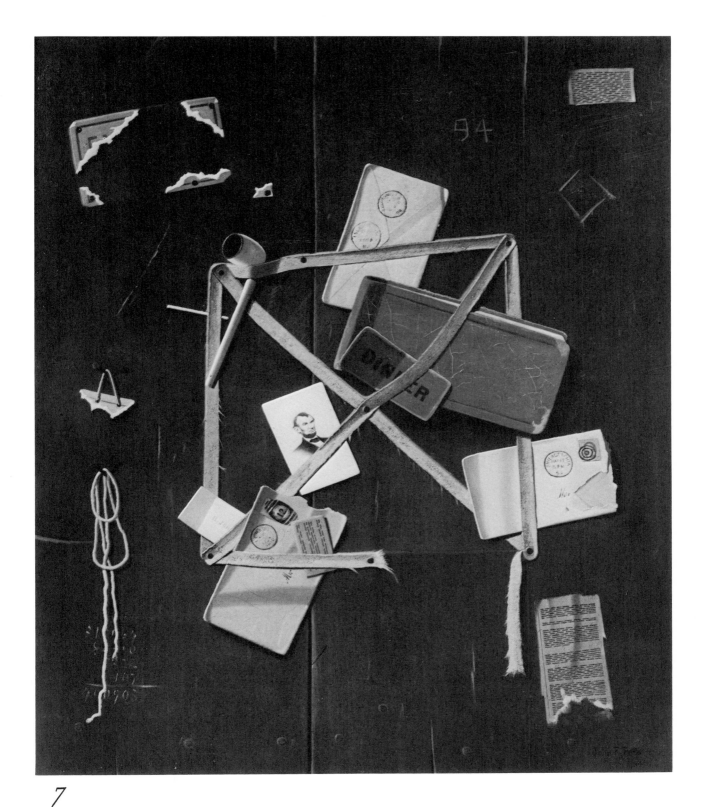

7

John Frederick Peto
Letter Rack with Lerado Postmark (30 x 25)
Museum of Fine Arts, Boston

8

Detail of *Old Scraps,* upper right, showing
Handwriting 1 and postmarks from
Lerado, Cincinnati, and Milford, Ohio.

9

Detail of *Old Scraps,* lower right, showing
Handwriting 2.

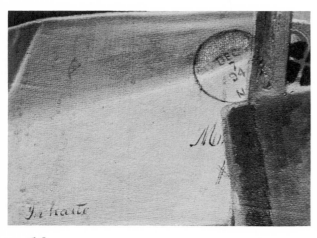

10

Detail of *Old Scraps,* center left, showing
Handwriting 3 and scraped postmark.

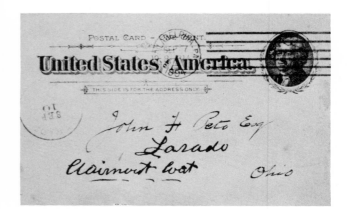

11

Postcard to John Frederick Peto
postmarked September 7, 1894.

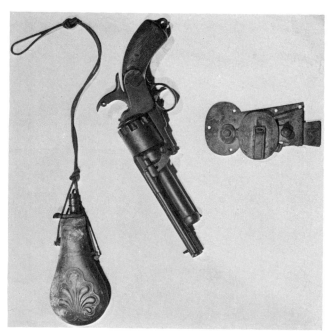

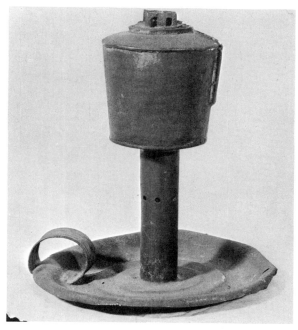

12

Objects found in the studio of
John Frederick Peto,
Island Heights, New Jersey.

13

"Lard lamp" in the studio of
John Frederick Peto, Island Heights, New Jersey
(cf. plate 2)

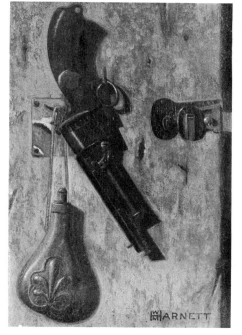

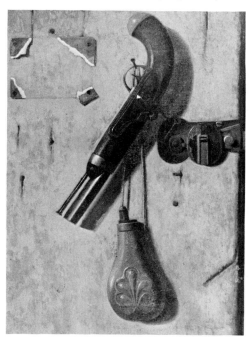

14

John Frederick Peto
(attributed to W. M. Harnett)
Protection (9 x 6)
Mrs. H. Gates Lloyd,
Haverford, Pennsylvania

15

John Frederick Peto
Pistol, Gate Latch, and Powder Horn (14 x 10)
Mr. and Mrs. Cheston M. B. Keyser,
Island Heights, New Jersey

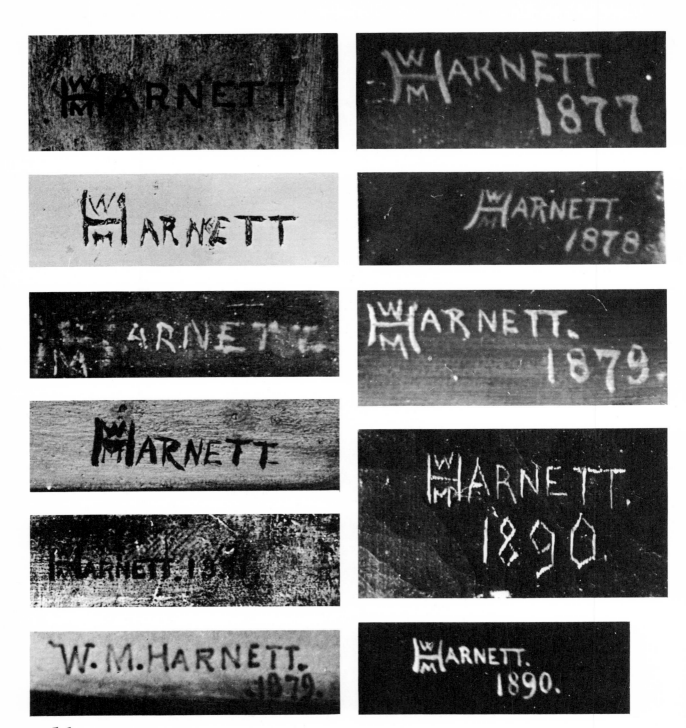

16

A montage of true and false Harnett signatures, by Albert S. Osborn. Forged signatures are in the left column, genuine in the right.

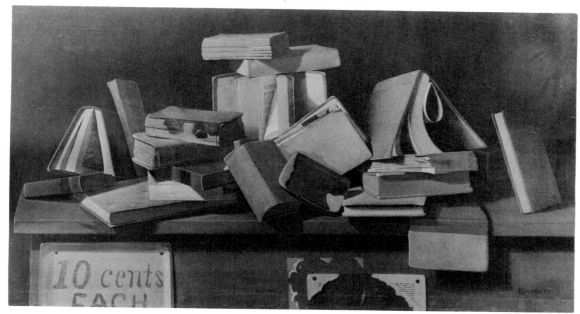

17

John Frederick Peto (attributed to W. M. Harnett)
Discarded Treasures (22 x 40)
Smith College Museum of Art, Northampton, Massachusetts

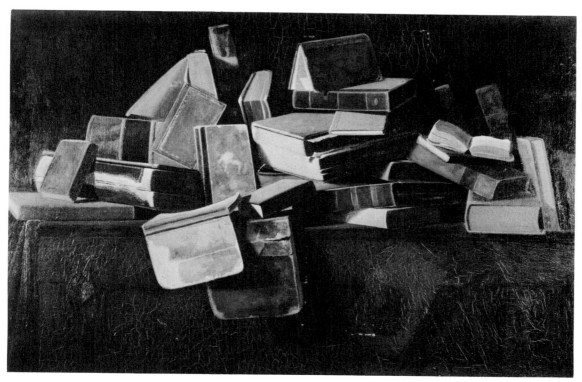

18

John Frederick Peto
Books, after 1890 (24 x 36)
Hawley Jaquith, Bernardsville, New Jersey

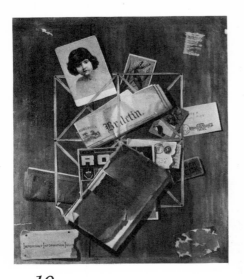

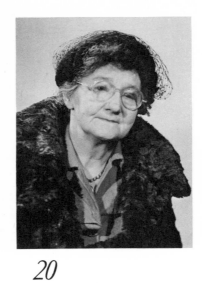

19

John Frederick Peto
(attributed to W. M. Harnett)
Old Souvenirs (27 x 22)
Oliver B. Jennings, New York

20

Helen Peto Smiley, 1951

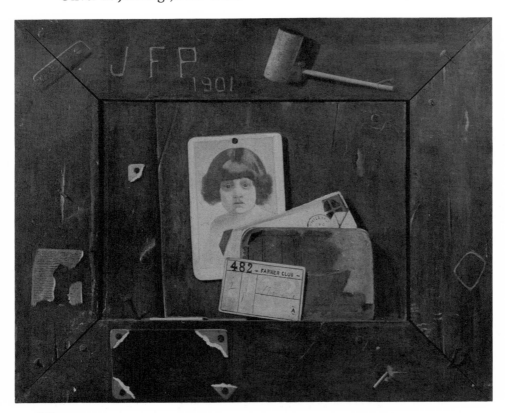

21

John Frederick Peto
Still Life with Portrait of the Artist's Daughter
(title from the tradition of the Keyser family)
1901 (12 x 14)
Howard Keyser, Island Heights, New Jersey

The Problem
and Its Solution

vertical of the "N" often extends below the base line and the second vertical above the crown line. The top horizontal stroke of the "E" is almost always shorter than the bottom horizontal. The two "T's" are always crossed with a single stroke, and there is often a period after the name. The "AR-NETT" is never on the same base line as the monogram. It is always a little above; sometimes the base line of the "ARNETT" is an imaginary projection of the crossbar of the "H." The date, invariably an unabbreviated year date, is always on a line by itself immediately below the signature and usually toward its right-hand end; the last two numerals of the date frequently project to the right of the final "T's." Paintings produced in Munich bear the name "München" on a separate line between the signature and the date.

There are three acceptable variants of this formula. In some of the early paintings (before 1880) the entire signature is slanted toward the right, as if it were in italic capitals, and in these the sidebars of the "H" are likely to be parallel rather than curved inward. In a few other early pictures, the monogram is similar to the one just mentioned, but the latter part of the name is in longhand rather than in printed capitals.

Regardless of period, whenever Harnett wants to pretend that his signature has been carved into a door (plate 16, right-hand column, second from bottom), he avoids curves except in the top part of the "R," the sidebars of the "H" are straight, the zeros in the dates are diamond shaped, and so are those parts of other numerals (6, 8, 9) which are ordinarily looped.[13] These "whittled" signatures are among Harnett's most amusing exercises in eye-fooling. Often one can see in them how the point of

the "knife" dug a little deeper as it turned a corner, and how, occasionally, the "knife" slipped out of its intended groove.

Harnett almost always placed his signature at a bottom corner of his canvas, either left or right. It is invariably modest in size. The artist always claims credit for his work and, with one single known exception, always tells the year in which it was done, but he never brags.

The forgers (not only those who forged Harnett's name to paintings by Peto but also those who added Harnett's name to paintings by others) wanted only to make quick sales to uncritical customers, and consequently few of them made much effort to imitate Harnett's signature convincingly (plate 16, left-hand column). The forged signatures are almost always large, and for a very good reason: they are calculated to strike the beholder in the face with Harnett's name.

The only characteristic of Harnett's signature which has been imitated with any degree of consistency is the monogram, but even this has been overlooked at least twice, and it has seldom been copied in its most frequent and typical form—with the sidebars of the "H" curved inward. Harnett's characteristic "R" has often been copied, his double "T" less often, his "E" almost never. The placement of the "ARNETT" on its high base line has often been overlooked, as has Harnett's confirmed habit with reference to dates. Only one genuine, finished, undated Harnett is known to exist. (It is unquestionably one of his earliest works.) The forgers usually affixed no dates at all, but when they did so, they often placed them on the same line with the "signature" and sometimes in abbreviated form.

Harnett applied his signature with a single stroke of the brush for each line of each letter; these strokes are of almost uniform width throughout, although they may thicken a little toward the bottom of a down stroke. A genuine Harnett signature has a lithe assurance, a kind of breathing plasticity, which is quite unmistakable. A forged Harnett signature is likely to be fussy, labored, and wavery—sometimes with several strokes to each line and with lumps or nodules here and there—or rigid, hard, and dead.

Buried Peto signatures have been found on num-

[13] At this point one should also mention the two very similar paintings which Harnett may be said, in a certain sense, not to have signed at all; both bear his name as an integral part of the composition and not as the separate entity one implies in the phrase "artist's signature." The first of these is *The Old Violin*, wherein Harnett's name appears as an address on a letter, and the date, "27 Avril 86," on the Paris postmark of the same envelope. The second is *Music and Good Luck*. Here the name is given on a calling-card, while the date, "1888," is "carved" into the painted frame. It is worth noting, by the way, that when Harnett signed his pictures in this manner he did not consider it necessary to add a signature of the conventional sort. The forgers who placed his name on the letters in *Old Scraps* and *Old Reminiscences* had not observed this point; they felt constrained to add conventional signatures as well.

The Problem
and Its Solution

bers 1 to 9 in the list given above. They were discovered with the naked eye on numbers 1 and 2. In number 1 the Peto signature can scarcely be said to have been "buried" at all; as soon as this painting was placed under a very bright light, preliminary to examining it with a microscope, it popped unarguably into view. In the case of number 2, which may very well be the *Hang Up the Fiddle and the Bow* sold at Freeman's in 1893, there were those who disputed the Peto signature, and it must be admitted that a passage in a painting which has come to the surface with time and repeated cleanings may be subject to conflicting interpretations. Albert Osborn, the handwriting expert, found the passage in question without prompting and without difficulty, and agreed that it was at least conceivably Peto's signature. According to Mr. Keck, "traces of an inscription into which the signature 'J. F. Peto' could have fitted were observed" on this canvas. Regardless of the problematical Peto signature, number 2 is in Peto's style, and the presumed Harnett signature which it bears is altogether inacceptable.

Laboratory work was required to bring out the Peto signatures on numbers 3 to 9. Numbers 3, 4, and 5 also yielded dates—"94" and "11.84," as we have seen, in numbers 3 and 4, and "91" in number 5. The Peto signatures on numbers 3 to 7 are very clear and unmistakable. They are somewhat less clear in numbers 8 and 9, but are still legible.

No Peto signatures were found by laboratory examination on numbers 10 to 15. Number 10 is a palimpsest; the picture on its surface is painted over another, and it is impossible to remove any part of the surface picture without running into the one beneath. It is significant, however, that Harnett is not known ever to have painted over a used canvas in this fashion, although Peto did so repeatedly. Smudgy overpaint similar to that found above the buried Peto signatures was located on number 12, but the owner had requested us not to remove any paint, and so we could not investigate further. A smudge suggesting that a signature had been removed was found on number 11.

It is not surprising that Peto signatures were, in some paintings, not forthcoming. It is surprising, rather, that so many were found. Unlike Harnett,

Peto left a large number of unsigned pictures, and, of course, it is possible that the forgers may have removed some Peto signatures which were originally present.

Numbers 16 to 21 in the Peto forgery list have never been submitted for laboratory examination, and so we have no evidence regarding possible Peto signatures on them. The Harnett "signature" on number 18 was scratched through the paint film with the point of a pin, a technique employed nowhere else among all the paintings discussed in this book.

The third chirographic question—that of inscriptions other than signatures—has already been dealt with in part. None of the paintings in the Peto forgery list bears an inscription in Harnett's handwriting, but numbers 3, 8, and 10 bear inscriptions in the handwriting of John F. Peto. Numbers 3 and 8 also bear inscriptions in unknown hands, these, and these alone, having been applied with ink over preëxisting inscriptions in paint. Several of the pictures, notably numbers 16, 20, and 21, exhibit Peto's characteristic manner of suggesting newspaper type with broken lines of black paint. Harnett's method for attaining the same result was much more laborious and much more successful; after he had laid down black, broken lines of the same sort, Harnett always crisscrossed the paint with a sharp point, producing something which people often declare they can read, but which is actually quite illegible. (On close inspection, Harnett's "type" looks oddly like Russian, but it would have caused Dostoevsky quite a little trouble.) Peto occasionally did something similar (as he did, indeed, in number 5 in the list), but much more crudely.

The following objects, all found at Island Heights, appear in unquestioned Petos and in the Harnett-Peto forgeries, but never in a provable Harnett nor in a painting stylistically consistent with the provable Harnetts. (After each entry we give in parentheses the number of the picture or pictures in the forgery list on which the object in question is represented as well as the numbers of the plates wherein photographs or painted representations of the objects may be found.)

1. Iron "lard-oil" lamp, seven inches high, six inches wide at the base. (6, 11; plates 2 and 13)

The Problem
and Its Solution

2. Combination candle snuffer and wick trimmer, iron, six and three-quarters inches long. (19)

3. Old French revolver, thirteen inches long. (14; plates 12 and 14)

4. Rusted iron gate-latch with traces of green paint, six and five-eighths inches long. (14; plates 12, 14, 15, and 91)

5. Iron candlestick with a lever for the ejection of the candle and a sharply bent hook on its lip, six and one-half inches high, three and five-eighths inches wide at its base. (13)

6. Mottled orange-covered book, with protruding leaves at pages 159–164; seven and one-quarter inches long, four and one-half inches wide, one and one-quarter inches thick. *The Eye,* by Obadiah Optic, Vol. I, Philadelphia. Printed and Published by John W. Scott, No. 147 Chesnut [*sic*] St., 1808." (In 13, as well as in 4, 15, and the fantastically problematical Peto, *Take Your Choice,* to be discussed in a moment.)

7. Portrait of Abraham Lincoln, oval steel engraving, heightened with pencil, nine and three-quarter inches high. This is an engraving after a Brady photograph originally published in oblong format with a border, by J. C. Buttre of New York, apparently in 1865. Peto removed the border, and the picture was nicked or torn at its upper left; it appears with this tear in all the paintings, questioned and unquestioned, in which it is employed. (8; plates 4 and 87)

There are in addition a number of models which appear in the forgeries and in unquestioned Petos but which have disappeared from Island Heights. One of these is a photograph of Peto's daughter at the age of seven or eight; it is used in a signed, unquestioned Peto of 1901 (plate 21) and appears at the top of the rack in number 10 (plate 19). This is the photograph of a little girl which, according to Professor Born's psychoanalytical interpretation of number 10, represents Harnett's "lament for a lost love." To be sure, Peto's daughter (plate 20) was not born until 1893 (the year after Harnett's death), and the painting is dated 1881 and belongs stylistically with Peto's other work of the early '80's, but the X ray shows clearly that the photograph of the little girl is a later addition and was painted over a preëxisting portrait, apparently of a little boy.

Number 10 also includes three other objects which appear in numerous Peto rack pictures of the same period but which are no longer in existence. These are a green pamphlet, always shown folded down the middle and bearing the title "Report" or "Report of the Pennsylvania Society," with varying dates; a small envelope, bright tan in color, inscribed with the words "Important Information Inside"; and a greeting card with a wide light-blue border on which a spotted lily has been painted and with a relatively small rectangular white space for the writing of a message. Other lost Peto models are a small photograph of Lincoln, quite different from the engraving just described, used in numbers 3 and 5 (plates 5, 6, and 7); and a mysterious-looking printed ticket (it appears in number 8), which, according to the Philadelphia *Inquirer* for February 24, 1893, is of a type then being issued by bookmakers at the racetrack in Gloucester, New Jersey (plates 4 and 21).

All these objects appear over and over again in Peto's known work and in pictures in Peto's style bearing inacceptable Harnett signatures, but never in a provable Harnett nor in a painting in the style of the provable Harnetts. None of them can be shown ever to have been in Harnett's hands. Admittedly, the catalogue of the Birch sale of Harnett's property does contain two omnibus entries—No. 246, "Lot Old Models," and No. 252, "Lot Models" —both of which can mean anything, but until someone discovers paintings in the "hard" style representing the objects just discussed, they will continue to point solely in Peto's direction.

Both Harnett and Peto were trained in the same school and worked in the same general area at the same time; consequently they used the same types of paints, glazes, and varnishes. But there are certain types of support which Peto often employed and Harnett, so far as is known, avoided. Among these is the Weber academy board, used in numbers 1, 6, 7, 11, and 12 of the Peto forgery list. Numbers 5, 14, and 15 are also on academy board, but the maker's labels have been removed from their backs. Number 16 is said to be on academy board but it has never been made available for my examination. I know it only through a photograph and cannot say what label it may bear.

After 1890 Peto used the Pfleger canvas-stretcher, apparently to the exclusion of all others; Harnett never employed this device. Numbers 3, 8, 9, and 13 are on Pfleger stretchers. The other paintings on canvas—numbers 2, 4, 10, 17, and 19—are on other types of stretchers. Numbers 4 and 10 were created

The Problem
and Its Solution

before the Pfleger stretcher was on the market. Number 17 has been recently remounted on a modern stretcher.

Number 18 is on wood, a substance often employed by both artists. But there is a certain type of wood panel—always very small, with a kind of flange around all four edges so that it looks like a box top—which belongs exclusively to Peto. This appears in numbers 20 and 21.

One must, unfortunately, discuss these secondary or confirmatory factors involved in the proof of the forgeries singly and separately, but in themselves they actually mean very little. They attain significance only in the light of their relationship to each other and to the primary factor of style. I have, for example, seen two perfectly genuine Harnetts with what are probably false Harnett signatures.[14] A spurious Harnett signature, therefore, is not a crucial or final factor in determining the genuineness or falsity of a picture ascribed to this painter. But it takes a cogent place in the chain of evidence when it is found on a picture which is stylistically inconsistent with Harnett's proven works, involves models which were provably possessed by another artist but cannot be shown ever to have been owned by Harnett, is on a piece of academy board or a stretcher of a type which the other artist is known to have used consistently and Harnett is not known to have used at all, presents inscriptions in the other artist's handwriting, and, finally, reveals the other artist's signature after it has been examined in the laboratory. To be sure, this complete chain is present in only a few of the Harnett-Peto forgeries (notably numbers 3 and 8), but in none are there less than two of the factors of evidence and in many there are three or four. In every forgery, involving Peto or others, it is the configuration, the relationship, the structure of the factors that counts. And the structure, each time, can lead to only one possible conclusion—that William Michael Harnett did not paint the pictures in question and that someone else did.

It is, of course, quite impossible to maintain that Harnett could have painted things or people, like the Government postcard of 1894, the Leaming catalogue of 1893, or Peto's daughter, not in existence during his lifetime. On the other hand it is quite easy to imagine situations in which some of our determining factors could appear in strange contexts. Harnett might have affixed his characteristic signature to a painting by someone else, might have used the Weber academy board or the Pfleger stretcher, and, on one of the visits to Peto's early studio in Philadelphia which he is known to have made, might have painted a picture of one of Peto's favorite lamps. But there is no evidence to show that he ever did anything of the sort, and even if he had, it would have no bearing at all on the question of the forgeries.

I emphasize this point strongly because at one time there was a disposition to argue about the confirmatory factors in a vacuum, without reference to their relationships, and to weave fine theories about them. All this merely makes for confusion and leads nowhere. Nevertheless there is one queer case in which everything came up wrong end to, and for the sake of the record it must be presented here.

There is a painting, in the collection of John Barnes of New York, which is obviously in Peto's style and bore his signature (undated) on its front. This is a picture of a box of books, very similar to number 4 in the Harnett-Peto forgery list, but looser and more slapdash in manner; it is, in fact, one of Peto's most careless productions. On the back of this canvas was an inscription in black paint:

TAKE YOUR CHOICE
ARTIST
PHILADELPHIA, PA.

Peto very often inscribed the backs of his pictures in this way, but here, and here alone, the entire inscription had been surrounded with white paint, and just before the word "ARTIST," where the paint-

[14] In one case (No. 46 in the catalogue of Harnett's works which appears later in this volume), the painting seems to have been left unfinished and therefore unsigned by Harnett; the signature it bears is dubious from a chirographic point of view and was probably added by someone else. In the other (No. 23), Harnett, in a strange departure from his usual practice, signed the canvas on the back with as beautiful and characteristic an example of his monogram as can be found, but omitted his signature from the front; therefore his name was placed on the front by an unknown person. The same sort of thing—pictures bearing false signatures of the painters who actually created them—has confronted biographers of other artists. Lloyd Goodrich informs me, for instance, that many of the works of Thomas Eakins were signed with his name by his wife after Eakins himself had died.

er's name would normally appear, the white paint was especially, particularly, and most suspiciously thick; obviously, someone wanted to cover up the name that had been there. At my suggestion, Mr. Barnes had the white paint removed, and the name of John F. Peto came out very clearly. Mr. Barnes also had the surface of the canvas cleaned, and, to everyone's intense astonishment, this revealed a second Peto signature with the date '85, and a typical forged Harnett signature as well. All theories advanced to account for this are hopelessly involved and necessitate the assumption of factors which so far have remained in the realm of the imaginary. Consequently I can only point to the Barnes picture as an unsolved facet of the Harnett-Peto problem.

VIII

PETO HIMSELF was altogether innocent; of this there can be no doubt whatever. He was strongly influenced by Harnett, but in a completely legitimate fashion, and everything he took over from the older artist he transformed in terms of his own style. He made no effort to imitate Harnett's manner or Harnett's models, he signed many of the paintings later forged as Harnetts, and some of these bear allusions to incidents in Peto's own life. Furthermore, he dated at least two of the paintings after Harnett's death, an event of which he was very well aware, since newspaper clippings concerned with it were found in his house at Island Heights. Finally, the forged Harnett signatures on some of the Petos are of the same type as those on paintings by other artists.

The real culprit or culprits will, in all probability, never be known. Laboratory examination shows that the forged signatures are not recent. Harnett's reputation was exceedingly high at the time of his death, and for at least a decade afterward unscrupulous dealers had excellent commercial reason to bring forth "newly discovered" works of his. Museum men have often told me about a quasi-amateur dealer, now dead, whose home in Philadelphia contained many works of obscure nineteenth-century

American artists adorned with spurious signatures of Sargent, Homer, Eakins, and Ryder. It is probably not insignificant that I first heard the name of this gentleman from the lips of Peto's daughter, who was quite unaware of his reputation, but who volunteered the information that he had acquired a considerable number of paintings by her father. If he sold them as works of Harnett, he probably did so before the official art world became interested in that artist, since he never mentioned Harnett to the museum people with whom he came in contact and nothing ascribed to either painter was offered in the sale of his collection after he died.

It was now apparent that the large number of second-rate Harnetts which, at the beginning of my study of the stylistic problem, I had put aside for later consideration, were probably all forgeries and had been painted by many different artists. It was also apparent that additional forgeries would come to light, and, perhaps, that new ones would, in time, be manufactured. In order to clarify the entire Harnett problem, prove forgery, dispel confusion and stop further faking, it would be necessary to deal in detail not with one or two late nineteenth-century American still life painters but with all of them, no matter how obscure or uninteresting they might be, and a piece of research that started out with a critical biography of Harnett as its only objective had to raise its sights to include the whole of American still life from 1870 to 1900.

This new program was, to say the least, staggering, and only a small fraction of it could be carried out. Diligent effort has so far failed to reveal even the point of approach for most of the artists who are listed in the concluding pages of this book. Many pictures ascribed to Harnett must be taken away from him solely on negative stylistic and chirographic grounds, without positive evidence pointing to their real creators. On the other hand, many of the actual creators can be discovered and their authorship of the questioned paintings can be proved. In almost every case wherein a genuine artistic personality manifests itself behind a Harnett forgery, that personality has left other traces, and these lead ultimately to a son or a daughter or a niece who has a scrapbook of clippings and a houseful of paintings saved from the junkman.

The Problem
and Its Solution

It has been my privilege to work out the stories of many of these important, forgotten painters, and to demonstrate that the American artistic heritage in this field and period is infinitely richer than had previously been thought. Some of the men I have had the honor of resurrecting are completely "new" and were not known to the art world at all when my work began. Some of them have not, so far as I can tell, been forged as Harnett, but might easily be at any time. At all events, although the Harnett forgery question is a central interest of this book, it is not, by any means, its only interest.

The present volume leaves untouched innumerable questions which I have been unable to solve. I can only hope that after the game-bag of this hunt has been emptied in the following pages, others with ammunition of longer range and swifter velocity will bring down the ones that got away.

Still Life with Mug, Pipe, and Antique Vase

WILLIAM MICHAEL HARNETT

*T*HIS IS MY WILL.

<div style="text-align: right;">April 10, 1923</div>

I wish to give to the following institutions 50 dollars:

> Woodstock College.
>
> Masses for the Family, Rev. Nelson Baker, Lackawanna, N.Y.
>
> St. Joseph's Home for the Blind, Jersey City.
>
> Bureau Catholic Indian Missions, 2021 H. St., Washington, D.C.
>
> Little Sisters of the Poor, 18 and Jefferson.
>
> St. Charles Seminary, Overbrook.
>
> Father Woolf, St. Barbara's Church.

Everything in my room and all the money is left to Catherine Barry, 4636 Larchwood Avenue.

<div style="text-align: center;">(signed) Ella Harnett
232 S. 3rd St., Phila.</div>

So William Michael Harnett's sister disposed of her earthly possessions in a document executed some ten weeks before she died. The last sentence of this document was admirably calculated to tantalize anyone interested in William Michael, for it seemed very likely that if the things which Ella had had in her room could be recovered they would include material of value in unraveling the story of her brother's life: Ella had been the executrix of William Michael's estate, and she was the last of his immediate relatives to die.

But no one knew who Catherine Barry was, and all efforts to obtain information about her met with failure. She had, to be sure, been listed at 4636 Larchwood Avenue in issues of the Philadelphia City Directory printed between 1924 and 1930, when that publication was suspended, but for the rest, there was nothing. Her name was absent from all the telephone books, old and new. There was no death certificate for her, and no reference to her in the obituary files of the newspapers or in the archives of the Orphans' Court, where wills and letters of administration are to be found. It looked as if Catherine Barry, like so many other persons involved in the Harnett story, had disappeared without a trace.

There remained, however, the remote, forlorn, but annoying possibility that Catherine Barry might still be alive somewhere; she might even be living in Philadelphia, telephone book or no telephone book. There was only one way to find out: go to 4636 Larchwood Avenue, ring the doorbell and see what might transpire.

A gracious, courteous lady answered my ring. I asked for Catherine Barry—if I had asked for Abraham Lincoln, she could not have shown greater surprise. She said Catherine Barry was her mother's sister, but had died many years before. (I never did find out when or where.) She also said her own name was Anne Whitaker; and she asked what brought me there. By this time the door had been open long enough for me to see a superb, unknown painting by Harnett on the living-room wall (plate 77). I quickly explained my errand, was invited inside to meet Anne Whitaker's sister, Nellie, and within a matter of minutes I held in my hands the richest collection of Harnettiana which has so far come to light.

Catherine Barry, it developed, had been a cousin of the Harnetts. Her mother and the mother of Ella and William had been sisters. Ella had left her not only the painting on the wall but three oil-sketches and a watercolor by her brother; two engravings by him; photographs of twenty-five of his completed canvases, only four of which were then known to exist (a fifth has since been discovered); notebooks crammed with sketches for engravings on silver; innumerable drawings of still life, human figures, and genre scenes; and a considerable scattering of documents. In order that I might study all this material at leisure and make the fullest possible use of it, the Misses Whitaker most generously presented me with it all, except, of course, for the framed canvas in their living-room. They also supplied some hitherto unknown data on the early history of the Harnetts and straightened out various confused or controversial points.

The connection between the Whitakers and the Harnetts goes back to three sisters named Holland who were born, raised, and married in County Cork, Ireland, and came to Philadelphia with their husbands and their first-born children in or about the year 1849. The Whitakers' grandmother was Ellen Holland, the wife of John Barry. Hannah Holland was married to William Harnett, and their second son was named William Michael. The first name

of the remaining Holland sister has been forgotten, as well as the first name of the man she married—one McCarthy. The McCarthys lost contact with the others but the Barrys and Harnetts maintained close relations until, with Ella's death, the Harnett family ceased to exist.

The Whitaker tradition agrees essentially with the statements regarding Harnett's birth made by his friend, E. Taylor Snow, in the biographical sketch cited in the first section of this book, but Snow is more specific: he says the artist was born at Clonakilty, County Cork, on August 10, 1848. This cannot be verified by the baptismal books in Clonakilty, but it is probably correct, even though some other Harnett documents—his death certificate, records of hospitals in which he was treated, his burial permit, certain obituary notices, and entries in the catalogues of art exhibitions—give a bewildering variety of dates for his birth, all of them from four to sixteen years later.

William and Hannah Harnett had five children. Patrick, the oldest, was born in Ireland, apparently in 1846, was trained as a saddlemaker, and died in Philadelphia in 1873. The artist's three sisters were all born in this country. Margaret, the only child of William and Hannah Harnett to marry, became the wife of a man named Koons, spent most of her life in New York, and died without issue in 1921. Anne became a dressmaker, like her mother and her sister, Ella; she lived for many years in Norristown and died in 1898. Ella, as we have seen, lived until 1923.

The earliest documentary reference to the Harnett family is to be found in the Philadelphia City Directory for 1869. Three of its members are listed, all as living at 803 Jayne Street, where Gimbel's department store stands today—Hannah, widow of William, seamstress; Patrick, harness-maker; and William, engraver. This is William, the future artist, and the entry tends to confirm the Whitaker-Snow tradition regarding the date of his birth. At all events, if he was old enough to have a professional listing in the city directory for 1869, he was certainly not born in 1864, as some of the documents would have us believe.

All we know for sure about William Harnett, father of the artist, William Michael, is that he died when William Michael was a child. According to the Misses Whitaker, he was drowned in the Delaware River and his body was never found. He is not buried in the plot in the Cathedral Cemetery of Philadelphia which Hannah Harnett bought on the day after Patrick's death in 1873, but all the others —Hannah herself, William Michael, Margaret, Anne, and Ella—came at last to rest there in one large grave.[1]

II

In 1889 or 1890, William Michael Harnett, then at the peak of his celebrity, gave a long interview to the New York *News* in which he provided much information about his life. This interview remains

[1] The names W. Harnett, William Harnett, and Hannah Harnett occur in Philadelphia city directories before 1869, but these listings are difficult to interpret and may refer to an entirely different family or families. If they do refer to the artist's parents, they have some bearing on the unsolved question of the artist's birth-date. The listings which may refer to the father are as follows:

W. Harnett, shoemaker, Cherry and Juniper Streets, 1846 through 1853.
William Harnett, cordwainer, 124 North Seventh Street, 1858 and 1859.
W. Harnett, shoemaker, 630 Cherry Street, 1860.
William Harnett, shoemaker, 725 Filbert Street, 1863.
William Harnett, bootmaker, 3 Fayette Street, 1864 and 1865.

At first glance, all these entries appear to deal with the same man, but it is not totally inconceivable that three or four different cobblers, all bearing the same far from uncommon name, could live in the same city during a period of two decades without being listed simultaneously in the directory for any one year. Regardless of this, if the W. Harnett first listed was the artist's father, then the family went to Philadelphia some years earlier than is commonly believed, and the artist, who was certainly born in Ireland before his parents emigrated, probably came into the world in 1844 or 1845. Hannah Harnett, widow, is listed at 7 Garwood Place in the Philadelphia City Directory for 1859. This is the only entry under that name before the one of 1869, and while it is of no importance, it provides a springboard for some rather amusing speculations. If the Widow Harnett of 1859 was the artist's mother, then clearly the listings for W. Harnett and William Harnett from 1860 to 1865 do not relate to the artist's father. On the other hand, there is evidence to suggest that the Widow Harnett of 1859 could not have been one of the artist's parents, for according to the death certificates of the artist's sisters, Anne and Ella, these ladies were born in 1860 and 1863, respectively. But Anne and Ella may have shaved a year or two off their ages; furthermore, death certificates can be filled out by guesswork, and are, in general, not to be taken as gospel. One rather strange fact about *the* Hannah Harnett is that the name of her late husband changes twice during the course of her City Directory listings. In 1869, as we have seen, she is the widow of

Still Life with Mug, Pipe, and Antique Vase

the prime source for biographical data about him. E. Taylor Snow clearly used it, and could add relatively little to it, when, immediately after Harnett's death, he supplied the daily newspapers and the Catholic weeklies of Philadelphia and New York with the material on which they based their Harnett obituary notices; furthermore, Snow's introductions to the Earle and Birch catalogues are derived from it. That part of the interview which deals with the artist's life from his childhood to the close of the first phase of his professional career reads as follows: [2]

"My first picture was not painted," said Mr. Harnett; "neither was it drawn with crayon, nor sketched with India ink, and what is more, there is no copy of it in existence. I was about 13 years old at that time, and my first picture was drawn on my slate in school. I cannot remember at this late date whether I was punished for it or not, but I probably was. My father died in Philadelphia when I was a little boy, and I was obliged to do something to help support my mother and the children. My first work was selling newspapers. After that I was an errand boy. I did not have much time to practice art, and consequently sometimes used the time in school that belonged to other duties.

"In telling you how I paint pictures from still-life models, it would be well for me to give you in brief a sketch of my early career in art, for the trials and hardships that I underwent were the sole reasons for my taking up that line of art work. Perhaps what I may say will be of some encouragement to young men who are situated as I was, and possibly my experience may prove to them that money and friends are not wholly necessary in beginning a career as an artist.

"When I was seventeen years old, I began to learn the engraver's trade. I worked on steel, copper and wood, and finally developed considerable skill in engraving silverware. This latter work then became my chief occupation. In 1867, when I was 19 years old, I entered the Philadelphia Acad-

emy of Fine Arts as a pupil, studying with the night class. Two years later I found work in this city, and came here to study in the National Academy of Design and take advantage of the free art school in the Cooper Institute. In this way I worked for various large jewelry firms during the day and at the art schools at night until 1875, when I gave up engraving and went wholly into painting.

"Before this time, however, I passed through several experiences that had much to do with shaping my career. I was not even well-to-do in those days, and my tuition and art work cost as much money as I could afford to spend and I was forced to be very economical. Still I ventured to take a course of lessons from Thomas Jensen, who was at that time a famous painter of portraits. I paid him in advance and intended to finish the course, but I couldn't do it. He didn't exactly say that I never would learn to paint, but he didn't offer me any encouragement. After I had studied with him ten days, I asked him how a certain fault of mine should be corrected. I shall never forget his answer.

" 'Young man,' he said, 'the whole secret of painting lies in putting right color in the right place.'

"The next day I went back to my old way of study. I couldn't do the things he set out for me to do the way he wanted them done. I might have attained the desired results, but never by following this method.

"The result of this discouragement was to make me work harder than ever. I felt that I was thrown on my own resources, and if I did not give a good account of my time no one was to blame but myself. I devoted more than half my days and evenings to my art studies, only working at my trade enough to supply me with money for clothes, food, shelter, paints and canvas. Consequently I had no money to spare.

"This very poverty led to my taking up the line of painting that I have followed for the past 15 years. It came about this way. I could not afford to hire models as the other students did, and I was forced to paint my first picture from still life models. These models were a pipe and a German beer mug. After the picture was finished I sent it to the Academy and to my intense delight it was accepted. What was more it was sold. I think it brought $50. That was the first money I ever earned with my brush and it seemed a small fortune to me.

"As I said before, I rented a studio in New York in 1875, and from that time on I made painting a profession. I stayed here for one year, and made such progress that at the end of that period I was able to go back to Philadelphia and open a studio in that city. In the three years that I was there I not only paid my expenses, but saved a few hundred dollars besides."

The slate to which Harnett refers came to light shortly after the interview was published and was exhibited at the Birch sale. The Birch catalogue describes it thus: "The slate used by Wm. M. Harnett

William, but from 1870 to 1872 she is the widow of James; then, after thirteen years' absence from the directory, she comes back as the widow of Garrett, and she remains so listed from 1885 to her death in 1891. There can be no doubt whatever that these entries refer to one and the same person and that this person was the artist's mother, since her children appear at the same addresses in the same years. In all probability, the shifts in the name of Hannah Harnett's deceased husband reveal nothing more than carelessness on the part of the City Directory's editors.

[2] From the copy preserved in the Blemly scrapbook. For this collection of Harnettiana, and for the Earle and Birch catalogues, see p. 6. Like most of the clippings in the Blemly scrapbook, Harnett's *News* interview is undated, but internal evidence places it in 1889 or 1890. Complete files of this rather obscure journal do not seem to exist, and it has not been possible to track the interview to the specific day of its publication.

Still Life with Mug, Pipe, and Antique Vase

during his school-boy days at the Zane Street School; upon which he has drawn four groupings of Still Life; dated 1861. This is probably his first attempt. The slate was found among the effects of his mother, after her death."

The slate has long since disappeared, but it is by no means insignificant that it bore drawings of still life; one may take with a grain of salt Harnett's statement that in later years he devoted himself to this type of subject mainly because, in his student days, he had been unable to afford live models. American art students in his time learned to depict the human figure principally from the observation of classical casts, and Harnett produced many excellent drawings of this kind (plate 27). Furthermore, he actually did use live models quite often, as is shown by numerous early sketches preserved by Ella Harnett and Catherine Barry; to be sure, these models were the people with whom he rubbed elbows in daily life and were not professionals posed in the nude before classes in art schools.

In addition to attending the Zane Street Grammar School, Harnett is said to have been a student at St. Mary's Parochial School, although his name is not to be found in the rolls of that institution. It is, however, preserved in the archives of the Pennsylvania Academy of the Fine Arts for 1868; this was apparently Harnett's second year of attendance there. A group of students, including Harnett, petitioned the Board of Directors of the Academy to appoint one Joseph John as their instructor; the records do not show whether or not this request was granted.

In his biography of Thomas Eakins, Lloyd Goodrich provides a description of the Pennsylvania Academy of the Fine Arts as it existed in the 1860's. Eakins left the Academy a year or two before Harnett entered, but the institution Harnett knew could not have been very different from the one in which his predecessor had studied. According to Goodrich:

Its collections consisted of casts from the antique, a few old masters of doubtful quality but imposing proportions, a group of early American portraits, and paintings in the grand "historic" style by Benjamin West, P. F. Rothermel, Christian Schussele, and other Philadelphia artists of the old school —— the chief works of art which the young man had seen, for this was one of the few museums in America

at the time. Visitors were infrequent, and there was little to disturb the drowsy peace. "Over it all there was a stillness," wrote a student of the time. "The smallest noise made an echo; it all seemed majestic."

The Academy had but meagre advantages to offer students. They were permitted to draw from the casts, copy the paintings, and attend anatomical lectures; but there was no organized school with regular instructors. Whatever desultory teaching existed, was not of a high grade; one of the masters used to set his pupils to copying his own work. Everything was based on the antique, which one had to draw for months or even years before one was allowed to look at the living model. This outworn system was the stale remnant of the "classic" tradition of teaching, expressed by a seventeenth-century French academician who said that "students should be trained to know the antiques so well that they can draw them from memory; only after this is achieved should the master place his pupils before the living model, and then, compass in hand, the measurements should be corrected—i.e., from the antique." Through being forced to copy dusty plaster casts in these funereal halls, Eakins developed a lifelong hatred of drawing from the antique.

Life classes were irregular, being organized occasionally by the students and artists, who clubbed together and hired models, the Academy merely lending the room. There was little instruction, and most of the members drew instead of painting. The curator of the Academy was present to see that nothing indecorous occurred, and Rule No. 1 was that "no conversation is permitted between the model and any member of the class." The female models wore masks, thus hiding their identity and their shame from the world.

Edwin Austin Abbey, a pupil of the Academy a few years after Eakins, later recalled its atmosphere: "What a fusty, fudgy place that Philadelphia Academy was in my day! The trail of Rembrandt Peale and of Charles Leslie, of Benjamin West, and all the dismal persons who thought themselves 'Old Masters,' was over the place, and the worthy young men who caught colds in that dank basement with me, and who slumbered peacefully by my side during long anatomical lectures, all thought the only thing worth doing was the grand business, the 'High Art' that Haydon was always raving about."

Eakins revolted against the Academy and could afford to do so. He came of an old, established Philadelphia family. He had received an excellent general education and was supported by his father throughout his entire artistic apprenticeship, including several years of work in Europe after he had parted company with the Academy in his native city. Harnett, on the other hand, came of a poor immigrant family, was given a rather meager general education and had to support himself. Most of his

Still Life with Mug,
Pipe, and Antique Vase

artistic studies were pursued in night classes, since he was employed at the engraver's trade during the day, and he could not afford to go abroad until five years after his professional career had begun. Consequently the whole picture of Harnett as a student is one of eager, not to say naïve docility. He accepted the discipline of the Academy without question, drew from its casts with all the others, and returned to lean on them when, several years later, he began, probably without instruction, to paint in oil (plate 26). There can be little doubt that his training and experience as an engraver conditioned him favorably toward the academic tradition of minute detail and high finish. As a result, when he left the Academy, Harnett did not move forward, as Eakins did, but backward; he quickly made an astonishing, fruitful retrogression to a still life style that had flourished in Philadelphia three-quarters of a century earlier.

Place a Harnett still life of the middle 1870's (plate 23) next to a Raphaelle Peale of 1815 (plate 22) and it is impossible to believe that they are separated by two generations, that the one belongs to the era of James Madison and the other to that of U. S. Grant. To be sure, there are differences in subject matter (so far as anyone knows, Harnett was the first to paint pictures of beer mugs, pipes, and newspapers) but for the rest, the two artists are nearly identical—in their glossy technique, their crisp, objective drawing, their composition, and their psychology. Raphaelle Peale's small pictures of a few ordinary, humble objects disposed in a pyramid on a table top against a background of empty space are echoed precisely by the early works of Harnett, and there is only one important stylistic difference between the later artist and his forerunner: Harnett will often build up a match head, a knife handle, or the rugged surface of a beer stein until it stands out from the canvas in a naïvely "realistic" relief. Raphaelle Peale was much too wise and subtle an artist to employ any such mechanism as this, and Harnett abandoned it after a few years' experience.

The Peale influence probably began during Harnett's youth in Philadelphia. A few still lifes by Raphaelle and his almost equally important uncle, James, are preserved today at the Pennsylvania Academy of the Fine Arts and were presumably there in Harnett's time. Furthermore the Philadelphia of the 1850's and 1860's swarmed with daughters and granddaughters, nieces and grandnieces of Raphaelle and James, and these venerable ladies emitted still lifes of their own with remarkable frequency and rapidity; Harnett may have been attracted to their work and through them have been introduced to pictures by the great men of their clan in their own and other private collections. All this, of course, is entirely speculative. We have no information whatever concerning the pictures that may have impressed Harnett during his childhood and adolescence, and in none of the available documents does he as much as mention the name of any other painter except the insignificant Jensen, whom he recalled only because Jensen treated him shabbily. His work shows clearly that throughout his life Harnett was sensitive to the art of the past and to some conservative tendencies in the art of his own day, but art-talk seems to have held no attraction for him.[3]

Anyone conversant with Harnett's paintings finds himself in a familiar atmosphere when he reads [4] that old Charles Willson Peale's famous "staircase portrait" of his sons, Titian and Raphaelle, had "filled an unused door frame in the [Peale] Museum, with a real step built out below to add to the illusion; and it is said that President Washington, invited to view some Indian figures in costumes, had been taken in by the hoax, courteously bowing as he passed the picture." As far back as 1795 Raphaelle had exhibited two pictures, now lost, entitled *A Bill* and *A Deception*. Deception, known today under the fancy label, *trompe l'oeil*, was to become a major part of Harnett's stock-in-trade, and there are exceedingly few examples of it between Raphaelle's era and his, but it is the title, *A Bill*, which is the really astonishing thing. According to the *Dictionary of American English,* the use of the word

[3] So it appears from the meager evidence available. Harnett is said to have written Snow numerous letters during his years abroad, and these may have contained observations on art and artists, but all but one of them have been destroyed. Only two letters of Harnett's are known to exist. Both are brief notes written during his serious illness in 1889 and are concerned primarily with the state of his health. They will be given in full at the proper place.

[4] All the references to the work of the Peales in this and the following paragraph are taken from Charles Coleman Sellers' *Charles Willson Peale, Vol. II, Later Life.*

Still Life with Mug,
Pipe, and Antique Vase

"bill" as a synonym for "banknote" can be found in American documents as early as 1682; if Raphaelle's bill was a piece of paper money, this work anticipated one of Harnett's favorite subjects by more than eighty years, and there are no known examples of the same subjects in American art in all the intervening time.

Raphaelle once painted a catalogue for his father's museum in the form of a large, open book whose pages people tried to turn. When his notorious *After the Bath* still stood on the easel in his home, his wife attempted to pull off the painted towel that covers its nude figure. On another occasion Mrs. Peale complained about the nuisances committed by an untrained puppy. Raphaelle therefore painted a piece of tin in the same pattern as his living-room rug and on top of that painted new evidence of the dog's misbehavior; this *chef-d'oeuvre* of *trompe l'oeil* had precisely the effect intended.

All these things, and the techniques and attitudes they reveal, indicate a direct line of descent from Raphaelle Peale to Harnett even though Peale died in 1825 and Harnett did not take up his work until a half-century later.[5] But if there are any intermediate links between them, they have yet to be discovered.

Other influences may have played upon Harnett's early work from different points of the artistic compass. Among the countless American still life painters active between 1825 and 1875 was John F. Francis of Philadelphia, Jeffersonville, and other Pennsylvania cities, who specialized in an American provincial adaptation of the elaborate seventeenth-century Dutch "luncheon piece," with bland color,

neat but unconcealed brushwork, and no perceptible effort at realistic illusionism (plate 106). Francis lacks Raphaelle Peale's consummate technique, ingratiating modesty, and originality in the choice of subject matter, but Harnett seems nevertheless to have studied his work. Francis' emphasis on narrow, elongated, vertical forms and their telling rhythmic placement in space is echoed in Harnett's early pictures, and a familiarity with Francis' paintings might also account for Harnett's use of larger canvases and more fully orchestrated compositions than those of the Peale tradition.[6]

The small, hard, round biscuits which appear so often in Harnett's youthful mug-and-pipe pictures are also frequently depicted by Francis, and, with one exception, by him alone among Harnett's known predecessors.

That one exception is the somewhat mysterious S. Roesen of Williamsport, Pennsylvania, who used the same type of biscuits in a startling canvas (plate 30), entitled *Dutch Lunch* by a former owner, which had been in the collection of James Budd Lamade in Williamsport. This work is even closer to Harnett in style, subject matter, and spirit than the still lifes of Raphaelle Peale; in fact, it contains several passages—notably the parsnips, the book, the knife, and the cigar at the table's edge—which could have been painted by Harnett himself. The picture is an isolated freak among the known paintings of Roesen;[7] it was painted in the 1860's for a Williamsport family, and there is nothing in its history to indicate that Harnett was acquainted with it; but pictures of its type were undoubtedly more common in the nineteenth century than they are today.

[5] Raphaelle Peale, it should be noted, was as much a man-against-his-time as Harnett. Peale's still lifes, most of which seem to have been produced after 1815, clearly derive from those of the minor Dutch masters of the early seventeenth century. The work of these artists was not unknown in America in Raphaelle's day, but it seems to have been distinctly out of vogue, and Raphaelle found pathetically few buyers for his wares. In an article on the Peales (*Art Quarterly*, Vol. 3, pp. 81–91), John I. H. Baur cites a letter, written in 1779, wherein the Swiss-American scientist and art collector, Pierre Eugene du Simitière, offers to sell to a Philadelphian ". . . pictures painted in oyl, on boards in black ebony frames, highly polished; of these kinds the Dutch settlers brought a great many with their other furniture . . . I pikt them up in New York, *in garrets, where they had been confined as unfashionable when that city was modernized.*" (Italics mine.) Du Simitière does not specifically state that these unfashionable paintings were still lifes, but Baur believes that there were at least a few still lifes among them, and this seems very likely.

[6] At least one work of Francis has been forged as Harnett. (See p. 175.) No paintings by Raphaelle Peale have been adorned with false Harnett signatures because the name of Peale has long been salable in its own right. Francis, however, was totally unrecognized until quite recently; he was one of the many artists rediscovered in the backwash of the Harnett revival.

[7] Of the 136 Roesens listed by Richard B. Stone in his pamphlet, *Not Quite Forgotten, A Study of the Williamsport Painter, S. Roesen* (Lycoming Historical Society, Proceedings and Papers No. 9, Williamsport, 1951), all but two—*Dutch Lunch* and a portrait—are still lifes of flowers and fruit, many of them containing wine glasses, compote dishes, baskets, and other vessels as well. According to Stone, Roesen appeared in Williamsport, probably from Germany, in 1858, and vanished from that city about 1871. Stone traces Roesen's style to German origins, but he overlooks the striking resemblance between many of his works and those of Francis, who was active in and about Williamsport at the same period.

*Still Life with Mug,
Pipe, and Antique Vase*

Occasionally one runs across other nineteenth-century American still lifes that seem prophetic of Harnettian trends, like the rack picture of the 1840's by the Washington cartographer, Goldsborough Bruff (New York: Oliver B. Jennings), or the picture of two large fish hanging against a wooden door produced in 1860 by the South Carolina genre painter, William Aiken Walker (Boston: Museum of Fine Arts). One hesitates, however, to suggest any direct connection between these paintings and those of Harnett; they represent exceedingly old and widespread conventions of subject matter to which Harnett probably came by other ways. But internal and external evidence alike suggest that Harnett *was* indebted to the Pennsylvania specialists in still life —Peale, Francis, perhaps Roesen, too—and these artists alone provide sufficient background to account for Harnett's early work as a painter and to start him on his way.

III

ACCORDING TO his statement in the *News* interview, Harnett found work in New York in 1869 and lived there until 1876. To be sure, he is listed in the Philadelphia City Directory for the first three of those seven years, and his name does not appear in the New York City Directory at any time during this period, but there is abundant evidence to show that New York was the center of his activities; furthermore, two of his New York addresses are known.

Among the "various large jewelry firms" in New York for which Harnett worked during the early 1870's was the house of Wood and Hughes. Here he sat at the same bench with William Ignatius Blemly, patiently engraving table silver. The friendship between Blemly and Harnett which sprang up lasted until the latter's death and resulted in the compilation of the now famous scrapbook.

Blemly preserved a number of Harnett's designs for engravings on silver, nearly all of them carefully dated by month, day, and year; they were produced between 1870 and 1874. Blemly's son also possessed a silver knife and two napkin rings engraved by

Harnett as a gift to his father, but by far the greatest enlightenment regarding Harnett's years as a craftsman is to be found in several sketchbooks, or fragments of sketchbooks, which his sister saved and left to Catherine Barry, and which eventually came, through the Misses Whitaker, into my hands.

In one of these sketchbooks is a design for the handle of a spoon, dated "Sept. 9—70" and signed with the earliest known example of the familiar Harnett monogram. Another design, a kind of fleur-de-lis, is drawn, like all silver-patterns in the Blemly collection, with colored ink (in this case green) and is dated "N. Y. June 21, 1870." On still another page is the inscription, not in the artist's handwriting, "Harnet [*sic*] engraver / 258 Elizabeth St. / New York City / with Miss C. Love."

The sketchbooks are filled with hundreds of decorative motifs, floral and geometric, all but the one just mentioned in pencil. One page is labeled "ladles"; some of the other designs indicate by their shape that they were intended for the blades of knives; many suggest wallpaper and architectural adornment in general, but were apparently intended, nevertheless, for table ware. Everything is lavish, involved, ornate, and despite the minute fineness of its drawing, in appalling taste.

On the last leaf of one sketchbook there appear, in addition to several of Harnett's conventional silver designs, three human faces, one of them a heavily moustachioed warrior in a medieval helmet. The exceedingly light draftsmanship of these faces and their offhand placement on the page indicate that they do not really belong there. They obviously played no role in Harnett's salaried labors but stole into his silver-book because they were part of a romantic reverie.

For at this time Harnett was also drawing shepherds and willowy shepherdesses, knights and nobles in fourteenth-century dress, wounded Civil War cavalrymen dying beside their faithful horses, and frontier scouts with fringed buckskin clothes, coonskin caps, and long rifles (plate 24). These sketches, all part of the Ella Harnett–Catherine Barry collection, were done on small bits of paper, some of them apparently torn from the above-mentioned sketchbooks, some of them from letterheads, menu cards, or theater programs. One of the few to appear on

Still Life with Mug,
Pipe, and Antique Vase

a full sheet of its own shows the gate of a singularly grim castle with a helmeted pikeman asleep under a tree before it; this drawing is signed and dated, most curiously, "Staten Island, September 24, 1872."

It is not impossible that some of the drawings reflect scenes and episodes which Harnett had witnessed on the stage; even so, they seem a trifle childish, and their approach is uniformly that of a beginner: the figures are flat and poorly articulated, and the line, produced by a hard pencil shaved to a rapierlike point, is as naïve as it is precise. The naïveté of the romantic sketches is offset, however, by the numerous genre scenes which Ella Harnett also preserved.

These reveal a shrewd, sympathetic observation of ordinary people doing ordinary things—women strolling in gardens, a mother and child buying candy from a cripple, a policeman comforting a lost boy in a crowd, a gang of urchins and their dogs leaping over a stone wall. The progress of Harnett's style as a draftsman can clearly be seen in this group of drawings. Some of them are in the crude manner of his romantic fantasies. In others, including a few sketches of the human face and figure outside the genre classification, the artist's handling of anatomy and modeling has clearly gone many steps forward; these pictures have an exquisite, Ingres-like crispness, and must be placed in the middle of the procession, chronologically speaking. Last of all, without much question, are the few figure drawings done in a quick, summary, offhand style, with a bold, broad line and a mature master's assured concern only with essentials of movement. It is a curious and highly noteworthy fact that there is no trace of this freedom in any of Harnett's known paintings, but there can be no doubt that Harnett is the author of the drawings in question, for several of them are signed with his name in his handwriting; moreover, his still life drawings trace exactly the same arc of development. He reserved the free style for his private jottings with a pencil; his brush was ruled by a different esthetic.

Much has been made of Harnett's reserved, impersonal character, his austere concern with lifeless objects and his eschewal of the human scene, but his genre drawings contradict this view. They show that throughout his career he affectionately set down the people he saw and the incidents he witnessed as he went about his daily activities.

As one would naturally expect, still life drawings outnumber those of other types in the Ella Harnett–Catherine Barry collection, but although there are many of these, only four can be identified with known paintings by Harnett—the *Mortality and Immortality* of 1876, *The Old Violin* of 1886, *The Old Cupboard Door* of 1889, and *Thieves in the Pantry* of 1879 (plate 33*a*). No doubt many of the other still life drawings are sketches for lost paintings, and some may represent the unrecognizable first ideas for existing oils which, in the process of development, were completely transformed. (One would hesitate to identify the sketch for *The Old Cupboard Door* [plate 80] with the completed painting [plate 81] if the line study were not labeled *The Old Cupboard.* Unfortunately, very few of the drawings bear titles.) Last of all, there are a few still life drawings which, one suspects, are not sketches for anything but were intended as independent, self-sufficient pictures. These, and these alone, involve shading and modeling. All the others are in open line, tight or free, and the freer ones, obviously later in date than those in the hard-pointed, naïve manner, frequently bear verbal notations to assist the artist in deciphering his graphic shorthand—"greenbacks," "sausage," "German paper," "apple with piece bit out." Verbal notations for color are completely absent.

Most of the still life drawings employ the table-top formula of composition, with mugs, pipes, vases, bottles, glasses, inkwells, ginger jars, fans, books, statuettes, dead game-birds, flowers, and fruit arranged in characteristic Harnettian patterns. Many of the specific objects depicted are quite familiar to students of Harnett's paintings, but in different pictorial contexts.

There are also a few still life drawings outside the table-top classification. These include the four sketches for known paintings mentioned above and a number of others which, if they were ever realized in oil, are unknown as such today. On the back of the sketch for *The Old Violin* is one for an incredibly complex rack picture. An amusing project in the department of *trompe l'oeil* is embodied in a drawing of a hand which proffers an open box of

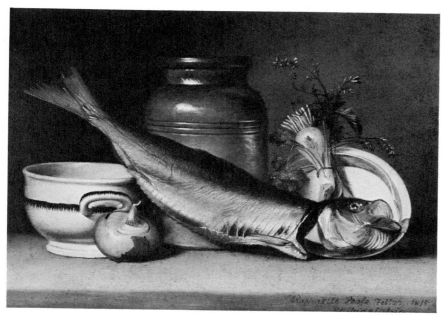

22

Raphaelle Peale
Still Life 1815 (10½ x 15)
Historical Society of Pennsylvania, Philadelphia, Pennsylvania

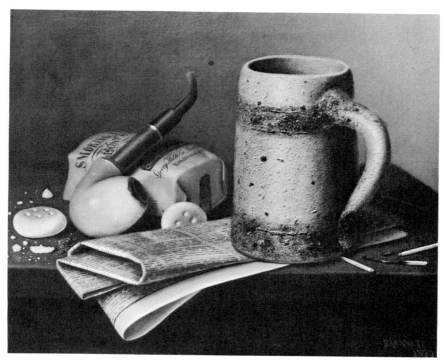

23

W. M. Harnett
Still Life 1877 (13¼ x 15½)
Dr. John J. McDonough, Youngstown, Ohio

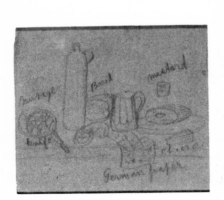

24

W. M. Harnett
Pencil sketches
Alfred Frankenstein, San Francisco

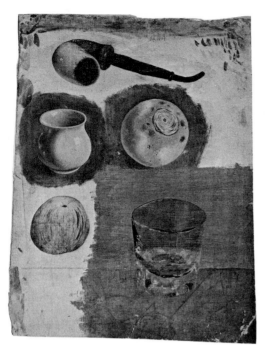

25

W. M. Harnett
Oil sketch September, 1874
(12½ x 7½)
Alfred Frankenstein,
San Francisco

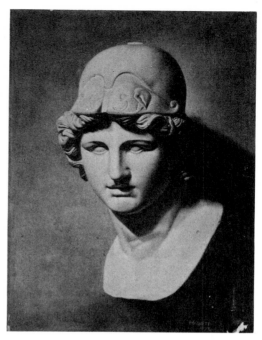

26

W. M. Harnett
Head of Minerva
(photograph of lost painting) 1874

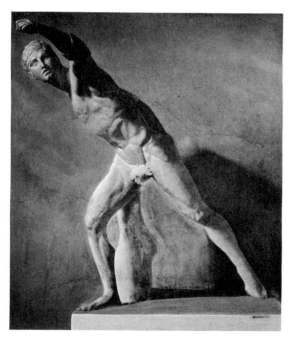

27

W. M. Harnett
Discus Thrower (crayon) 1873
(37½ x 33½)
Formerly collection Philip D. Folwell,
Merion, Pennsylvania

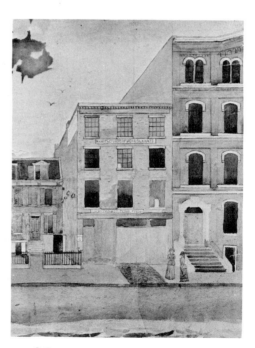

28

W. M. Harnett
View from the artist's window,
104 East Eleventh Street, New York
(watercolor) 1875 (18½ x 14)
Alfred Frankenstein, San Francisco

29

W. M. Harnett
The Social Club 1879 (13 x 20)
Mr. and Mrs. J. William Middendorf, New York

30

S. Roesen
Dutch Lunch (19 x 28)
Formerly collection John Budd Lamade,
Williamsport, Pennsylvania

Still Life with Mug,
Pipe, and Antique Vase

perfectos; beneath this is the title, *Take a Cigar.* One of the trickiest ideas Harnett ever had is set forth in a sketch of a window overgrown with fruit-bearing grapevines; directly on the other side of the glass, and seen through it, are three small shelves full of curios, including figures of an angel, a woman, a knight in armor, and a man on horse-back.

All these drawings—romantic sketches, genre scenes, and still life—are, to repeat, on very small pieces of paper with torn, ragged edges. None of them seem to have been done in or for the art classes Harnett attended; they are, rather, a coat-pocket accumulation of offhand scraps. As such, they reveal not only the natural bent of the artist's mind but his poverty and frugality as well. He often used both sides of the paper and sometimes did two or three different drawings on a single side. On one surface of a sheet which measures, roughly, seven by four and a half inches there are no less than eight separate sketches (seven still lifes and a study of a dog in a kennel); each of these sketches is neatly boxed and there are verbal notes for a ninth picture in still another "box" in the lower right-hand corner.[8]

Ella Harnett also kept some of her brother's

[8] Another sidelight on Harnett's spare and homely habits is to be found in a series of calling-cards, preserved by Catherine Barry, which are imprinted with Harnett's name and address, "1227 Broadway / Cor. 30th St.," but from every one of which the lower left-hand corner has been torn away. Comparison with the cards preserved in the Blemly scrapbook shows that what has been removed is the phrase, "Studio 13 / Third Floor." One gathers that Harnett had moved his studio from one floor to another in the same building, but that instead of having new cards printed, he methodically tore from his remaining stock the lines referring to his old location. The New York City Directory shows that Harnett's studio was at 1227 Broadway from 1890 to his death in 1892; his home was at 132 East Sixteenth Street, where he had resided since 1887. According to his obituary notices, Harnett sold everything he painted in the last few years of his life and was, presumably, in fair financial condition. If this is true, one can account for his treatment of his calling-cards only on the ground of ingrained thrift and a lack of concern for the niceties; on the other hand, a thrifty man who was making money would not have left an estate which consisted, as Harnett's did, of "five paintings of uncertain value and four hundred dollars cash."

Incidentally, the Catherine Barry collection also contains some Harnett calling-cards with their lower left corners similarly torn off, but the address, "42 West 30th Street / Cor. Broadway." This tends to confirm my theory that 42 West Thirtieth Street, an address given for Harnett in some exhibition-catalogues of the early 1890's but never in the city directory, was the side entrance at 1227 Broadway. It may have pleased Harnett's sense of humor to give two different addresses for the same studio, but there may also have been some practical reason for this apparent quiddity.

school-work—charcoal drawings of classical casts. But his best works of this type are those long preserved by Snow's daughter and by Philip Folwell of Merion, Pennsylvania, the nephew of Harnett's Philadelphia friend and patron, William Folwell. The Folwell picture, a large charcoal of a discus-thrower signed and dated 1873 (plate 27), is especially interesting.

According to the Folwell family tradition, their drawing served Harnett as a kind of entrance examination for the Pennsylvania Academy of the Fine Arts, but it is much too late to have served this function, since Harnett had been a pupil at the Pennsylvania Academy as far back as 1867. However, E. Taylor Snow states that in the 1870's Harnett gained entrance to the National Academy of Design in New York by making a drawing "from the most difficult plaster cast in their schools." In all probability, therefore, the Folwell tradition is correct so far as the original purpose of the drawing is concerned, but wrong as regards the school involved. If so, the *Discus Thrower* provides the specific date for Harnett's period of study at the National Academy, which has not preserved its student records for this era. Harnett's name appears in the list of students at Cooper Union (which, following a common but incorrect practice of his time, Harnett calls "Cooper Institute") in the annual report of that organization for the year 1871, and from Cooper Union to the National Academy of Design was a logical progression.

IV

DURING THE early stages of my research I found it difficult to believe E. Taylor Snow's statement that Harnett produced his first paintings in 1874, for this meant that he had not dipped his brush in oil throughout seven years of study in three different art schools. However, in the light of fuller information, especially that provided by the drawings just discussed, this no longer seems strange; and I eventually discovered positive proof for Snow's assertion in Snow's own house.

Still Life with Mug, Pipe, and Antique Vase

Harnett's training in those three art schools must have been rather sketchy and haphazard. He seems to have been enrolled only in night classes, since he was making his living as an engraver during the day, and there were probably extended periods during the seven years when he did not go to school at all. The academic art-training of Harnett's time demanded a very long apprenticeship in the drawing of classical casts; there is little evidence to show that Harnett ever progressed beyond this stage so far as his school attendance is concerned, and there is a good deal of evidence to suggest that he could not have gone much further. When he finally did turn to oil painting, it was, in all probability, entirely on his own.

Conceivably, Harnett started to paint his still lifes because he had nothing else to do. Snow indicates that his trade had been ruined by technological progress and that he was out of work at the time. If hand engraving had continued to pay, Harnett might well have continued in the schools. Certainly there is nothing to indicate that the Harnett of 1874 could be even remotely regarded as the finished product of an art academy. His known work of that year is timid, tentative, and almost childish, although it contains some premonitory flashes of mature realization. Before 1874, such flashes are so rare as to be all but unobservable. His earlier drawings are not only timid but rather commonplace as well, and they contain no hint that the person who produced them was to become a distinguished artist. His early development seems clearly to have been painful, uncertain, unsophisticated, and extremely slow, and so it might have remained if the engraver's trade had continued to provide him with a living. Many a man suddenly blossoms in the work he really wants to do when he is forced out of the work he previously thought he had to do, and William M. Harnett seems to have been such a man. It is certain that by 1876 his style had settled into the highly individual grooves it was to follow for the rest of his career.

Five Harnett paintings of 1874 are known to exist, and there are photographs of two more among the things preserved by the artist's sister. All are exceedingly interesting, but the most important are the two canvases which formerly belonged to Snow's daughter and were once in the collection of the Downtown Gallery. One of these is a beautifully wrought still life, four inches high and four and a quarter wide, which depicts a paint tube and a cluster of four grapes lying on the lid of a cigar box labeled "Conchas"; it is signed "Sep 1874 Harnett." The other picture, an eighth of an inch narrower and distinctly less expert in its handling, represents a semitransparent glass object, apparently the lid of a candy or compote dish, on the top of a table; the signature here reads "Harnett Oct. 74." Both of these modest works are enclosed in a single frame along with two other things. One is a note in Harnett's handwriting which reads "Compliments of Wm. M. Harnett to Friend E. T. Snow my first paintings in oil." The other is a color chart in watercolor signed and dated "Wm. M. Harnett July 71."

Harnett, then, painted his first oils in the fall of 1874 and eventually gave them to Snow. He gave his sister two oil sketches and one unfinished painting of the same year and season, and these ultimately came, through the Misses Whitaker, into the present writer's possession.

Both of the oil sketches consist of several separate, unrelated studies, the first of a slice of watermelon, a cantaloupe and a pear. The melons are dated "Sep 9—74" and the pear "Sep 18." The second (plate 25) is dated "Sep. 1874" and contains a meerschaum pipe, a white jar, a rutabaga, an apple, and a glass of the kind now used for old fashioned cocktails, this last posed on a dark brown table top against a lighter brown background. The third oil in the collection (8⅝ x 6½) shows a bright green, drop-shaped perfume bottle with a brass stopper, also placed on a dark brown table top against an unfinished background of a lighter brown hue. This picture is dated "Nov 74."

As in the two little oils preserved by Snow, the objects in this group of pictures are exceedingly uneven in the quality of their rendering. The white jar and the rutabaga are beautifully realized and could be transformed without incongruity to a still life of Harnett's mature years. The perfume bottle and the apple are competent student work, while the pear and the cantaloupe are as flat as if they had been done by a backwoods primitive. Clumsiest of all is the one object Harnett was destined to paint

Still Life with Mug, Pipe, and Antique Vase

more often than any other—the cherry-stemmed meerschaum pipe, which here seems to be made of soft rubber rather than baked clay and wood. The careful dating of each little sketch by the month and sometimes by the day shows that the artist was keeping track of his progress in a very earnest, studentlike fashion.

As indicated above, two Harnetts dated 1874 are known only through photographs. Both represent classical casts—one, a head of Minerva (plate 26), the other, Cupid leaning on his quiver. Unlike the other photographs preserved by Harnett, these prints bear no inscriptions to indicate the size of the canvases, but they appear to have been considerably larger than those just discussed. While making his small, rather fumbling experiments in still life, Harnett, at the outset of his venture in oil, apparently sought support from the academic models he had drawn in charcoal through all those years of night school.

With this experience, William M. Harnett opened his professional studio and began sending still lifes to the National Academy of Design.

V

HARNETT FIRST appeared before the public in the annual exhibition at the National Academy in the spring of 1875. According to the artist's statement in the *News* interview, his picture represented a pipe and a German beer mug and was sold for fifty dollars, but the catalogue of the exhibition itself tells an entirely different story. This document reveals that Harnett actually made his debut with a painting called *Fruit*, priced at seventy-five dollars. Regardless of what Harnett asked or received for his first exhibition-piece (now unfortunately lost), it is interesting that he ultimately forgot what it was. He had painted so many mug-and-pipe still lifes in his early days that, when talking to the reporter for the *News*, he naturally thought he had begun his public career with a work of this kind.

Harnett's address, as given in the National Academy catalogue just cited, was 104 East Eleventh

Street. Since, in all probability, he lived there only in 1875,[9] the view from his window at 104 East Eleventh (plate 28) which forms part of the Catherine Barry collection may be assigned to that year. This work is in Harnett's most naïve manner and shows no progress over the oil-sketches of 1874; in fact, it is not so well achieved, probably because it deals with a type of subject in which he had no real interest—except for two or three little drawings, it is his only known landscape. It is also in watercolor, a medium that clearly possessed little attraction for him, since no other Harnett watercolor is known to exist, barring the above-mentioned color chart.

The view from Harnett's window is unfinished, unsigned, and undated. It shows, from left to right, a small cottage, a four-story building, and a considerably larger four-and-a-half-story structure which is still standing. The building in the middle bears two business signs on its front, and one of these—"I. H. Brown & Co. Flour, Feed, &c.,"—is significant. The New York City Directory reveals that Isaac H. Brown and Company, dealers in "flour, feed, &c.," were located at 111 East Eleventh Street from the middle 1860's to the middle 1880's, and it is through this that one is able to identify the scene.

One of Harnett's friends during this period was James E. Kelly,[10] who was long active in New York as a sculptor and magazine illustrator, and who left an autobiography, still unpublished, in which there

[9] In the *News* interview, Harnett is quoted as saying "I rented a studio in New York in 1875." This studio could only have been at the East Eleventh Street address, and Harnett's phrase implies that he had not previously been located there. He returned to Philadelphia in 1876.

[10] Harnett is known to have exhibited, apparently with some pomp and ceremony, in the show-rooms (not the windows), of Black, Starr and Frost, successors to "Ball-Black's Jewelry Store," in 1890, when that firm was located on Fifth Avenue at Twenty-Eighth Street. This, of course, was at the height of his career, after he had returned from Europe and long after he had first shown at the Academy. There is no evidence to support Kelly's assertion that he exhibited in Ball, Black's window in his early days as a painter, although he might have done so: for a silver-engraver to have had friends in the jewelry business is logical enough, but it is certain that any sales Harnett may have made through Ball, Black and Company in the 1870's were of no special importance and could not have resulted in assuring his financial stability. Kelly to the contrary notwithstanding, Harnett did not "stay in his old quarters" (East Eleventh Street is here implied) until his departure for Munich, but pulled up stakes and went back to Philadelphia in 1876, and he certainly did not die in 1899.

The excerpts from Kelly's manuscript are printed with the kind permission of Robert Bruce, editor of the Kelly memoirs.

Still Life with Mug, Pipe, and Antique Vase

are two passages concerning Harnett. These two passages were obviously written many years apart; the second repeats some of the data given in the first and must have been set down without any recollection that the first existed. Kelly telescopes episodes and is manifestly wrong on certain points. On the other hand, the seemingly improbable story of the hanging committee's plan to soak off a label from the front of a picture Harnett had submitted for exhibition may very well be true. At all events, a Harnett with an exhibition label painted in its lower left-hand corner is still in existence (plate 39).

At 104 East 11th Street, [Kelly wrote] Harnett, the still life painter, lived, worked and almost starved. His works were wonderful in their realism; he used to paint pictures such as *Jack's Supper*—a sausage, rye loaf, an orange, etc.; Harnett said that he differed from most artists, for after painting them, he could eat his models. Carroll called on him with some friends one night after the Academy, and he treated them to some red herrings smoked until they looked like old brass. As they were trying to munch them, he said, "I read that they are such a fine article of food that if it were not for their cheapness, they would be used as a banquet for princes."

Harnett was tall, gaunt and grim, with full forehead, and very near-sighted; his glasses were jammed close to the eye socket, through which he seemed to glare from his intense strain to see, but his eyes were microscopic. A quid of tobacco bulged his cheek, marring the symmetry of his regular, refined features. Fame and wealth came to him in his later days. Share told me a joke on him, saying "Harnett was so near-sighted that when a patron gave him an order to paint her picture, he had to sit so close to her that when it was finished, she could see the milling on his clothes."

The story is told of his painting a tag to go on the back of a picture; he painted it on the front, and the Committee were about to soak it off when they saw that it was a part of the picture. He had painted and sent a bill, which he put under glass; and they say the Committee thought at first that it was a genuine bill framed. There are several yarns told about him, characteristic of what he could do, as he was always up to tricks; but I don't vouch for them.

❖ ❖ ❖

William M. Harnett was internationally famous as well as successful as a still life painter. The first time I met him was in the late '70's at the evening class at the Academy of Design. He was tall, lean, solemn, Celtic and wise; being different, we naturally attracted each other. He was then laboring and existing in a small hall room in a rickety old two-story tenement over an old Dutch beer saloon on East 11th Street near 4th Avenue. He worked at odd times at his trade, jewelry engraving, due evidently to uncertain income.

The place was just large enough for an easel, cot, and chair, and had a poor light; squalid surroundings, and the smallest, coolest cook stove in the city. The table was filled with still-life objects—fruit, quaint dishes, hunters' horns, etc., even matches he made important, as well as cobwebs, by which he was plentifully surrounded. He generally started the eatable part of the subject first, it thereby answering the double purpose of a model and a meal.

He was always firmly cheerful over his frugal diet, feeling that it gave him the liberty to carry out his ideas. I have often seen him glorifying a three course supper of salt herring, cheese sandwich and pickled onions—ship biscuits with each course. Some of these were, in a moment of abstraction, gleaned from the free lunch counter when acquiring the beer from the friendly Dutchman in the basement. Even the never-ending trombone, aided by the clarionet practice—his neighbors being two members of the Manhattan Band—seemed to soothe and inspire him—or perhaps drive him—to extra effort.

So he plodded on—dealers buying his paintings at their own prices, getting odd jobs, and doing the mysterious "tiding over" that is reserved for the art world. The Academy was not friendly. But his opportunity came when, helped by an employee in Ball-Black's Jewelry Store at Broadway and Prince Street, he got permission to exhibit in the window. At first he received offers which his business friend refused; this resulted in his getting hundreds where he expected twenties. He sold steadily there for a few years, until his financial condition was safe; and then sent to the Academy two pictures, one a glass-framed picture in oil, representing a $10 bill.

The Academicians had the glass removed to prove it was not pasted on. His contributions were never afterward slighted. He still stayed in his old quarters, until he found that he could afford to satisfy a long deferred wish to study in Europe. In Munich he met many students from the Academy; they advised him to change his style, but as he was the only student whose work was hung, and always sold in the exhibitions, he told them he would wait until he stopped selling. In London a Royal Academician invited him to a State dinner, where they overlooked his funereal Prince Albert in their regard for his ability.

In the Salon, Paris, his great success was bought by a rich American, Mr. Theodore Stewart, for $5,000. *Barn Door with Trophies of the Hunt* is a great attraction in Stewart's famous restaurant in Warren Street. Bets were freely made on the objects being real until proved by examination; it was protected by a railing and lighted. Under the reflection it is the most realistic painting I have ever seen—about 10 feet x 8 feet. Prosperity did not bring him health; he traveled to every Spa in this country and Europe, with but slight relief; and passed away in his studio, corner 30th Street and Broad-

way, about 1899, surrounded by orders which he was unable to finish.

VI

HARNETT'S RETURN to Philadelphia may have been dictated, at least in part, by a desire to see the Centennial Exposition which brought the whole world to Fairmount Park in the summer of 1876—at any rate he exhibited another seventy-five-dollar fruit piece there.[11] (According to Snow, he had made his bow before the public of his native city with a mug-and-pipe picture sent down from New York and exhibited at Earle's Galleries in the previous year.) Once again in Philadelphia, Harnett established residence with his mother and his sister, Ella, at 806 South Thirteenth Street, and opened the studio in the famous old Wistar House, 400 Locust Street, which was to be the center of his activities for three exceedingly busy and fruitful years. He studied at the Pennsylvania Academy of the Fine Arts, which lists him among its students for the year 1876, and drifted back into the life of the town. He made important friendships, with fellow artists like E. Taylor Snow and John Frederick Peto, and with admiring patrons like the textile manufacturers, William and Nathan Folwell. He also joined societies, professional and otherwise; Martin J. Griffin tells us [12] he was fond of sketching portraits of fellow members of the Catholic Philopatrian Literary Institute and painted one of his most convincing dollar bills for a dues notice posted on the Philopatrians' bulletin board.

[11] The Centennial art catalogue gives his address as "New York," but this proves only that the material for the catalogue was assembled before Harnett decided to go home. Hasty biographers sometimes make mistakes, usually trivial but occasionally important, through failure to realize that 19th-century handbooks and directories had to be compiled months in advance of their publication. During the period of our study, the city directories of New York and Philadelphia were printed in May of each year on the basis of material collected the previous autumn; consequently every entry in the city directories of this period must be thrown back a year in order to reveal its true chronological significance. If the directory is to be taken at its face value, Harnett was living in New York in 1893, but he died on October 29, 1892.

[12] In an addendum to Snow's obituary notice published in *American Catholic Historic Researches*, Vol. X, 1893.

Of the four known Harnetts of 1876, two are of special importance—*Mortality and Immortality*, now in the Art Museum at Wichita, Kansas (plate 31), and *A Wooden Basket of Catawba Grapes*, at the Charles and Emma Frye Museum, Seattle (plate 32). Both are rather large and represent exceptionally ambitious attempts for the Harnett of this period, but there is no way of telling what other pictures he may have produced in the same year; perhaps there were none at all, and perhaps there were a hundred or more. We know that from 1878 onward, when he had completely mastered his technique, Harnett painted very rapidly, but it is likely that in 1876 his tempo was still relatively slow.

In *Mortality and Immortality* Harnett falls back upon the most piously platitudinous of traditional still life motifs—that of the so-called *Vanitas* picture, which juxtaposes a skull with works of art, living things, and, occasionally, jewelry and precious stones. (The worthless baubles that you can't take with you are usually painted with much more interest and loving care than anything else.) Harnett omits the jewels—a subject he never seems to have attempted at all—but places his skull on top of two brown books which are in turn placed on a table covered with a dark-green, brown-embroidered drape; this drape recurs in several of his other early works. At the extreme left, a small book leans against the two which support the skull, and there is a pale pink rose near the table's edge. In the center foreground is an open book with a brilliant red ribbon dangling from between its leaves. In the background at the right is a half-burned candle; before this is a violin; beneath the violin are a bow, a green cover for a piece of music, the music itself, and another music cover, this time in a bright, light yellow.

Several stylistic characteristics of this painting show that at the time Harnett produced it he was not yet in full command of his powers. There is, for example, the curiously flat, primitive-looking rose; Harnett was never greatly interested in flowers, but none of his other professional productions contains so feeble a flower as this. The brass knob at the end of the bow jabs right through the picture

Still Life with Mug, Pipe, and Antique Vase

plane with a "built-up" blob of paint; so do the nearest corner of the open book and the twisted lower end of the red ribbon. This naïve confusion between painting and relief sculpture, obviously the result of an effort at extreme realistic illusion, is to be found only in Harnett's pictures produced before 1880, when he went to Europe. To be sure, he often piles up paint in his later works, but these later built-up passages are light traps, not descriptive incidents of sculptural relief. The most heavily built-up episode in any known work of Harnett is to be found in the bell of the hunting horn in his *After the Hunt* of 1885; this produces a burst of light where the illumination falls upon the conical curve of the brass, and it has no other function; the blob of paint is rough, shapeless, and meaningless in any descriptive sense, and cannot be interpreted in any other terms than those indicated. It is not even noticed by most spectators, although the book corners, metal knobs, and other objects which Harnett builds up in his earlier canvases invariably attract attention.

Mortality and Immortality looks forward to Harnett's maturity in its concern with contrasts of texture—the polished, varnished wood of the violin versus the leather and paper of the books, and these played off against the brown ivory of the bone and the softness of the green cloth—although this tactile interest is not carried as far as it is to be carried later. Typically Harnettian, also, is the emphasis upon old things—books with worn leather spines, frayed music, and so on—but these are deployed in an atmosphere of slightly cheap Victorian elegance that will, unfortunately, return in some of Harnett's last paintings. Likewise prophetic is the adaptation of an old Dutch compositional formula which Harnett may have learned from Francis—the sheets of music falling over the edge of the table top to form a roughly triangular counterthrust to the generally pyramidal arrangement of the objects placed on the table itself. In later pictures by Harnett the apex of the pyramid lies directly, or almost directly, above the point of the triangle; their upward and downward movements define the vertical limits of the active composition as a whole and provide it with a central axis. Here, however, the apex of the pyramid is far to the left, the point of the triangle is

far to the right, and the tension between them is therefore not very strong.

The pages of the open book, and the sheet music as well, display a lightness and thinness and grace which are eminently Harnettian. This is one feature of Harnett's style at all periods which was obviously the despair of his imitators, like Claude Raguet Hirst or N. A. Brooks, whose heavy, often woolly slabs try desperately to masquerade as crisp paper leaves.

Mortality and Immortality brings up certain general considerations with regard to Harnett's iconography. He is fascinated by books, but he has no interest in their literary implications. Any book will do so long as its shape, color, and texture are right for his pictorial purposes; what the book may signify as a work of poetry or prose does not concern him in the least. Whenever the spine of a book stands forth in the light, its title is indicated, but Harnett makes no parade of these titles; in fact, they are very frequently covered in part by objects placed in front of them, so that they are, to all intents and purposes, illegible.[13]

Similarly, printed pages are, for Harnett, merely another texture; as we have seen, the body type of his books and newspapers is never legible, but consists of black lines of paint elaborately cross-hatched with a pin or the end of a brush. Harnett's painted sheet-music is also entirely a matter of texture, but there is reason to believe that he originally bought much of the music he depicted for his own use as an amateur flutist. He probably read very few of the books that appear in his canvases, but acquired them solely as studio props;[14] his painted music, on the

[13] The book directly under the skull in the Wichita picture, largely obscured by the leaves of the open volume on the table before it, bears the title "Le Trib . . . / D'Ath . . . / Mino . . . ," and, at the bottom of the spine, "Paris / 18[39?]." The book below this is entitled "Shakespeare's Works / Volume . . ." At least that is the title it bore at the time the painting was photographed. When I saw it in Wichita in November, 1947, this passage could not be read at all, and there is abundant evidence to show that other Harnett book titles, painted in gold, have wholly or partially flaked off or been cleaned off.

[14] Thanks to the Birch catalogue and to Harnett's pictures themselves, we know specifically what books Harnett used as models, especially in the last dozen years of his life. At least one of them was a dummy—a handsome binding enclosing blank pages. The rest were in half a dozen different languages and on a wild scattering of subjects. It is difficult to imagine Harnett's reading the *Dissertationus in Priviligia Statuum Provincialum* of J. C. Weixler, Zwingern's *Geweissenhaffte Apothecar* [sic], Schutz's *Compendium Juris*, or the

Still Life with Mug,
Pipe, and Antique Vase

other hand, provides us with unintended clues to his tastes and activities in this art. Nearly all of it is well adapted to the flute and to the capacities of a casual flutist; one therefore suspects that when Harnett wished to paint a sheet of music he selected one at random from the stack he had on hand, but it clearly lost all musical meaning for him as soon as it was set up as a model. Nevertheless, Harnett's painted notes, clefs, and bar lines are always strictly accurate.

Harnett's favorite model for his sheet music was a dreadful Victorian salon piece entitled *Hélas, Quelle Douleur,* by one Servel. *Mortality and Immortality* takes us into much more respectable aural surroundings. The music represented here is headed "De l'Opera *Norma*" and is a duet in D major, apparently for two flutes, distinguished in the painting as No. 17. (In the original score, this is the Norma-Adalgisa duet, *Con te li prendi;* No. 9, in C major.) According to Snow's daughter, Harnett often played flute duets with her father, and she also believes that a skull her father cherished for years is the one in this picture. It is rather curious, but probably accidental and meaningless, that the same tune from *Norma,* now arranged as a solo and in the key of G, shows up in Harnett's *Old Cupboard Door,* painted thirteen years after *Mortality and Immortality.*

Incidentally, Harnett depicted the flute—one particular flute—more often than any other musical instrument, and never made any mistakes in its rendering. His violins, on the other hand, are always incorrectly strung; the strings are attached to the wrong pegs. (This is not observable in *Mortality and Immortality* because the peg-box is not shown.) In other words, Harnett did not know how to play the violin and strung it any-which-way—but his fellow illusionists, Chalfant and Peto, did know how to perform on that instrument, and the strings of their painted fiddles are always inserted in the right pegs.

If *Mortality and Immortality* is conventional in its theme, *A Wooden Basket of Catawba Grapes,* Harnett's other major painting of 1876, is little

short of iconoclastic. In an age that stressed subject matter to a degree almost incomprehensible today, and an age which demanded that its still life painters devote themselves to "objects intrinsically beautiful," [15] Harnett here dares to deal with an object of the humblest and most ordinary kind. He does not feel called upon to display his grapes, Francis-fashion, in painted, perforated bowls with scalloped edges, surround them with an indigestible riot of other fruits, and place the whole on a carved French sideboard along with embroidered napkins, gilded tableware, and a bit of fancy landscape seen through a corner window; he merely gives us a simple wooden market basket on a bare marble table against a Peale-like background of empty air.

The basket is beautiful in its proportions and its precise placement in space. To quote a line used elsewhere in this book, you always know where an object *is* when Harnett paints it; at least you do in all but a handful of his less successful works. The texture, color, and thin elasticity of the wood are exquisitely achieved, and Harnett's sure sense of design leads him to paint the ribs and handle of the basket in a slightly darker, yellower tone than the rest. But having arrived at a little masterpiece of representation, he is unable, at this period of his career, to let well enough alone—the sixteen nail heads in the basket are all built up in relief and penetrate the picture plane like the book corner and the violin bow of *Mortality and Immortality,* thereby ruining the very effect of realism they were intended to achieve.

The grapes of a lady Peale are dead little glass balls. The grapes of a Chardin are subtle studies in the winy, symphonic richness of color and light. Harnett was no Chardin, but neither was he a lady Peale. His red, translucent grapes fairly leap with their vitamins; they pop over the edge of the basket and through the slit at its right as eagerly as so many puppies. Ordinarily one would not think there

Medicinae Theorica et Empirica of Bruelis Gualtri, even if he could manage enough Latin or German to plow through them; these were simply fine-looking old books to be used as still life subjects.

[15] This phrase comes from the catalogue of the collection of the Philadelphia steel king, William B. Bement, published in 1884. The context indicates that by "objects intrinsically beautiful" the author means objects of precious metals adorned with precious stones. Bement was for many years a trustee of the Pennsylvania Academy of the Fine Arts, and his collection, to which several Harnetts were ultimately added, is eminently typical of its period. It will be discussed in some detail later.

Still Life with Mug, Pipe, and Antique Vase

would be much room for humor in the realistic painting of a basket of grapes, but there it is. Carlyle Burrows [16] once pointed out that Peto often endows his still life subjects with a kind of genre feeling. He does not anthropomorphize them, but approaches them with a sympathy and emotional identification which throws them into unexpected, extremely vivid dimensions. This is part of the "heightened realism" or "magic realism" which so many critics have found in the work of both artists, and it is quite as true of Harnett as of Peto. *A Wooden Basket of Catawba Grapes* is the earliest known example of it, and one of the best.

Twenty-three Harnetts of 1877 are known to exist. In two ways, they are quite different from the surviving Harnetts of the previous year—they are all small, and, in subject matter, exhibit four definite formulas which Harnett exploited over and over again. These formulas are the fruit piece, the mug-and-pipe picture, the bank note, and the writing table.

Documents already cited show that Harnett had painted fruit pieces before 1877, but, except for the oil sketches of this type which Catherine Barry preserved, the earlier fruit pictures are lost. The five which he painted in 1877 are listed and described, with all the other known works of Harnett, in the catalogue at the end of this book, but in the main body of the text there is room to discuss only the key pictures and none of the fruit pieces falls into this category. Harnett very quickly lost interest in fruit as a principal motif; it figures only incidentally in his later known still lifes, and in not too many of these. His fruit pictures are usually composed around a strong vertical axis provided by a cylindrical or conical vase that towers above the pears, apples, plums, or peaches. One vase, a rather gaudy Chinese affair, is covered with ideographs which some of my Chinese friends in San Francisco have found no difficulty in reading; the inscription has something to do with an episode in the history of the Ming Dynasty. We have no reason at all to think that Harnett could read Chinese, but his observation was so acute and painstaking that he seems

to have made no errors in transcribing these characters.

The mug-and-pipe motif is the one which Harnett employed more often than any other. It appears in many different manifestations and has numerous subvarieties; perhaps it would be best to label this large group of pictures with William Ignatius Blemly's unsophisticated phrase, "smoking scene," or Born's "bachelor's still life," for some few of these still lifes do not depict any mugs at all.

The archetypical picture of this variety (plate 23) shows a roughly glazed gray beer stein surrounded by a band of blue glaze at the bottom and another an inch or two below the lip. This stands on a table top, either of brown wood or veined marble, along with a folded newspaper, a sack, box, pouch, tin, or oblong package of tobacco; some small, round, hard biscuits; some matches, burnt and unburnt; and a meerschaum pipe. The pipe has a richly stained bowl, a cherry-wood stem, and a rubber bit, and there are bright brass fittings at the point where the bit fits into the stem and around the upper end of the bowl.

This formula is subject to infinite variations, and yet the effect is always very much the same. Its one constant is the pipe, which occasionally is a briar rather than a meerschaum. The mugs are sometimes of pewter rather than stoneware, and once in a while Harnett will substitute a stoneware jug or vase for the beer stein. The folded newspapers may lie on the table or may stand up to reveal their mastheads and dates; the dates are always of the year inscribed after Harnett's signature, or of the previous year. Often there is a glowing ember in the bowl of the pipe and a wisp of smoke proceeding from it. Sometimes the composition includes matchboxes, as well as books, inkwells, and other motifs taken over from the writing-table pictures.

Harnett seems to have turned out these paintings almost on a mass-production basis from 1875 through 1880, his first year in Europe. After 1880, other objects creep in, and the formula loses its special identity. But in 1888 Harnett suddenly returned to the mug-and-pipe picture in its simplest, barest, most Peale-like form and produced three examples of it.

[16] In his review of the Peto exhibition at the Brooklyn Museum; New York *Herald Tribune*, April 16, 1950.

Still Life with Mug, Pipe, and Antique Vase

Many of the "smoking scenes" of this period are, to all intents and purposes, replicas of each other; they differ only in the names and dates of the newspapers. Harnett repeatedly uses the same stein, the same meerschaum, the same biscuits, the same matches, and the same blue oblong package covered with revenue stamps and a narrow white label on which one may read the phrase "1—Kilo Tabac Caporal." These objects are arranged in exactly the same way with monotonous persistence, yet variations on the theme could go very far. The greatest known variation is a painting of 1877, now in the collection of Cresson Pugh at Mamaroneck, New York, in which the pipe (one with a highly exceptional stem covered with brass fittings) lies, with the stein and the matches, on the top of a rough wooden packing case with a hunk of Bologna sausage and a loaf of crusty French bread.

All of Harnett's "smoking scenes" are full of built-up paint. The match heads, burnt or sulphur tipped, stand far out in relief, and often the round, heavily blackened rims of the pipe bowls, the rough glaze of the beer steins, and, in one painting, large grains of salt on a piece of pretzel, are sculpted with the same kind of "realism." This literal mechanism, I repeat, is to be found in practically all the works of Harnett up to 1880; if it is not mentioned in further discussions of the early works it is because its presence can be taken for granted.

The "smoking scene" is, so far as anyone knows, a Harnett rediscovery; so is the writing-table still life. Both have seventeenth-century European forebears, but there are no known examples of them in American art before Harnett's time. The "smoking scene" was very often imitated by Harnett's contemporaries, sometimes with great skill, charm, and individuality, as in the works of Peto, but more often in dull, listless, and mechanical style.

Harnett may also have originated the bank-note picture so far as American art is concerned. European paintings in which paper money is represented go at least as far back as the end of the eighteenth century, but they are scattered and rare. Raphaelle Peale may have painted a bank note in his picture of 1795 entitled *A Bill*, but the earliest American paint-ing of paper money which is known to exist is Harnett's *Five Dollar Note* of 1877, now in the Philadelphia Museum of Art.

According to several writers, the pictures of paper money painted by Harnett and his school reflect the American love of filthy lucre during the Gilded Age, but this is nonsense. Harnett's favorite monetary model was a frayed little ten-cent "shinplaster" of the kind issued during the Civil War (plates 38 and 39); these bills had been repudiated in 1875 and were worth exactly nothing, either as legal tender or as collector's items, at the time Harnett painted them; their very name indicates that they were notoriously valueless.

Harnett's pictures of paper currency, however, do possess a greater significance than is apparent to the casual eye. They show him beginning to come to grips with an exceedingly subtle problem—the problem of depth in illusionistic art. It is by no means accidental that all masters of *trompe l'oeil,* from Wallerant Vaillant in the seventeenth century to Andy Warhol and the pop artists in the twentieth, show a marked preference for flat or at least very shallow subjects—watches, knives, seals, engravings, letters, and papers of every kind. There is a very good psychological, even physiological reason for this, but it is best discussed in connection with Harnett's most important known work in that tradition, the rack picture of 1879.

Quite a few paintings of currency bear forged Harnett signatures and have been mistakenly accepted as his works. This is readily understandable; the object of these paintings is to produce the closest possible facsimile of the original, and the subject therefore provides little leeway for the expression of individual stylistic traits. Nevertheless such traits come through even here, and Harnett had his own unique method for turning the trick of the canvas bank note. His painted bills are always worn, dull, and dirt stained, and they possess a rough, pitted texture in which one may see little channel-like marks apparently made with the handle of a brush. When the surface of a bank-note painting attributed to him is smooth, when its emphasis is upon line rather than tone, and when its color is bright, there is always something wrong with its signature, too,

Still Life with Mug, Pipe, and Antique Vase

and suspiciously non-Harnettian materials, like academy board, are likely to be present.

Harnett's writing-table pictures (plate 34), like those of the mug-and-pipe formula, were, for the most part, painted in Philadelphia between 1877 and 1879, but there are far fewer writing-table still lifes than mugs-and-pipes, and this motif is handled much less repetitiously so far as composition is concerned. Almost invariably (although not in plate 34), these paintings contain, among their most striking *dramatis personae,* a conical stoneware ink bottle with a bright yellow label showing a border of interlinked capital "A's," the label of the London firm of F. and J. Arnold. A quill pen is often stuck into the mouth of the bottle or lies beside it; there are usually books, rolls of bills, coins, and, not infrequently, desk lamps on the table. But the most amusing feature of the writing-table "scene" is the folded letter, which is seldom absent.

As is pointed out above, Harnett's newspaper clippings are never legible, in marked distinction to those, for example, of Haberle and Chalfant, which can always be read and are usually excerpts from reviews in praise of the artist. Harnett took no interest in painting literature as such, but in his folded letters, which are mostly but not entirely confined to his writing-table pictures, he creates a very special literature of his own.

These letters usually present a few tantalizing sentences, most of them incomplete, but all of them in Harnett's characteristic handwriting, with no attempt at disguise: they are letters from the artist himself. Many contain lines which are now illegible and may have been so originally; words are sometimes painted as though they had been smudged when the ink was still wet, and there are overwritings, deletions, and caretted interlineations.

I am convinced that the texts of these letters have no real meaning, but were contrived to amuse the spectator by giving him the sensation of secretly reading someone else's private correspondence. As Born has pointed out, Harnett's carefully haphazard still life arrangements often create the impression that the owner and user of the represented objects has just stepped momentarily out of the room. Then the spectator comes on tiptoe, perhaps looking over his shoulder to make sure he is not observed, to see what the absent one has been reading. The legible pages are always upside down. To have placed them right side up would have called attention to them too blatantly and spoiled their whole effect.

In a few paintings the letters seem to concern themselves with the sale of Harnett's work, and in these there is usually an addressed envelope to identify the actual or prospective buyer—Dennis Gale, the Philadelphia art dealer, or Thomas B. Clarke, the famous New York collector, for example. (One writing-table picture of 1879 contains no letter but a memorandum pad on which is written "June 28 / See Mr. Clarke / at St. George Hotel." Clarke is known to have had one Harnett and may have owned more.) In the majority, however, the contents of the letters are completely cryptic; in my opinion, intentionally so. The letter in the writing-table picture of 1877 reads "received you . . . early part of last month (?) and was extremely glad to hear that . . . had a succ . . . ful . . . reflecting . . ." In another of Harnett's painted letters one may decipher the following: "say now, Mr. Lask I would like / you to call upon . . . / and we will make arrangements to spend the . . . / in the Adirondacks if you . . ." In still another, the letter, dated "New York / Dec. 5," says "Mr. Stevenson / Dear Sir, I believe you / have been waiting to hear / from me for some time, but . . ." (The texts of all the painted letters are given in the catalogue of Harnett's pictures on pages 163–181.)

From 1877, then, comes our earliest knowledge of many important Harnettian ideas, although at least two of these ideas—those of the fruit piece and the "smoking scene"—had certainly been manifested earlier in works now lost. It was in 1877, also, that Harnett exhibited for the first time at the Pennsylvania Academy of the Fine Arts. He showed two pictures that year—*A Study Table* and *Fruit*—but if these canvases exist today, they cannot be identified by these titles.

Harnett obviously did not regard the annual exhibitions of the Pennsylvania Academy as particularly important, for throughout his entire career he displayed only six paintings there—two in 1877, one each in 1878 and 1879, and two in 1881. But Har-

nett's name appears twenty-six times in the catalogues of the regular spring and special autumn exhibitions at the National Academy of Design in New York; from the beginning of his professional activity in 1875 to his death in 1892, he showed from one to four pictures each year at the National Academy except in 1880, 1885, 1887, and 1890. (In 1880 he had just gone abroad, was finding himself in Europe, and apparently had no time to send anything back. In 1885 he was slaving furiously at the largest painting of his life, his Paris Salon piece, *After the Hunt.* Throughout a large part of the year 1890 he was inactive because of his health. No explanation can be offered for his failure to exhibit at the National Academy in 1887.)

Nineteenth-century art catalogues were, unfortunately, not printed for the benefit of twentieth-century historians. They provide no measurements, no descriptions, no means of identification other than titles, and Harnett's titles were often exceedingly noncommittal; *Fruit, A Lunch,* or most maddeningly, *Still Life.* Consequently one can seldom be sure just what Harnett may have shown at any given place or time, but his prices, as recorded in the National Academy's annual handbook, are unexpectedly interesting.

At the beginning, of course, he asked little—fifty or seventy-five dollars. His prices climbed to a high of six hundred for the lost picture, *After a Hard Night's Work,* in 1878, but in the early 1880's they declined sharply; the four pictures sent from Munich in 1883 were priced from fifty dollars to two hundred and twenty-five. After his return to this country in 1886, Harnett's prices rose again and reached their peak with a painting called *For Sunday's Dinner,* for which he asked a thousand dollars at the autumn exhibition of 1888.

All this is a measure not so much of Harnett's reputation as of the size of his canvases. He painted some large pictures in Philadelphia in the late 'seventies, but in his Munich days, doubtless under certain European influences, he experimented for some time with a miniaturistic manner, and produced some of the smallest works of his entire career. Back in the United States, after the success of his enormous *After the Hunt,* Harnett continued to use a relatively large canvas, although his comparatively high prices after 1886 doubtless reflect also the fact that his reputation was at its height.

VII

WILLIAM AND Nathan Folwell were figures of great prominence in the Philadelphia textile trade in the 1870's, and their firm, Folwell Brothers and Company, was long one of the most eminent in its field. The Folwells became enthusiastic patrons of Harnett, introduced him to their business associates, and were no doubt responsible for the fact that an article on Harnetts owned by members of the textile industry appeared in the *Dry Goods Economist* of Philadelphia on November 1, 1892, just two days after the artist's death. This article states that William Folwell owned Harnett's *After a Hard Night's Study,* and that Nathan possessed "another specimen representing an old bull's-eye watch lying on an ancient book which is so realistic that you almost expect to hear the watch tick"; a "study of fruit" belonged to George Hulings, and "another of this artist's latest productions" was in "the counting house of Strawbridge and Clothier," while "B. Nugent of B. Nugent and Bro., the well known St. Louis dry goods jobbers, owns his celebrated book picture entitled *Job Lot,*" and "Paul Hackey, of the firm of Hugus and Hackey, owns a very fine example entitled *Old Friends.*"

Actually, William Folwell seems to have possessed at least four pictures by Harnett, two of which are still in existence. I found the great *Job Lot* (plate 3) in the home of B. Nugent's son, Julian, in St. Louis, and Nathan Folwell's "specimen" with the bull's-eye watch long kept company with Harnett's charcoal *Discus Thrower* of 1873 in the living room of Nathan's son, Philip, at Merion, Pennsylvania. The Strawbridge and Clothier picture has disappeared, and so have the families and the collections of Paul Hackey and George Hulings.

The catalogue of the commemorative exhibition of paintings by Harnett held at Earle's Galleries in

Still Life with Mug, Pipe, and Antique Vase

Philadelphia in 1892 provided the clue to the Folwells and the rather intricate aspects of the Harnett story in which they were involved. Because this catalogue lists thirty-eight pictures and fourteen lenders, but does not indicate who lent what, it was clearly necessary to investigate all the lenders [17] through their wills and other public documents. Among a great many other things, this investigation led me to Folwell Brothers and Company, and ultimately to William Folwell's daughter, Mrs. May Hoisington, of Rye, New York.

Mrs. Hoisington well remembered her father's admiration for Harnett and she cherished a copy of the catalogue of the Earle exhibition, to which her father had taken her. She told me, however, that all the Harnetts her father had owned had long since been sold, and she could not remember which they were. In the hope that reproductions might stimulate her memory, I showed her many Harnett photographs. When we reached the *Still Life with Bric-a-Brac,* now in the Fogg Museum at Harvard University (plate 35), Mrs. Hoisington gasped; the Harvard picture represents fifteen objects on a table-top, and seven of those objects were there in Mrs. Hoisington's living room (plate 36). Later I learned that an eighth object in the painting, the bronze bust of Minerva, was given to the Public Library at Columbus, Georgia, by Mrs. Hoisington's sister, Mrs. Thomas Hudson.

Clearly, then, the Harvard still life was painted for William Folwell using Folwell's own property for models; these are the only Harnett models which are now known to exist. The iconography of the picture is very different from that which Harnett employed when he chose his own subject matter, at least at this period. The objects are much more elaborate and more sharply contrasted in color, and it is very likely that Harnett, ardent Catholic that he was, would not have given house room to a copy

of Fox's *Book of Martyrs,* even though it makes a handsome model.[18]

Harnett rarely served, as he did here as a portrayer of other people's bric-a-brac, and most of his models were his own carefully selected property. But in another picture executed for William Folwell, long in the hands of his granddaughter, Mrs. Natalie Thomson of New York, Harnett depicts the same bright tan plaster vase with gold and black borders that appears at the extreme left in the Harvard painting; the rest of the Thomson picture is, iconographically speaking, typically Harnettian. The framed portrait represented on this canvas is a copy of Raphael's *Bindo Altoviti,* now in the National Gallery at Washington, D.C. This was long believed by some authorities to be a self-portrait, and an "old master portrait of Raphael" is listed among Harnett's effects in the catalogue of the Birch sale.

The still life painted for Nathan Folwell likewise

[17] The list of lenders in the Earle catalogue includes the names of the Folwells and Hulings, but not that of Hackey, although *Old Friends,* the title of the picture which the *Dry Goods Economist* gives to Hackey, appears in the list of the paintings. This title was taken from the Earle catalogue and arbitrarily assigned to a small still life, then believed to be a Harnett, which now turns out to be a Peto with a forged Harnett signature. The same procedure has been followed elsewhere, and although there is nothing reprehensible about it, it makes for much confusion.

[18] Two minor but exceedingly annoying problems arise in connection with the Harvard picture and its relationship to the objects in Mrs. Hoisington's house.

Before calling upon Mrs. Hoisington, in the spring of 1948, I had met Mrs. Harry Harmstad, the daughter of E. Taylor Snow, and among the things she had shown me was an old photograph, apparently of the Harvard painting, but with one rather curious and startling difference: the center of the dish standing on its edge was filled, not with a bird on a branch, as in plate 35, but with the head of a little girl. Mrs. Hoisington has the actual dish with the girl's head (plate 36, in which, one trusts, that detail will be visible, since it is rather faint in the photograph), but no plate with the bird on a branch.

I assumed that, at some time after the picture passed out of the hands of the Folwell family, but before it passed into the possession of Grenville Winthrop, who presented it to Harvard, some unknown person painted out the girl's head and substituted the bird, but this could not be confirmed by X-ray. The X-ray went completely through the pigment at this point and revealed nothing whatever.

My assumption regarding the Harvard picture was badly shaken when, in March, 1950, I discovered the collection of Harnettiana left by Catherine Barry. This collection contained a print of the same photograph shown me by Mrs. Harmstad, and it was inscribed on its back in Harnett's handwriting "Phila. 1879 / $ to T. B. Clark of N.Y. 28 x 38 in." Since the painting in the photograph, like the one at Harvard, is clearly dated 1878, the inscription on the back is subject to two different interpretations. It may mean that in 1879 Harnett made a replica of the Folwell picture for Thomas B. Clarke, and if so he might have made a second replica, altering the girl's head to the bird on the branch. The dimensions given on the back of the photograph are three inches smaller, in both height and width, than the dimensions of the painting now at Harvard.

On the other hand, Harnett's inscription on the back of that photograph may have been a complete error; he may have thought that a painting of 1879 was represented on the other side of the card on which it was mounted. It is difficult to understand why he would make replicas of a picture created to order for a particular patron and dealing with that patron's household furnishings. The work possessed unique meaning for William Folwell but no special meaning for anyone else.

Still Life with Mug,
Pipe, and Antique Vase

exhibits a mixture of characteristically Harnettian subject matter with subject matter which, one suspects, was added to order. The old, frayed books, the Arnold ink bottle, the drape, and the folded letter are Harnett's special stock in trade, but it is probable that the watch was a Folwell family heirloom and that the Greek vase—obviously a plaster copy and so new that you can practically smell its paint—was, like the bronze statuette of a greyhound, recently acquired by Nathan.

All three of the Folwell pictures which still exist, the two produced for William and the one produced for Nathan, were done in 1878. So was the painting which Harnett sold to the Folwells' friend, Byron Nugent.

The *Dry Goods Economist* calls the Nugent painting (plate 3) "Harnett's celebrated book picture entitled *Job Lot.*" Why it was "celebrated" in the 1890's we do not know, but the adjective is interesting because by modern standards this is one of Harnett's major masterpieces. Its real title is *Job Lot Cheap,* as is indicated by the sign at the lower left. A group of old, worn, dog-eared books is piled helter-skelter on the top of a packing case. All the books are studied with characteristic minuteness, and the textures of their bindings—smooth leather and frayed, spotted leather and clear, stamped cloth, unbacked paper, and paper pasted to cardboard—are elaborated in Harnett's most masterly fashion. All the toolings and stampings and adornments with gold leaf are set down, and every separate page is described in such of the book-tops and fore-edges as are shown. But what gives this work its stature is its mastery of rectilinear forms. The picture is composed like a cubist abstraction. This may be accidental, but it is none the less true, and there is nothing like it even in the works of so great a book painter as the seventeenth-century Frenchman, Jean Baptiste Oudry.

The lower portion of this work is as important as the upper. The sign, "Job Lot Cheap," flimsily painted on the inside of an orphan book-cover, takes us again to Mr. Burrows' crossroads between still life and genre; it is just such a sign as would be dashed off by the proprietor of a second-hand bookshop. The labels pasted to the packing case along the extreme lower edge of the canvas lead us away

from genre to surrealism. They are as carefully differentiated in color and lettering as the books represented above. Some have been pasted over others. All have been partly torn off, and only one, the "Just Publishe . . ." at the right, is in any way intelligible. Harnett seldom returned to the motif of the torn-off label, but it was to become an obsession with his friend and follower, John F. Peto. Peto himself painted many excellent still lifes of books, and one of these, *Discarded Treasures* (plate 17), now in the Smith College Museum of Art, is clearly an imitation of the Harnett under discussion. One need only glance at the bookshop proprietor's sign, "10 cents EACH," at the lower left of the Peto, to find the inspiration for this canvas, which bears a forged Harnett signature and was for years widely admired as one of Harnett's best works. (It remains one of the best works of the school. Taking it away from Harnett merely increases Peto's stature; it does not in any way diminish the importance of the painting.)

It is worth adding, as a significant final comment on *Job Lot Cheap,* that Harnett gave a photograph of it to the fellow artist, friend, and biographer whose name has been so often invoked in these pages, and inscribed it as follows: "To E. T. Snow, thanks for the idea, Yours Truly, William M. Harnett."

The torn-off paper label appears in another Harnett of 1878, a most unusual work known only through old photographs preserved by Snow's daughter and by Catherine Barry. This (plate 52) is a picture of a little colored boy in a three-cornered hat made of a sheet of newspaper; he stands erect in a ragged "uniform" carrying a mop-pole for a gun. The torn label—actually a large advertisement for a "Grand Excursion"—appears on the wooden fence or wall behind him. Snow tells us that Harnett, in his Philadelphia days, painted a picture called *Front Face,* and this may very well be it.

The gamin picture was a special genre of genre in Harnett's time, and practically every American artist of that era contributed to it. Homer, Eakins, Hovenden, Eastman Johnson—they all did gamin pictures, and J. G. Brown built practically his entire career on this one motif. But none of these artists would have studied the brass buttons of the child's

Still Life with Mug,
Pipe, and Antique Vase

vest so lovingly, none would have detailed each line of type in the newspaper of his hat nor indicated that it was made from a sheet of the Philadelphia *Public Ledger,* and none would have spent so much time on the grain, cracks, stains, chalk marks, carved initials, and ruined advertisements of the wall in the background. For a parallel to this last manifestation, one must go to Peter Blume, Louis Guglielmi, Walter Stuempfig, and other American artists influenced by surrealism.

The photograph of Harnett's gamin picture which came to me through Catherine Barry bears on its back a notation to the effect that it measured 36 by 28 inches. Canvases of this or approximately equal size are common among the Harnetts of 1878, including all those so far discussed, in marked distinction to the uniformly small dimensions of the known Harnetts which date from the previous year. Another large, important Harnett of 1878 is *Music and Literature* (plate 37), in the Albright-Knox Gallery in Buffalo. This is one of the few early Harnetts which is known today under the artist's own title, as confirmed by a captioned cut of the picture in the Blemly scrapbook. *Music and Literature* makes much use of piled-up books, quite like those of *Job Lot, Cheap,* but its composition is more intricate, aerated, and less dense, and as Andrew Ritchie points out in his catalogue to the permanent collection at the Albright, its tactile contrasts include effects of implied temperature—the coldness of the metal versus the relative warmth of the wood and the leather. The whole composition wheels around the jutting built-up point of the book which lies open on the table. This book, with its dangling red ribbon twisted at the end, clearly comes from the *Mortality and Immortality* (plate 31) of 1876, but is now the axle which turns the entire movement of the painting. Here, for the first time, Harnett paints his flute, with its cracked ivory head, and his characteristic translucent candle. The Arnold ink bottle and the folded letter are familiar motifs. The music curving over the edge of the table is a set of trashy variations for flute solo on themes from *La Traviata.* The frayed, bright blue music cover, rolled up and tied with string behind the candle at the right, is covered with letters in extremely large type. No complete word is legible or even guessable here, yet these letters indicate that the top of the cover is at the left-hand end of the roll. Similarly, one cannot read more than one complete bar of the printed music tied up inside this torn cover, but there are just enough notes and clefs to show that the music is upside down.

This last is the sort of thing which only a virtuoso would care to do, and virtuosity is one of the key words in any discussion of Harnett. One often runs across the idea that minutely detailed painting like his is of necessity labored, but nothing could be further from the truth. Harnett worked very fast. He told the reporter for the New York *News* that he spent three whole months on *After the Hunt,* the largest canvas of his life, implying that three months was an heroically long time to give to a single picture, even one six feet high. Harnett's kind of painting must be brought off like an act of prestidigitation; otherwise it loses its spirit. In this respect, Harnett's style is brother under the skin to that of William Merritt Chase and the other flashing artistic swordsmen of that era who made much of palpable brushwork and a slam-bang sketchiness which Harnett avoids, but neither the artists nor the critics of that time perceived this kinship.

It was in this year of 1878 that Harnett received his first known mention in the press. He showed three paintings at the National Academy of Design that spring, and the New York *Times* devoted a single sentence to one of them, obviously the one entitled *A Bad Counterfeit.* "William H. [*sic*] Harnett of Philadelphia shows great dexterity, but nothing more, in a painting of a ten-dollar note on a panel."

VIII

TWENTY-FOUR HARNETTS of 1878 are known to exist. We do not know how many more Harnett may have turned out in that year, but there is a contemporary photograph of one—the Negro gamin picture just discussed. This photograph, with twenty-four others, was in the Catherine Barry collection. The originals of only five of these twenty-five re-

Still Life with Mug, Pipe, and Antique Vase

productions can be located today. This, I am convinced, provides a rough guide to Harnett's total output—in other words, not more than a fifth of his work has so far come to light. "New" Harnetts are constantly being found, however, and I should not be astonished if by the time this book goes to press half a dozen hitherto unknown pictures of 1878 were discovered.

In addition to the paintings discussed in the preceding section, the known Harnetts of 1878 include two writing-table pictures and nine mug-and-pipe still lifes. Known works for 1879 consist of nine writing tables, four mugs-and-pipes, one fruit piece, two money pictures, the great card rack, and a Shakespearian *memento mori*—eighteen in all. One other Harnett of this year is known through a photograph preserved by the artist's sister.

The writing-table and mug-and-pipe pictures of 1879 bring up nothing new. The fruit piece, known by the dealer's title, *The Blue Carafe,* is the first known Harnett to emphasize the tricky problems involved in painting transparent glassware; in fact, the primary concern is with the glassware and the red wine inside it, and the fruit plays second fiddle.

The two money pictures of 1879 are very curious, especially by comparison with each other. They are nearly identical, and it is the very slightness of their differences that makes them interesting.

Both these paintings are on mahogany panel. One (plate 38), measuring 5½ by 7½, is in the Philadelphia Museum of Art, and the other (plate 39), a half-inch smaller in both dimensions, belongs to the New York collector, Donald Stralem. Since the Stralem version is somewhat more elaborate, it may be later than the other, but both are signed and dated 1879.

Both pictures represent the ten-cent "shinplaster" and a newspaper clipping, and the Philadelphia Museum version contains nothing else. In the Museum's picture, there is a frayed scallop at the lower right of the bill; the clipping shows six lines of text and extends past the column rule on its right-hand side. In the Stralem picture, the frayed scallop is at the upper right instead of the lower right, there is an additional deep tear at the lower right corner, and the bill is entirely surrounded with built-up glaze to simulate paste pressed out around the edges when the bill was affixed to the board. Otherwise the two bills are almost precisely alike, down to the placement of the folds which run through the center of the man's face at the left and through the crux of the X at the right. The clipping in this painting also contains six lines, but extends past the column rule on the left instead of the right. At the lower left of the picture is a painted exhibition label with the number "37." (This may be the picture with the exhibition label to which James E. Kelly refers.)

These variations between the two paintings are amusing, but the most amusing thing of all is to compare the "texts" of the two newspaper clippings. As is always true with Harnett, there are no legible words, but merely broken lines of black paint scratched through to suggest type. Nevertheless, the first lines of these two clippings are almost exactly alike. There are nine "words" in the first line of the Museum's clipping and eight in the first line of the other, and the first five "words" in each of these lines are of the same lengths. Harnett obviously started out to make an exact replica of that painted clipping, but there was a limit to the patience even of William Harnett when it came to the madder aspects of artistic virtuosity.

Still life is by definition the painting of objects which are not capable of independent movement, but the Harnett of 1879 which survives through a photograph (plate 33) is indubitably a still life even though it contains five exceedingly frisky mice. These mice are on a pantry shelf nibbling greedily at an immense piece of cheese. Sticking into the cheese is a heavily stained knife with a cracked ivory handle. To the left of the cheese are a stained old crock, some parsnips, and a candlestick; to its right are a battered canister, a piece of fruit, and a crude bowl containing a small package and more pieces of fruit; a loop of string hangs from the shelf above, directly over the bowl, and both shelves are lined with frayed, torn newspaper cut in a saw-tooth pattern. This is one of the most entertaining genre still lifes Harnett ever painted, and it is one of his last expressions of delight in the humble, the commonplace, the every-day, and the ordinary. Within a year's time his whole attitude toward subject matter was to change, and so far as we know, he seldom returned to motifs of this delightful sort.

Still Life with Mug, Pipe, and Antique Vase

This picture must be the one called *Thieves in the Pantry* which Harnett exhibited at the Pennsylvania Academy of the Fine Arts in 1879. According to the notation on the back of the photograph it measured 16 by 35 inches and was sold to "Moehring, Frankfurt." Harnett was in Frankfurt for the last six months of 1880. Obviously, he took this canvas with him, and he may have taken others as well.

Harnett sent only one painting to the annual exhibition at the National Academy of Design in 1879 —*The Social Club* (plate 29), now in the collection of Mr. and Mrs. J. William Middendorf. In reviewing the Academy show on April 26 the anonymous critic of the New York *Tribune* wrote as follows. This notice, so far as is known, is the most extensive contemporary review of Harnett's work.

Just as there are scores of people who look at and admire Mr. Heade's picture (*Tropical Flowers*), while comparatively few either look at or admire Mr. Sargent's picture (*Little Wanton Boys*) hung just beneath it, so there are many who stop and look with delight at Mr. W. M. Harnett's *The Social Club* . . .

Last year Mr. William M. Harnett had several pictures in the exhibition of the same general character as this *Social Club*,[19] and they attracted the attention that is always given to curiosities, to works in which the skill of the human hand is ostentatiously displayed working in deceptive imitation of Nature.

An essay might be written on this subject of imitative art, and it could be shown by a score of examples culled from old books, from Pliny down to Vasari, that even in the ages we call the best this attempt to deceive the senses has been reckoned one of the legitimate aims of art. But it is equally true that all the greatest artists—even Dürer and Holbein—have known how to keep this imitative skill in its true place, as servant not as master, as a means or adjunct, not as an end, while the very greatest names of all in the list of men of genius never attempted imitation at all; Raphael in the details of some of his matchless portraits—in the fur collar of his *Violin Player*, in the hand-bell and the chair-knob with its reflection in the *Leo X*—coming as near to the dangerous point of excess as is compatible with the true aims of art.

Only a very few artists of merit have ever condescended to apply their skill to the sole purpose of imitation, making so-called pictures out of dead objects painted to deceive the eye as far as possible, for there still remains a little dignity of purpose attaching to flower-pieces, fruit-pieces, game-pieces and the like, and great painters, among them Vollon of our own time, have occasionally wreaked their superfluous strength and sportive leisure on painting pots and pans so sublimely as almost to make us ashamed of our principles. But we must remember that this is only the play of good painters, never their serious employment; and the exquisite works of a Blaise Desgoffe, a Steinheil or a Benedictus ought not to make us forget that their pictures are to true art what a catch or glee is to true music.

The real fact is that this charge of inferiority is justified by the consideration that this imitative work is not really so difficult as it seems to the layman, and though there are degrees of it, yet when we come down to works like this of Mr. Harnett, it is evident that only time and industry are necessary to the indefinite multiplication of them. There are sign-painters in plenty in this city of ours—and in all great cities today—who have only to be sufficiently discontented with their honest calling to aim at the name of artist, to rival Mr. Harnett, Mr. Guy,[20] Mr. Ream, Mr. Huntington in the painting of externals. There is far too much of this

[19] As we have seen, Harnett had been exhibiting regularly at the National Academy since 1875, but the critic of the *Tribune* did not seem to be aware of that fact. Harnett's entries through 1877 must all have been modest in size and might easily have been overlooked, but, as previously indicated, one of his entries for 1878 was priced at six hundred dollars and was therefore, in all probability, a sizeable canvas which would not be so quickly passed by.

[20] "Mr. Guy" was presumably Seymour J. (1824–1910), a National Academician and one of the founders of the American Water Color Society, who was especially well known as a genre painter. In the catalogue of the Thomas B. Clarke sale held at the American Art Galleries in 1899, he is said to have been "a finished draughtsman, with an agreeable and conscientious method." "Mr. Huntington" must have been the great Daniel (1816–1906), pupil of S. F. B. Morse and Henry Inman, and one of the most prolific nineteenth-century American painters of portraits, historic scenes, and landscape. In 1879 he was in the second year of his long second presidency of the National Academy itself.

There were two brothers named Ream, both still life painters, but not exclusive specialists in this type of subject. They were born in Lancaster, Ohio, Cadurcis Plantagenet in 1838, Morston in 1840. The city directory shows that they shared studios at various addresses in the Union Square district of New York in the early 1870's, but in 1878 Cadurcis Plantagenet Ream (being able to resurrect a name like that makes research worth while) went to Chicago, where he lived until his death in 1917. Morston Ream, who died in 1898, seems to have remained in New York. A pleasant little still life of fruit, nuts, and a wine glass by Morston Ream is in the Museum of Fine Arts at Springfield, Massachusetts, and is reproduced by Born. A few other still lifes by Morston have turned up in New York dealers' galleries in recent years; they are almost uniformly flashy, obvious, and uninteresting. To judge from the two examples of his art preserved at the Henry Gallery of the University of Washington in Seattle, the work of Cadurcis is not very exciting, either. The Art Institute of Chicago owns one of his still lifes, but it has been on permanent loan for years to the Juvenile Detention Home, presumably not as evidence of a misspent youth.

Martin Johnson Heade (1819–1903), painter of flowers, of Brazilian hummingbirds, and of landscape, scarcely needs identification today, although he would certainly have needed it twenty years ago. He is one of the many nineteenth-century American artists, like Harnett himself, who have been brought forth from obscurity by contemporary taste.

Some notes on the European still life painters mentioned by the *Tribune* critic will be given later, in the discussion of Harnett's European activities.

31

W. M. Harnett
Mortality and Immortality 1876 (22 x 27)
Roland P. Murdock Collection, Art Museum, Wichita, Kansas

32

W. M. Harnett
A Wooden Basket of Catawba Grapes 1876 (27½ x 22)
Charles and Emma Frye Museum, Seattle

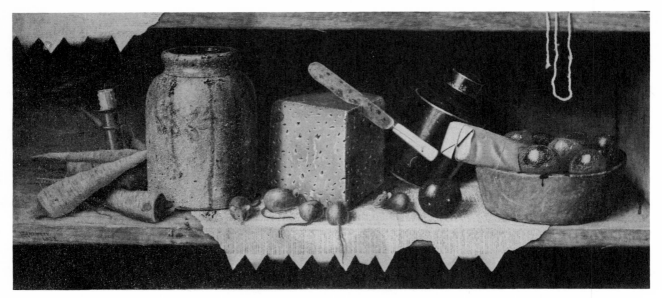

33

W. M. Harnett
Thieves in the Pantry (photograph of lost painting inscribed with dimensions of original, 16 x 35) 1879

33a

W. M. Harnett
Sketch for
Thieves in the Pantry (?)

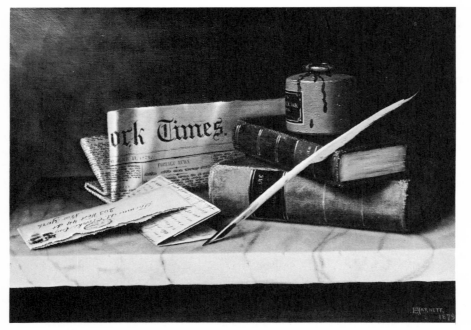

34

W. M. Harnett
Still Life with Letter to Thomas B. Clarke 1879 (11 x 15)
Addison Gallery of American Art, Phillips Academy, Andover, Massachusetts

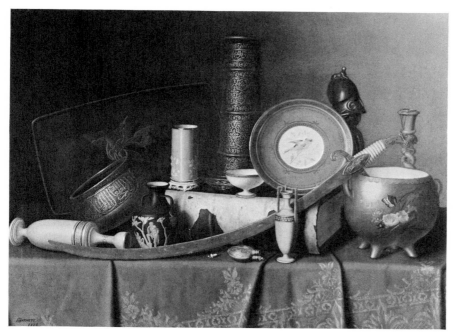

35

W. M. Harnett
Still Life with Bric-a-Brac 1878 (31 x 41¼)
Grenville Lindall Winthrop Collection, Fogg Art Museum,
Harvard University, Cambridge, Massachusetts

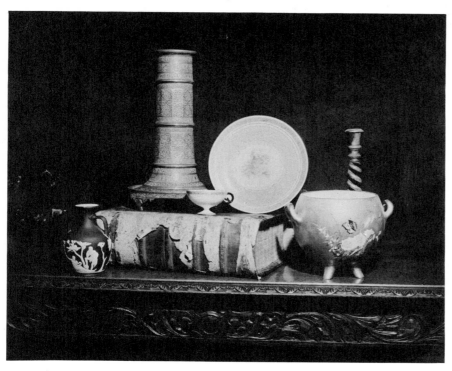

36

Objects in the home of Mrs. May Hoisington, Rye, New York

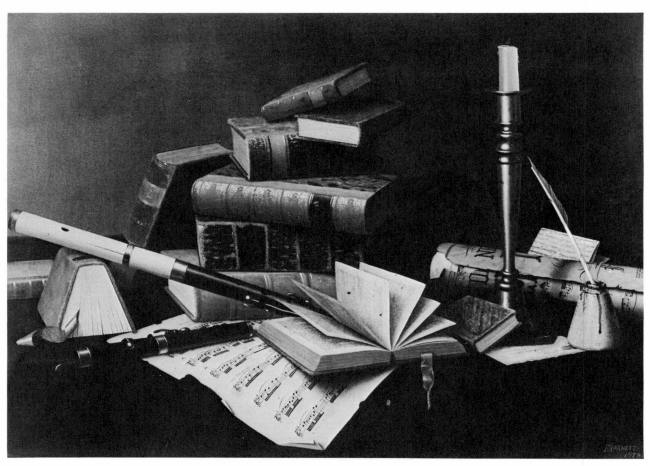

37 W. M. Harnett
Music and Literature 1878 (24 x 32)
Albright-Knox Art Gallery, Buffalo, New York

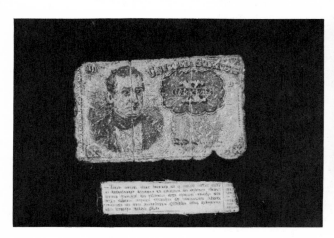

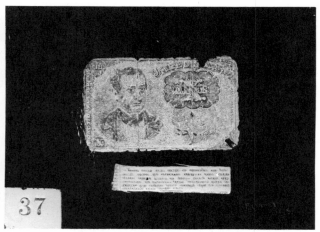

38 (*Reproduced by special permission of the Secretary of the Treasury. Further reproduction in whole or in part is strictly forbidden.*)

W. M. Harnett
Shinplaster 1879 (5½ x 7½)
Philadelphia Museum of Art,
Philadelphia, Pennsylvania

39 (*Reproduced by special permission of the Secretary of the Treasury. Further reproduction in whole or in part is strictly forbidden.*)

W. M. Harnett
Shinplaster with Exhibition Label 1879 (5 x 7)
Mr. and Mrs. Donald Stralem, New York

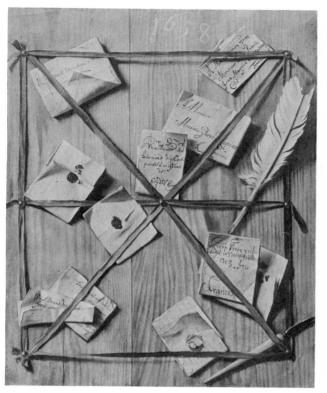

40

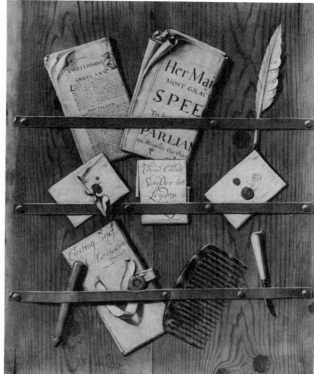

41

Wallerant Vaillant
Letter Rack 1658
Gemälde Gallerie, Dresden, Germany

Everett Collier (Evert Colyer)
Letter Rack 1706 (25½ x 20½)
Formerly Edwin Hewitt Gallery, New York

42

Unknown artist
The All-Seeing Eye 1827 (16¼ x 28½)
Wadsworth Atheneum, Hartford, Connecticut

43
Raphaelle Peale
Patch Picture for Dr. Physick 1808 (21½ x 17½)
Formerly collection Cy Des Cartes, Brooklyn, New York

44
F. E. Church
The Letter Revenge before 1847 (8¼ x 10¼)
Oberlin College, Oberlin, Ohio

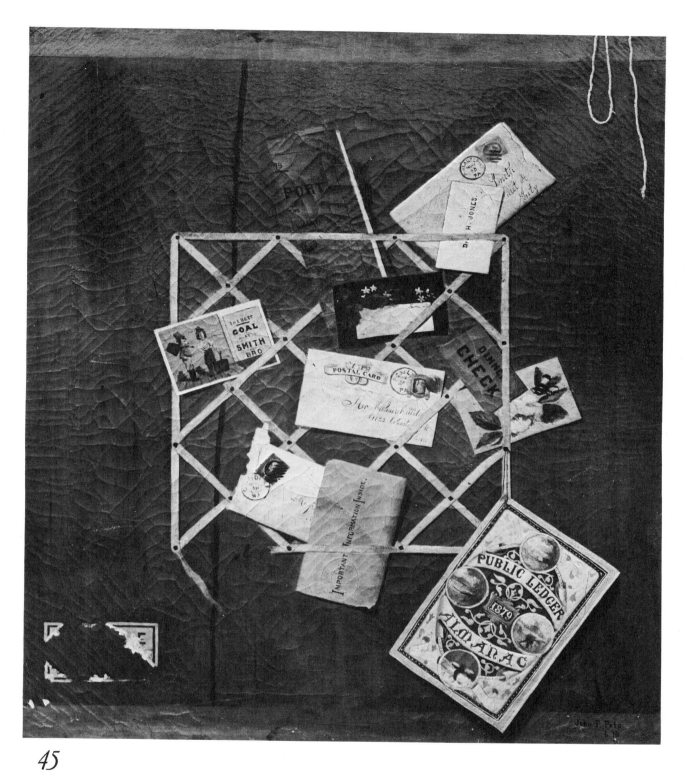

45

John Frederick Peto
Office Board for Smith Brothers Coal Company June, 1879 (28 x 24)
Formerly collection G. David Thompson, Pittsburgh, Pennsylvania

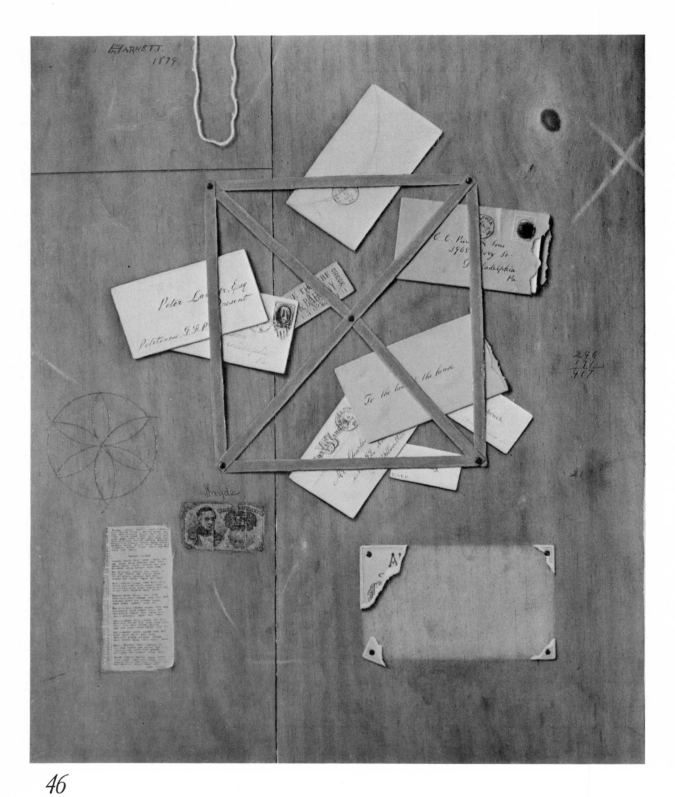

46

W. M. Harnett
The Artist's Card Rack August, 1879 (30 x 25)
Metropolitan Museum of Art, New York

Still Life with Mug,
Pipe, and Antique Vase

merely external painting in our Academy, this painting by recipe, of which the critics complain, and in their complaint only give voice to the discontent of the general public.

Except for the marvelous inconsistency between its opening and closing, this review is typical of contemporary professional opinion regarding Harnett and all the members of his school. Few contemporary critics, to be sure, begin by asserting that Harnett appeals only to the crowd and end by stating that he does not appeal to the general public, but in general the *Tribune* critic voices the attitude of his fellows, and of the best-known painters of their day, toward Harnett's work. In the last years of his life reviewers occasionally expressed approval of Harnett, since by that time he was something of a celebrity and could be taken for granted, but all the extended comments on his work by artists and professional critics are distinctly unflattering and unfavorable. Apparently their eyes were completely closed to the formal values in Harnett's painting which we have learned to see, thanks to the discipline of modern art. They were completely enslaved to the ideal of fancy brushwork, and when the *Tribune* critic accuses Martin Johnson Heade and William Michael Harnett of ostentatious display, comparing them unfavorably with John Singer Sargent (even though the Sargent involved is a gamin picture), one wonders if the mental processes of that critic's generation were not entirely different from the mental processes of the present.

After the Harnett revival of 1939, much attention was paid to the three enigmatic, surrealistic, rack pictures ascribed to him. It has since been shown that all three of these are actually by Harnett's friend, John Frederick Peto, but at the same time I discovered the evidence of Peto's authorship in his daughter's home I found also a stack of old glass negatives, presumably his, among which was a shot of a rack painting, indubitably in Harnett's style, signed by Harnett and dated 1879. I assumed that Peto had used this Harnett rack as the direct prototype for his own paintings of the same sort, but the original painting, which has since come to light (plate 46), presents evidence to show that this is not so. There is good reason to believe that here Peto was the forerunner and Harnett the follower, although, so far as other motifs common to both

artists are concerned, the reverse seems to be true.

Peto seems to have painted dozens of "racks." He called them "office boards," and most of them were clearly executed to adorn places of business. Peto's earliest known picture of this type (plate 45) is the *Office Board for Smith Brothers Coal Company* (my title), signed and dated, in Peto's usual fashion, "6.79." (i.e., June, 1879.) Its rack is a very elaborate grid of ten tapes within a rectangle. It displays objects which Peto used with extraordinary persistence in his early paintings on this theme—the green "Report" pamphlet, the greeting card with a floral border, the tan envelope imprinted with the phrase, "Important Information Inside," the card of Dr. S. H. Jones, and a copy of the *Public Ledger* Almanac. The card of Smith Brothers Coal Company is at the upper left of the rack; note also the torn-off label at the extreme lower left of the canvas, the loop of string at the extreme upper right, the postcard addressed to Peto in the middle of the rack, and the "Dinner Check." The work was formerly in the collection of G. David Thompson of Pittsburgh.

This painting by Peto seems to antedate the Harnett rack by two months, for the Harnett, dated 1879, bears, behind its lowest horizontal tape, a postcard apparently postmarked "Aug. 26." (This is the so-called "B" card, issued in 1875;[21] Peto also represents it in the Thompson picture and in many others.)

Harnett's rack is an exceedingly simple one—merely the X and the rectangle. It is made of rose-colored tapes, and they are tacked to a wall at a point where three pieces of wood come together. The Mondrianesque lines of division between these pieces of wood are indicated with the most subtly built up paint in any work of Harnett. (This is the only known painting in which Harnett shows the grain of the natural wood, but he makes little parade of it.)

Everything in Harnett's rack seems on first glance as if it should be intelligible, but actually nothing is. At the left is an unstamped white envelope inscribed "Peter Lan . . . Jr., Esq / . . . resent / Politeness, G.F.P." Below this is a green envelope, stamped,

[21] See *A Description of United States Postage Stamps and Postal Cards*, Washington, 1927.

Still Life with Mug, Pipe, and Antique Vase

postmarked, and addressed to ". . . son / Philadelphia / Pa." At the top of the rack is a yellow envelope with its addressed side facing the wall; it bears a Philadelphia postmark on its back. At the right is a blue envelope, its stamp canceled with a smudge of ink; this envelope, addressed to "C. C. Peir . . . & Sons / 3908 . . . tory St. / Philadelphia / Pa.," has been torn open to reveal a white letter within. At the lower right of the rack is an empty, torn-open, orange envelope inscribed "To the lad. .f the house." Below this is a calling-card on which is engraved ". . . bruch"; along the lower edge of this card is a line in longhand: "34th . . . ring Sts." At the extreme lower right of the rack is another calling-card on which one may make out only the lower parts of a shaded lower-case "n" and "g"; in the lower left corner are the printed letters "R.S.V.P." The postcard bears, in addition to its Philadelphia postmark of August 26, the longhand address "Mr. Charles . . . / N . . . 92 Na . . . / Philadelphia." To the left of the center of the rack is a ticket which reads ". . . UE TH . . TRE / . . . & BALC . . NY"; there is a series of Arabic numerals along the lower edge of the ticket and at its right-hand end is the word "CHECK."

The inscriptions on the envelopes for "Peter Lan . . . Jr." and for "C. C. Peir . . . & Sons" are in Harnett's handwriting; the other inscriptions are in four different, more or less completely disguised scripts.

In the free space on the board to the right of the rack are, reading from top to bottom, a knothole; a chalked cross-mark; a mathematical calculation which proves beyond a doubt that 246 plus 171 equals 417; the isolated figure 21; and a torn label, light violet in color, with built-up nail heads; this label had obviously been there for a long time, for the board at the place where the greater part of it has been removed is much lighter in color than the rest.

In the free space on the board to the left of the rack are, top to bottom, a loop of string hanging from an invisible point above; a rosette of inscribed circles; the ten-cent "shinplaster"; and a newspaper clipping. Just above the shinplaster, painted as if carved into the door, is the word "Snyde." The newspaper clipping is one of the most amusing in

all of Harnett. As usual, not one word is legible; nevertheless one can clearly see that there is a paragraph of prose followed by a title, nine quatrains of verse, and the author's name at the bottom.

From the point of view of color and abstract design, this is one of Harnett's finest works. Three of its distinctive iconographic elements appear in other paintings of the same period by the same artist— the loop of string in *Thieves in the Pantry* (plate 33), the torn-off label in *Job Lot Cheap* (plate 3), and the ten-cent bill in the Carlen and Philadelphia Museum pictures (plates 38 and 39). The loop of string and the torn-off label also appear in the Peto rack of June, 1879, as well as in numerous later Petos of the same type; later Peto racks also have arithmetical inscriptions and the rosette of inscribed circles; furthermore in his later works Peto adopts the simple X and quadrangle for the tapes, while a Peto patch picture of 1897 has an envelope inscribed ". . . of the house." Obviously Peto, although he may have preceded Harnett in using the rack formula, later on made good use of his photograph of Harnett's rack of August 26, 1879.

This is one of the very few works of Harnett of which we possess the complete history. It was sold when new to Israel Reifsnyder, a Philadelphia wool merchant, and passed on his death in 1892 to his son Howard. Howard Reifsnyder died in 1929, and his collection was dispersed at auction by the American Art Association of New York. (According to the catalogue, the collection also contained two other Harnetts, a writing table and a mug-and-pipe, both dated 1878.) The rack painting of 1879 was bought at the Howard Reifsnyder sale by the father of Leonora Schinasi, who married Arthur Hornblow, Jr. The picture hung for years in their livingroom; it is now in the Metropolitan Museum.

Although Mr. Henry Reifsnyder, president of I. Reifsnyder, Son, and Company, believed that the picture was not expressly painted for his grandfather, there is at least some slight evidence to suggest that it actually was. There is, for one thing, the strange word, "Snyde," inscribed above the ten-cent bill; this might well have been a nickname for Reifsnyder. Israel Reifsnyder had a partner named Caleb D. Peirce, and Caleb D. Peirce had a son named Clifford C.; one of the envelopes of the

Still Life with Mug,
Pipe, and Antique Vase

painting is addressed to "C. C. Peir . . . & Sons," but neither Caleb nor Clifford C. Peirce seems ever to have been mixed up with an address that looks even vaguely like the "3908 . . . tory St." which appears on the same envelope in the picture. One can find traces of a clerk named Peter Lane, Jr., in the Philadelphia city directories of the late 1870's and early 1880's, but he seems to have had no connection with the Reifsnyders or the Peirces. In other words, certain inscriptions on the Harnett rack seem maddeningly close to being verifiable, but actually none can be verified.

Harnett probably painted at least one more rack picture. In the Blemly scrapbook and in the Ella Harnett–Catherine Barry collection are prints of an old photograph which represents either a rack painting or the model for one. The design is rather more cluttered than that of the Hornblow picture, but the photograph is so badly out of focus that one can really tell very little about it. Perhaps Harnett painted numerous rack pictures. All we can be sure of is that he painted the one of 1879, that so far as this motif is concerned, he and Peto seem to have been mutually influential, and that Harnett won a good deal of unwarranted fame from the Peto racks which were at one time ascribed to him.

The card rack is an artistic motif with a long, if obscure and problematical history. The earliest known example of it is a painting by the Franco-Flemish artist, Wallerant Vaillant, dated 1658 (plate 40). There are numerous racks by a Dutch painter, active in London as well as in his native Leyden around 1700, who signed his name variously as Edwaert Colyer, Evert Colyer, and Everett Collier (plate 41), and the theme seems to have been much favored by French and English engravers, etchers, and watercolorists throughout the eighteenth and early nineteenth centuries. Celebrated American examples include the painting called *The All-Seeing-Eye* (plate 42), dated in 1827, which is ascribed to one Nathaniel Peck on the exceedingly shaky ground that that name is one of several inscribed on the envelopes it contains; *Assorted Prints,* painted about 1840 by the Washington cartographer, J. Goldsborough Bruff; and *The Letter Revenge* (plate 44), by the well-known landscapist, Frederick E. Church, which was also produced in the 1840's. But the old

master, Raphaelle Peale, seems to have preceded all the other Americans with a rack picture (plate 43) created in 1808.[22]

The story of Church's painting casts much light on the psychology of the rack motif. This small picture represents an envelope addressed to Church himself; it has been tacked to a wall, and two other envelopes have been tucked behind it. The painting was presented to Oberlin College in 1904 by a gentleman named Olney who had acquired it from the artist and who claimed, apparently with good reason, that it had been "painted to deceive a friend who made the statement that a work of art is meritorious only as it may be mistaken for the original"; consequently Mr. Olney gave the picture the title, *The Letter Revenge.*[23] I fail to understand just why Church should have been regarded as having taken revenge on his friend when he embodied that friend's esthetic principles on canvas; at all events, the significance of the picture and the story behind it is that when Church was challenged to produce

[22] This work came to light during the course of my own research. For its history and for the evidence on which it was ascribed to Peale, see *The Magazine Antiques,* October, 1952, p. 320.

[23] A very similar story is told by Katherine Metcalf Roof in her *Life and Art of William Merritt Chase.* (New York, 1917.) It occurs in Miss Roof's chapter on Chase's years as a student in Munich, and runs as follows:

"Discussions concerning the old and new ideas of art were rife in those days. Chase recalled one that had an amusing result. He had been insisting that the exact reproduction of nature had nothing in common with art. (I remember well the harassed frown with which he used to say to his students: 'You have all heard of the picture of the fruit which was so natural that the birds flew down to peck at it? I do not need to see that canvas to know that it was a Terrible Thing!') Talking, no doubt, along some such line as this, another student challenged Chase with the remark that, whether art or not, such painting represented skill of a sort, and that Chase himself was doubtless unable to paint an object so that it would deceive anyone. As a result of this friendly contention, the students agreed that if Chase *could* perform the feat, he would give all the students a dinner. Chase accepted the challenge.

"The next day when Professor Raab arrived to criticize his pupils, he turned, upon entering, to hang his hat on the usual peg on the wall. The hat, before the eyes of the waiting class, fell to the ground. The professor picked it up and tried again, thinking he had missed the nail; but his hat fell again to the floor. When the same thing happened a third time, the old German looked intently at the wall, then, without a change of expression, laid his hat upon a chair and began his criticism. After his departure, the class gathered to examine the highly successful imitation of a nail painted upon the wall by William Chase in place of the real peg of which he had painstakingly removed all traces. That night the students enjoyed an excellent dinner at their favorite *Kneipe.*"

I quote this story at length because the same tale is told of Harnett, not in print but in the word-of-mouth folklore of the dealers and museums; Harnett's painted hat peg, however, is supposed to have adorned the wall of a New York saloon.

Still Life with Mug,
Pipe, and Antique Vase

a painting that could be "mistaken for the original," he chose as his subject papers tacked flat to a wall. The representation of flat or very shallow objects is of the very essence of *trompe l'oeil*. Hence the age-old fascination of illusionistic painters with the rack motif; hence also the fascination of Harnett and his school with paper money.

Our perception of depth in nature is achieved through two optical phenomena—binocular accommodation and binocular parallax. Near objects require a different accommodation, muscular adjustment, or focus of our two eyes from that which is required for distant objects, and we continuously make such adjustments without, of course, being consciously aware of the muscular activity involved. But the representation of depth in a picture requires no binocular accommodation at all: the eyes are focussed upon the single plane of the picture surface and the effect of depth is conveyed by psychological association. We remember, from our experience of nature, that distant objects look smaller than near ones, that objects in nature seem to recede toward a vanishing point, and that the atmosphere at a distance seems to be bluer and hazier than the atmosphere near at hand. So, by manipulating the relative sizes of the objects represented on his canvas, their illumination and their convergence toward the apparent vanishing point, the painter secures a suggestion of deep space, but the muscles of the spectator's eye are not deceived. They remain fixed in adjustment to the picture surface; the changes in accommodation required for depth perception in nature are not experienced, and consequently illusions of space and depth in art can never be complete. There is not and there never can be such a thing as a *trompe l'oeil* landscape, but if depth can be eliminated entirely or reduced to the shallowest possible dimensions, the discrepancy between the muscular experience required for the perception of nature and that which is required for the perception of painting is correspondingly reduced and the pictorial illusion of reality is correspondingly heightened. Consequently illusionistic artists, as they have from the very beginning of still life, will stop the eye in its backward progress by painting as background a wooden door or wall which seems to be located directly behind the picture frame, and upon this door or wall they will, most often, represent the flattest possible objects—letters, maps, bank notes, engravings, combs, knives, and so on.

Binocular parallax—the phenomenon whereby, as we move forward, objects near at hand seem to move backward, while objects at a distance seem to move forward with us—works in a similar fashion. It is experienced with both vertical and horizontal movement, so that if our eyes can be believed the world contains no stable things at all, but is constantly reeling, collapsing, expanding, rising, sinking, falling inward and outward in all directions at once; compared to a walk across one's living room, the maddest surrealistic movie ever concocted is the stillest of still lifes. Binocular parallax, however, is an effect which no work of art can simulate. Place two books on the top of a table and take a step toward them: the upper book will move forward, the lower book will move backward, and the farther edge of the table will rise straight up in the air. It is the absence of these parallactic movements among the represented objects of a table-top still life that gives the picture its air of mystery and strangeness; this and the query that registers, consciously or subconsciously, from the absence of any need for binocular accommodation. But stopping the eye with a door or wall and painting flat objects upon it reduces to a minimum the problems of parallax and accommodation, and the illusion of reality is therefore greater with this type of composition. Table-top still lifes may be triumphs of taste and skill, but triumphs of artistic deception can be achieved only with flat objects and a rendering from which nearly every trace of depth has been eliminated.

IX

IN THE first part of Harnett's interview with the reporter for the New York *News,* quoted earlier, Harnett said that in his three years in Philadelphia, 1876–1879, he had managed to make a living and to save a few hundred dollars beside. He continued:

"Now I was able to indulge in the one cherished dream of my life. I could go to Europe and pursue my studies in

the home of art. I gave up my studio and sailed for England. Instead of following the example of American artists, and going direct to Paris or Germany, I decided to make London my temporary home. Accordingly, I opened a studio in that city, and remained there several months. I painted a number of pictures and sold some of them, but my success was not marked until an old acquaintance, whom I had known in Philadelphia, visited my workshop. He was a wealthy resident of Frankfort and had bought one or two of my paintings while he was stopping in Philadelphia. He invited me to spend a few months at his home and work exclusively for him. It is needless to say that I accepted the offer.

"I stopped in Frankfort for six months and filled all the orders that he gave me until I grew impatient of the work. I wanted to go to Munich and go on with my studies. Every time I had hinted of leaving Frankfort my friend suggested a new order, and it took some time and considerable obstinacy on my part to finally get away. At last I reached Munich, which was my home during the next four years. When I visited the art galleries and studios in this city I had even a poorer opinion of myself than I had before. I wanted to do such work as the other young artists were doing, and I wanted to follow the instructions of the older painters. But I had the same difficulty I experienced with Mr. Jensen. I could not attain the desired results by using the methods they taught. After making repeated trials I became discouraged and went back to my own original way of working.

"During the four years I lived in Munich I did very well, comparatively speaking. I sold pictures to American travelers; Germans, Frenchmen and even Englishmen were numbered among the purchasers.

"In 1884, I determined to test the merits of my work. I decided to discover whether the line of work I had been pursuing had or had not artistic merit. Some of the Munich professors and students had criticised me severely, and I wanted to refer the question of my ability as a painter to a higher court. Accordingly, I went to Paris and spent three months painting one picture.

"I put into it the best work I was capable of. I called it '*After the Hunt.*' It is now on exhibition in this city and a reproduction of it in India ink accompanies this article. After it was finished I sent it to the salon and it was accepted. That was not all. M. Louis Énault, the famous French critic, who annually publishes a book in which he gives reproductions of 40 paintings from the current saloon, [*sic!*] included my picture among those he chose for that year. After the exhibition I remained six months in Paris, and while I was there I sent several pictures to England. One of them, a 10 x 14 inch painting of a sheet of music, vase and some books, was accepted by the Royal Academy in London, and was hung on the line between pictures of Sir John Millais and Luke Fielders [*sic*]. It was bought by George Richardson, R.A., [*sic*] who urged me to come to

London and make that city my home. But I was homesick. All the money I could have made would not have compensated me for a longer stay abroad, and consequently I gathered together my belongings and came back to New York. Here I was astonished to find that my work sold better than I had anticipated. This has been my home ever since.

"In this sketch of my life, with its struggles and its victories, I have given you a fair idea of the hard work that is necessary for a friendless boy to undergo before he becomes recognized. Art is not an easy mistress and those who win her favors must work patiently and strive persistently.

"Now, let me tell you something about the painting of pictures from still life models. I always group my figures, so as to try and make an artistic composition. I endeavor to make the composition tell a story. The chief difficulty I have found has not been the grouping of my models, but their choice. To find a subject that paints well is not an easy task. As a rule, new things do not paint well. New silon [24] does not look well in a picture. I want my models to have the mellowing effect of age. For instance, some old and most new ivory paints like bone. From other pieces I can get the rich effect that age and usage gives to it—a soft tint that harmonizes well with the tone of the painting.

"New models selected without judgment as to their painting qualities, would be utterly devoid of picturesqueness, and would mar the effect of the painting beyond all hope of reparation.

"Let me illustrate what I mean by referring to my Salon painting, '*After the Hunt.*' Take for instance the handle of the old sword that is suspended from the door. The ivory has a particularly mellow tint. Had I chosen a sword with an ivory handle of a different tint the tone of the picture would have been ruined.

"In painting from still life I do not closely imitate nature. Many points I leave out and many I add. Some models are only suggestions. [25] Take the flute in one of the accompanying illustrations. The flute that served as a model is not exactly like the one in the picture. The ivory was not on the flute at all, and the silver effects for the keys and bands I got from a bright silver dollar. The gold band on the pipe was painted from a new gold coin. The whole effect in still

[24] "Silon" is a mysterious word not to be found in any English dictionary. When the *News* interview was reprinted in *The Magazine Antiques* for June, 1943, "silon" was changed to "silver," but this emendation is most unconvincing, especially in the light of Harnett's comment, two paragraphs later, on the painting of gold and silver coins. John Jennings of the University of California Press points out that "xylon" is the Greek word for "wood" and that it might be spelled "silon" by someone who had no classical training. This is an extremely shrewd suggestion and one that provides an interpretation of the passage which is entirely in keeping with Harnett's practice. It may be that Harnett used this Greek word in order to impress the *News* reporter with his learning, but there is nothing to show that he was given to that kind of verbal pretense.

[25] These three sentences have sometimes been quoted out of context in order to suggest that Harnett was a self-conscious abstractionist, but the paragraph as a whole admits of no such interpretation.

Still Life with Mug, Pipe, and Antique Vase

life painting comes from its tone, and the nearer one attains perfection, the more realistic the effect will be.

"Several years ago I had an experience that is far more amusing to recollect than it was to pass through, and illustrates the peculiar hardships that a still life painter sometimes undergoes when he makes an unlucky choice of a model. I painted three United States notes on panels. They were old bills, frayed at the edges and full of creases, and I painted them life-size.

"A few days after, one of them was exhibited in this city, and had attracted several notices from the daily newspapers. I received a call from two well-dressed men at my studio.

"While one of them was asking my name, the other was suspiciously poking his cane into the corners of my room, back of my models and under the shelves.

"'Have you got any more of them here?' he asked, after he had finished a hasty search.

"'More of what?' I replied.

"'Those counterfeits!' he answered.

"Then the other detective, for both were Special Treasury officers, explained their mission. I was suspected of turning out counterfeit bank notes and they had come to arrest me and seize whatever illegal property they could find. They were very polite but extremely firm and I went down-town with them to Chief Drummond's office.

"I explained to the chief how I had happened to do the work and I showed him the harmless nature of it. Harmless though it was, it was clearly against the law, and I was let go with a warning not to paint any more life-like representations of the national currency—a warning it is almost needless to say that was conscientiously heeded.

"With the exception of two finished portrait sketches all of my art work has been in the still life line. There is rather an interesting story connected with these two sketches. I painted them in Munich, and of all the life studies that I made these were the only ones that I finished. I attached little value to them and kept them on the walls of my studio chiefly as a reminder of my student days.

"One day in this city a dealer called on me, and, catching a glimpse of my studies, asked their price. I told him they were not for sale. He offered me $10 apiece for them, and I refused it.

"A few days later he called again and offered me $20 apiece, which I also refused.

"He called several times after this, apparently upon other business, but always managed to suggest these studies and ask me to fix a price on them. Becoming tired of his importunities, I concluded, one day, that I would put a stop to his haggling by putting a prohibitory price on the two pictures. Accordingly, I told him he could have them for $100. To my surprise, he gave me a check and carried them off with him.

"I had almost forgotten the circumstances when, several months later, he called again.

"'I had a picture sale the other day,' he said, 'and do you know how much I got for your two studies?'"

"I told him I did not.

"'Well,' he went on, 'one of them brought $600 and the other $400.'

"To say that I was surprised would express it mildly; and had I believed that he was telling the truth, I would have even been pained."

Passports were not required of American citizens traveling abroad in Harnett's time, and so there is no official record to indicate when Harnett left this country. It appears, however, that he went to Europe very early in 1880, spent the spring of that year in London and its last six months in Frankfurt, and proceeded to Munich early in 1881. Unmistakable European influences appear in his work for the first time in a mug-and-pipe picture containing a newspaper dated March 2, 1880, and such influences were to remain with him, for better and also distinctly for the worse, throughout the rest of his life.

His statement to the *News* reporter implies that, although he was eager for European experience and European training, he was not eager to follow the crowd of American art students to France or Germany. Like a dutiful son of the Peales and their generation, he went to London, despite the fact that Benjamin West had been sixty years in his grave. At no point in the interview does Harnett state or imply that he went to Europe to study his own specialty, and although there can be no doubt that he immediately came under the spell of contemporary European art, there is nothing to indicate that that spell was exercised by the contemporary European still life painters, at least during his first year abroad.

To begin with, it is very difficult to remember the name of a single nineteenth-century European specialist in illusionistic still life. It may be true, as Thomas Carr Howe, Jr., suggests,[26] that *trompe l'oeil* came into its own in Europe in the seventeenth century, continued in vogue throughout the eighteenth century, and then jumped to America for the next hundred years. I am very uneasy about that suggestion, however, for neither Mr. Howe nor any-

[26] In his introduction to the catalogue of the exhibition, *Illusionism and Trompe l'Oeil,* held at the California Palace of the Legion of Honor, San Francisco, May 3 to June 12, 1949.

Still Life with Mug, Pipe, and Antique Vase

one else could have made it before the *Nature-Vivre* show at the Downtown Gallery in 1939. The whole of nineteenth-century American *trompe l'oeil* was here before that time, but no one was aware of it. As with folk painting, which has been emphasized only in this country and has therefore been assumed to be a distinctively American phenomenon, we know no more than our own part of the nineteenth-century still life story, and we have come to know it only recently; there may very well be a whole school of nineteenth-century European illusionists awaiting an Edith Halpert to resurrect it. One possible implication of Mr. Howe's remark cannot be seriously entertained: that American taste was a century behind the taste of Europe. Nineteenth-century America bought as fast as Europe could paint, and it was the proud boast of the Bement catalogue that "the best pictures painted in European studios now find their way to this country, for the merchant princes of this wealthy land can outbid royalty itself for the possession of purchasable treasures." [27] Furthermore, nineteenth-century European critics, like Richard Muther, constantly complained that American artists were doing precisely the same things as their European colleagues.

The historians cast no light on the question of nineteenth-century European *trompe l'oeil*. Art historians, especially those of the nineteenth century, are ruled by the philosophy of progress; they see the history of art as a kind of endless relay race on a straight course, one *avant-gardiste* handing the torch to another. Those, like the nineteenth-century *trompe l'oeil* painters, who run in the opposite direction, are always ignored until they get so far behind the race that they complete a full circle and come back as the latest thing.

The literature, then, tells us only what official nineteenth-century taste approved of, and official nineteenth-century taste was unanimous when it came to still life. The critic of the New York *Tribune,* in 1879, had invoked the names of Blaise Desgoffe (plate 48) and Antoine Vollon (plate 47) in his effort to put the upstart Harnett in his place. Desgoffe and Vollon are the only nineteenth-century still life painters given more than passing mention in Mrs. C. H. Stranahan's big *History of French Painting* (1897), which is eminently typical of its time, and, with Philippe Rousseau, are the only nineteenth-century still life painters mentioned at all in the staggeringly encyclopedic twenty-three hundred pages of Muther's *History of Modern Painting.* (American edition, 1896.)

Muther's remarks on this subject are well worth giving in detail:

In all periods which have learnt to see the world through a pictorial medium, still life has held an important place in the practice of art. A technical instinct, which is itself art, delights in investing musical instruments, golden and silver vessels, fruit and other eatables, glasses and goblets, coverings of precious work, gauntlets and armor, all imaginable *petit-riens,* with an artistic magic, in recognizing and executing pictorial problems everywhere. After the transition from historical and genre painting had been made to painting proper, there once more appeared great painters of still life in France, as there did in Chardin's days.

Yet *Blaise Desgoffe,* who painted piecemeal and with laborious patience goldsmith's work, crystal vases, Venetian glass, and such things, is certainly rather petty. In France he was the chief representative of that precise and detailed painting which understands by art a deceptive imitation of objects, and sees its end attained when the Sunday public gathers round the pictures as the birds gathered round the grapes of Zeuxis.

It is as if an old master had revived in *Philippe Rousseau.* He had the same earnest qualities as the Dutch and Flemish Classic masters—a broad, liquid, pasty method of execution, a fine harmony of clear and powerful tones—and with all this a marvelous address in so composing objects that no trace of "composition" is discernible. His work arose from

[27] This catalogue, issued in 1884 by the Philadelphia steel tycoon, William B. Bement, for his friends and relatives, "that they may see the evidence of my success in life, the direction of my taste, and the sources of enjoyment provided for myself and family in our declining years," is one of the most fabulous documents in the history of American collecting. It will be discussed at length later, in connection with *The Old Cupboard Door,* which Harnett painted for Bement in 1889. Incidentally, it has become the fashion for certain American critics to sneer at people like Bement (who was for many years a trustee of the Pennsylvania Academy of the Fine Arts) for their failure to buy the work of the more advanced European artists of their era. These critics forget that the effort to strangle experimental tendencies in European painting took place at home, and that the artists in question found recognition in the United States almost as quickly as they did on their own soil, but always, at the beginning, with a relatively small group, wherever it may have been. It was no American, but an authoritative Frenchman, Henri Houssaye, who wrote in 1882, "Impressionism receives every form of sarcasm when it takes the names Manet, Monet, Renoir, Caillebotte, Degas; every honor when it is called Jean Beraud, or Dagnan-Bouveret." A neater separation of sheep and goats could scarcely be accomplished. Harnett was, I suspect, totally unaware of the Impressionist controversy. Although he was in Paris for some months in 1884 and 1885, I should not be a bit surprised to discover that he had never as much as heard any of the names mentioned by M. Houssaye.

Still Life with Mug,
Pipe, and Antique Vase

the animal picture. His painting of dogs and cats is to be ranked with the best of the century. He makes a fourth with Gillot, Chardin and Decamps as the great painters of monkeys. As a decorator of genius, like Hondekoeter, he embellished a whole series of dining-halls with splendidly colored representations of poultry, and, like Snyders, he heaped together game, dead and living fowl, fruit, lobsters, and oysters into huge life-size masses of still life. Behind them the cook may be seen, and thievish cats steal around. But, like Kalf, he has also painted, with an exquisite feeling for color, Japanese porcelain bowls, with bunches of grapes, quinces and apricots, metal and ivory work, helmets and fiddles, against that delicately gray-brown-green tone of background which Chardin loved.

Antoine Vollon became the greatest painter of still life in the century. Indeed, Vollon is as broad and nervous as Desgoffe is precious and pedantic. Flowers, fruit and fish— they are all painted in with a firm hand, and shine out of the dark background with a full liquid freshness of color. He paints dead salt-water fish like Abraham van Beyeren, grapes and crystal goblets like Davids de Heem, dead game like Frans Snyders, skinned pigs like Rembrandt and Maes. He is a master in the representation of freshly gathered flowers, delicate vegetables, copper kettles, weapons and suits of armor. Since Chardin no painter has depicted the qualities of the skin of fresh fruit, its life and its play of color, and the moist bloom that rests upon it, with this truth to nature. His fish in particular will always remain the wonder of all painters and connoisseurs. But landscapes, Dutch canal views, and figure-pictures are also to be found amongst his works. He has painted everything that is picturesque, and the history of art must do him honor as, in a specifically pictorial sense, one of the greatest in the century.[28]

The monkeys of Philippe Rousseau have long since been driven from the galleries by those of a later Rousseau whose work Herr Muther might have regarded as falling a trifle short of the ideal, and today the taste for nervous fish is amply fed by the still lifes of Chase, who, according to his biographer, Katherine Roof, had several works by Vollon in his own collection and valued that artist highly. It is obvious that neither Rousseau nor Vollon could have had much to offer Harnett. Desgoffe, on the other hand, did have something to offer him, but I insist that, the literature to the contrary notwithstanding, Desgoffe may not have been the only painter in Europe of whom this can be said.

Muther's antithesis between the great still life painters and the mere eye-foolers may be significant; it is precisely the antithesis that had been made by the critic of the New York *Tribune* in 1879, and precisely the antithesis which, as we shall see, was posed by the critic of the Munich *Handelsblatt* in 1884; Mrs. Stranahan observes that Vollon's public "is the public of connoisseurs who care not for any tricks of *trompe l'oeil,* but for art." Who, then, were these worthless, nameless tricksters? It is conceivable that, so far as Muther is concerned, one of them was William Michael Harnett. Muther had been Keeper of the Prints at the Pinakothek during Harnett's years in Munich; he was indefatigably curious about all aspects of painting in his time, and in the oceanic reaches of his book one finds him discussing some quite unexpected artists, such as William Sidney Mount. But when a San Francisco junk shop yields up some delightful "patch" pictures signed and dated 1882 by an otherwise unknown Berliner named Theodor Flügel, and when a visit to a home in Los Angeles turns up two of the exquisitely painted, immaculately descriptive still lifes of Camilla Friedländer,[29] one can only wonder what the Muthers have been overlooking; California, after all, is scarcely promising territory in which to undertake research directed toward a reëvaluation of the history of art in the German-speaking countries.

Be all that as it may, it seems very likely that the most important influence exercised on Harnett during his first year in Europe did not proceed from any still life specialist, but from a very celebrated French artist whose name, up to now, has not

[28] Muther, *op. cit.,* Vol. II, pp. 550–552. The subsequent reputations of these artists are neatly indicated by the attention, or lack of attention, accorded them in two general histories of still life which appeared in the 1920's. In Arthur Edwin Bye's *Pots and Pans,* published in Princeton, New Jersey, in 1921, Vollon is still treated as the great nineteenth-century master. Bye also has a good word for Rousseau, as well as for François Bonvin and Germain Ribot, whom Muther mentions only for their work in portraiture and genre, but, so far as Bye is concerned, Desgoffe is an "example of all that still life painting never ought to be." Six years later, Herbert Furst, in his *Art of Still Life Painting* (London, 1927), completely omits this entire group. (Rousseau, by the way, was born in 1816 and died in 1887. The dates for Desgoffe are 1830–1901 and for Vollon 1833–1900.)

[29] Camilla Friedländer, Edle von Malheim, was born in Vienna on November 12, 1856. She studied with her father, Friedrich Friedländer, once celebrated as a painter of battle scenes, and with various masters in Paris. According to Thieme and Becker, she became a nun in 1901, and gave up painting. The date of her death is not recorded. She was younger than Harnett and may have been influenced by him in her "Stilleben von Antiquitäten, Küchenstücken, Blumen u. dgl. in minutiösester Ausführung," but it is more likely that both artists worked in response to healthily retrogressive currents of their time which have been wholly or partly passed over by the art historians.

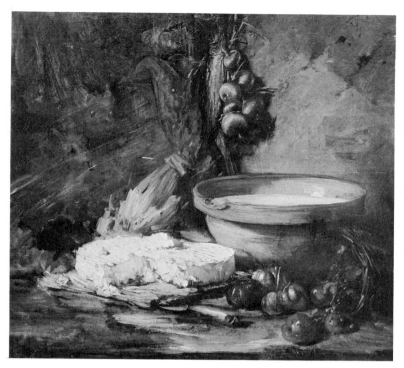

47

Antoine Vollon
The Big White Cheese (33⅜ x 35⅜)
Metropolitan Museum of Art, New York

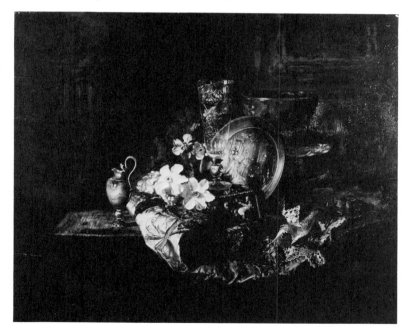

48

Blaise Desgoffe
Objects of Art in the Louvre (23½ x 29½)
George Walter Vincent Smith Art Museum,
Springfield, Massachusetts

49

50

W. M. Harnett
Searching the Scriptures 1880
(30⅛ x 25⅛)
Mrs. M. D. Snyder, Philadelphia

Ernest Meissonier *The Philosopher* 1872
Photograph from New York Public Library
from reproduction in
The Complete Works of E. Meissonier

51

52

W. M. Harnett
Head of a German Girl 1881 (19½ x 16½)
Paul J. Sachs Collection, Fogg Art Museum,
Harvard University,
Cambridge, Massachusetts

W. M. Harnett
Front Face (photograph of lost painting
inscribed with dimensions of
original, 36 x 28) 1878

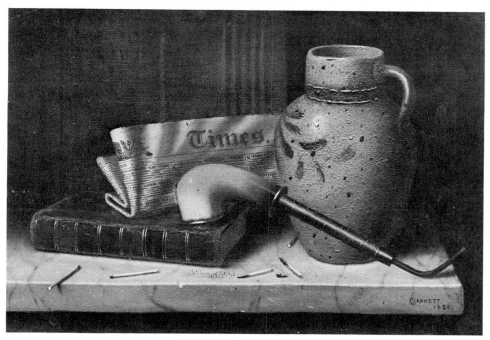

53

W. M. Harnett
London Times April 9, 1880 (5¾ x 8½)
Private collection, New York

54

W. M. Harnett
Ye Knights of Old 1880 or 1881
Photograph from New York Public Library from reproduction in the Birch
catalogue

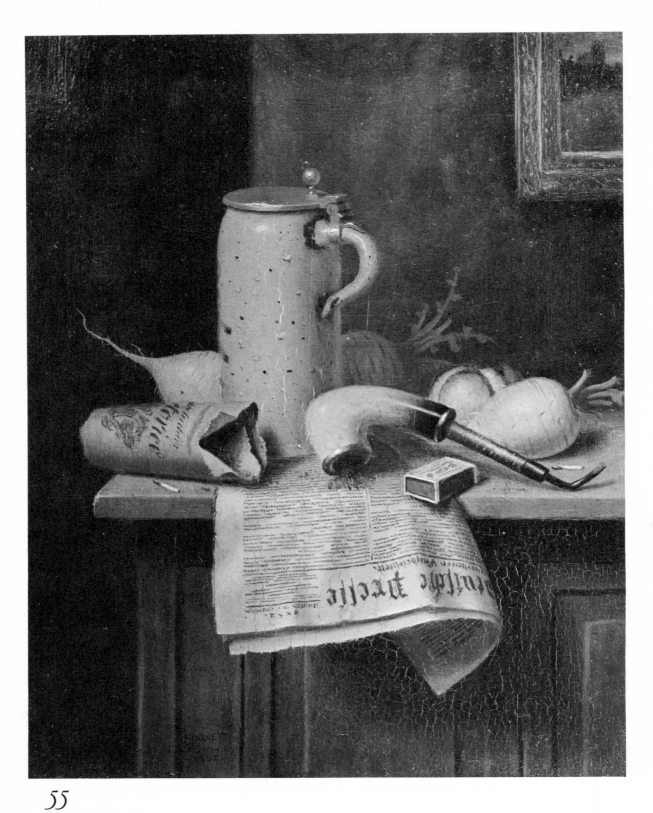

55

W. M. Harnett
Deutsche Presse 1882 (7½ x 6)
Mrs. John Barnes, New York

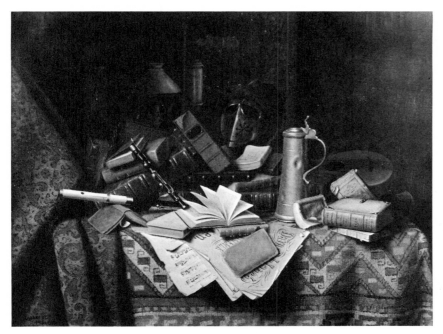

56

W. M. Harnett
A Study Table 1882 (11½ x 14½)
Munson-Williams-Proctor Institute, Utica, New York

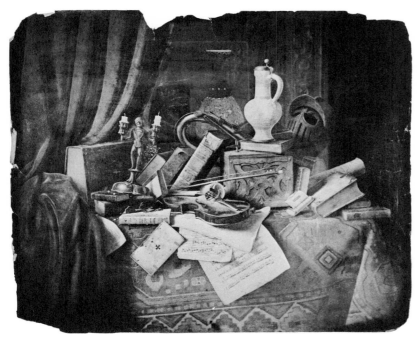

57

W. M. Harnett
George Fryer's Still Life (photograph of lost painting inscribed with
dimensions of original, 46 x 56) 1884

58

W. M. Harnett
After the Hunt (first version) 1883 (52½ x 36)
Gallery of Fine Arts, Columbus, Ohio

been linked with his—Jean Louis Ernest Meissonier.

Meissonier stood for Success with a capital "S" in Harnett's day. Every millionaire in the world had to have half a dozen of the famous Frenchman's pictures, and, despite their extremely small size, they sold at enormous prices. During his European years and afterward Harnett clearly made a deliberate effort to appeal to the Meissonier audience; in fact, he may have been attracted in the direction of this artist even before he went abroad. Harnett's *Front Face* of 1878 (plate 52)—the painting of the little colored boy standing before a wooden fence covered with tattered posters—seems like a Mark-Twainish, colloquial American commentary on Meissonier's *L'Incroyable* of 1858, with its magnificently dressed dandy strutting near a stone wall covered with meticulously detailed theatrical announcements. This parallelism in subject-matter may have been accidental, but the resemblance between Harnett's *Searching the Scriptures* of 1880 (plate 49) and Meissonier's *The Philosopher* of 1872 (plate 50) can scarcely be accounted for on a basis of pure chance.

These two pictures are identical in subject and very similar in composition. In both, a bearded savant sits, facing toward the left, before an open book on a draped table. The table is covered with still more books, and, in the Harnett, with other objects as well, while in both versions there is a whole library of ancient tomes on shelves and within easy reach of the hero's left hand. Meissonier's philosopher has a Colyeresque letter rack, stuffed with documents, on the grainy boards which form the back wall of his room, and these boards also display explosive, craterlike holes where the knots have fallen out.

Meissonier approaches his scene from an angle in order to give it as much depth as possible. Harnett, on the other hand, uses the classic Raphaelle Peale still life approach, arranging his composition parallel to the plane of the canvas; he avoids depth as much as he can, but he silhouettes the head of his bearded monk before a dark recess, precisely as he silhouetted the beer steins in his mug-and-pipe pictures of the same year (see plate 53).

The main interest in the Harnett lies in the still life arrangement on the top of the table. Harnett separates his objects, lets air flow around them, treats them with full respect, and does his utmost with them by way of abstract design and contrasted textures and temperatures; he invites the spectator to linger over the vellum, the calfskin, and the paper, the green cloth of the table, the icy silver inkwell, and the coppery bronze candlestick with its translucent candle stub. Meissonier's still life, by comparison, is cluttered and monotonous. The Frenchman is content to give us dozens of books, and although they are beautifully rendered, with vibrant edges which make Harnett's books seem dry, there are far too many of them and they have no pictorial meaning; they are there simply to tell us that the philosopher was a learned man. In the Meissonier the quill pen is a mere stub in the philosopher's fingers, but in the Harnett it is a superbly spirited dart placed in careful isolation on the edge of the table, where it penetrates the picture plane.

In other words, Harnett is trying to follow his eminent contemporary but his natural bent keeps driving its own way, and when the exigencies of the subject demand that he forsake his own territory, he flounders almost ludicrously. Meissonier is scrupulously careful to use costumes and accessories which are correctly and consistently in period, but Harnett's gray-robed medieval monk sits in a comfortable bourgeois living room on a chair of 1830 beneath a fancily carved Victorian picture frame; the perspective in which the chair is drawn would have caused Meissonier much concern, and so would the inexplicable sag of the brass-bound binding on the large book which stands upright in Harnett's foreground. (Unfortunately one of the most delightful episodes in the Harnett does not register in the photograph—the two lead weights which hang by chains from an invisible clock placed high on the wall between the bookcase and the picture frame.)

According to information provided by the Frick Art Reference Library, the Meissonier is known to have belonged to a Londoner named David Price in the year 1884 and was sold at Christie's with the rest of the Price collection after its owner's death in 1892; there is thus a strong likelihood that *The Philosopher* was in London in 1880 and that Harnett became acquainted with it there when he first went to Europe. I have not been able to ascertain its pres-

*Still Life with Mug,
Pipe, and Antique Vase*

ent whereabouts and am acquainted with it only through reproductions.

According to the Price catalogue, Meissonier's *Philosopher* was only eight and one-quarter inches high and six and one-quarter wide. *L'Incroyable* was not much bigger, but *Front Face* measures thirty-six by twenty-eight, and the dimensions of *Searching the Scriptures* (Philadelphia: Mrs. M. D. Snyder) are thirty and one-eighth by twenty-five and one-eighth. The next step was for Harnett to return to small-sized canvases, *à la* Meissonier, and this he did in a series of pictures painted in the same year, 1880.

There are eleven of these paintings, all but one of the mug-and-pipe variety, and all but one containing dated newspapers which provide clues to the months in which they were created. It looks almost as if Harnett had used this device deliberately —as if, in his new environment, transferring new impressions to canvas, he had self-consciously set out to develop a new technique with his favorite old theme and carefully dated each experiment, as he had his first oil sketches. This, to be sure, is a purely speculative suggestion. We have sixteen Harnetts from 1880 and we do not know what else Harnett may have painted in that year, although it is obvious that he must have painted many different things during his six months in Frankfurt; but the pictures with the dated newspapers and the persistent return to the mug-and-pipe motif remind one of the manner in which, half a century later, Stuart Davis put an egg-beater and a salt-cellar on a table and spent a year painting this assemblage in different stages of abstraction.

A list of these pictures follows; they are identified not by the titles under which they are commonly known, but by the names of the newspapers represented, the dates on the newspapers, and the size of each canvas or panel.[30]

New York *Times*, November 9, 1879. (But the signature is dated 1880.) 10 x 14. (New York: Oliver B. Jennings.)

New York *Herald*, January 9, 1880. 12 x 16. (New York: Kennedy Galleries.)
London *Daily Telegraph*, February 10, 1880. 14⅛ x 20. (Denver Art Museum.)
Philadelphia *Public Ledger*, March 2, 1880. 9¼ x 14. (Bethesda, Maryland, Robert H. Smith.)
New York *Herald*, March 10, 1880. 14 x 12. (London: formerly in the collection of Robert Frank.)
Le Mot d'Or(dre?), 27 Mars, 1880. 7 x 6. (San Francisco: Mrs. M. H. Crowe.)
London *Times*, April 9, 1880. 5¾ x 8½. (New York: private collection.)
New York *Herald*, July 11, 1880. 5¼ x 7. (New York: Miriam Bloch.)
New York *Herald*, July 26, 1880. 7½ x 9½. (New York: Mrs. Norman B. Woolworth.)

The first thing suggested by this list is, of course, that Harnett must have gone to London between January 9 and February 10. But the Philadelphia *Public Ledger* appears after the London *Daily Telegraph,* and the New York *Herald* (which had not yet established its foreign editions) after the London *Times.* This is unsettling; because of it one cannot assert dogmatically that Harnett's use of British newspapers in this series proves that he was in the British capital at the time the pictures were painted. Nevertheless I suspect that he was. This view is bolstered by the fact that two of these paintings came to light in England, although their discoverer, Mr. Frank, insisted that the ornate Victorian frames in which they were found are not characteristic of British taste; furthermore Mr. Frank points out that he purchased these works from an English family with American connections.

A new and exceedingly important stylistic trait appears in the very first mug-and-pipe picture of 1880 and runs with increasing emphasis throughout the entire series: Harnett now begins to specify his backgrounds. If my chronology for the events of 1880 is correct, this development was not initiated in Europe, but it was unquestionably worked out in greater detail after Harnett arrived in London, along with still other developments revealed by the group of pictures in question.

In his article on the Peales, John I. H. Baur speaks of the objects in Raphaelle's table-top still lifes as being posed against walls, and Born uses the same

[30] The Brooklyn Museum's mug-and-pipe piece of 1880 contains no dated newspaper but is closely related to those listed above. Because of its carved-panel background and its can of British pipe tobacco, it obviously belongs later rather than earlier in the sequence.

Still Life with Mug, Pipe, and Antique Vase

terminology with reference to Harnett's early writing-table and mug-and-pipe pictures. Actually, there is nothing in the paintings themselves to justify this interpretation. The typical Raphaelle Peale background, and the typical Harnett background up to 1880, is an ambiguous expanse of gray-green; it is not so much a wall as a conventional sign for empty space. But in the mug-and-pipe picture with the New York *Times* of November 9, 1879, a little more than a third of the space in the left background is filled with the very definite corner of a plaster wall; the rest is a dark recess against which Harnett places his main vertical, the mug. For the rest of his career, Harnett will almost invariably use the same formula for the mug-and-pipe picture or for related table-top still lifes: a specific, palpable background and a dark niche or recess, almost always at the right-hand side, with the main vertical object—a mug, vase, or jar—silhouetted against this dark, empty space, and with the illumination coming from the left. Beginning in 1880, also, Harnett begins to show one corner of his tables, usually the left-hand corner. Before this time he had shown only a central segment of the table top without any corners at all.[31] Throughout his career, corner or no corner, Harnett always places his table edges parallel to the picture plane and not, as is common in the work of nonillusionistic still life painters, at an angle to it, leading the eye back into deep space. Deep space is antithetical to Harnett's philosophy.

The background in the picture with the New York *Herald* of January 9, 1880, is identical with that in the painting with the New York *Times* dated two months earlier. In the painting containing the London *Daily Telegraph* of February 10, a piece of cloth is draped behind the table at the left, and the still life with the Philadelphia *Public*

Ledger of March 2 has a fully orchestrated background of carved paneling which stretches across its entire width. (This is one of the very few mug-and-pipe pictures painted after 1879 in which there is no dark recess behind the main vertical.) Henceforth carved paneling is to be a nearly invariable rule for the backgrounds of Harnett's table-top pictures, whether the subject be the mug-and-pipe or still life objects of a different sort. The paneling will be carved in many different patterns, and they will often seem very ugly to modern taste. The paneling will also undergo several interesting variations in rendering but it will seldom be absent from the scene.

The reason for this has already been discussed, in connection with the rack picture of 1879. Whether it be a paneled wall or a door covered with hinges and nailholes, the specific background stops the eye in its backward progress; it gives the picture space a definite, shallow limit and accordingly heightens the effect of *trompe l'oeil*. And it is worth reiterating here, in connection with this effect, that in all the known Harnett table-top still lifes, from the earliest efforts of 1876 to such *grandes machines* as the *Emblems of Peace* of 1890, the objects seem to crowd forward toward the picture surface, almost as if by their own mysterious volition. The artist is inevitably, almost helplessly driven, by the very nature of his art, to eschew deep space; even when he paints a gamin in a paper hat he poses him flat against a wall.

Beginning with the *Public Ledger* picture of March 2, 1880, Harnett employs an altogether new approach in his drawing and rendering. His canvases decrease dramatically in size, and his whole method takes on a deft, miniaturistic, almost microscopic touch. The new method is carried considerably further and is realized in its full completeness in the London *Times* picture of April 9 (plate 53), and those containing the New York *Herald* of July 11 and 26; it is to remain a very distinctive feature of Harnett's work until 1884, and its traces can be observed sporadically throughout the eight remaining years of the artist's life. Perhaps paradoxically, this manner—defter, smaller-scaled, and much lighter in weight than Harnett's previous style—is also a little

[31] In an article on the eye-track in the perception of painting, (*Art Quarterly*, Autumn, 1950) Mercedes Gaffron points out that illumination from the left, causing a bank-up of objects on the right-hand side, is one of the most widespread conventions in Western art. Illumination from the left might also have been a factor in pushing Harnett's tables from the center of the picture toward the right, so that the left-hand corner comes into view. Miss Gaffron offers no explanation for the phenomenon she describes, but it is obvious that a right-handed person prefers light from the left, and that the Western world reads from left to right.

Still Life with Mug,
Pipe, and Antique Vase

freer: edges are not quite so hard; there are tiny sparkling highlights; the pictures show a little less of the discipline of classical cast-drawing, and the "painterly" touch is momentarily emphasized.

All this I suspect, comes from Meissonier; miniaturism and the "painterly" approach were that artist's stock-in-trade. And there are still other ways in which Harnett and Meissonier seem to be linked. Meissonier's watercolor of a violin, books, sheet music, and a Turkish rug [32] (a type of composition which Harnett adopted in 1881, conceivably from Meissonier's example but more plausibly from the old Dutch masters whom Meissonier himself had carefully studied) is closer to Harnett than any other nineteenth-century European still life I have seen. Moreover, among the maxims of Meissonier [33] one may find the following: " 'Beware!' I said this morning to X. . . . 'you cannot get relief in painting by piling up the impasto. You must get it by the skilful juxtaposition of the tones.' " Harnett very quickly learned this lesson. Descriptive relief in paint is definitely played down in the mug-and-pipe pictures of 1880; after 1880, it disappears almost entirely.

In Catherine Barry's collection of Harnettiana are two quaint little New Year's cards, both postmarked in Frankfurt on December 31, 1880, both addressed to "Herrn. W. Harnet" [*sic*] "bei F. Cronau, Staufenstrasse No. 37, Dahier." One of these cards is signed "E. Badersbach," the other "Elise Badersbach." Frankfurt directories and other records of that time, which have been searched for me through the kindness of Dr. Albert Rapp, director of the Historisches Museum in that city, reveal no "F. Cronau," but they do reveal a Johann Conrad Cronau, listed as a retired gentleman, at Stauffenstrasse 37, in 1880. This, then, was, in all probability, the "wealthy resident of Frankfurt" in whose house Harnett lived for six months and for whom he painted many pictures. There are also documentary traces of the Badersbachs and of the "Moehring" of Frankfurt to whom, according to the inscription on the back of the photograph, Harnett sold *Thieves in*

the Pantry, but all these families have long since disappeared and their descendants cannot be located today.

X

THE NEW YEAR's cards from the Badersbachs are both inscribed with the heartiest congratulations of their senders. *Searching the Scriptures,* Harnett's period genre scene apparently after Meissonier, signed and dated 1880, bears on its back an old American exhibition label which states that this work won honorable mention at the "Munich Exhibition" at some unstated time. One wonders if the congratulations were offered because of that honor, and if it had anything to do with Harnett's departure for Munich in the following year.

The good burghers of Munich apparently received Harnett well and bought enough of his work to keep him there three and a half or four years. They admitted him to their *Kunstverein* (an admission which, to be sure, may not have called for anything more than the payment of a few marks), and opened their exhibitions to his paintings, and one of their critics even found a grudgingly good word to say for him. [34] Finally, their *Gemütlichkeit* almost catastrophically corrupted his taste, so that as one proceeds into a folder of Harnett photographs for the Munich days one seems to be entering into a deliberately concocted chamber of mid-Victorian horrors.

Harnett, the master of the "bachelor's still life," the mug-and-pipe, the writing table, the frayed "shinplaster," the cheap job lot of second-hand books, the mouse-nibbled cheese and the battered crock on a pantry-shelf lined with torn newspaper, now goes in for Herr Muther's "golden and silver

[32] This picture is reproduced by Vallery C. O. Gréard in his *Meissonier, His Life and His Art.* (American edition, New York, 1897, p. 29.) It is undated, and it is not listed in Gréard's catalogue of Meissonier's works.

[33] Gréard, *op. cit.,* p. 216.

[34] *"News from the Kunstverein.* The exhibition at present is in the usual midsummer doldrums; thanks to this situation, a 'still life' takes first place this week. A fairly large picture by W. Harnett, *Table with Books, Sheet Music and Musical Instruments,* must be called a masterpiece of its type. It is scarcely possible to paint these objects with greater truth to nature and in a more pleasing manner. The partly yellowed music-sheets and the cracked flute worked in precious ivory provide more food for thought than any of your wooden, badly executed human figures." (Translated from a clipping in the Blemly scrapbook which, according to a penciled notation, comes from the Munich *Neueste Nachrichten* of August, 1882.)

Still Life with Mug, Pipe, and Antique Vase

vessels, . . . glasses and goblets, coverings of precious work, gauntlets and armor, all imaginable *petit-riens*," but with a detailed verisimilitude ruled out by Muther's esthetics. Perhaps the example of Blaise Desgoffe, with his "priceless onyxes, enamels, porcelains, crystals, rare and ancient stuffs, and jewels of the Louvre artistically grouped and copied with a finish of detail beyond which finish can go no further," [35] had something to do with this, but Harnett's subjects, like his rendering, are devoid of Desgoffe's slick Parisian chic. Harnett's subjects at this period are often heavy, *echt deutsch*, and sometimes suggest a cheap, machine-made elegance and pseudo-antiquity. The rendering continues in the Dutch-inspired realistic tradition of Raphaelle Peale or in the daintier, more miniaturistic vein, *à la* Meissonier, and it was to be a long time before Harnett made a satisfactory synthesis of these several elements. The confusion and abashment before the collections, professors, and artistic sophistication of Munich of which Harnett speaks in the *News* interview are reflected in the total spread of his work during the first Munich years; ultimately, as he had eight or ten years earlier in New York, he gave up the attempt to fit himself into the approved procession and went his own way.

The Munich Academy was the right place for a Chase, a Shirlaw, a Duveneck, or a Currier, but Harnett could learn little from the Pilotys, Kaulbachs, Lenbachs, and Leibls, then the lords of artistic creation in the capital of Bavaria. His effort to learn from them is doubtless reflected in an entry in the Earle catalogue: "Female Head, Rembrandt Effect." The catalogue does not state whether this was a drawing or a painting, but a Harnett drawing of a female head, without any perceptible "Rembrandt effect," signed and dated "München, 1881," came on the market some years ago and was promptly added by Professor Paul J. Sachs to the collection of graphic

art at the Fogg Museum of Harvard University (plate 51). From the point of view of characterization and rendering, this is certainly Harnett's finest known study of the human figure; it is also one of the very few works of Harnett known to me in which the illumination comes from the right-hand side. Two more crayon drawings of heads survive from the Munich days. One, dated 1881, is almost as good as Professor Sachs' young girl; it is a fine, incisive portrait of a young man with long dark hair who is dressed in peasant costume. The other, dated 1882, also represents a young man, this time with black hair and moustache; the open collar of his shirt is fully shown, in white, but the rest of his clothing is indicated only with a few sketchy lines, quite unlike the clothing in the other two drawings, which is described in complete Harnettian detail.[36]

Beside the two drawings, the known Harnetts signed "München, 1881," [37] are small still lifes

[35] Stranahan, *op. cit.*, p. 457. According to the Bement catalogue, Desgoffe was the only person in France "allowed free access to the treasures of the Louvre." Like Mrs. Stranahan, the author of the Bement catalogue cites the high opinion of Desgoffe held by the English critic, P. G. Hamerton, who assigns this artist "a higher position than that occupied by the laborious imitators of the Dutch and Flemish schools. But" continues Mr. Bement's cataloguer, "while these old masters were content to study things uninteresting in themselves, such as kitchen-utensils and other familiar objects, Desgoffe makes choice of things intrinsically beautiful."

[36] On February 7, 8, and 9, 1893, St. Elizabeth's Church in Philadelphia had a three-day festival adorned with an exhibition of art. Among its lenders were those excellent Harnettians, John Hedges, Philip Heebner, and E. Taylor Snow, and eleven works of Harnett were included. Among these were a *Study of a German Girl*, a *Study of an Italian Peasant*, and a *Study of an Italian Brigand*. These, I suspect, were the drawings just discussed. To be sure, the catalogue of the exhibition at St. Elizabeth's gives measurements of 18 by 14 for all three pictures and the three mentioned above are all slightly larger, but such discrepancies in the measurements of pictures as recorded at different times are maddeningly common and in this case may have arisen from the fact that in 1893 they were measured within their frames. At all events, the man in the drawing of 1882 looks enough like an Italian brigand to play the second baritone lead in any opera by Verdi, and although the man of 1881 has been given the title *Tyrolean*, there is little to suggest the Tyrol either in his face or his costume. The St. Elizabeth's exhibition also contained some existing Harnettian still lifes, all, likewise, with slightly smaller measurements than those given for them today, and some Harnetts which today cannot be identified. Among these was a painting called *Whistling*, which reminds one of a famous Duveneck, and must have been a figure piece of some sort. In other words, when Harnett told the *News* reporter that all his work had been "in the still life line" except for two portrait sketches later bought by a New York dealer, he had a rather serious lapse of memory. He had forgotten the *Front Face* of 1878, of which he himself preserved the photograph now in my possession, as well as *Searching the Scriptures* and *The Old Munich Model*. (Kelly speaks of his being engaged to paint a woman's portrait, and the Birch catalogue lists, in addition to numerous small figure drawings like those which came to me through Catherine Barry, "Old House, Fourth and Locust Streets, painted by Mr. Harnett, 1877, looking from his studio.")

[37] As is pointed out in our study of true and false Harnett signatures in the first section of this book, Harnett seems to have been determined to let the world know which of his works were created in Munich; he appears to have designated all of them with the name of that city, in its German form, on a separate line between the signature and the date. Unfortunately he did not inscribe pictures painted elsewhere in a similar fashion.

in the "Meissonier" style, like the *Frankfurter Zeitung* in the collection of the IBM Corporation. Its objects include a wine bottle, fruit, books, a cigar box, a cigar stump in an ivory holder, the newspaper which names the painting, a *repoussé* bronze plaque and a wineglass. Also included for the first time in any known work of our artist, are an Oriental rug as a table covering, and an embroidered drape in the background; these devices will reappear very often henceforth. The picture as a whole is one of Harnett's most "painterly" works, and it need scarcely be pointed out that the "painterly" approach consorts well with miniature dimensions, for both are nonillusionistic. One does not fool the spectator's eye very seriously with pictures of objects represented on a scale markedly smaller or larger than that of life.

Despite its miniaturistic sparkle, the *Frankfurter Zeitung* still life has no more swank of rug and drape than is necessary to please an upper-middle-class German buyer, but with the two paintings of 1881 known only through reproductions in the Birch catalogue [38] we enter, like Blaise Desgoffe in the treasury of the Louvre, the world of grandeur revealed by those great international expositions of which the nineteenth century was so proud and of which Muther speaks as one of the crowning cultural achievements of his age.

In both pictures, entitled, according to the Birch catalogue, *Reminiscences of Olden Time* and *Ye Knights of Old* (plate 54), a guffawing, rust-spotted medieval helmet and a brass-bound ivory-handled sword rest on an old book, the tables are draped (one with a very rich embroidery), there are more *repoussé* plaques, a Japanese lacquer tray, card cases covered with mother-of-pearl, and vaguely Grecian vases like those Harnett painted for the Folwells right after the Philadelphia Centennial, but here one of the Greek vases is covered with Chinese ideographs just to make it that much more exotic and rare. The whole performance is a queer mixture of the real and the pseudo, with emphasis on the

pseudo; at this time Harnett's conception of "things intrinsically beautiful" does not go much beyond the world's-fair souvenir.

Beginning with his first year in Munich, Harnett assembled a collection of still life "curios" to use as models—armor and musical instruments, vases, jars, and tankards of all sorts, snuff boxes and jewel cases, candelabra, statuettes, lamps, old guns, and vellum-bound books. Some of Harnett's studio props were objects of real quality and interest, whether old or new. Many, old and new, were simply fancy junk. Throughout the rest of his life he drew heavily upon this stock of models, and after he died the entire collection was sold at auction by Thomas Birch's Sons in Philadelphia, together with such paintings as Harnett left in his studio, and other memorabilia. The Birch catalogue lists Harnett's collection of *objets d'art* in great detail and provides photographs of numerous pieces; consequently this catalogue is a document of great interest when it comes to identifying, verifying, and authenticating works of Harnett produced after 1880.

Among the Harnetts of 1882, three are particularly interesting.

One (New York: Mrs. John Barnes, plate 55), is in the miniaturistic, sparkling style. It shows a pewter-lidded beer stein surrounded by turnips, a torn-open roll of German tobacco, a meerschaum pipe, and a box of Swedish matches. These objects stand on top of a bare, worn sideboard, and a newspaper called the *Deutsche Presse* hangs over its edge. At top right and top left one may see, against two walls, the corners of picture frames rendered with an almost Duveneckian "painterly" freedom; and the frame at the right reveals a portion of a somber, "painterly" landscape. In other words, Harnett has been going to the museums in Munich and seeing the Dutch masters, and they have recalled him to the tradition from which he came. Without forsaking his newly won miniaturistic technique, he goes back for a moment to "things uninteresting in themselves, such as kitchen-utensils and other familiar objects"; there are no adornments of carpet or portière, no "antiques"; and those square corners of the picture frames form, with the left-hand edge of the lighter wall, the beer stein, the newspaper, the top of the sideboard and its paneled front, an

[38] The Birch catalogue lists them both as having been painted in Munich in 1880, but according to my reading of the evidence, Harnett did not get to Munich until the following year. No signatures are visible in the cuts. If the paintings turn up and prove to have been done in Munich in 1880, my chronology will have to be revised accordingly.

Still Life with Mug,
Pipe, and Antique Vase

abstract composition of verticals and horizontals in the great line of the Dutch masters. (Salvador Dali insists that from Vermeer and De Hooch, with their painted maps and framed pictures, their gates and doorways and checkerboard floors, it is the simplest, most logical of steps to Piet Mondrian.)

Another painting of 1882 (plate 56) shows Harnett attempting, and quite successfully achieving, a compromise between the spare Dutch taste in iconography and composition and the fancier taste revealed by the still lifes of the previous year. This work (Utica, New York: Munson-Williams-Proctor Institute) heaps a number of books and other objects on a table like the Harnetts produced in the late 1870's. The composition achieves the classic pyramid with its apex in the same medieval helmet which Harnett had used in the knightly pictures of the Birch catalogue; behind the helmet stands a paneled cabinet and the usual dark recess at the right, and a triangular counterthrust to the apex of the pyramid is provided by sheet music hanging down over the edge of the table. This compositional formula—an upward-thrusting pyramid of objects receding (but never very far) from the table's edge and balanced by a downward-pointing triangle in a forward plane, the edge of the table acting as a long horizontal stabilizer for the whole—is, of course, very old. It is quite common in the works of the Dutch masters and Chardin; Francis knew it, but the Peales, apparently, did not. It is a very simple, not to say obvious pattern, but many subtle changes can be rung upon it. Harnett had used it before, but never quite so effectively as in this example. Henceforth he is to use it considerably more often than any other compositional device.

As in the *Music and Literature* of 1878 (plate 37), an open book lies near the edge of the table. Its leaves, sprouting outward in all directions, are spokes on which the entire picture seems to wheel. Note well that the nearest corner of the book at the table's edge is not built up and does not penetrate the picture plane in relief, as it does in the work of 1878. Very much of the Munich period are the Turkish rug over the entire table top and the heavy green embroidered textile at the right.

Three iconographic devices appear in this picture for the first time. One is the paneled cabinet in

the background, seen only dimly here. Another is the torn-off book cover which hangs by a single thread over the table edge.[38a] Harnett will use this often again and here Peto will follow him. (Perhaps Peto used it first, but the Dutch masters of still life had indulged in similar visual acrobatics centuries earlier as witness the match sticks in plate 75.) At the right corner of the table stands the third new device, a thick vellum-bound book with its title specified on its spine: "Andreas Valensis, 1560." According to the Birch catalogue, Harnett owned "Vallensis [*sic*] Andrae, *Juris Canonici,* Coloniae, 1651." Harnett has pushed the date of the book back a full century and would have us believe it was published twenty-six years before its author, Johann Valentin Andrae (1586–1654), was born, so determined is he to confer upon his models "the mellowing effect of age." Nearly all of Harnett's known table-top still lifes painted after 1882 contain vellum-bound books with similarly specified titles. Most of these will be Dante's *Divina Commedia,* or separate parts of it, or the plays of Shakespeare, and the copies of Shakespeare's plays will almost always be dated at least a quarter-century before the dramas in question were written. Harnett will soon begin also to exploit medieval missals with their four-line staffs in red, their handsome black neumes and their beautiful varicolored lettering, but now he is content with an unidentifiable flute solo that he is to use several times again, and a music cover reading *Dame Blanche.* Harnett's favorite flute is also here, his dented pewter tankard makes its debut, and there is a guitar, an instrument he seldom uses for a model. The Utica picture is small, but it is not in Harnett's miniaturistic manner, with the shower of highlights; the artist's approach is like that of the 1870's, but reduced in scale.[39]

[38a] So it was in 1953. The same device appears, however, in a recently discovered Harnett of 1879, the Shakespearian *memento mori* entitled *To This Favour,* now in the Cleveland Museum of Art. Attention should be called, before we leave the year 1882, to Harnett's obsessive repetition of a bright red lobster in still lifes of that time. (See below, Catalogue numbers 76F, G, H, and I.) This was also the year of Harnett's greatest portrait in oil, *The Old Munich Model.* (Catalogue number 80A.)

[39] A highly mysterious painting, apparently a very weak altered copy of the one just described, is in the Philadelphia Museum of Art. Its general iconography is the same, but the color is very poor, the drawing is shaky, and the whole composition has been pushed forward so that it loses all its elegance and grace. There are also many

Still Life with Mug, Pipe, and Antique Vase

Another important Harnett of 1882 is his earliest known "game piece"—a plucked chicken, nude except for its crest and tail-feathers, hanging by one foot from a string and dangling against the cracked green door he was often to use again. Game pieces continue in 1883. There are two pictures of ducks, hanging by one foot from a string against a door, which seem to be preliminary exercises toward one of the minor climaxes of Harnett's career—the first version of *After the Hunt*, also painted in 1883, in which there are two very similar fowl. This version of *After the Hunt* (plate 58) is a very large work (52½ by 36) which was ultimately sold to Francis C. Sessions of Columbus, Ohio, along with one of Harnett's miniaturistic still lifes; Sessions gave them both to the Columbus Gallery of Fine Arts, and *After the Hunt* remains there.

There is, of course, no trace of the miniaturistic manner in any of the four versions of *After the Hunt*. In the Columbus version, the background is a dull green door with fancy, rusty hinges, large, flat rivets, and a rusty, shield-shaped key escutcheon. At the top of the painting is a Tyrolean felt hat with its *Schnurbart* of feathers. It hangs on an invisible peg which also supports a huge hunting horn partly covered with a green cord as well as a gun with a running deer carved on its stock, a curving powderhorn, a game-bag, and a dead dove. A sheaf of grain stands against the door behind the bell of the horn. At the right are the two ducks and and a quail, hanging from nothing in particular. Likewise without visible means of support is the lion-headed, ivory-handled sword at the left—the same sword that Harnett had used in the lost paintings of knighthood in ye olden time.

It is quite impossible to believe that when Harnett painted this picture, and the fourth, largest and most celebrated version of it which he exhibited at the

Paris Salon two years later, he did not have before him some or all of the game pieces produced about 1860 by the Alsatian photographer, Adolphe Braun (plate 59). Braun (1811–1877) was one of the most skilful photographers of all time, and the firm he founded is one of the most important of its kind in Europe today. In the brochure published by Établissements Braun et Cie. in celebration of its hundredth anniversary [40] one reads that Adolphe Braun spent many years compiling and publishing an enormous collection of photographs of paintings in the churches and museums of Europe and thereby won much acclaim from contemporary artists of the brush; an admiring letter from Odilon Redon, written in 1862, is cited as part of the evidence for this. Braun would seem to have done as much work and to have had as much patronage in Germany as in France, and Harnett might well have come across his photographs in Munich.

Seven of Braun's game pieces survive. I am informed by Beaumont Newhall of George Eastman House that, incredible as it may seem, they are all contact prints: the smallest measures 27¼ by 17⅜, the largest 29½ by 22, and since they are contact prints, the negatives were of that size. Their composition is rather haphazard, but their handling of light and texture is masterly, and four of them directly anticipate the game pieces of Harnett and his American contemporaries. [41]

The four photographs all use as a background a wooden door or wall with a very conspicuous grain. In all four, the objects hang from nails driven into the wood. All have guns hanging transversely through the composition, as in Harnett. All have leaves, twigs, and sprigs of dead vegetation, like Harnett's sheaf of grain. All have hunting horns, in two of the photographs very large ones, precisely like those of Harnett, which are displayed, like his, at the top of the pictures. All have powder horns,

differences between the two versions: the guitar is not visible in the presumed copy, the pattern of the rug has been reduced to an unpleasantly loud, angular series of chevrons, the music is not the same, in the one place where Harnett specifies a book title the copy has no title, but on most of the other books, where Harnett avoids titles, titles are provided, and one of these (*Webster's Dictionary*) is ludicrously misspelled. There are other differences, too, but they are not worth detailing. I should not mention this picture at all if it were not for the fact that the Harnett signature it bears (undated and without the word "München") looks startlingly good. It is the only thing in the entire canvas painted with any spirit or assurance.

[40] *Un siècle de technique.* Mulhouse, 1948.
[41] The fourth version of *After the Hunt* was Harnett's most celebrated painting. It hung for a quarter-century in Theodore Stewart's New York saloon, and I have found ten or eleven variants of it by other artists, all later than the Harnett. I have previously published the suggestion that these later variants were all imitated from Harnett, but now I am not so sure. Some may have come directly from Braun, some from Harnett and Braun together, and it is by no means unlikely that some other painter or photographer is to be discovered in back of Braun himself.

59

Adolphe Braun
Still Life circa 1860

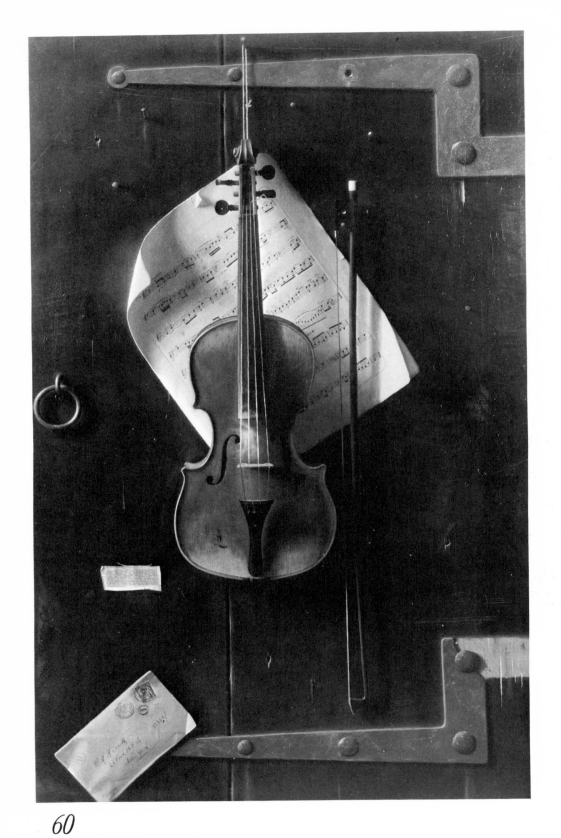

60

W. M. Harnett
The Old Violin 1886 (38 x 24)
William J. Williams, Cincinnati, Ohio

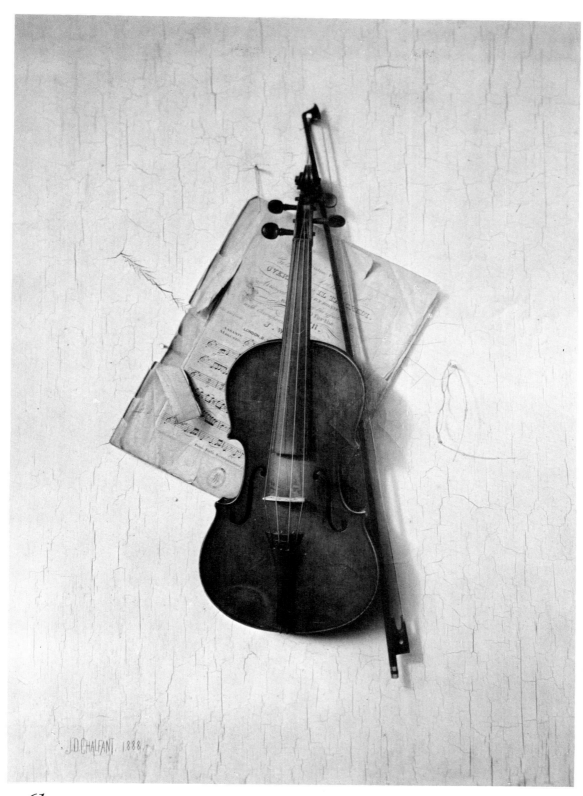

61

J. D. Chalfant
The Old Violin 1888 (38 x 28⅛)
Wilmington Society of the Fine Arts, Delaware Art Center,
Wilmington, Delaware

62

W. M. Harnett
The Old Violin, detail

62a

Gus Ilg
Chromolithograph after *The Old Violin*, detail

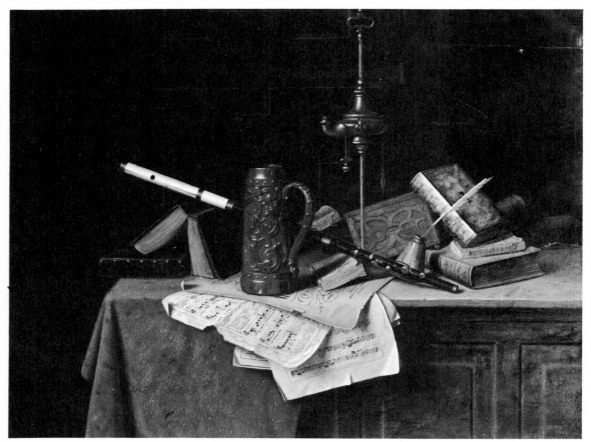

63

W. M. Harnett
Still Life with Tankard 1885 (21⅛ x 16½)
Mr. and Mrs. Mortimer Spiller, Buffalo, New York

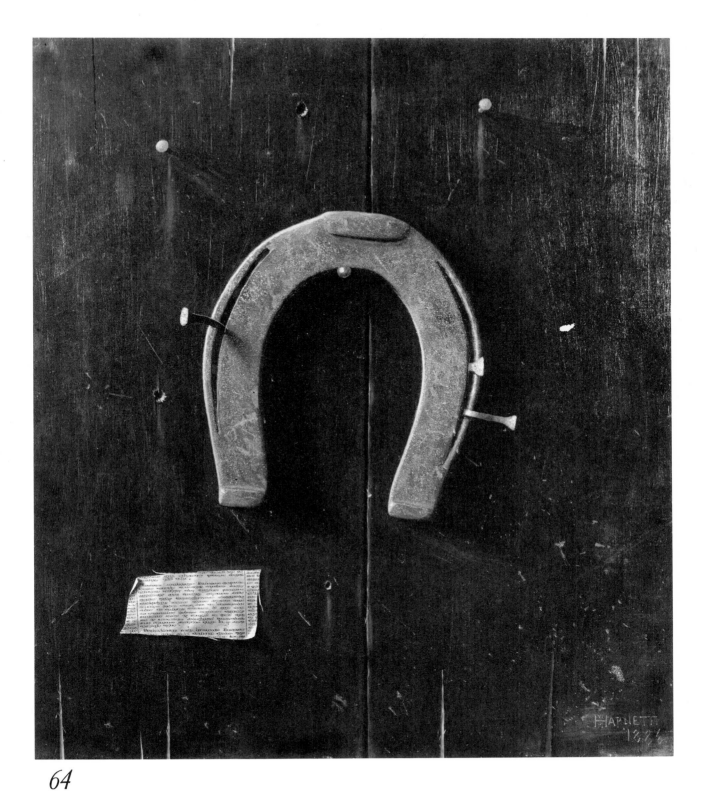

64

W. M. Harnett
Golden Horseshoe 1886 (13½ x 15½)
Mr. and Mrs. James W. Alsdorf, Winnetka, Illinois

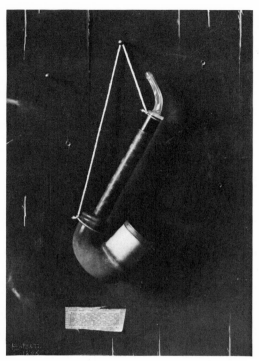

65

W. M. Harnett
Meerschaum Pipe 1886 (16½ x 11½)
Martin B. Grossman, New York

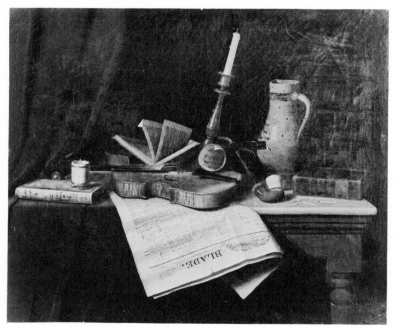

66

W. M. Harnett
Toledo Blade 1886 (20 x 24)
Toledo Museum of Art

Still Life with Mug, Pipe, and Antique Vase

three curved like those of Harnett, and one in the shape of a flattened sphere strongly suggesting the canteen which hangs at the bottom of Harnett's later version. Three have game bags, not the leather game bags of Harnett but the crocheted game bags of J. D. Chalfant. Braun's dead ducks and doves are fantastically like the ducks and doves of Harnett, his dead rabbit fantastically like the one Harnett uses in the Paris version and elsewhere, his dead swan amazingly like the one painted by Alexander Pope which hung for years, somewhat incongruously, in the headquarters of the Massachusetts Society for the Prevention of Cruelty to Animals and is now in the Metropolitan. Fortunately, Braun's dead deer and fox are not imitated by the painters.

It may be argued that a dead duck is a dead duck at all times and places and will hang with its wings spread out in very much the same way whether or not anyone is going to paint it or photograph it. That is true; what counts here is not so much the specific motif employed as the composition, the arrangement, the pictorial idea, and there is complete consistency here between Harnett and his fellow painters and the photographer who long preceded them. The whole group of pictures suggests two things: first, that there is much still to be learned about the elaborately orchestrated, symphonic game piece,[42] of which there may have been many different examples in different media before Harnett's time, and, second, that painters who are noted for their photographic exactitude may have learned a trick or two from the photographers themselves.

Harnett's remaining activities for 1883 are partly documented by a series of eight photographs of paintings in the Catherine Barry collection. All bear inscriptions on their backs, in Harnett's handwriting, that indicate their sizes and the names of their buyers.

Three of these works—including the still life

with a pewter tankard, a ginger jar, fruit, bottles, and other objects which Francis C. Sessions gave to the Columbus Gallery of Fine Arts along with the first version of *After the Hunt*—are known to exist today. With one exception, all eight of the paintings with which we are here concerned are quite small table-top pictures. In each one, about a quarter of the background is taken up with a deep recess. In four, the rest of the background is given over to paneling, but this now reveals itself, by means of hinges and locks, to be the paneling of a large cabinet or wardrobe (a different cabinet or wardrobe each time).[43] In three, the pewter tankard of the Utica picture, which is not the same as the one in the Sessions still life, appears, always with its handle to the left so that the dent in its side will show. (It finally turns around and reveals its undented side in Harnett's *Just Dessert* of 1891, now in the Art Institute of Chicago.) In general these pictures demonstrate that Harnett remains fond of the mug-and-pipe formula of the late 1870's and 1880, but is no longer satisfied with its simplicity; he now feels constrained to surround his mugs and pipes with all manner of other objects. One of these pictures has "sporty" connotations, which are quite rare in Harnett: there is a bottle of champagne in a bucket of ice, there are cigarettes on the table, one of them burning at its edge, and, unlike all the other pictures of this series, there is not a book in sight. (This is Harnett's only known painting to represent cigarettes.) In another painting of this group, the gun and the hunting horn of the first *After the Hunt* appear on the wall behind the table.

[42] I use the phrase "elaborately orchestrated, symphonic game piece" advisedly. I am not talking about the pictures of a single dead duck or quail or ratty snipe which exist by the millions in the form of paintings, etchings, photographs, and chromos. These are a cluttered nuisance and have provided my sole and only cause for regret that I undertook this research. Harnett's cold plucked chicken may have been intended as a burlesque of these. Peto's even nuder chicken, imitated from Harnett's, seems definitely satirical in its intention.

[43] As is evident from all that has been said, from 1880 onward Harnett likes paneling in the backgrounds of his table-top pictures, but he does not like it throughout the entire width of his canvas; he insists upon a dark space against which to pose his main vertical, usually a stein, jug, or something of the sort. This, however, is difficult to "explain": the panel suddenly stops, but the dark space cannot be a doorway because the table extends across it; from any descriptive point of view, it is an enigma and an anomaly. In the Barnes picture of 1882 Harnett tries to solve this dilemma by using two walls, one darkly shaded, but, while the results are magnificent so far as abstract design is concerned, this only makes matters worse, descriptively speaking; the angle at which those two walls join is most ambiguous, and so is their relationship to the sideboard and the things placed upon it. If, however, the paneling can be "explained" by means of hinges and keyholes, as the front of a cabinet, then the dark recess can be explained, too; the cabinet is against the wall, the table is in front of the cabinet, the most feebly literal-minded professor at the Munich Academy is satisfied, and everybody is happy.

Still Life with Mug, Pipe, and Antique Vase

Harnett had his own peculiar method of indicating sales, a dollar sign followed by the name of the buyer, which appears on the backs of nearly all his photographs and occasionally on the backs of his paintings. Three of the photographs just mentioned, and also the one of the Barnes picture of 1882, are inscribed "$ Carmer of N.Y." Three others are inscribed "$ to Rothschild of New York." (Always in that way: Carmer has no "to" and the name of the city is always abbreviated, but not so Rothschild. Harnett was a systematic man.) Art dealers named Carmer and Rothschild are listed in old New York directories, but all other trace of them has long since disappeared. It seems highly improbable that any private collector would buy so many pictures which are so much alike in size, subject, and treatment.

Harnett's photograph of the Sessions still life bears a very curious inscription:

$ in Munich to Ulm Dombau Lotterie
$ No. 2 to F. C. Sessions of Columbus, O.
$ No. 3 to Rothschild of New York

This implies, of course, that Harnett made three different versions of the same picture. Whether or not they were exact replicas, we do not know; no exact, finished duplicates by Harnett have so far been found,[44] although there are numerous known examples of his painting two or more very similar studies of one subject. Nothing even remotely like a duplicate of the Sessions still life has so far turned up, however, and until we find the versions sold to the Ulm Cathedral lottery and to Rothschild, the question of exact replicas will have to remain open.

Last of the Harnetts of 1883 represented in the old photographs is a painting, somewhat larger than the others (the inscription gives its dimensions as 10½ by 14 inches), which was "$ to Neustadt of N.Y." (perhaps the well-known capitalist, Sigmund Neustadt, but his son does not recall seeing anything of

the sort in his father's large collection). This is in Harnett's fancy, pretentious vein, with a medieval helmet, a small bronze bust of Dante, a keyed bugle, music, and many books, including a *Divina Commedia* of 1505 with its cover hanging by a thread. The paneled door at the back is very elaborate, displaying an heraldic eagle and other armorial signs. But the escutcheon around the keyhole in the door of the sideboard at the lower right, a brass affair in the form of a little boy, is a most delightful thing, and looks forward to the famous key escutcheon in the form of a medieval warrior in the second version of *After the Hunt*.

XI

Among Harnett's works of 1884 are two which are known to us only through photographs in the Catherine Barry collection. One of these (plate 57) is a large photograph of a large painting—46 by 56, according to the inscription. It was "$ London—Geo. Fryer." (Fryer was a London dealer.) If the photograph can be trusted this picture is lush and tasteless. All the usual paraphernalia is there—paneled cabinet, rugs, drapes, books (including a Tasso of 1510 with its cover torn off and hanging by the usual thread), a page from a medieval missal, a piece of modern music which reveals by its double-stops that it is for the violin rather than the flute, a helmet, a fancy Japanese vase, a little ivory snuff-box, a candle-snuffer, a violin, an ornate old strong-box with a big key, the keyed bugle, an appalling candlestick in the form of a medieval soldier, and last of all, making her debut like a star ballerina, The Dutch Jar.

Capitals everywhere, please; The Dutch Jar is the queen of the Harnettian iconography. Although it was merely a nineteenth-century German affair not worth storage room in a modern museum, its shape was interesting and so was the textural contrast between its glazed body and its pewter lid and foot. Harnett was to paint it many times, invariably from a slightly less than three-quarter view, with its striped handle always to the right, and showing on

[44] The University of California possesses an unsigned, unfinished replica of the Harnett writing-table picture of 1879 now in the collection of Mrs. S. B. Wattles, Senior, of Healdsburg, California. The University's version may be a preliminary sketch for the Healdsburg painting, and it is worthy of note that the Healdsburg version itself seems to be incomplete in its lower left-hand corner. Both these paintings were apparently purchased directly from the artist by Mrs. Wattles' grandfather; the transaction is said to have taken place in New York in the late 1880's. Apparently Harnett was in need of money and disposed of some odds and ends for what they would bring.

Still Life with Mug, Pipe, and Antique Vase

its body the crudely painted figures of a windmill, a house, a picket fence, a tree, and a cow. He never alters the position of the jar by as much as a half-inch, and he studies all its cracks, crackles, specks, and abraded spots with the most minute and loving care, but he will often leave out the cow, the tree or the house. It was from just such iconographic by-play within exceedingly narrow limits that Harnett clearly derived one of his major pleasures, and much of the pleasure of following his track arises from observing these minor, esthetically insignificant variations.

The jar appears also in the other photographed painting of 1884, a smaller and less exuberant one, with a simple cloth on the sideboard and, on its top, a violin, books, a candlestick, the bust of Dante, and the flute solo used in the Utica picture. Once again the background is a paneled cabinet—a new one. Although Harnett loves to repeat his still life models, he never once repeats the panel pattern of a cabinet. The photograph of this painting is inscribed "15 x 12½ inches. $ in London." Added to this in pencil, apparently at a later time, is "to Fryer London. With pewter tankard to Columbus, Ohio." If it is in Columbus now, no one knows about it. It is not in the Sessions collection.

Harnett told the reporter for the New York *News* that in 1884 he "decided to refer the question" of his ability "to the higher court of Paris" because some of the professors and students in Munich had criticized him severely. The nature of their criticism is made explicit by the following clipping from the Munich *Handelsblatt* preserved in the Blemly scrapbook. It is dated merely "1884."

Everyone knows the tale of Zeuxis and Parrhasios. W. Harnett might, not unjustifiably, be called a true modern Parrhasios, deceiving people with the still life of his which is exhibited this week at the Kunstverein. One would think it possible to remove the hat, the hunting horn, the flintlock, the sword, the powder horn and the game bag from their nails and with them equip one's self for the hunt. One could become a veritable Nimrod with these hunting utensils which project so plastically from the old door that serves as background. There is not a tiny splinter, not a nailhead, nothing that is not depicted to perfection, so that one does not know which to admire more—the artist's gigantic patience or his astonishing powers of observation and imitation. But the pedantry shown in the rendering also

dominates the composition. For us this is—how shall we say it?—far too painstaking in its orderliness, so that its painterly effect is impaired. But, just as was the case with the famous hare at the last exhibition, Harnett's still life is surrounded by an astonished, admiring crowd, and we do not wish to be the last to voice our wonder at this eminent "work of art." So far as realism is concerned, one can scarcely do better.

Those quotation marks around the phrase "work of art" may have hurt worst of all.

Just when Harnett left for Paris we do not know. The Blemly scrapbook contains a certificate of residence for him—Schleissheimerstrasse 28—issued by the Munich police on September 24, 1884, so he was there at least until then. He said he went to Paris and spent three whole months painting the fourth version of *After the Hunt* (frontispiece), which was thereupon accepted for the Salon, and since the Salon of that year opened on May 1, he might not have arrived in Paris until after the turn of the year.

According to a calling-card in the Blemly scrapbook, he set himself up at 7 rue Tourtaque; he then bought the biggest piece of canvas in town (71 by 48 inches), and started to work. But, like Picasso throwing disemboweled horses to left and right in his passionate preparation for *Guernica*, Harnett painted at least one study for his fourth *After the Hunt* before buckling down to the major assignment. This is the dead rabbit, hanging by the inevitable string against the inevitable door, which is to be found today in the Carnegie Institute at Pittsburgh. The *Handelsblatt* review suggests the reason for this preliminary study. Someone—very likely Harnett himself—had made a hit in Munich with a picture of a rabbit. He was now playing the game for blood, and since the "bekannte berühmte Hase" of Munich had been a success, a rabbit had better go into the new version of *After the Hunt*.

The Carnegie rabbit is signed in the same amusing fashion as the big Salon piece: the artist's name and the date are painted as if they had been whittled into the door; one can see how the knife dug a little deeper when it turned corners, and how, once in a while, the blade slipped out of its groove. In this work, also, there is a nice, subtle play of color, texture, and "story" between old, brown, rusty rivets and bright, fresh new ones.

Still Life with Mug, Pipe, and Antique Vase

In the long obituary notice of Harnett published in the Philadelphia *Times* two days after his death, there is a passage of reminiscence about him quoted from an unnamed person who knew him in Paris. This unidentified friend informs us that:

One day in 1885 he sent for me to look at a picture he had just completed. It was his first great work in still life, the beginning of his career as an artist without a peer in that particular line of work. It was the now famous *After the Hunt,* a panel piece showing a brace of rabbits and some implements of the chase. He had it inserted in a door of his studio, of which it seemed a part. I went in ecstasies over it. Harnett said sadly: "I must have some money to send home. Get me $400 for it if you can." Poor fellow, he would gladly have taken less.

I insisted, however, that it should be sent to the Paris Salon, whose spring exhibition was about opening. But Harnett had neither a frame nor the money to buy one. Then an inspiration seized him. He got four strips of wood, nailed them roughly together around the canvas, painted them a deep black and the painting was brought out with marvelous life-likeness. In that shape it was sent to the Paris Salon, was placed in the line and Harnett's fame was made.

Before that victory was achieved, however, he, by my advice, sent a little bit of still life he had to the Royal Academy which was about opening its exhibition in London. The very day he sent *After the Hunt* to the Salon, we succeeded in raising $6 between us and had a frame made for the small picture. Harnett wished to mark its price 4 pounds. I made it 30. The picture was seen when the box was opened by Mr. Richmond, a member of the Royal Academy, and he seized it even before it was exhibited. By return mail Harnett received a check for $150, the greater part of which was immediately forwarded to Philadelphia.

He then was anxious to return home but did not have sufficient money, *After the Hunt* remaining unsold. He had meanwhile completed another picture and by my advice he took it to George Fryer, the well known dealer in London, who the moment he saw it said: "I can sell that quickly." It was placed in the window and while Harnett was still in the store two strangers entered and asked the price of the painting but when told it was eighty pounds they murmured and left. Poor Harnett tore his hair and cried out to Fryer that he would take much less. "Wait," said the dealer calmly. In half an hour the two men returned and paid the stipulated sum. With that my friend returned to America, bearing the Salon victor with him.

In all probability, Harnett's unknown friend, like Harnett himself (as quoted in the *News* interview), exaggerates the success which *After the Hunt* was accorded at the Paris Salon. It won neither prize nor honorable mention, it found no buyer, and the professional critics gave it a grand total of six lines, four in one newspaper and two in another. Louis Énault, whom Harnett calls "the famous French critic," was no critic at all, but a novelist and literary jack-of-all-trades who worked in the great French tradition whereby literary men express themselves on all the arts whether or not they know anything about them. His remarks on *After the Hunt* in his book on the Paris Salon of 1885 show that, so far as biographical fact is concerned, he did not hesitate to use his imagination.

Harnett (William Michael) was born in Ireland of American parents, in contradistinction to many of his contemporaries who were born in America of Irish parents, for immigration follows the sun and goes, like it, from east to west, and it bids fair not to stop until it has colonized all the deserts of the Far West.

But talent, by the grace of God, has nothing to do with geography; it is born, grows up, flourishes and blooms in every latitude. This young Irishman, son of Americans, is a natural-born painter, and in his *After the Hunt,* which every hunter would love to see hung on the wall of his vestibule or dining room, or in the grand hall of his château, he gives evidence of truly remarkable talent. In my judgment his picture is done with a master hand.

I really do not believe that I can be accused of easily-aroused enthusiasm; I am not excited in the least by still life, and more than one kettle, even of reddest brass, has left me completely cold.

But I should be unjust if I refused to recognize the dexterity of hand which M. Harnett has shown to the highest possible degree in this decorative panel. I have rarely seen such powerful relief. The guns, the pistols, the horn and the sword, the quail, the rabbit and the stag horns stand out from the wall with a crispness and vigor attaining *trompe l'oeil.* It would really be difficult to do better.

The daily press was most laconic. The *Cri du Peuple,* in its review of the Salon, found room to mention "last of all, an American painting by M. Harnett which is a *trompe l'oeil* of very curious effect." *Gil Blas* pontificated: "M. Harnett, *Trophées de chasse.* Well done. But why paint a rabbit killed yesterday along with weapons not used in hunting, like an arquebus?" And that, it seems, was all. The picture really did not come into its own until Harnett brought it back to this country and sold it to Theodore Stewart, but that is another story.

Many of the statements made by Harnett's un-

Still Life with Mug, Pipe, and Antique Vase

known friend of the Paris days are verified by supplementary documents, among them three bills from dealers in artists' materials which Harnett gave Blemly and which Blemly pasted into his scrapbook. The earliest of these, dated March 2, 1885, is from "A. Lefranc, Fabrique de Couleurs, Vernis et Encres d'Imprimerie." It reads "Received from M. Harnett the sum of one hundred francs on his account." (In other words, Harnett did not have enough money to satisfy the entire bill.) The second bill is from "P. Detrimont, Tableaux Modernes, Dorure." It is dated April 9, 1885, and is for "One frame, 45 francs" (approximately the six dollars mentioned by Harnett's friend as the price they paid for the frame Harnett put on the picture he sent to London). Finally, there is a bill from Lefranc, dated July 25, 1885, which is itemized as follows (the sums, of course, are in francs and centimes).

May 5: 1 heavy panel	6.00
May 9: Sending a picture to London	4.10
May 30: Idem	16.00
June 12: Repair and packing of a panel	2.50
July 9: Returning a picture from the Salon	10.00
July 22: One chest (caisse)	35.00

The Salon, then, had closed by July 9, and Harnett's purchase of a *caisse* (perhaps a trunk rather than a chest) indicates that he was ready to pack up and leave Paris for good.

A panel picture of this period (but one stamped with the name of a different dealer in artist's materials) survives in the collection of Mortimer Spiller in Buffalo, New York (plate 63). It is signed and dated 1885, and bears on its back, inscribed in ink and possibly in the artist's handwriting, "Painted by W. M. Harnett of Paris."

This work anticipates Harnett's home-coming and sums up the best aspects of his European education. The Arnold ink bottle, the good companion of the artist's Philadelphia days, now returns to the scene, and there is also a hint of the old Philadelphia touch in the fact that the table covering is a piece of drab, unfigured velvet, worn and patched. The compositional formula of the pyramid and triangle remains, as does the carved-panel background, to say nothing of the dated sixteenth-century vellum book (*Divina Commedia*). Most important of all,

perhaps, is the fact that the scale of the represented objects (flute, Roman lamp, strongbox, burnished copper flagon, etc.) remains smaller than that of nature. This is the legacy of Harnett's miniaturistic experiments, but "painterly" dabs and sparkles of free brushwork have gone for good; the smooth, glossy finish of Raphaelle Peale, with all brushwork hidden, once again rules the scene.

Harnett returned to London in the summer of 1885. He is recorded in Algernon Charles Graves' *Royal Academy Exhibitors, 1769–1904,* as residing at 32 Hanway Street, and as having exhibited a still life at the Royal Academy in that year. This was the picture purchased by George Richmond, then one of the most popular painters in England. It was resold at Christie's, with the rest of George Richmond's collection, after that gentleman's death in 1897, and was bought by his son-in-law, Sir William Rann Kennedy. The Kennedy family has died out and the whereabouts of the painting is not known, but Harnett kept a photograph of it, which is now in my possession. The picture was small; according to Harnett's notation, it measured 14 by 10½, and was bought by Richmond for a hundred and twenty-five dollars. Iconographically, it is reminiscent of the Paris panel picture just described. Like it, it shows Harnett's flute completely assembled and not pulled into sections, as it commonly is; the patched, drab drape is also there, and so are the paneled cabinet, the Roman lamp, the Arnold ink bottle, the page from a missal, and the Japanese vase employed in the large Munich painting in 1884 which Harnett sold to Fryer.

XII

HARNETT WAS back in this country by the middle of April, 1886. *The Old Violin,* one of his two most celebrated works (plate 60), is signed on its painted envelope with the artist's name and address, 28 East Fourteenth Street, New York, and bears a Paris postmark of April 27 in that year. Many artists had studios along Fourteenth Street in those days, and

Still Life with Mug, Pipe, and Antique Vase

Harnett was to remain among them until his second trip to Europe, in 1889.[45]

An unnamed critic who once wrote on Harnett for the bulletin of the Springfield Museum of Fine Arts observed that he lived in the nineteenth century as if he had been living in the seventeenth, and to a certain degree this is true. But what the writer is really saying is that Harnett showed no response to currents of nineteenth-century artistic thought which the twentieth century believes to have been progressive. He certainly did not begin to paint in the manner of Claude Monet the moment he set foot in Paris, and if he had, he would not be remembered today. We must, of course, judge Harnett's works in the light of our own esthetics—there is no other way in which we *can* judge them—but we must try to approach *his* esthetic orientation in its special and particular terms.

Harnett's self-conscious esthetics, as revealed in his work and in his interview in the New York *News,* do not go much beyond those of Raphaelle Peale; nevertheless we have seen him flirting, in Europe, with something suspiciously like Meissonier, and even, if gingerly and momentarily, with the slapdash Münchenisms of Duveneck et al. And we must never forget something which modern esthetics force us unknowingly to forget—that Harnett's audience placed immense emphasis upon subject matter. "I always group my figures so as to try and make an artistic composition," said Harnett. "I endeavor to make the composition tell a story. The chief difficulty I have found has not been the grouping of my models, but their choice."

The study of Harnett must be a constant, running study of iconography as well as a study of style; this was insufficiently realized during the early years of the Harnett revival, and that is one good reason why so many forgeries were accepted without question as works by our artist. The iconography of Harnett's paintings of 1886 shows an immediate response to the American environment and one which was very much to the good. Now (plate 64) he paints the big, worn, rusty shoe of a drayhorse nailed to a door which is devoid of visible hinges or fanciness of any kind. A newspaper clipping with threadlike projections at top and bottom is pasted across the deep line of division between the two boards of the door, and the entire background is fabulous for the pattern, the energy, the spirit, and the verisimilitude of its cracks, splinters, and rusty nails—even for its empty nail holes. Harnett has learned that an artist does not need medieval hinges and locks with which to make a door interesting; he has here gone back to the homeliest of the homely, the most commonplace of the commonplace, and with it achieved a new subtlety both of design and connotation.[46]

In 1886, likewise, Harnett takes an old German pipe with a meerschaum bowl, a long cherry stem and an amber bit, hangs it by a string from a nail in a door, and with it achieves a masterpiece of taut abstract pattern. There are three known versions of this picture. They are very much alike, but they are not replicas: one (New York: Martin Grossman, plate 65) exhibits a newspaper clipping, while the other (Oberlin College) does not; there are also differences in the cracks, nail holes, chalk marks, and finger smudgings on the green board, and the more one studies these, the more important they become, while the fact that the two pictures represent the same pipe and piece of string forming the same design sinks into comparative insignificance. Now it becomes apparent why Harnett does not like the natural wood grain of the old tradition—he can

[45] Rather curiously, his name recurs, after an absence of seven years, in the Philadelphia City Directory for 1885. This directory was, of course, prepared in the previous year, and the entry probably means that when Harnett decided to leave Munich in 1884 he wrote his mother and told her he was coming home. His name is absent from the Philadelphia City Directories of 1886 and 1887, but comes back in 1888 and remains in subsequent issues to the year of his mother's death. All these entries, one suspects, were his mother's doing, for William did not actually live in Philadelphia at any time during this period.

Incidentally, the New York City Directory gives Harnett a residence address, 132 East Sixteenth Street, in its issues from 1888 through 1893, which was, of course, the year after he died. He may have lived in the Fourteenth Street studio during the first year in New York after his return, not permitting himself the luxury of separate living quarters until he began to make some money. On the other hand, he may simply have neglected to record his residence until he was definitely settled.

[46] Another version of this painting is called *Colossal Luck,* but the horseshoe is in the bad-luck position, pointing downward, as is the horseshoe at the top of the second *After the Hunt.* Peto faithfully paints *his* numerous horseshoes in the good-luck position, with the result that they are considerably less interesting both as design and, perhaps, as subconscious psychological revelation.

Still Life with Mug, Pipe, and Antique Vase

do so many more interesting things with a painted door that has been thoroughly weathered, battered, and abused.[47]

One would like to be able to say that the lushness, the fanciness, the excesses of rich drapery, ugly paneling, and cheaply expensive "antiques" which were so marked a feature of Harnett's Munich pictures, and which became less prominent in the still lifes painted in Paris, disappear entirely after his return to this country, but that, unfortunately, is not true. The Munich pretentiousness will keep cropping out again, here and there, as it seems to crop out in another Harnett of 1886 known only through a photograph in the Catherine Barry portfolio. It is a table-top picture with unfigured velvet drapes, music, a candlestick, and a clarinet. There are also books; the inevitable vellum-bound tome is now a *Divina Commedia* of 1498. What links this work to Munich is the tasteless, pseudo-Greek bronze bust of a woman which forms the apex of its pyramid. "As a rule, new things do not paint well," said Harnett. "I want my models to have the mellowing effect of age." But he had some very curious ideas about what was old and what was new.

Also from 1886 date two very similar table-top still lifes, one with the Toledo *Blade* of September 17 (Toledo, Ohio: Museum of Art, plate 66) and one with the Philadelphia *Times* of October 20 (New Britain Art Institute). These works are, in fact, identical in iconography and composition except for their books, the color of their table tops, and the names of their newspapers (which, though they bear different mastheads and dates, are the same in their folds and small, accidental tears); the Toledo version substitutes an ivory match case for one of the books used in the New Britain picture. The pyramid-and-triangle formula is, of course, employed. (Henceforth the term "table-top still life" can be assumed to imply this; that formula appears in all the table-top pictures after 1880, as it has, in a less dramatic form, in most of those produced be-

fore that time. The phrase "table-top still life" can also be assumed to imply the presence of the inevitable vellum-bound book, usually a Dante or a Shakespeare, with a conspicuously early date.)

The principal *dramatis personae* in the Toledo and New Britain still lifes are a stoneware jar, a violin, the pipe of the Grossman and Oberlin pictures, a tilted candlestick, and an open book with a curious dog ear on the corner of one leaf. Harnett loads on his pigment at this point, not to cut the picture plane but to make that corner the highest spot of light in the painting. In general rendition, both works are close to the Paris panel picture now in Northampton; the scale of the objects is less than life, but the whole is done with high gloss and polish. Both of these canvases show that Harnett has finally mastered a feat of drawing which has been the despair of more than one great draftsman, including Harnett himself when he worked for the Folwells in 1878: how to depict a violin lying on its back so that it does not look as if it were made of rubber and bent in the middle.

By far the most celebrated violin of Harnett's career, however, is the one mentioned at the beginning of this section—the violin hanging by a string against a door, along with a piece of music, a bow, a newspaper clipping, and a letter (plate 60). The letter is addressed to Harnett at 28 East Fourteenth Street, New York, and bears a French stamp and a postmark of the third *arrondissement* of Paris dated "27 Avril, '86." Today in thousands of American homes, barrooms, restaurants, music stores, barber shops, and amusement parks hang copies of the magnificent chromolithograph of this painting produced in 1887 by its first purchaser, Frank Tuchfarber of Cincinnati. I have seen the Tuchfarber chromo in Vermont junk shops, in the proudly modern office of the president of the Musicians' Union in Detroit, and in the Rosicrucian Library at San Jose, California; for some inexplicable reason, it seems to be particularly prevalent in Colorado. And today, in quite a few American homes, art museums, and dealer's establishments—but probably not in thousands—there hang copies or adaptations of that chromo in oil on canvas, not a few of them incorrectly ascribed to Harnett. Legends have

[47] In all of these works—the horseshoes and the pipes—Harnett continues to use his Paris trick of painting his signature as if it had been whittled into the door. In studying the signature on the Grossman picture with a magnifying glass, I saw in the painted grooves painted splinters which were not visible to the naked eye.

Still Life with Mug,
Pipe, and Antique Vase

sprung up and cling around these things, both the chromos and the oil copies. *The Old Violin* is part of American folklore as well as a chapter by itself in the history of American art.

Let it be said at once: there is only one *Old Violin* by William Michael Harnett. It hangs today in the residence of William Williams in Cincinnati, and it has never been owned outside that city since Harnett sold it to Tuchfarber at the thirteenth Cincinnati Industrial Exposition in September, 1886. The legend that it once belonged to the fabulous Edward L. Stokes and hung for years in the bar of the Hoffman House in New York is moonshine, but it is far from the weirdest moonshine ever concocted about this famous subject.

The Old Violin is one of Harnett's finest abstractions. Juan Gris himself never created a more fascinating pattern of rectangular shapes counterpointed against baroque curves. Here, also, Harnett continues to play his much-favored game of lights and darks with rivets and nails: some of these are old and rusty, like the hinges, but some are bright replacements, while the ring on the door at the left is merely middle-aged; it is neither bright nor brown. The body of the violin exhibits a bit of shrewd observation which I have never seen recorded by any other painter: the light, entering the f-hole at the left, is reflected by the inside surface of the back, so that the right f-hole, although it is on the shaded side, is brighter than the one on the left because it reveals the illumination on the wood beneath. But Harnett, the flute player, never learned to string a violin correctly; his strings are attached to the wrong tuning pegs.

Harnett also does much with the light caught by the folded corner of the music at its top left; this again is a bit of heavy impasto to catch the sun, not to stand forth in relief, and it reflects its light on the door below it. There are two pieces of music on the one sheet. The piece at the bottom is Harnett's favorite *Hélas, Quelle Douleur,* but the piece at the top is untitled and I have never been able to identify it. It is a dreadful tune, but it plays an important role in much that follows here.

In the Blemly scrapbook there is a newspaper clipping credited to the Philadelphia *Item* of June 11, 1895, nearly three years after Harnett's death:

Mr. George Hulings, Fourth and Wharton streets, tells an interesting incident of the late Mr. Harnett, the celebrated still life painter.

Harnett jumped into fame with his painting of a five-dollar bill.

It was so excellently done that report has it that the Secret Service Bureau of the United States Government ordered him to exercise his skill in another direction.

Mr. Hulings has several paintings by Harnett, one of which he prizes very highly.

It represents a home made card and letter rack made of tape in which has been placed a number of cards and letters from his friends.

"When Harnett became famous and he found Philadelphia was too small a field," said Mr. Hulings, "he went to New York. I visited him at his studio, and found he was one of the busiest of men.

"No one ever saw a picture hanging upon the walls of his studio.

"They were sold upon his easel long before they were finished.

"I asked him to paint me a fiddle, but as his prices had risen with his rise to fame I asked him to take his time and do it at odd moments.

"Sometime afterwards I saw him and he told me that my fiddle had been painted, but that it didn't satisfy him. 'It is too flat,' said he, 'and don't stand out at all.'

"My answer was that the first time I visited New York I would call at his studio and judge for myself.

"Shortly after that I had occasion to visit the Metropolis. I went to his studio and found it locked.

"I inquired his whereabouts of the janitress and learned that he had gone to one of the New York hospitals suffering with a severe attack of inflammatory rheumatism.

"I endeavored to find him, but without avail, and returned to this city without seeing my picture.

"A relative of mine who resides in Covington, Ky., who was on a visit to this city, saw this Harnett and told me that upon a recent visit to the Cincinnati Exposition, he saw a most remarkable painting by Harnett.

"I asked him to describe it and judge of my surprise when I heard him describe minutely the picture I had ordered Mr. Harnett to make for me.

"I heard also that the picture was being reproduced in chrome-lithographs and was commanding the large price of $15 per copy.

"I have known Harnett for years. We were on the most intimate terms and I knew he was as straight as a string, but I felt so annoyed that I determined to go to New York and make inquiry. I did so, went to his studio and succeeded in learning the name of the hospital to which he had gone.

"I proceeded thither only to learn that he had left the hospital the week before.

"He had come to Philadelphia.

Still Life with Mug, Pipe, and Antique Vase

"Back I came and found he was stopping upon Fitzwater street.

"He was out when I called and I left a note asking him to call upon me.

"He did so and greeted me with the remark that he knew what I wanted.

"He then proceeded to tell me the following remarkable story:

"While he was ill in the hospital the Commissioners of the Cincinnati Exposition visited him and asked him to contribute.

"He told them that he had but one picture in his studio and that was sold to a Philadelphia friend.

"After bidding him good-bye they went to his studio, took away my picture and exhibited it at the Exhibition.

"It attracted general attention and without consulting Harnett they subsequently sold it to a lithographer for $250, who reproduced it, as stated before.

"Harnett brought suit against the Commissioners before the Common Pleas Court of Hamilton county, Ohio, and recovered $500.

"Considering the immense sum asked for chromo-litho productions, $15, and the large sale of them, it seems to me that ten times that sum would have been a small verdict."

The Court of Common Pleas of Hamilton County, Ohio, which is in Cincinnati, has, of course, complete records of every suit ever filed or tried therein. It has no record of any such suit as that described by Hulings. The painting was brought to Cincinnati by Edwin L. Mehner, Harvard graduate and proprietor of a large wholesale grocery firm in Cincinnati and Indianapolis, who was then and for many years afterward chairman of the department of fine arts and ceramics of the Cincinnati Industrial Exposition. There is no record of any Harnett suit against Mehner, either, and Hulings' picture of a man of his standing breaking down doors and stealing paintings from artists' studios to put on public exhibition is a little difficult to credit. One also wonders what Harnett was doing on Fitzwater Street when his family lived at 806 South Thirteenth; but the most interesting part of the Hulings story is the statement that this gentleman owned a painting by Harnett representing "a home made card and letter rack made of tape in which has been placed a number of card and letters from his friends." As already noted, the Peto letter rack of 1894 at the Museum of Modern Art, a canvas with a forged Harnett signature which was long accepted as a work of Harnett himself, bears, on one of its cards,

written in ink in an unidentifiable hand, over a previous painted inscription now illegible, the phrase ". . . . lings / and Wharton St. / Philadelphia / Penn.," an added inscription which has been placed on a postcard bearing as part of its original paint-film the postmark of Cincinnati, Ohio. . . .

Historians of American art are beginning to make much of the role played in our cultural development by the great world's fairs—Philadelphia, 1876; Chicago, 1893; St. Louis, 1904; San Francisco, 1915. This is as it should be, but the historians are overlooking something of equal if not greater importance—the industrial expositions which were held annually in various Middle Western cities for many years. These expositions all featured very large art shows. Practically every painter discussed in this book contributed to them; so did the American celebrities of their time, and many a European artist did not consider it beneath his dignity to sell a picture or two to those American customers who were detained at home and unable to make the Grand Tour. These exposition art shows served the Middle West much as the annual exhibitions at the National Academy of Design and the Pennsylvania Academy of the Fine Arts served the East. Museums sprang up around them, and it is symbolic of this whole situation that the Art Institute of Chicago stands today on the site of the building erected shortly after the Civil War for that city's annual Interstate Industrial display.

Harnett had sent some mug-and-pipe pictures to the Cincinnati Industrial Exposition in 1879, just before he left for Europe, and now he looked to it again, immediately on his return. Three of his pictures are listed in the catalogue of the Cincinnati show for 1886, but not *The Old Violin*. The following, from the Cincinnati *Commercial Gazette* of September 16, explains why:

The little collection of pictures secured by Commissioner Mehner a little too late to be catalogued, are now being placed in position and attracting great attention. One of these pictures especially, a study of still life, by W. H. Hartnett [sic], of New York City, is a remarkable bit of realism. It is called "The Violin." It is hung upon the north wall, but visitors need no guide-post; they will find it by following the crowd. It represents a rather shabby barn-door, hung by immense iron hinges, and against it hangs an old violin and bow and a sheet of time-stained music. Stuck in the

Still Life with Mug,
Pipe, and Antique Vase

edge of the frame is a foreign letter, in a dark blue envelope, and a little newspaper clipping is pasted upon the boards. So real is it, that one of Captain Wise's specials has been detailed to stand beside the picture and suppress any attempts to take down the fiddle and the bow.

While the iron hinges, the ring and staple and the rest are marvelous, the newspaper clipping is simply a miracle. The writer being one of those doubting Thomases who are by no means disposed to believe their own eyes, was permitted to allay his conscientious scruples by feeling of it, and is prepared to kiss the book, and s'help me, it is painted. Mr. Hartnett is of the Munich school, and he takes a wicked delight in defying the possibilities. His picture sold as soon as it was unpacked, and at his own price. It is hoped he will send in one of his U.S. National bank-notes, which Commissioner Mehner says put his violin quite out of tune.

Other reporters on the exposition beat handled this story in the same way, recording bets among the spectators that the clipping was real, as well as the slightly pathetic effort of an aged musician to take down the fiddle and play it. All these stories contain a statement that will often be repeated, not only with reference to Harnett but also with reference to other artists discussed in this book—the statement that special officers had to be assigned to keep the public from thumbing the paint off the canvas. But the professional critics responded in their usual manner. The critic for the *Enquirer* began by observing that it had become fashionable to rave about Harnett's *Old Violin;* he also described the crowds and the special policeman, but wound up:

Harnett, who is a New Yorker with a Munich finish to the artistic side of his nature, is now not more than thirty-five years of age, and thus far has confined his efforts to studies of this questionable character—questionable, because aside from the technical excellence manifest, there is nothing in them to attract. His may be one of those queerly constituted natures that run to fiddles and rusty hinges, just as Ruben's [*sic*] before him doted on babies. If it is not so, then he ought to give wider scope to abilities so genuine and play upon living, breathing subjects.

It will be noted that the *Commercial Gazette's* reporter said Harnett's picture "sold as soon as it was unpacked and at the artist's own price." The buyer, Frank Tuchfarber, had invented a process for lithography on glass with which he made brightly colored signs for Cincinnati stores. It is far from insignificant that Tuchfarber was the founder of the Cincinnati Grand Orchestral Company,

which later became the Cincinnati Symphony Orchestra, and "appreciated the instruments used by the artists, their luminosity of coloring and their resonance and mellow tone-quality. He experimented with and for years studied the problems of violin varnishes and claimed to have rediscovered the secret of the Cremona makers." [48]

Tuchfarber produced two versions of his chromo. One, much the rarer and better, is on glass. The other is on paper. Tuchfarber's copyright-line and the date, 1887, should be in the lower right corner, but this has often been cut away in order to make the chromo seem more like a painting. (The paper version was originally mounted on canvas and a stretcher for the same reason.) There are also some copies on which the name of the Donaldson Art Sign Company of Covington, Kentucky, a suburb of Cincinnati, has been substituted for that of Tuchfarber. Tuchfarber's advertisement, preserved in the Blemly scrapbook, shows by its illustration that the chromo was originally offered for sale in a relatively simple, narrow frame, carved in a floral motif and with a brass beading around its inside edge; this is still very common, but the chromo sometimes shows up today in an elaborate frame with carved hinges extending those of the picture itself, and with a carved padlock on the left-hand side. Hidden in the meaningless, simulated, Harnettian print of the newspaper clipping in the last line of the chromo one may usually read "Gus Ilg: Cin.," but this, for some unknown reason, has been effaced from some copies, leaving a clearly perceptible smudge or hiatus. Gus Ilg was listed for years in the Cincinnati City Directory as a lithographer; clearly he was the technician who did the actual work in Tuchfarber's shop and made the fatal mistake whereby his copyists can be caught.

Harnett knew music and always set it down correctly. To be sure, the key signature on the staff lines behind the shoulder of *The Old Violin* at the spectator's left, with their flats on C and F or C and E, indicate a highly problematical B flat major, but many a composer is almost equally hasty with signatures, and Harnett's notes are right. Ilg's notes are often wrong; furthermore, he did not under-

[48] Lewis Alexander Leonard, *Greater Cincinnati and Its People*, Cincinnati, 1927.

Still Life with Mug, Pipe, and Antique Vase

stand Harnett's "cantabile" written over the upbeat, and reproduced this as quasi-Russian-looking non-sense. Ilg's worst mistake, however, is on the first full bar of the second line, where he reproduces Harnett's first B flat as a C, leaves out the dot after the last B flat in the bar, omits the bar line that should follow the sixteenth-note A, the accent mark over the quarter-note A immediately following, and the dot after the G which comes after that (plate 62, *a* and *b*). He probably made other errors, but these are enough—all the painters who have made oil copies after the chromo have sedulously repeated Ilg's musical mistakes (often adding a few of their own for good measure), and this provides the surest possible proof that an oil copy of this picture is not a replica by Harnett, as they are frequently claimed to be. To be sure, you can always tell these copies half a mile away by the crudities of their style, but fond owners are never impressed with that argument, which is, of course, the first, foremost, and only important one, but you can always beat them down with a little icono-graphic demonstration such as this.

I have so far seen thirteen copies or paraphrases in oil after the Harnett chromo. At least three of these have been bought as Harnetts—the one by Harry H. Baker in the Butler Art Institute at Youngstown, Ohio, the one by Peto in the Metro-politan Museum in New York, and the one inscribed with the name of Julia Robb in the New York col-lection of Mrs. Robert Freund. The paraphrases out-number the copies, and some of the copies are not completely literal, since the names, addresses, stamps, and postmarks on their letters are different from those in the original. The postmark will usu-ally provide the date of the copy (in one as late as 1911) and the name on the letter is often demon-strably that of the painter, who honestly signs his work as Harnett did, but we cannot assume that the name on the envelope provides the signature in every painting.

The commonest variant is to change the music, and there are numerous other alterations as well. The most amusing adaptations I know are two quite crude ones (New York: Thomas Fine Howard), signed by an otherwise unknown Paul Powys, whose fiddles glare like Halloween pumpkins through their right-hand f-holes. A *Krakoviak* is behind the violin and a jack of spades is stuck under the top-most hinge. In one of the Powys paintings, in place of Harnett's letter, there is a card with a picture of a jackass inscribed "Wishing You Happy Days," while in the other there is a portrait of Charles Dickens. Peto's version is pleasant but is not one of that artist's major achievements. By far the best adaptation of *The Old Violin* is the masterly work of J. D. Chalfant in the Wilmington Art Center (plate 61). Here the perfectly painted violin and music are hung against a white, crackled wall, and there is a magnificently rendered pair of steel-rimmed spectacles hanging alongside. When this picture was shown at the Downtown Gallery in 1948, a scene like that of Cincinnati, 1886, was repeated, but now it was none other than Marcel Duchamp, master of collage, who insisted that the music (the first violin part of Rossini's overture to *Tancredi*) could not be painted and must be the real thing.

So the grand design is repeated in reverse. Sixty years ago it was the common herd that was im-pressed with *trompe l'oeil* and took it seriously; to-day it is the *avant-garde*. The *avant-garde* has caught up with and joined the crowd, but it took the Har-nett revival to give it the impetus.

In 1938 an amateur painter sent an apparent adaptation of the Harnett chromo, produced in all good faith, to the annual exhibition of the Asso-ciated Artists of Pittsburgh, and with it won a modest third prize. The jury of award, composed of three exceedingly well-known members of the art world of New York, had obviously never heard of Harnett (the revival did not begin until the following year), but the people of Pittsburgh had; copies of the chromo were trotted forth and published in the newspapers to emphasize the similarity. In other words, the art world is not the whole world, and to say that Harnett was unknown before 1939 is only to say that he was unknown to the better dealers, the critics, and the museum men. But there is a vast traffic in works of art which Fifty-Seventh Street ignores and disdains.

No picture can be as popular as *The Old Violin* without breeding its swarm of myths. Thus the woman in North Dakota who presented her copy of the chromo to the Fargo YWCA and thereby

led to the discovery of H. H. Baker (as told later)—wrote me afterward that the actual violin—so she had been informed—belonged to a musician who was ill and poor and had lost everything but his beloved Strad. "He finally sent word to his friend the artist—but when he arrived the musician had passed on. The artist painted the violin as he found it, hanging on the door. It was afterward sold for a large sum. Of course we have no way of knowing whether or not all this is true. I am only repeating the story told to us. We never found anyone who could read the clipping. That might reveal all we would like to know." Then there is the story, circulated in a pamphlet printed in Denver, to the effect that an adaptation of the Harnett chromo by one William A. Knapp is a memorial to the blighted love affair of a budding Sarasate who had gone to heal his broken heart in the solitude of the Great Smokies and had there met the painter and told him his sad life history. So far, there has been no ballad about *The Old Violin;* as the Pittsburgh incident demonstrates, it has never been the "picture turned to the wall."

The much-repeated legend that Harnett's *Old Violin*—which was painted in April, 1886, and was sold to Tuchfarber of Cincinnati in the following September—hung for years in the bar of the Hoffman House in New York, stems from a long, lively article about the picture, headed "Found—A Celebrated American Painting," written by a columnist named David Gibson and published in the *News-Journal* of Mansfield, Ohio, on November 3, 1934. (This was just three years before the *Art Digest* correspondent in Columbus, fifty miles away, reviewing an exhibition dredged up from "the limbo of forgotten men," was to ask, "Who today remembers William M. Harnett?") Gibson had seen *The Old Violin* in the Cincinnati hotel run by William M. Haas, through whose hands it passed on its way from Tuchfarber to its present owner. It stirred his recollections, including one of a singular masterpiece of *trompe l'oeil* by Harnett which he had seen in Munich. It was a portrait of a man; but portraiture like this was never taught at the Pennsylvania Academy of the Fine Arts nor yet by Professor Kaulbach. "You could walk up to it and pull the necktie up from the subject's vest," says Gibson—and he places *The Old Violin* in the bar of the Hoffman House.

Perhaps the Hoffman House had a copy of the Tuchfarber chromo, along with its famous Bouguereaus and whatnot, but when Gibson says the picture there was "so widely discussed, even up to the mid 90's, that the hotel management, in compliance with insistent demand, was forced to close the bar one morning each week, so far as drinks were concerned, in order to allow a view by the fair sex," even the most elementary Harnettist can tell you what he is really thinking of. He is not remembering *The Old Violin* and the Hoffman House at all; he is recalling *After the Hunt* at Theodore Stewart's equally famous Warren Street groggery, far downtown.

Theodore Stewart died on August 11, 1887, and since, according to the pamphlet about his two establishments published in 1903 by his successors in business, he himself acquired all the works of art with which both saloons were furbished, it is logical to assume that he purchased *After the Hunt* shortly after Harnett had brought it over from Paris. Three more Harnetts hung with the big Salon picture at Stewart's, 8 Warren Street—*The Sideboard, Music,* and a *Ten Dollar Bill*—and in his saloon at 4 and 6 John Street, Stewart had a Harnett *Five Dollar Bill*.

According to one of the more crotchety corners of the Blemly scrapbook, three of these four Harnetts were painted on commission from the saloonkeeper himself. Blemly preserved two published letters of his own to editors of New York newspapers complaining that in their descriptions of "the late Mr. Theodore Stewart's paintings" (apparently in an obituary notice) they had credited *After the Hunt* to a "Mr. Warren." "I beg to say," continues Blemly, "Mr. William M. Harnett of 28 East Fourteenth Street is the artist who painted *After the Hunt* while in Paris a few years ago. The *Music Scene, Fruit Scene* and *Ten Dollar Bill* were all painted in his Fourteenth Street studio to the order of Mr. Stewart, I myself being an eye-witness." Blemly kept many clippings about Theodore Stewart and his places of business, but did not preserve

Still Life with Mug, Pipe, and Antique Vase

the offending stories wherein the name of the artist is confused with the address of the saloon.[49]

The pamphlet of 1903 is illustrated with cuts of several gems in the Stewart collection, including *After the Hunt* and another painting which many old-timers still remember—George Wright's *Fresh Rolls for Breakfast,* a far from appetizing scene in the dining saloon of a North German Lloyd liner in midocean. According to this pamphlet, Stewart filled his Warren Street establishment

with choice paintings and valuable curios, and continued to collect specimens of the rare and beautiful, until upon the walls there is scarcely space for an additional gem. Of late years the fame of the Warren Street place has spread so rapidly that its patronage as an art gallery has almost equalled in point of numbers, its regular saloon business. The attendance also is not entirely restricted to the sterner sex, for so many applications have been received from ladies to view the pictures that the hours between nine and eleven o'clock are known as ladies' hours. Every morning many ladies take advantage of this opportunity to inspect the artistic and curious decorations of the place, and loud are their expressions of wonder and admiration.

A photograph of the interior of Stewart's Warren Street saloon, apparently taken about 1910, is preserved by the New York Historical Society. The décor is considerably less ornate, considerably more businesslike, than one would expect, but the walls are crowded with pictures. Resting on the glass case of the cigar counter in the foreground is something that looks much like a Harnett bill picture. A painting of a sideboard or "fruit scene" stands opposite, and on the left-hand wall in the middle distance is an enormous shrouded cabinet or shadow box, pro-

tected with a guardrail, like the one in which, according to descriptions of the 1880's, *After the Hunt* was displayed.

Apparently Warren Street was toned down a little after the turn of the century. Various newspaper accounts inform us that in Harnett's time it contained, in addition to oils, watercolors, and etchings, "broadswords and rapiers, musquetoons and horse pistols, inlaid and chain armor, probably worn by the victors of Cressy and Agincourt, a scimitar that might have been worn by a Saladin, a battle-axe that would tax the strength of a Coeur de Lion . . . ingenious automatons, costly and queer old clocks, pretty little statuettes, and a New York directory of 1830." The paintings included copies after Gérome, Meissonier, Rubens, Titian, Giorgione, Mantegna, Andrea del Sarto, Tintoretto, and Hogarth; but the glory of the house was *After the Hunt.*

Not long after this painting was added to the Stewart collection, a correspondent for the London *Commercial Gazette* wrote a long article for his paper about the splendid saloons he had seen in America. Stewart's, Warren Street, is his Exhibit A, and *After the Hunt* is the climax of Stewart's:

The possession of this masterpiece alone should stamp its home as the "Mecca" of art worshipers for many leagues around—a shrine more sacred than the tomb of Mahomet to the Moslems. Whatever Mr. Harnett has done before or since, he has immortalized his name in this one superb triumph.

On a barn door is painted a hunting trophy of weapons, birds, a rabbit, a hunting horn of brass, a drinking cup made from an ox horn, a man's hat, and above all a pendent bottle hanging by a string, which is fastened to one of the objects above. The door has immense rusty hinges of hammered iron, artistic in construction and of the fifteenth century in style. In the center, upon the left hand side, is the keyhole, with its plate of battered bronze. It is shaped like a halberdier and is greenish in parts with age, which gives it a quaint, queer aspect, so that it looks as if some one had dug up from the entrails of the earth an ancient Toltec bronze and punched into it a keyhole.

Men come and stand before this picture for fifteen minutes at a time, and the remarks passed upon it are curious indeed. As a rule, city men are enraptured with it, and go into ecstasies over the feathery plumage of the birds and the furry coat of the rabbit, over the wonderful representation of the butt-end of an old snap-lock gun, over the extraordinary imitation of the brass work of the horn. But gentle-

[49] The *Music Scene,* the *Fruit Scene* and the two bill pictures have disappeared. In an anonymous newspaper story in the Blemly scrapbook, there is a fairly detailed description of the *Music Scene* which makes it look exactly like the Harnett now in the collection of Paul Peralta Ramos (plate 78)—including "a vase in which are some common meadow daisies"—but the Ramos picture is dated 1888, after Theodore Stewart's death. Blemly has told us that the *Music Scene* was hung at Warren Street before Stewart died, and the unknown writer who describes the picture also indicates, in another part of his article, that Stewart was still alive. The Ramos picture must therefore be a replica of Stewart's *Music Scene,* but probably not an exact one. Still another version of this subject, with dried, white straw flowers in its vase, with a different rug from that of the Ramos painting, and without the velvet drape at the left, was given by Harnett to his sister and passed through the hands of Catherine Barry to the Whitakers (plate 77). This is the picture I saw on the wall of the Whitakers' living room when I first rang their doorbell. It is dated 1887.

Still Life with Mug, Pipe, and Antique Vase

men from the country, and especially from Chicago, who see it for the first time, declare that nobody can take them in, and that the objects are real objects, hung up with an intent to deceive people. A drummer from the city of sin was very angry over the obvious imposition, and wagered $5 that the thing was not a painting. "Feel it," said his friend. He felt it, and found that it was a flat panel. "Well," he said, "I admit that the rabbit and the birds are painted. I ought to have seen that from the first, because, although they are wonderfully lifelike, there is a sort of yielding of the muscles in a dead thing which you don't see in this. But what got me was the hanging up of that bottle, because I could see in a moment that the string was real." The crowd behind them burst into a roar of laughter, and the drummer made a dash for the bottle; but his hands met only the flat surface of a panel. He was dumfounded. "Gee whittakers!" at last broke from his lips; "that beats Chicago. It's all painted, frame and all, and that's what makes the illusion so perfect." There was another roar from the crowd that was taking in the scene with huge delight.

One of the artists of *Puck,* who is now, indeed, the leading artist of the *Judge,* went over the way to see the marvel, and found that he could very fairly resist the artist's endeavor to cheat him, save in one particular. The keyhole did look so natural that it was hard to believe that it was not there. He looked at it from different ways; first from a front near view, then from a side view, then from a distance, and could not make up his mind absolutely whether it was a dummy or a real object introduced to heighten the deception. At last he bethought himself of a plan. He placed his hand close to the nearest of the side lights, and flashed a shadow upon the poor keyhole, which at once he imagined to be a deception. Others who saw his maneuvers imitated him in high glee, and found that they, too, thought they had a point upon the picture, and thought they could prevent it from deceiving them. But this was an exceptional man, and it is safe to say, that out of the hundreds who visit the place daily, almost everyone believes, like the Chicago man, that the panel is a door upon which objects have been grouped to simulate a painting.

Hundreds of prominent citizens—artists, journalists, judges, lawyers, men about town and actors—visit this wonderful work of art daily, and wildly wager and express opinions as to its being an optical illusion or a real painting. One western man wickedly stuck his cane into the painting and slightly damaged it, fortunately not injuring it. He was unceremoniously shown out the door, with the request never to enter the place again.

Other newspaper accounts to the same general effect might be quoted, but not one of these writers, who uniformly go into ecstasies over the picture's realism, seems to have noticed that its long alpen-

stock is suspended on empty air.[50] There is nothing whatever to hold this object in place but the inexorable esthetic necessity to balance, reinforce, and extend the diagonal of the gun barrel, and to provide a strong counterpoint to the opposing movements of the hunting horn, the antlers, the powder horn, and the sword, to say nothing of the relationship of the alpenstock to the downward-thrusting movements of the dead game and the canteen anchoring the whole at the bottom. *After the Hunt* is Harnett's most complicated work of sheer design, but the professionals were as oblivious to this as the amateurs. George Inness fulminated:

Why in thunder can't we put in something that's out of tone? . . . A picture without passion has no meaning, and it would be far better had it never been painted. Imitation is worthless. Photography does it much better than you or I could. In a bar-room in New York is a painting of a barn door with hinges on it and a keyhole. It is painted so well that you would swear the hinges were real and you could put your finger in the keyhole; but it is not real! It is not what it represents. It is a lie. Clever, yes, but it gives you no sensation of truth because before you look at it you are told that it is a lie. The only charm in the picture is in deceiving you into the belief that it is a real barn door. Now, in art, true art, we are not seeking to deceive. We do not pretend that this is a real tree, a real river; but we use the tree or the river as a means to give you the feeling or impression that under certain conditions a certain effect is produced upon us.[51]

One of the contemporary writers on *After the Hunt*—his name is not given on the clipping in the Blemly scrapbook, nor do we know the name or

[50] An alpenstock in that position would have to be suspended from the presumed hook or nail which holds the hat, the horn, the gun, and other objects in the painting, and would have to be hung on a cord as long as itself or longer, attached to the stick near both ends. This would be nonsense, descriptively speaking, and so Harnett leaves it out. (One might attach a little thong to the upper end of an alpenstock, but one would never carry it in such an unwieldly sling.) Literal-minded as this observation may sound, it actually underlines the remarks made above about the purely esthetic function of that big diagonal: if Harnett had been concerned solely with effects of realism, he would never have chosen this motif at all, or else he would have dangled the stick straight down from a thong, thereby producing a picture which no one would have bothered to look at twice, either at Theodore Stewart's saloon or at the California Palace of the Legion of Honor, where it hangs today. Incidentally, the position of the sword in *After the Hunt* is also impossible to "explain," but see how perfectly it balances the two ends of the gun and the left antler to form a huge X on which are superimposed the circles of the hat and horn and the tilted rectangle of the gamebag.

[51] George Inness, Jr., *The Life, Art, and Letters of George Inness.* New York, 1917, p. 124.

Still Life with Mug, Pipe, and Antique Vase

date of the paper in which his article appeared—approached this marvelous phenomenon from an eminently scientific point of view. He was up on optics, the theory of color, and the latest on light; he quotes Helmholtz and other German physicists; he gives elaborate directions regarding the angles of incidence at which the illumination is to fall upon the painting in order to bring out its illusion and then dispel it. As if to refute (or perhaps to shake the hand of) Inness, he observes that "readers who have paid some attention to principles of art will know how slight an error in tone, shade or tint is sufficient to spoil the impression of reality in a picture," and he provides a paragraph which has a startlingly modern ring, despite the fact that its second sentence, torn from context by Snow, has often been requoted to demonstrate how unmodern our grandfathers were:

> The artist shows the highest skill in the representation of textures. The wood *is* wood, the iron is iron, the brass is brass, the leather is leather. The fur of the rabbit and the feathers of the birds tempt the hand to feel their delicate softness. The extreme care which reason convinces the beholder must have been constantly exercised in finishing all the exquisite details of such a painting is entirely concealed. We see not the artist nor his method of working. The things themselves only are seen.

This scientist has clearly penetrated to the psychological truth which explains why guards and rails were put around the paintings of Harnett to keep people from pulling off their "real" envelopes and newspaper clippings. And two weeks of lectures by the entire membership of the American Society for Esthetics could not more skillfully deflate the school of Chase and Currier than the single deft sentence of this unknown commentator written in praise of Harnett: "We see not the artist nor his method of working."

Stewart's two saloons, with their Harnetts and at least some of their other works of art, lasted until Prohibition. They were very widely imitated. The Denver Public Library preserves an undated clipping from the Denver *Republican* in which there is a reference to "still life studies of a game piece on a barn door" which "faintly suggest Stewart's John Street place." Warren Street, of course, is meant, but

the point is that this writer, addressing an audience in Denver, does not consider it necessary to tell them that Stewart's is in New York; he assumes it is as famous as Delmonico's, or as the Stork Club would be today. And so, thanks to the celebrity of Stewart's, it came about that the production of "still life studies of a game piece on a barn door" developed into a major industry among American painters in the saloon era of American art—in fact, it even outlasted the saloon era, since the latest such work in my collection of photographs is dated 1927—and for all we know to the contrary may be going on yet. Many excellent artists produced major works of this type (plates 67–74), especially Chalfant, Peto, Goodwin, and Platt; the tradition has sprouted iconographic and compositional side issues and subvarieties, and some artists, notably Goodwin, have turned out innumerable contributions to it. It has been suggested that Harnett was indebted to the photographer, Adolphe Braun, for important elements of iconography and composition in both versions of *After the Hunt,* and that some of his followers also may have been influenced by that Alsatian artist of the camera. But one suspects, at least, that all the barn-door paintings exploiting a soft hat at the top were inspired by Harnett, and it is interesting to see how the subtle eye of Peto takes over Harnett's floating diagonal alpenstock and transforms it into an equally untrammeled diagonal boathook.

When one compares the entire group of paintings with Braun's photographs, one sees more dramatically than ever that Harnett's painted textures are actually realer than reality, and always have been. Harnett completely beats the photographer at the game of representation because he has gone far beyond representation. It is also evident that the works of the best painters in this group have infinitely more power and verisimilitude than those of the photographer, partly because of the painters' ability to heighten relief, but mainly because the brushmen retain complete control over their design. Harnett and Peto (plate 73) are certainly the best composers here. I also have great respect for the Goodwin (plate 69), the Platt (plate 71), and the Chalfant (plate 67), but if one compares the cluttered work

Still Life with Mug, Pipe, and Antique Vase

of this last artist with the superbly organized Harnett, one sees at once what can be accomplished by a little air in the arrangement and a little subtlety in the movement of shapes, the ability of the two artists to render literal fact remaining equally remarkable.

Eight Warren Street is the only building in New York associated with the life and work of Harnett which remains standing. When I visited it in 1948, it was occupied by an office-supply house, but its heavily leaded transoms still testify to its former use. Its site helps to indicate why Stewart's was popular; the place is only an easy, consoling stagger from the old City Hall and its weighty problems of state. That may explain why Harnett was arrested for counterfeiting. He had some money pictures at Stewart's, and Stewart's was patronized by officers of the law.

The counterfeiting story is the van Gogh's ear of the Harnett saga. From 1886 to the day before yesterday, no one has written about Harnett without mentioning this episode; it is always good as an entering wedge in any newspaper office in the land, but no one has bothered to find out why this incident really happened. Harnett himself dwells on the occurrence in the *News* interview, Snow gives it long paragraphs in his biographical notices written for the Earle and Birch catalogues, and the Blemly scrapbook contains news stories, columnist's quips, and sarcastic editorials about it. But the most authoritative account is the one which Lyle J. Holverstott compiled for me from material in the National Archives.

An examination of the reports of A. L. Drummond, Secret Service Operative of the New York District, disclosed the following information that may be pertinent to your inquiry: Mr. Drummond in his report for November 23, 1886, at New York City states that in an interview with William M. Harnett, the latter confessed to having painted, in all, four United States Treasury notes, two (of five and ten dollar denominations) for Theodore Stewart, a saloon keeper at No. 8 Warren Street, New York, one for Detective Taggart at Philadelphia, and the fourth for Alex Campbell, an attorney in Philadelphia.

Mr. Drummond, in his report for December 3, 1886, acknowledged the receipt of a letter from the Chief of the Secret Service Division which referred to a copy of the opinion of the Solicitor of the Treasury regarding the painting of a facsimile of the face of a five dollar United States Treasury note on wood by W. M. Harnett for Theodore Stewart of No. 4 and 6 John Street, New York City. The opinion held that "the painting comes within the spirit of Section 5430, of the R. S. of the United States but does not advise prosecution in this particular case, as evidently no fraud was intended, but suggests that neither these people or others engage in such practices again." The Chief's letter directed Mr. Drummond to see Mr. Stewart and request him to retire the picture to his private gallery of art.

The last reference which was found on this case among Mr. Drummond's reports was in the report for December 29, 1886. At that time Assistant Blackwood reported to Mr. Drummond that Mr. Stewart had not retired any of his paintings to his private gallery of art.

There was excellent reason for Harnett's arrest. It was very well justified, but at the time only the arresting officers could have known this; certainly Harnett could not have understood why the law suddenly descended on him, but a glance at the history of American counterfeiting will instantly explain what was up. What Harnett did not know, what the journalistic quipsters and the sympathetic editorial writers did not know, was that ever since 1879 Drummond and his colleagues had been looking for a unique and extraordinary counterfeiter who did not print his bills but drew and painted them, with artists' materials, and with a professional artist's imitative skill. The men of the Secret Service, of course, had no idea who this person was, and so they gave him a nickname, taken from that of a celebrated English forger of a previous generation, which was destined to become part of American folklore. They called him Jim the Penman. When he was finally caught in 1896, he turned out to be a florid German named Emanuel Ninger who operated in Flagtown, New Jersey. According to Laurence Dwight Smith,[52] "So remarkable and artistic were his notes considered to be at the time, that there was public protest after his arrest, subsequent to his passing a hundred-dollar bill in New York. Collectors paid high rates for specimens of his work." (Smith adds in a footnote: "At that time there was no law, as there is now, requiring that counterfeits be turned over immediately to the Secret Service.")

"Collectors paid high rates for specimens of his work." One wonders if any Ningers are going the rounds today with forged Harnett signatures. I have

[52] *Counterfeiting, Crime Against the People.* New York, 1944, p. 88.

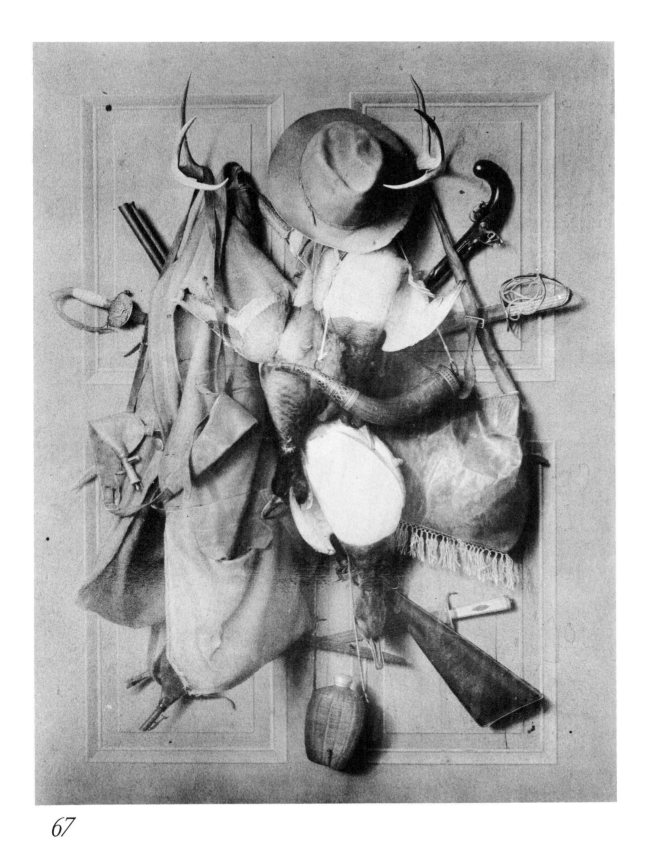

67

J. D. Chalfant
After the Hunt (photograph of lost painting) 1888

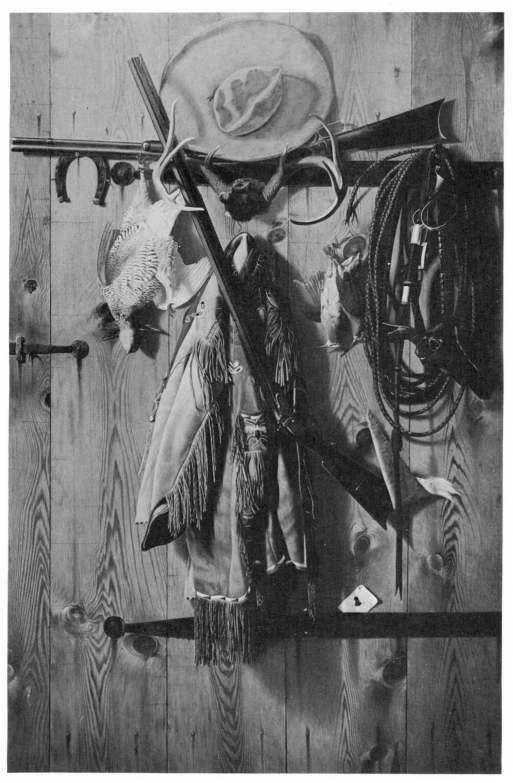

68

George Cope
Buffalo Bill's Traps (photograph of lost painting) 1894

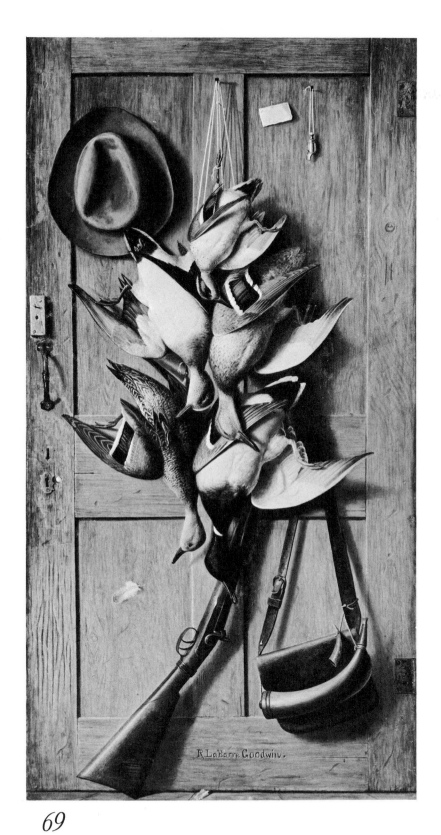

69

Richard LaBarre Goodwin
Theodore Roosevelt's Cabin Door 1905 (c. 72 x 48)
Claribel Goodwin, New York

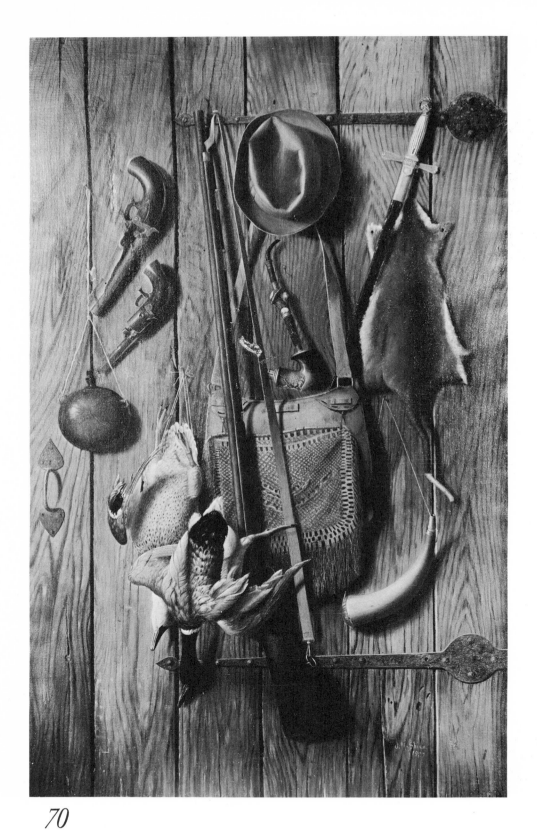

70

John Marion Shinn
The Old Barn Door 1927 (70 x 42)
Formerly collection Florentine Club, Shreveport, Louisiana

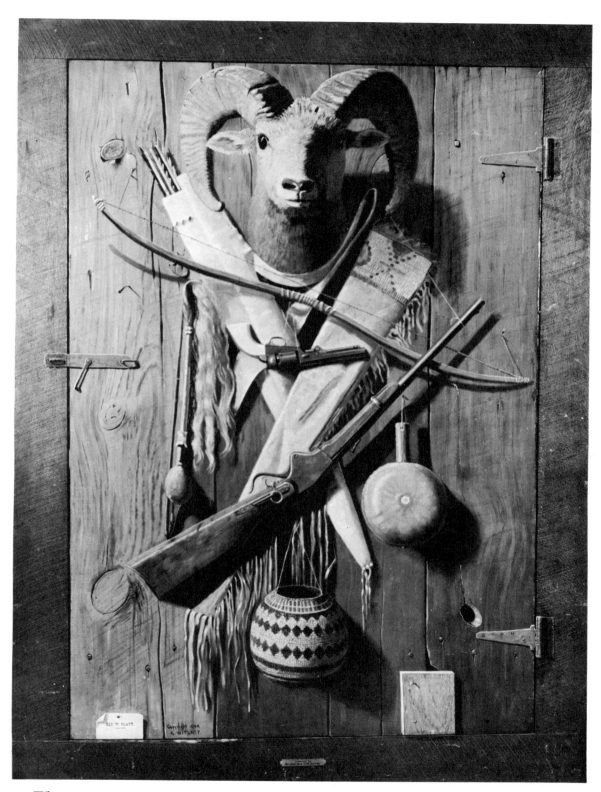

71

George W. Platt
Wild West 1894 (c. 70 x 50)
Eldon P. Harvey, El Paso, Texas

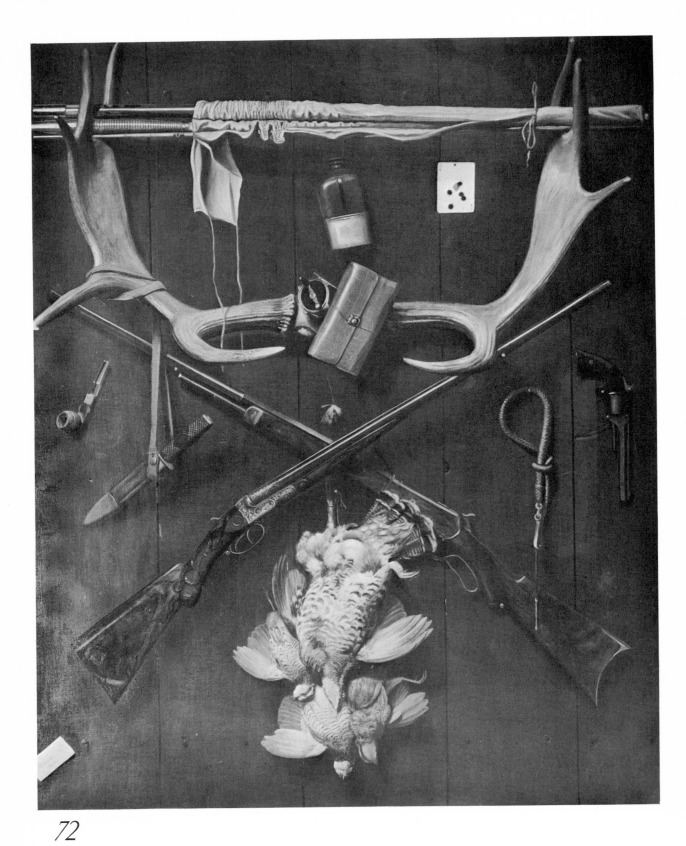

72

Alexander Pope
Sportsman's Still Life (53½ x 41½)
Mrs. A. Perley Chase, Medford, Massachusetts

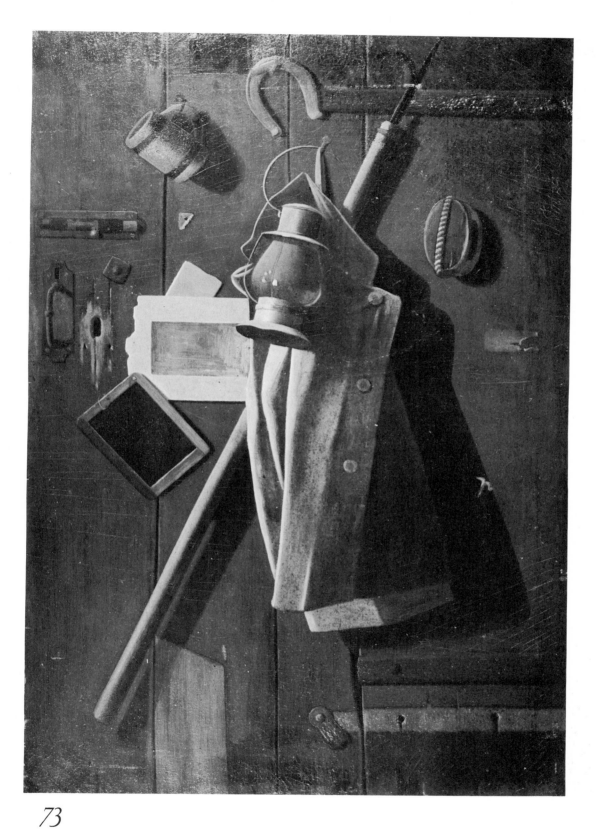

73

John Frederick Peto
The Fish House Door after 1890 (30 x 20⅛)
Private collection, New York

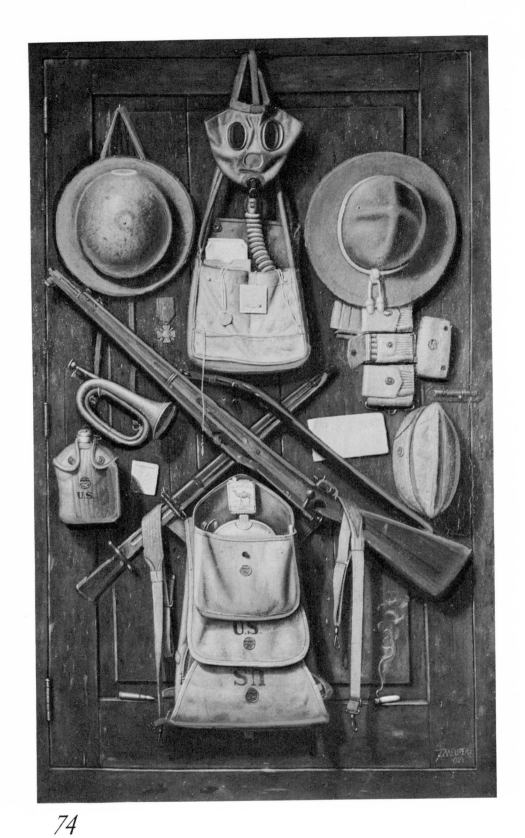

74

C. A. Meurer
Doughboy's Equipment 1921 (68 x 40)
Formerly collection C. A. Meurer, Terrace Park, Ohio

*Still Life with Mug,
Pipe, and Antique Vase*

seen many bill pictures with Harnett's name falsely inscribed, but none on paper and none painted on both sides. From the literary point of view, it is too late for works of Jim the Penman to turn up with Harnett's name in counterfeit script—that story, if it was to be written at all, should have been handled by O. Henry.[53]

XIII

THE YEAR 1886 marks a climax in Harnett's activities. After this time illness forced him to take long rests, and his production slowed down markedly. Snow says he had "inflammatory rheumatism," and Snow traces this condition to the privations he suffered during his Munich years. Yet Harnett could not have been aware of the fact that his health was seriously impaired, since, according to the family tradition preserved by Anne and Nellie Whitaker, he became engaged to be married shortly before he died.

Only two Harnetts of 1887 are known to me. Both are strikingly beautiful table-top pictures, smaller than life, employing very familiar motifs and relying upon Harnett's inevitable compositional formula for paintings of this kind. Both use the Dutch jar.

In one (plate 77, the Potamkin picture previously mentioned in a footnote) Harnett removes the jar's pewter lid, pretends it has no handle, gives it a flaring neck, and puts flowers into it. In the other (formerly in the collection of J. S. Newberry) he uses, for the first time, the one distinguished piece in his painted library of flute solos—Papageno's *Vogelfänger* aria from *The Magic Flute*.

One other Harnett of 1887 is known through a photograph. It was called *Ease*. It was painted to order for James T. Abbe, a paper manufacturer of Holyoke, Massachusetts, using Abbe's own books and bric-a-brac for models. The table is covered with an exceedingly ugly piece of embroidered velvet; the books, the palm leaf fan, and the lamp are commonplace, and the *repoussé* ewer and cup are hideous. Comparing the subject matter of this work with the two known Harnetts of 1887, one can see again the very dramatic contrast between the artist's own simple, natural taste and the flamboyant taste of his patrons. Abbe's *Ease* is described in laborious detail in the Springfield *Republican* of November 7, 1887, which also tells us that the picture "has been placed, handsomely framed in a dark and unobtrusive, though rich, carved frame, set in red plush and curtained with maroon plush, in a room opening from Mr. Abbe's office in the Holyoke Envelope Company's factory, and is shown by gaslight."

The gaslight did not shine upon it long, however. In fact, the pigment was not decently dry before Abbe sold it to Collis P. Huntington[54] and commissioned Haberle to paint a considerably more pretentious picture as a substitute. This was a fabulous project. It involved transporting a fireplace and the better part of an entire wall out of an old Massachusetts farmhouse and installing them in Haberle's studio in New Haven. The painting that resulted—*Grandma's Hearthstone* (plate 95), now in the Detroit Institute of Arts—is the largest known canvas in the entire American tradition of illusionistic still life (it is eight feet high and five and a half feet

[53] Harnett had, of course, painted more money pictures than the four he acknowledged before Drummond, but he doubtless did cease and desist from producing such things when legally admonished to do so. At the time of his arrest, he had a five-dollar bill in process for E. T. Snow, but he immediately stopped work on it, signed it in ink on the blank oblong where the bill would have been, and presented the canvas to Snow as a memento of the affair.

The suggestion of the Solicitor of the Treasury to the effect that *"neither these people or others"* engage in such practices again" is, of course, significant. On September 22, 1888, James Earle, the Philadelphia art dealer, informed Chalfant by letter that he was sure he could find a buyer for this artist's *Perfect Counterfeit*, but "as it is so good a copy of the note, we write to ask you whether we will be quite free from investigation or injunction by the United States Government. Some time since," continues Earle, "a similar work by Harnett gave rise to considerable trouble to its owner, Mr. Stewart of New York, and Mr. Harnett was put under bond to do so no more. In case your picture arrives here, will you undertake the risks and the cost of trial?"

How Chalfant answered, we do not know, but we do know that John Haberle painted money pictures in deliberate defiance and mockery of the law, such being Haberle's peppery temperament (plate 94). Practically all the other artists considered in this book also produced pictures of paper money, but Harnett seems to have preceded all his contemporaries in the use of this subject.

[54] Huntington may have had at least one other Harnett. It is impossible to tell, from the scattered mentions of Huntington in Harnett's obituary notices and elsewhere, whether or not the painting by our artist called *Confusion*, which the California railroad king is said to have owned, is the same as the *Ease* which he bought from Abbe. Any confusion that may exist on this head is, however, purely academic, for the Huntington Harnett or Harnetts seem to have been destroyed in the San Francisco fire of 1906.

Still Life with Mug, Pipe, and Antique Vase

wide) and its creation cost Haberle two years of effort. James T. Abbe was not a man to do things by halves.

Abbe gave Haberle the photograph of Harnett's *Ease* through which this work is known. I found it in Haberle's house, accompanied by the following statement, written in a flowing, unidentifiable longhand, which, although it adds nothing new, underlines the attitude of the period toward works of the kind discussed here.

> A photograph of a painting, at best, conveys but a poor idea of the painting itself. The variety and accuracy of coloring—the thoroughness of detail and the perfect semblance (when effected) in the reproduction are not within the power of the camera. The subject matter alone, is conveyed, without the art displayed, and an idea formed from the photograph must necessarily be one of conception, if more than the outlines are desired. To impress one, not having seen the painting *Ease*, of its wonderful accuracy in all its variety, a comparison of the photograph with what might be imagined a photograph of the original table and contents, as arranged for the artist, will, perhaps, in a measure illustrate the character of the work. An irresistible desire to touch many of the articles as evidence of their being but the result of the brush is almost universal and this fact is in itself the highest endorsement of the truthfulness of the canvas. Mr. Harnett possesses a peculiar ability and stands alone as a painter of still-life.

The one detail not apparent in Haberle's photograph of *Ease* is the only imaginable detail not discussed by the reporter for the Springfield *Republican*. The painting shows a lighted cigar resting on a newspaper and burning a hole in it; the name of this newspaper was overlooked by the *Republican's* reporter, perhaps deliberately, but in the catalogue of the sale of Harnett's models at Birch's is the following entry: "No. 302. *Cincinnati Enquirer*. This was painted in a picture ordered by Joseph P. Abbe [55] of Holyoke, Mass., for which he gave $5000 and is as represented. Burnt." Now, a Harnett representing, among other things, a copy of the Cincinnati *Enquirer* with a hole burned in it, turned up in 1948 in Catoosa, Oklahoma, near Tulsa (plate 76). It was the property of the late Mrs. Nina Mathews, who had many paintings, most of them acquired through Tulsa dealers. (Mrs. Mathews had heard me talking about Harnett on the radio and wrote to tell me what she owned.) The picture is altogether different from *Ease*. It is a typical table-top still life, with the familiar Dutch jar, the pipe of the Grossman and Oberlin paintings, the rectangular tobacco box Harnett was to use again, and the hard, round biscuits which he had been neglecting for some years. It is dated 1888. Harnett, then, may have painted more than one picture for the Massachusetts paper maker, and the Catoosa still life may have been one of these.

The Catoosa picture exhibits one curious and unprecedented feature—Harnett's only representation of a newspaper in which one can read headlines and subheads. The date of the newspaper is not given on the painting, but the files show that what confronts us here is the *Enquirer* for May 8, 1888, although it has been completely switched about. The *Enquirer* then ran nine columns to the page; Harnett's page, though folded, implies eight columns. The large heading, "Gath," which appears in the extreme left-hand column of Harnett's painted newspaper, appears in the extreme right-hand column of the original. All the rest of Harnett's legible headlines were actually printed in the *Enquirer* of May 8, but in no case where Harnett shows them to be. ("In painting from still life I do not closely imitate nature. Many points I leave out and many I add. Some models are only suggestions.")

In addition to the table-top still life found in Catoosa (and now in the collection of Karl Matheus of Monterrey, Mexico), the Harnetts of 1888 include four others of this type. All five paintings display the Dutch jar. In one (New York: Paul Peralta Ramos, plate 78) the jar has again been changed to a vase, now filled with daisies; this work is richer than the others in the connotations of its subject matter, thanks to its figured Turkish rug, its medieval helmet, its missal page, and its corner of an old engraving. The table-top pictures of 1888 owned by the Metropolitan and the National Gallery are, by contrast, quite austere. Except for the vellum book, they contain no expensive antiques, and both use the drab, unfigured, gray-green table covering, now frayed and patched. The National Gallery picture also brings back the Arnold ink bottle, recalling the early days of Harnett's career.

Much more dramatic in its recall, however, is the

[55] There was no Joseph P. Abbe. James T. Abbe is obviously meant.

Still Life with Mug, Pipe, and Antique Vase

series of three small mug-and-pipe pictures which Harnett produced in this year. We have seen nothing like them since Philadelphia, 1879. They represent nothing but the mug (in one actually a stoneware pitcher and in another the Dutch jar), a pipe, a folded newspaper, some hard biscuits, and a scattering of crumbs and burnt matches, all set on a bare table top posed against empty space.

Only one of these three pictures is known to exist (New York: formerly in the collection of William McKim) but all three are accounted for in a photograph preserved by Catherine Barry. Harnett had them snapped on a single negative, then made notations on the back of the print to show that the McKim picture and the one with the stoneware pitcher were "$ John Hedges Phila.," and the one with the Dutch jar was "$ Earle and Sons, Phila." Obviously, Philadelphia taste, once set, remains in its grooves. It is further evidence of that pedantically methodical quality in Harnett that in all three of these mug-and-pipe still lifes of 1888 the main vertical (stein, pitcher, or jar) is at the left-hand side; in those of 1877–1880, it is almost invariably on the right.

An extremely important Harnett of 1888 is *Music and Good Luck* (New York: Metropolitan, plate 79), a somewhat complicated variant of *The Old Violin*. Now the fiddle hangs on a light, greenish-gray door, partly open. (This is the only painting known to me in which Harnett's door is light in color and tone; elsewhere it is always dark green.) This work indulges in much incidental sport with an open padlock adorned with an "all-seeing eye," a brass wall holder for matches with a mysterious monogram which can be read either as "D.M." or "M.D.," the usual fresh versus rusty nails and rivets, a piccolo hanging by a string, a slotted hasp dangling from an ordinary staple which curves to the left, and a horseshoe in bad-luck position rakishly cocked in the upper right corner. A gay Irish song, its reel-like introduction completely, meticulously, and quite playably copied, sets the emotional tone for this entire bright, irresponsible picture. *Music and Good Luck* may not be one of Harnett's greatest works from the point of view of design, but it is one of his most completely flawless achievements in realistic rendering, in its suggestion

of pleasant, old, common things with a slightly aristocratic touch to them, and, above all, in its placement of its objects within its shallow space.

As pointed out earlier, you always know where a thing *is* when Harnett paints it. There can be no doubt that the bow of *Music and Good Luck* is well in front of the door and the hinges, with air between it and them, that the lower end of the dangling piccolo is touching the door while its upper end is swinging forward, and so on. We take these things too much for granted in Harnett; one has to study the bungling, ambiguous spatial placement of his followers, even the best of them, fully to appreciate Harnett's mastery in this regard.

Within the very limited depth of a door picture like this one, "relief" or spatial placement cannot be obtained by perspective; it can be obtained only by the adroit handling of the shadows cast by the flat or shallow objects. Cover the shadow cast by the piccolo, the bow, or the shuttle, and see how these objects immediately glue themselves to the door.

No artist in history has studied shadows more shrewdly than Harnett—their lightness or density as the objects which throw them are nearer to or farther from the shadowed surface, their distortions of shape (look at the shadow of the fingerboard and scroll of the violin in *Music and Good Luck*), their closeness to a near object and their distance from a far object, their soft, dissolving edges—and he has never made so much of shadows as he does in this remarkable painting. He exploits them, of course, mostly in his door pictures, and it is worth adding here that it is the cast shadow of the alpenstock in the second *After the Hunt* that tells you it is floating free in space, but the door of *After the Hunt* is dark and so is not as good a shadow screen as the one in *Music and Good Luck,* which is certainly Harnett's most dramatic and masterly shadow picture.

In 1888, and only in this year so far as I can determine, Harnett employs a shorthand sign which apparently means he was trying to keep a record of his works. The photographs of the three little mug-and-pipe pictures bear notations in Arabic numerals —a 5, a 6, and a 7, each with a line drawn under it and the figure 88 beneath. The numeral above the line is always much bigger than the 88 below. The same sort of thing appears on the backs of some of

*Still Life with Mug,
Pipe, and Antique Vase*

the paintings themselves. The McKim picture is 7/88, as it is in the photograph, *Music and Good Luck* is 10/88, and Harnett had an old photographic print of the National Gallery picture which shows it was number 2. But he apparently tired of recording the sequence of his pictures in this fashion; at all events, there is nothing to show that he used this device in any other year.

Harnett's prices at the National Academy of Design reached their peak with the special autumn exhibition of 1888, in which he asked a thousand dollars for a painting called *For Sunday's Dinner,* another study of a plucked chicken hanging against a door, which is inscribed on its back "14/88." (Chicago: Art Institute.) He also showed a picture called *Recreation,* priced at $250. The *Times* critic said, "As to still life, there are illusive pieces by Harnett in the corridor and West Room, but lovers of a more poetic touch may prefer some lettuce overflowing a bowl of pale yellow pottery which hangs in the East Room and bears the name A. E. Wilmot." The *Herald* critic, however, broke down and confessed that "Harnett has never painted a better piece of still life than his plucked fowl, *For Sunday's Dinner.*"

During 1888 Harnett must have given much thought to a commission which had been offered him toward the end of the previous year by the famous Minneapolis collector, T. B. Walker. Apparently Harnett never acted on Walker's proposals —perhaps his health would not permit him to do so—but he carefully preserved Walker's letter of September 16, 1887, and it came to me as part of the Catherine Barry collection. It is the only letter to Harnett now known to exist, and it reads as follows:

Your letter of September 3rd has come to hand, I have been waiting some days to examine one of your pictures that was sent here for sale.

As regards the flower piece, you speak of, I do not remember it distinctly. The large game piece I of course remember very well, and it is something more of that kind that I desire, rather than a flower piece.

Could I not get you to undertake for me a picture about 28" x 44". My son who was with me when I visited you, died this summer. He frequently talked about you and your paintings and desired very much to have me obtain a good one of them. In fact he admired your work more than that

of any painter we met with in our travels and more than anything I have in my collection.

He owned a beautiful Winchester Rifle, that he had made expressly for his own use. It is rather a short and finely made gun about 41" in length. He was also a fine mechanic and made me a very nice tomahawk hunting hatchet.

I would like very much to have a picture containing these two pieces with a belt and bullet pouch of leather ducking that he carried his cartridges in and two or three other articles to make up a picture of about the size I mentioned. Perhaps the picture would need to be a little larger to get in this amount of work.

To have these hung up on a door or panelling.

I wish you would tell me what sum you would charge me for a picture of this sort. About when you would be likely to get it done. You to guarantee only that the work is as carefully and finely done as the Ohio picture that I referred to.

I know you have plenty of work on hand, but would like you to undertake this one for me if you will.

When you get the benefit of the Hot Springs, I think you will feel improved. I sincerely hope that you will have a great many years of better health, not only for your own sake, but for that of American art, as I regard your work as being the most careful and striking of any painter in this country or in Europe that I am acquainted with.

I hope you will undertake to paint me a picture and not lay my case aside for that of any other person.

Accept my thanks for your offer to send flower piece as I should be willing to pay the expressage here and back in order to see it, but as this is not exactly the kind of piece I am looking for, I fear it might influence you in painting for me this picture that I desire to get from you.

The Minneapolis City Library Board, of which I am the President, are constructing a Library Building and Art Gallery and when it is completed, I desire very much to have one of your large size paintings properly framed and lighted in this building, and if you would be inclined to take an order for a second picture to be painted within the next year, I would be glad to make arrangements with you for it, but not to interfere with this one I am now writing you about.

Please let me hear from you and greatly oblige.

XIV

By 1889 Harnett's reputation was at its height. He had painted the greatest saloon piece of his time, perhaps of all time, and it had done him much good. He could ask a thousand dollars at a National Academy annual with justifiable expectation of getting it. There are reports (to be sure, unauthenti-

Still Life with Mug, Pipe, and Antique Vase

cated and probably very much exaggerated) of his receiving five and ten times that sum from the Abbes and the Huntingtons, and of his refusing fifteen thousand for a replica of *After the Hunt.* T. B. Walker had beaten several paths to his door, Thomas B. Clarke had bought, and in February, 1889, he was represented in the elaborate members' annual at the New York Athletic Club with an unidentifiable work called *Mighty Monarchs,* property of a broker named Edwin C. Ray. And now a product of his brush was to be added to "the evidence of my success in life" assembled by one of the most notable collectors of his own home town.

Several references have been made to the catalogue of the William B. Bement collection, published by its owner for the benefit of his friends and poor relations in the year 1884. Bement manufactured machine tools and other products of iron and steel. He was a director of the Pennsylvania Academy of the Fine Arts from 1874 to 1897, shortly before he died. He was a man of great wealth and he believed in spending his money. Consequently his catalogue, lavishly illustrated with photographs of his paintings, his bric-a-brac, and the interiors and exteriors of his several residences, is a major monument to the "conspicuous consumption" of his era, and it would be well worth reprinting in full as a contribution to the history of American taste. A description of it is distinctly in order here, for Bement was a conservative collector of the kind to whom Harnett's precisionism appealed. One can see clearly in studying Harnett's work after 1880 that there was perennial if unformulated warfare between Harnett's taste and the taste of these mansion-dwellers; and Harnett's pictures swing now in the one direction and now in the other.

The catalogue opens with a dedication by Bement himself:

To my family, relatives and friends, I dedicate this book, illustrative of my tastes and hobbies, as an indication of remembrance and a token of affectionate regard.

Many of my relatives and friends live at a great distance from Philadelphia, and have never seen my home or its contents. For this reason I have prepared this descriptive and illustrative catalogue of my works of art, with additional pages devoted to my summer and winter homes and my workshop, that they may see the evidences of my success in life, the direction of my tastes, and the sources of enjoyment provided for myself and family in our declining years.

The works of art in my possession were not purchased with a view to selfishly enjoying them; for, believing that collectors of good pictures serve as educators in art and tend to foster a refined and healthful taste, I have freely opened my gallery to the public. My friends need no invitation, for they know that a cordial welcome always awaits them in our homes. . . .

There follows a preface by the actual compiler of the catalogue, Charles M. Skinner of Brooklyn, in which that authority observes, as mentioned earlier, that "the best pictures painted in Europe now find their way to this country, for the merchant princes of this wealthy land can outbid royalty itself for the possession of purchasable treasures." Skinner continues:

This influx of foreign pictures has had the best effect upon American artists, for it has stimulated them to rivalry, with results that have created astonishment in those who have watched this country's aesthetic progress through the last decade. It is safe to say that in that period the number of artists in this country has trebled, and a higher standard of excellence has been realized than was ever before attained, while the annual exhibitions in our large cities compare favorably, except in point of size, with those of Paris, Munich and London. The American pictures in the Bement gallery (about one fifth of the total number) bear out the truth of this statement.

The contemporary emphasis of Skinner's remarks is well worth underlining. Bement did not have a single old master in his picture gallery (although he seems to have had one elsewhere in his house), and most of his bric-a-brac was also of his own time.

The Bement catalogue continues, after the dedication and preface, with some two hundred pages of photographs, each preceded by a page of descriptive prose. First we are privileged to see the house in general, although, according to Skinner, photography could not do justice to "the rooms in Mr. Bement's mansion, their size, their height, their elegance of decoration, their luxury of furnishing, their amplitude of appointment, their pictures and cabinets and bric-a-brac." The parlor was noteworthy for the "old-gold drapery" at its windows and for its "point-lace curtains, rich portière and luxurious carpet"; these "combine with the paintings, statu-

ettes, vases and unique furniture to constitute a *tout ensemble* in which are manifest all the tokens of an elevated taste." Skinner likewise speaks with great enthusiasm of the drawing room, and especially of its "foreground columns . . . of black walnut, with mahogany trimmings and magnolia-wood panels," while "the view beyond, through the library and into the picture gallery, is almost [*sic!*] impressive in its extent." The "literary furnishings" of that library included "richly-bound editions of the English and American classics, and art works from all the civilized countries of the globe—a brave display of vellum, morocco, tree-calf, and crushed levant."

Many objects in the dining room are described, but its most remarkable object, unfortunately, is not, nor was it listed among Bement's effects on the occasion of the sale held after his death. The photographs show on one wall of this room a strikingly Colyeresque still life of a globe, a large shell, papers, books, a glass of wine, and other things in a niche, while in the upper right-hand corner of the painting, tacked to the surface of the wall in which the niche was cut, hung a ragged paper containing a notice of some kind. This work bears far more than a casual resemblance to the celebrated American still life, *Vanity of an Artist's Dream,* painted about 1830 by Charles Bird King, who had spent some time in Philadelphia, but it is not that picture.[56]

Bement's catalogue goes on with pages devoted to his music-room, his bed ("carved exquisitely, polished like a mirror, adorned with statuettes, and fitted with a canopy of upholstery and heavy hangings"), and his country retreat at Lake George; then we come to the bric-a-brac. Twelve plates are filled with candelabra, vases, "statuary," and similar things, but these did not by any means exhaust the subject. "The quantity of bric-a-brac in Mr. Bement's residence is so great that it was necessary to make selections from it for pictorial representation, it being impossible to photograph the whole without unduly expanding this volume." There are porcelain objects of every conceivable description, size, and shape; objects of horn and agate, onyx and gold,

lacquer and crystal; bronzes in every style, Greek, Roman, Chinese, and Egyptian; ivories and cameos by the case; and, it goes without saying, one of those veiled marble heads without which no collection like this could have been complete.

Bement's picture gallery contained about a hundred and twenty paintings, all of which are reproduced in the catalogue. Its most celebrated work was Pierre Cot's *The Coming Storm,* that famous jigsaw-puzzle picture, now in the Metropolitan, of a boy and girl running arm-in-arm before the wind, with a veil billowing out behind them. Its most surprising work was the *Vase of Mixed Flowers* by Martin J. Heade now in the Karolik Collection at the Boston Museum (Born, plate 71). The great majority of Bement's pictures were costume genre scenes in the manner of Meissonier, but he also had a considerable number of landscapes and figure-studies. All were very competently done, but only a few of the artists involved—Alfred Stevens, Bouguereau, Bierstadt, Thomas Hill, J. G. Brown—retain even a shred of reputation today. Of all the forgotten artists represented, only one—Milne Ramsey—seems worth reviving, and even much of his work is best left undisturbed. But as the Harnett revival amply demonstrates, taste changes strangely, and there may come a time when the world will again treasure the paintings of Lucius Rossi, Vicente Palmaroli, Ricardo Madrazo, Paul Viry, I. Ittenbach, F. Kraus, Albert Lambron, H. Sinkel, Salvator Aly, and all the others whose efforts gave Bement such marked delight.

As one would naturally expect, *The Old Cupboard Door* (plate 81), the painting Harnett produced for Bement five years after the catalogue was printed, is one of his largest. It is five feet, one and a half inches high and three feet, five inches wide; so far as size is concerned, it is second only to *After the Hunt* (Paris version) among Harnett's known works. It was bought at the sale of the Bement collection held at the American Art Galleries of New York on February 27 and 28, 1899, by the firm of Fischel, Adler and Schwartz, which must have resold it at once to H. H. Andrew of Sheffield, England, for on August 10 of that year Andrew deposited it in the Mappin Art Gallery of Sheffield,

[56] The King is reproduced by Born, and by Virgil Barker in his *American Painting,* New York, 1950, p. 305.

Still Life with Mug, Pipe, and Antique Vase

now consolidated with the Graves Art Gallery of that city, and there it remains today.[57]

Although Bement owned more bric-a-brac than any other twenty men in Philadelphia, Harnett celebrates none of it in *The Old Cupboard Door*. Practically every object in the picture—the violin, the key, the tambourine, the statuette, the large pearl shell, the old copy of *Don Quixote,* the small vase, the silver candlestick, and the candle snuffer—is accounted for in the Birch catalogue of Harnett's studio props, always with the notation that it was used in William Bement's *Old Cupboard Door*. (It is from this that we are able to identify the picture and give it its proper title.) Only the door itself, its iron hinges and other fittings, the music, the newspaper clipping, and four of the books are unidentified in the handbook of the Birch sale. The

visible music is *The Last Rose of Summer,* followed by an arrangement of the duet from Bellini's *Norma* different from that depicted thirteen years earlier in *Mortality and Immortality*.

The Old Cupboard Door is one of three paintings by Harnett of which we can, with certainty, say we possess the original sketch (plate 80). The other two are *The Old Violin* and *Mortality and Immortality*. The sketch for *The Old Violin* differs from the final version in only one respect: Harnett had originally planned to carry the hinges of the door in a straight line from right to left instead of bending them up and down to frame the fiddle. The sketch for *Mortality and Immortality* shows merely the skull and the violin on the top of the table; the books, the music, the rose, the candlestick, and the elaborated composition in which these objects are included, all came later. But the most interesting contrast between sketch and completed painting is to be found with *The Old Cupboard Door*.

The sketch entitled *The Old Cupboard* shows as its background a door with two long hinges extending from right to left. This door is surrounded by a flat, square-cut frame on both sides and at the top, while a ledge or narrow shelf juts out below its bottom edge. Just to the left of the center of the door is a violin hanging on a string, and behind this are two sheets of music labeled "blue." On the doorframe to the left of the violin is a padlock, and above this is a key hanging from a nail. The lock and key are balanced on the opposite side of the picture with a small book, labeled "almanac," hanging by a string. At the extreme upper left of the drawing, outside the doorframe, is a banjo, so labeled. On the ledge at the bottom are a palm leaf fan, a flute leaning against the doorframe at the right, and a meerschaum pipe.

Below all this is a variant sketch for the lower part of the picture. The flat doorframe has become a fluted moulding. The banjo is now in the dead center of the door and its drum covers a stamped envelope which shows through. The almanac hangs on the left moulding instead of to the right, there is a narrow hinge with four rivets, and the only object on the ledge is a cornet. The ledge is no longer

[57] Three separate sets of measurements have been given for this canvas at different times. According to the Bement sale catalogue, it was 62 inches high and 41½ inches wide, but when deposited at the Mappin Gallery, its measurements were recorded as 63 by 42. Today's dimensions are 61½ by 41. These discrepancies are not important, and they are partly explained by the fact that the picture, having been blown from its canvas by a bomb hit during World War II, has recently been restretched. Often, however, there are much worse discrepancies between the measurements of a picture recorded at one place and time and those recorded at another. In the case of an artist like Harnett, this can be exceedingly troublesome, because of possible replicas, variants, copies, and forgeries, to say nothing of the additional difficulties caused by the fact that Harnett's titles have a way of slipping from one canvas to another.

In the Bement sale catalogue, *The Old Cupboard Door* is given the fantastic title, *On the Window Shutter*, but the description and dimensions provided for it make it clear that this is the work under discussion; its real title can be found in the Birch and Earle catalogues and on Harnett's original pencil sketch (plate 80), which is in my possession. (Harnett calls it simply *The Old Cupboard*.)

Just to make matters more complicated, the title, *The Old Cupboard Door,* was applied to the Harnett now in the Boston Museum until I demonstrated, by means of documentary evidence discussed in the main body of our text, that this name could be applied only to the picture in Sheffield; the title of the Boston picture (plate 82), as is shown by the Earle and Birch catalogues, is either *My Models* or *Old Models*.

This confusion in the matter of the title of the Boston picture goes far back. In the catalogue prepared for the sale of the collection of one A. Ludwig, held at the Fifth Avenue Galleries in New York on February 1 and 2, 1898—a year before the Bement sale—one finds listed "W. M. Harnett: *The Old Cupboard Door*, 53 x 28." The dimensions given for the Boston picture are 54½ by 28½; I therefore suggest that Ludwig actually had *Old Models*, but it is difficult to explain how or why the switch in titles occurred.

Ludwig, by the way, owned two other Harnetts and Bement owned one. Ludwig's were *Ye Knights of Old*, which is discussed above on the basis of its reproduction in the Earle catalogue, and *The Professor's Old Friends*, a late work to which we shall shortly come. Bement's second Harnett was an unknown picture called *In Bohemia*. It measured 25½ by 22½ and was signed and dated 1888.

Still Life with Mug, Pipe, and Antique Vase

at the very bottom of the sketch; there is a space between it and the picture frame labeled "plaster," and there are notes for the picture frame itself: it was to be made of walnut painted with gilt.

By the time Harnett had finished the painting, its proportions had markedly changed. It is much wider in relationship to its height than the drawing, in order to accommodate its considerably expanded cast of still life characters. The fluted moulding remains, but below the ledge is an expanse of vertically grooved paneling instead of plaster. The hinges are now very fancy affairs and so is the lock, and they have changed places; the hinges are at the left and the lock at the right; the key hangs at the upper right corner of the door. The violin has been shifted upward and toward the left, and there is much more music behind it than in the sketch. The semitransparent drum of the banjo covering a stamped envelope has become a semitransparent tambourine covering another sheet of music, a corner of which remains visible through the tambourine skin. The almanac has become a newspaper clipping pasted to the door, and the diagonal line of the flute leaning from the ledge toward the right has become the bow of the violin leaning in the same direction but resting on the left side of the tambourine. The boards of the door are inset on the bias to echo the line of the bow, and there is a deep gash in the boards just above the lock to reëmphasize this diagonal. On the ledge is a completely new series of objects: five books (including an old Spanish copy of *Don Quixote*), a bronze statuette of Bacchus, a snail shell, a vase containing a rose, a candlestick with a half-burnt candle, and a candle snuffer.

It is regrettable that Harnett did not stick to his much simpler original conception for this work, but Bement, like everyone else in his time, doubtless valued such paintings only as prodigies of representation (his sale catalogue stresses what it elegantly calls the picture's "*vraisemblance*") and Harnett obligingly gave him what he wanted. As a result, the composition is confused and uninteresting; too many objects are dragged in, and the fascinating design of which Harnett was capable is not in evidence. But the picture does display some remarkable feats of realistic rendering, notably the music seen through the translucent skin of the tambourine. The

newspaper clipping is similar to the one in the *Card Rack* of 1879: although it is, as always, totally illegible, it is none the less clearly composed of two stanzas of verse, each of eight lines, and the even-numbered lines are all indented.

For many years E. T. Snow and his daughter preserved an enormous crusted palette in a shadow box. (It now belongs to the New York art dealer, Victor Spark.) Whittled into it are Harnett's signature and the date, 1889. On the back of the shadow box is the following typewritten statement, signed by Snow and countersigned by Harnett:

This palette was used by William M. Harnett in painting all his pictures from the time he went to Munich until he finished the large *The Old Cupboard* which was purchased by William B. Bement, including his famous Salon picture, *After the Hunt*. The writer called on him in his studio in New York in 1889 when he was putting the finishing touches to Bement's picture, and he handed him the palette after cutting his name and the date on it and with the fresh paint still clinging to it, and remarked that as soon as he delivered the painting he was going to Carlsbad to try and regain his health and would not paint another picture for a year.

Harnett's illness at this period is well documented. Among the documents are the only letters from his hand which are known to exist today. Both are in the collection of the Downtown Gallery.

He was admitted to the St. Francis Hospital of New York (now the St. Francis Home) on December 11, 1888. While still a patient there, on January 24, 1889, he wrote as follows to one W. J. Hughes:

Dear Friend,

The very day I received your letter I was taken with my old complaint and have been in the Hospital since. I was in Phila for the holidays and saw the chicken you refer to in Wanamaker's window. It was as you say, a very bad light. I sold it here in the Fall exhibition of the Academy. A Phila dealer bought it, which accounts for its appearance there.

Tony Ryan has been here twice. He sends his regards. I am getting along very well and expect to be out soon. Thanks for the suggestion about exhibiting in Washington. I have nothing at present but will consider it when I have.[58]

Yours Truly
Wm M. Harnett

[58] The "chicken" mentioned in this letter is, in all probability, the painting entitled *For Sunday's Dinner*, now in the collection of the Art Institute of Chicago, which Harnett had shown at the National Academy of Design in the fall of 1888 and sold to the Philadelphia dealer, John Hedges. Tony Ryan and W. J. Hughes cannot be positively identified, but a man named A. A. Ryan was one of the pall-

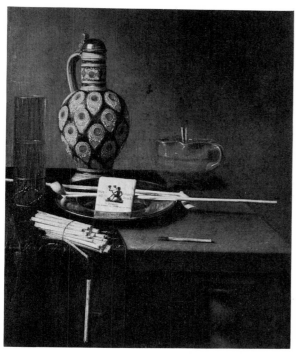

75

Hubert van Ravesteyn
Still Life 1664 (16½ x 13½)
Ryksmuseum, Amsterdam, the Netherlands

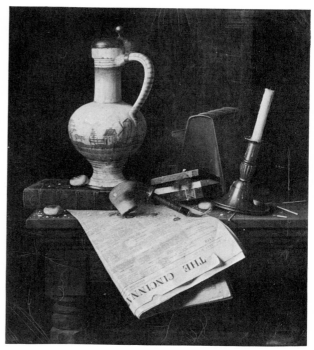

76

W. M. Harnett
Cincinnati Enquirer 1888 (29½ x 25)
Admiral Carl R. Matheus,
Monterrey, Mexico

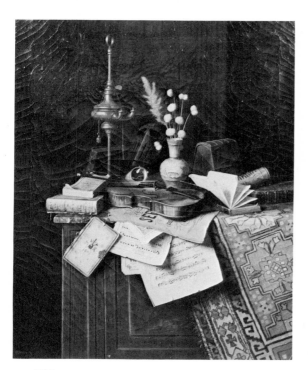

77

W. M. Harnett
Still Life 1887 (24 x 20)
Mr. and Mrs. Meyer Potamkin, Philadelphia

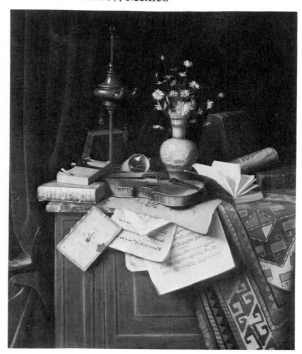

78

W. M. Harnett
Still Life 1888 (48½ x 46)
Paul Peralta-Ramos, New York

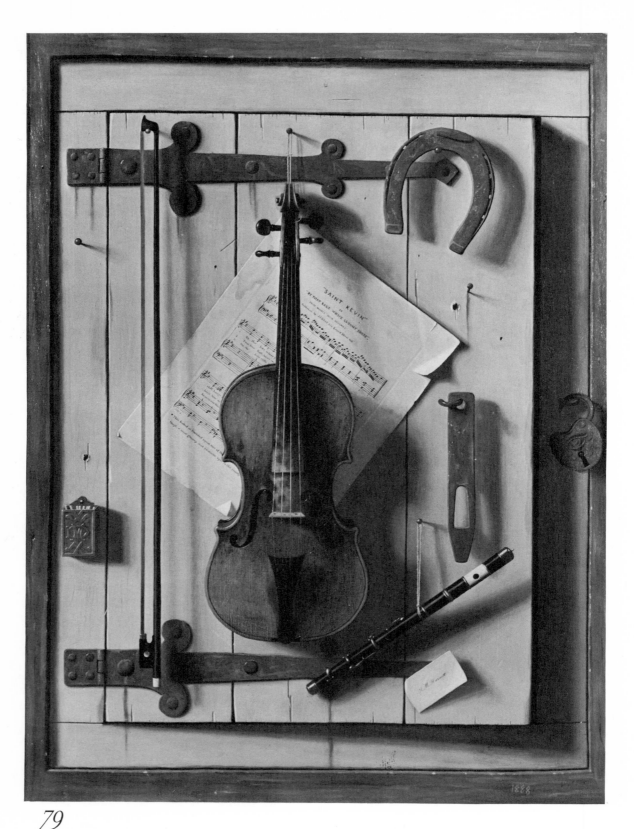

79

W. M. Harnett
Music and Good Luck 1888 (40 x 30)
Metropolitan Museum of Art, New York

W. M. Harnett
Sketches for *The Old Cupboard Door* 1889 (5½ x 2¾)
Alfred Frankenstein, San Francisco

81

W. M. Harnett
The Old Cupboard Door 1889 (61½ x 41)
Graves Art Gallery, Sheffield, England

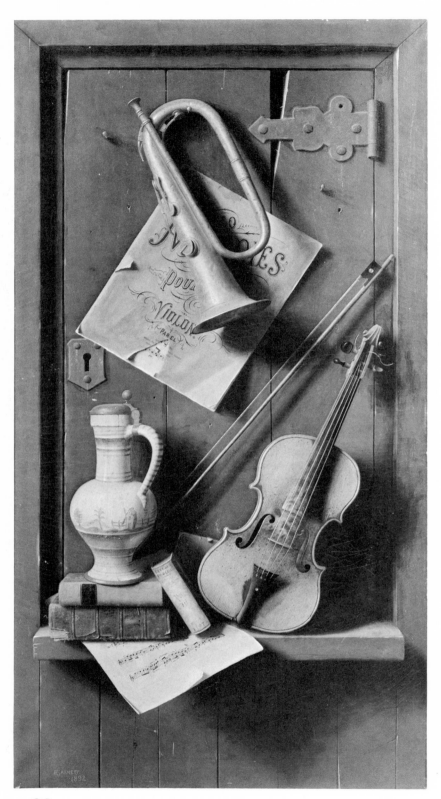

82

W. M. Harnett
Old Models 1892 (54½ x 28¼)
Museum of Fine Arts, Boston, Massachusetts

Still Life with Mug, Pipe, and Antique Vase

His expectations notwithstanding, Harnett was not "out soon." He was not discharged from the St. Francis Hospital until February 22, 1889, and he was back again in less than three weeks, on March 9, remaining until March 16. The diagnosis given on his record card for March 9 is "Acute Uremia" and "Subacute Arthritic Rheumatism and Nephritis."

Harnett was well enough to depart for Carlsbad sometime before July 26; this, at least, seems to be the significance of a playbill from the Stadt Theater in that city for that date which is preserved in the Blemly scrapbook. The entertainment Harnett attended was *Der Mikado, oder Ein Tag in Titipu, Burleske Operette in Zwei Akten von W. S. Gilbert, Musik von Arthur Sullivan.* On September 5 he wrote to Snow from Wiesbaden:

Dear Friend,

I will not write a long letter as I will not be here long. The weather in Carlsbad was miserably cold all summer, rain every day. I was recommended to finish up here before going home. I have not got over my lameness yet. I hope Laura [59] is better. I have often thought of her. She was very ill when I left. I will not stay long enough to receive an answer. Hoping to see you soon I remain

Yours Truly
Wm M. Harnett

The "finishing up" in Wiesbaden does not seem to have been very successful, however, for Harnett entered the New York Hospital not long after his return; he was there from December 5 to December 24.

All this readily explains why *The Old Cupboard Door* is the only known Harnett of 1889 and why Harnett seems to have produced relatively little during the remaining three years of his life.

The art traffic of the nineteenth century was less rigidly confined to specialized galleries than it is at present, and for an isolated work of art to be exhibited for sale at Wanamaker's was not at all exceptional. The Blemly scrapbook contains an undated clipping from a publication called *The Epoch* concerned with two Harnetts displayed in the show-

rooms of the New York jewelry firm, Black, Starr and Frost, successors to the Ball, Black and Company whose window, according to James E. Kelly, had been host to some of Harnett's earliest efforts. The description in *The Epoch* clearly refers to *The Faithful Colt* and, in all probability, to *Emblems of Peace,* both produced in 1890.

The Faithful Colt (plate 1) was the pilot piece of the Harnett revival. *Emblems of Peace* is a large, handsome table-top painting which, shortly after it was finished, became the property of Charles Shean, proprietor of the Hotel Charles in Springfield, Massachusetts, who ultimately gave it to the Springfield Museum of Fine Arts, where it remains. The Hotel Charles boasted a gallery-full of paintings, many of them of the *trompe l'oeil* variety, in its lobby. Its *After the Hunt* was a big cabin-door picture by Richard LaBarre Goodwin, and there were still lifes by Haberle, Morston Ream, and others. Shean seems to have left his entire collection to the Springfield Museum, which is therefore second only to the Wadsworth Atheneum in Hartford as a center for the study of American *trompe l'oeil.* (Thanks to the interest of its former director, Arthur Everett Austin, Jr., Hartford has not only *The Faithful Colt* but also important works of Peto and Raphaelle Peale and a number of extremely obscure but interesting things, including "Nathaniel Peck's" *All-Seeing Eye* [plate 42], and *Time Is Money* [plate 125], one of the most elaborate works of *trompe l'oeil* in existence, by an otherwise completely unknown artist who signed his name F. Danton, Jr.) [60]

Three other Harnetts of 1890 are known to exist, among them *An Evening's Comfort* (New York: Mrs. Norman Woolworth) and *With the Staats Zeitung* (St. Louis: City Art Museum). These are

bearers at Harnett's funeral, and since all the other pallbearers seem to have been old friends and fellow workers from Harnett's days in the silver shops, Ryan may have been one as well. And Harnett was employed, when he first went to New York in 1869, by the silver-engraving firm of Wood and Hughes.

[59] Snow's daughter.

[60] In the introduction to the undated catalogue of a Wadsworth Atheneum show called *Twenty-Five American Paintings from the Revolution to the Civil War,* Austin made some extremely penetrating observations regarding Harnett's style:

"The eye is enabled to experience in the picture what it is not permitted to do in actuality, that is to focus on a much larger area in complete detail, rather than having to be content to focus on one detail at a time. It is as though one were wearing a wide-angled telescope for glasses or could observe nature always in terms of the sharpened clarity and heightened color of an image thrown on the ground glass finder of a camera."

(Just what Harnett was doing in an exhibition of pictures painted between the Revolution and the Civil War is not perfectly clear—but let that pass.)

Still Life with Mug, Pipe, and Antique Vase

mug-and-pipes, almost identical in subject matter but different in composition and in approach.

Both pictures employ the same bare wooden table, the same square panels in the background, the same pewter-lidded stein, and the same large meerschaum pipe propped in a fold of a newspaper against Harnett's beloved blue tobacco box; but in the Woolworth, the stein is at the left and the other objects at the right, whereas in the version in St. Louis the stein is at the right and the pipe, newspaper, and box, arranged in exactly the same fashion, are at the left. What is important in the contrast of the two paintings, however, is not this mere mechanical switching about, but the difference in their relationship to the spectator's eye.

In the St. Louis version, very little of the support for the table top is shown. The table top itself provides a low horizon line; the spectator is brought very close to the objects, which are relatively large in their rendering, and they fill a relatively large canvas (14 by 20¼). In the Woolworth, on the other hand, much of the table bottom is exhibited; the horizon line is correspondingly high, the objects are relatively far from the spectator, are therefore small, and are painted on a small panel (6 by 8). This change of approach in the painting of near-replicas is very rare in Harnett, and would, in all probability, not have occurred to him in the early days of his career.

We have only two Harnetts of 1891—*The Professor's Old Friends* (Rockland, Maine: Farnsworth Art Museum), an excellent table-top piece with a clarinet and a rather squat jug, as well as the Roman lamp, books, music, and the Arnold ink bottle; and *Just Dessert* (Art Institute of Chicago).

All the table-top pictures of Harnett's last years are excellent, important works, but they offer nothing new. Only one observation, perhaps, need be made about them. Not only are their paneled backgrounds darker and less obtrusive than those of the middle 1880's, but the design of these panels is in much better taste. They no longer display the prodigies of carving and joiner's work in which Harnett formerly delighted; they now present only a simple pattern of rectangles.

Just Dessert, however, is an exceptional creation. It is a "fruit scene" with grapes, a maraschino bottle,

a fine sprig of leaves, the pewter tankard of 1883 facing the left and showing its undented side, a ginger jar, a juicy half coconut (even the shell of that coconut was sold with Harnett's effects at Birch's and is accounted for in the catalogue), a small box of figs, and a large copper pitcher. This is the only known work of Harnett in which the copper pitcher is represented; a "fruit scene" with this motif is known to have hung in Peter Dooner's Philadelphia hotel, and perhaps this is it, but a photograph of it stirred no memories in Peter Dooner's son, Albert. The fig box is firmly nailed shut, but it nevertheless shows some smudgy fig seeds—this was too good a chance for a little passage of virtuosity, logic or no logic.

Harnett's only painting for 1892 is *Old Models,* the Boston Museum picture (plate 82); it is not only his last work (according to the Birch catalogue), but it may also be his finest. In some ways it is reminiscent of *The Old Cupboard Door,* and it is not astonishing that there has been confusion between these two canvases; in fact, it is quite possible that both paintings were elaborated from the same sketch, but *Old Models* shows what Harnett could do when he did not have a Bement looking over his shoulder.

The Birch catalogue states that this picture was painted for the World's Columbian Exposition, held at Chicago in 1893, but, because of the artist's death on October 29, 1892, it was sold at Birch's with the rest of his property and never reached the fair. Conceivably, however, the fact that it was painted with the world's fair in mind had something to do with its exceptionally tall, narrow shape and with the fact that the objects represented in it carry at a distance better than those in any other from Harnett's brush. It would have had much competition in Chicago, where some 6,000 pieces of canvas were displayed in one building, and any ordinary composition might well have been lost in the shuffle.

As in the Bement picture—and in no other known work of Harnett—*Old Models* deals with still life objects set on a ledge before the recessed door of a wall cabinet. The frame of the door is simple and square, not fluted as in the Bement version, and the door itself is composed of three boards set vertically, not of eight set diagonally. The hinges of the Boston

Still Life with Mug, Pipe, and Antique Vase

door are much simpler than those in the other work, and one of them is heavily obscured by the shadow of the violin falling across it. The space beneath the ledge in *Old Models* is taken up with simple boards, not with ugly tongue-and-groove paneling.

Most remarkable of all, however, is the comparison between the objects on the ledge in both paintings. *The Old Cupboard Door* presents us with a prim little squad of knick-knacks set out like curios in a store window. *Old Models* presents us with a monumental design. The Dutch jar, the keyed bugle, and the violin form an immense triangular pattern; the bow, set at almost the same angle as the one in *The Old Cupboard Door,* really functions as an element of composition and so does the tilted rectangle of the sheet music. The whole area of the Boston picture is full of subtleties of movement and countermovement, of positive and negative shapes. By comparison, *The Old Cupboard Door* is as formless as a plate of scrambled eggs; and *Old Models* sacrifices none of Harnett's acute observation of fact, none of his tactile, textural interest, none of his little niceties of description, like the light shining through the f-hole of the violin on its shaded side, the cracks, splinters, and nailholes of the door, or the red and blue threads showing through where the spine of the big old book has been torn away.

According to several of Harnett's obituary notices, he went, in the fall of 1892, to "the hot springs of Arkansas" in search of relief from his various ailments. This trip failed of its intended effect. On October 27, 1892, he was found in a coma before the door of the studio at 1227 Broadway (or 40 West Thirtieth Street) which he had occupied since his return from Europe late in 1889. He was taken to the New York Hospital, and he died there two days later.

His body was not removed to his own home, 132 East Sixteenth Street (where, apparently, he merely rented a room), but to William Ignatius Blemly's house at 428 West Thirty-First Street. Blemly, Cornelius Sheehan, and others accompanied his body to Philadelphia, and a Requiem Mass for the repose of his soul was sung at St. Augustine's Church on November 2. The pallbearers at his funeral were Charles and Joseph McCann, A. A. Ryan, and James McCloskey. He was buried in the Cathedral Ceme-

tery in Philadelphia, beside his brother, his mother, and his sister, Anne; many years later, his surviving sisters, Ella Harnett and Margaret Koons, were also laid to rest there.

He left no will. Ella was appointed executrix of his estate, which, as we have seen, consisted, according to the official inventory, of "five paintings of uncertain value and four hundred dollars cash." Then came the Earle exhibition and sale, apparently in November or December, 1892, and the Birch sale of February 23 and 24, 1893. What was left was divided into two parts. One part was kept by Ella, and what remains of it is now in my possession. The other part was sent to the young woman to whom Harnett had become engaged at some time during the last year of his life. The Misses Whitaker remember only that her name was Enright and that she lived in New York. What happened to her, and to the mementos of William Michael Harnett which came so tragically into her possession, no one knows, and it is very likely that no one ever will.

XV

It is highly prophetic that three general histories of still life, apparently the first books of their kind ever written, were published in the 1920's. One of these I have never been able to find, and I should not be able to read it if a copy should turn up. Its title in English would be *The Problem of Still Life;* it was written in Russian by one B. Wipper and was printed in Kazan in 1922. The two other books are readily available and have already been cited; they are Arthur Edwin Bye's *Pots and Pans* (Princeton, New Jersey, 1921) and Herbert Furst's *The Art of Still Life Painting* (London, 1927). Neither book, of course, so much as mentions any of the painters discussed here. Philadelphian though he was, Bye seems never to have heard even of James and Raphaelle Peale, or else he did not consider them worthy of notice; he begins his chapter on American still life with John LaFarge, writes a panegyric on the work of Emil Carlsen, and is much delighted with the still lifes of such notables as Wilton Lock-

wood, Julia Dillon, Howard Gardiner Cushing, Hugh H. Breckinridge, and Henry R. Rittenberg. ("Who, might ask a gallery visitor under forty, were. . . .") Furst, being an Englishman, mentions no American artists at all.

I turn to Bye and Furst, however, not for the pleasure of emphasizing their omissions, but for a considerably more cogent reason. Both these critics begin their books in the same way. In the second paragraph of his preface, Furst whets the reader's appetite for his subject with the following observations:

> Still life painting is, to this day, generally regarded as the lowest form of pictorial art; as a dull subject; and it certainly does not include pictures which command fabulous prices in the sale-room: three excellent grounds for the neglect of which this exceptionally interesting category of work has been the victim.

Bye is even more obsequiously apologetic than Furst. He devotes an entire chapter to explaining why nobody likes still life; the nub of his explanation is that "pots and pans" cannot convey implications of the sublime. But as one studies their books one gradually perceives that these writers, balancing precariously on the edge of the contemporary era, dimly adumbrate modern esthetic principles. This is especially true of Furst, a much more sophisticated and a better-informed critic than Bye. Unlike Bye, Furst has no difficulty in accepting Cézanne; *his* troubles arise when he contemplates Matisse and Picasso, but he at least tries to grapple with these painters, while his American colleague skims over them in nervous and gingerly style. Most significantly, Furst includes, possibly for the first time in any book on the history of art, reproductions of Vaillant's *Letter Rack* and a rack picture by Colyer, he brings in such old masters of fantastic painting and *trompe l'oeil* as Arcimboldo, Oudry, and Baschenis, who are much admired today but were overlooked by the nineteenth century, and he reproduces an anonymous English watercolor of flat papers startlingly like the rack picture by Goldsborough Bruff. Furst does not admire these things, any more than he admires Matisse and Picasso, but he cannot get along without them. And one ultimately sees, through these portents of Furst's, that it was the modern doctrine that subject matter doesn't count

which eventually brought still life into its own. This principle leveled all subjects to a common plane. Consequently a modern critic like C. J. Bulliet can assert as axiomatic that an apple by Cézanne is more important than a Madonna by Raphael; thanks to this attitude, which would have been incomprehensible to Muther or Énault or the newspaper critics of the 1880's, the way was paved for Harnett's return. Without it, Harnett's works would still be in the junk shops.

To be sure, the doctrine that subject matter has no bearing on esthetic evaluation has proven a very shaky guide so far as Harnett is concerned. As we have seen, it discouraged inquiry into Harnett's iconography and into Harnett's own esthetic ideas. It therefore prevented a clear formulation of stylistic criteria for him and consequently permitted the acceptance, as Harnetts, of works depicting objects which did not come into existence until after his death. It has also encouraged the ascription to Harnett of all manner of modern artistic motivations which are totally outside his thinking, and this has further obscured the picture. Even as late as 1948 one can find a responsible critic talking about Harnett's "imaginative grouping of unrelated objects in abstract patterns, similar to the most advanced directions in painting today." The patterns may be abstract enough, in a certain sense of that word, but the objects are certainly not unrelated. This idea, as has previously been pointed out, arose from inability to "explain" the subject matter of three rack pictures by Peto which were wrongly ascribed to Harnett, but even in the light of what was known and believed in the *Nature-Vivre* days, one could not justifiably say that the "grouping of unrelated objects" was true of Harnett's work as a whole.

When a profound and universally respected thinker like Paul Cézanne affirms that his time must forge a new art like that of the museums, we solemnly agree that the great, basic principles of esthetics are the same at all times and in all places. When a little provincial like E. Taylor Snow talks about "artistic composition," we feel uneasy, especially when Snow immediately follows that phrase with the observation that Harnett "endeavored to make the composition tell a story." This much is

Still Life with Mug, Pipe, and Antique Vase

certain: the insights into form which make the works of Harnett and his school valuable for us today are very old; they are derived from the art of the museums, and they guided the hands of Hubert van Ravesteyn (plate 75), Jean-Baptiste-Siméon Chardin, Raphaelle Peale, Paul Cézanne, William Michael Harnett, and John Frederick Peto, each according to his temperament, his capacity, and his limitations. Today the word for these insights is "abstraction." The word in Harnett's time was "artistic composition," if there was any word for it at all.

Harnett's own age was completely blind to the compositional virtues of his work. Nowhere in the contemporary literature are these virtues mentioned, either by the uneducated, who admired Harnett, or by the sophisticated, who condemned him. Yet one cannot avoid the suspicion that those of Harnett's era who were moved by his pictures were unconsciously swayed by his powers of design, just as the artist himself seems to have employed those powers with little or no self-conscious formulation. If so, it follows that the esthetically unwashed were more perspicacious than the professionals. The critics are always an easy target; therefore, as one who has made a living out of criticism for more than twenty years, I content myself with observing that George Inness should have known better.

I do not share the hand-wringing which followed when, in 1949, the public was asked to vote upon its favorite pictures in a large historic exhibition at the Corcoran Gallery of Art in Washington and chose, overwhelmingly, Harnett's *Old Models,* followed by works of Thomas Hovenden, Albert Bierstadt, Eastman Johnson, and Winslow Homer, while the moderns were passed up entirely. There might have been cause for alarm if the public had chosen, as its favorites, works of Henry Peters Gray, George P. A. Healy, or Cephus Giovanni Thompson, but I suspect that the Corcoran gave its visitors no opportunity to make such a choice; furthermore, I have not heard that this museum has ever turned down the prospective gift of a Harnett, a Hovenden, a Bierstadt, a Johnson, or a Homer.

In an article on this experiment,[61] Eleanor B. Swenson of the Corcoran staff points out that the phrases which recurred most frequently on the Harnett ballots were "perfect imitation," "painstaking correctness," and "so like the real thing," . . . only five visitors, in naming *Old Models* as their favorite, mentioned anything like "composition," "imagination," or "the mystery created by the painting of a closed closet door." . . . One Harnett admirer went so far as to write that he liked the picture best because the artist "does not inflict his personal idiosyncrasies on me!"

So be it. Yet one wonders if the results of the balloting at the Corcoran do not show that the public, although it may know what it likes, may not know why it likes it. And my hat is off to the gentleman who admired Harnett because Harnett does not inflict his personal idiosyncrasies on his beholders. "We see not the artist nor his method of working." Perhaps there is room for such in this world.

"The mystery created by the painting of a closed closet door." With this phrase we arrive at the threshold of the new psychological criticism. "Making the picture tell a story," an aim which Harnett declared to be his own, is no longer fashionable in so simple and overt a form. Now the story must be read in terms of subconscious revelation, but such readings usually collapse in the light of research.[62]

In the last analysis Harnett appears as a decidedly normal product of his background and environment. He was not, apparently, a man of great sophistication, but he had a genius for painting. The most important aspects of that genius were not understood in his time, or if they *were* understood, were not singled out or particularly prized. Consequently, since Harnett was not one to snap his fingers at the world's demands, his immense and highly original gifts in the department of "artistic composition" are only fitfully exhibited. As he himself put it, "the chief difficulty I have found has not been the grouping of my models, but their choice. To find a subject that paints well is not an easy task." He was too readily content with a few simple com-

61 Published in *Right Angle,* the monthly magazine of the American University of Washington, April, 1949.

62 According to Born, the portrait of the little girl in *Old Souvenirs* represents Harnett's "lament for a lost love," the picture called *Off to the Opera* "seems in a roundabout way to disclose [Harnett's] negative attitude toward men," and the dying sparks in *Emblems of Peace* signify that the artist was resigned to a life of celibacy. But we now know that Harnett painted neither *Old Souvenirs* nor *Off to the Opera* and that he became engaged to be married shortly after he created *Emblems of Peace.*

Still Life with Mug,
Pipe, and Antique Vase

positional formulas and deviated from them only rarely, he was too often concerned with surface rendering as an end in itself, and he compromised too often with the taste of his time in its more commonplace aspects. He was not, like Cézanne or van Gogh, heroically dedicated to the pursuit of his own vision, and even in his best work there is no trace of individualistic contempt for the limitations of the crowd. Like most of us, he was full of contradictions and weaknesses, and it is possible that if, like Peto, he had had but little success and had accordingly been left alone, he might have been a greater artist. He loved the homely and the simple, but his patrons did not; from this fact arises the principal conflict so far as Harnett is concerned, not only as regards subject matter but as regards the greater aspects of picture making as well.

In two aspects of picture making he is perennially a past master—in the local rendering of individual forms, and in the tactile differentiation of varied surfaces. His use of color is inseparable from his textural interests, but if one were to make an arbitrary separation between his color and his texture, one would be forced to observe that, as colorist, Harnett is a product of the Brown Decades. His favorite models, with their "mellowing effects of age," tend toward the darker end of the spectrum, but he relieves their somberness with the bright red labels pasted to the spines of his brown leather books, with the cerulean blues, canary yellows, and light greens of his music covers, and the ivory whites of his sheet music, newspapers, and book pages. Sometimes these high-pitched accents are scattered through his paintings like those in a *kermesse* by

Breughel, but never so elaborately; and often they are totally absent. The ground tone is always a subtle dark, and the bright flashes, when they do appear, are flashes of metal or paper or cloth, not effects of color for its own sake; they are also, at times, eruptions of heat and congealments of cold.

Reviewing the biography of Harnett set forth in the preceding pages, one is appalled at the meagerness of the information on which it is based. So little is known, so much remains to be known, and so much, in all probability, will never come to light. Harnett walked the streets of New York and Philadelphia at a time well within the memory of thousands now living, yet one is forced to speculate on his relations with his mother on such evidence as is provided by listings in the Philadelphia City Directory. There are two reasons for this paucity of material. One is that, since Harnett did not appeal to the official art world of his time, the art world did not record his activities. The other reason is that his age was, in general, not historically minded.

One can verify every reference in Raphaelle Peale's rack picture of 1808, but the references in Harnett's rack of 1879 remain completely unexplained. The early American republic had its eyes on the future; it knew it was making a great beginning and it carefully preserved its documents. The age of Harnett had lost this anchor; it roared high, wide, and handsome toward the horizon and let the present go hang. Perhaps the 1880's had the right idea. Perhaps it is best to let each age die and make room for those to come. But the present acquires a deeper resonance when the structure of its past is clarified.

Arbitrary Juxtapositions, Unrelated Objects

JOHN FREDERICK PETO

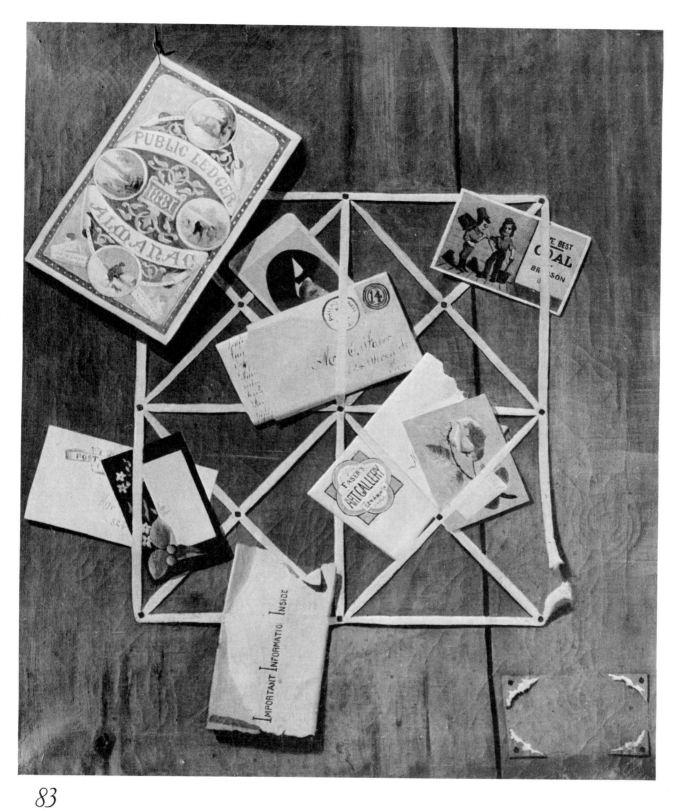

83

John Frederick Peto
Office Board for Christian Faser (30 x 25)
Mrs. John Barnes, New York

84

John Frederick Peto
The Poor Man's Store 1885 (35½ x 25½)
Museum of Fine Arts, Boston

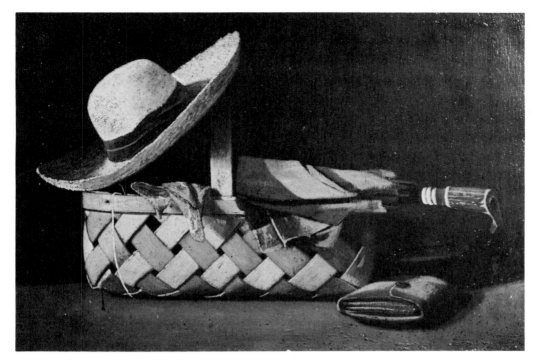

85

John Frederick Peto
Market Basket, Hat, and Umbrella after 1890 (12 x 18)
Private collection, New York

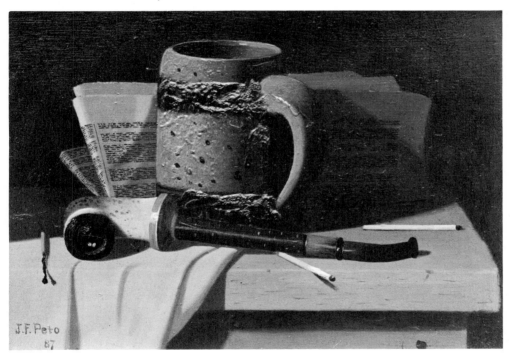

86

John Frederick Peto
Mug, Pipe, and Newspaper 1887 (6 x 8)
Mrs. John Barnes, New York

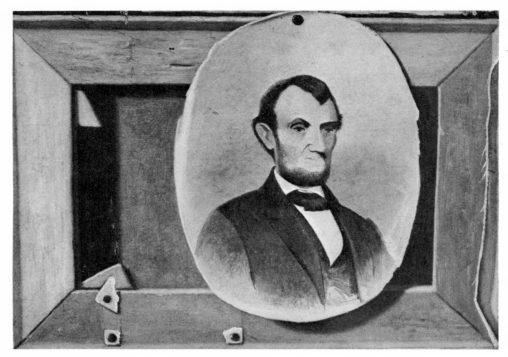

87

John Frederick Peto
Lincoln and the Pfleger Stretcher 1898 (10 x 14)
Howard Keyser, Philadelphia, Pennsylvania

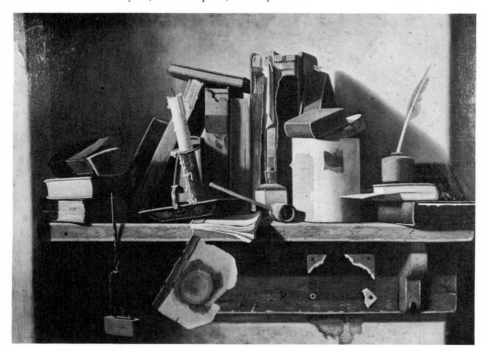

88

John Frederick Peto
Old Companions 1904 (22 x 30)
Mr. and Mrs. J. William Middendorf, New York

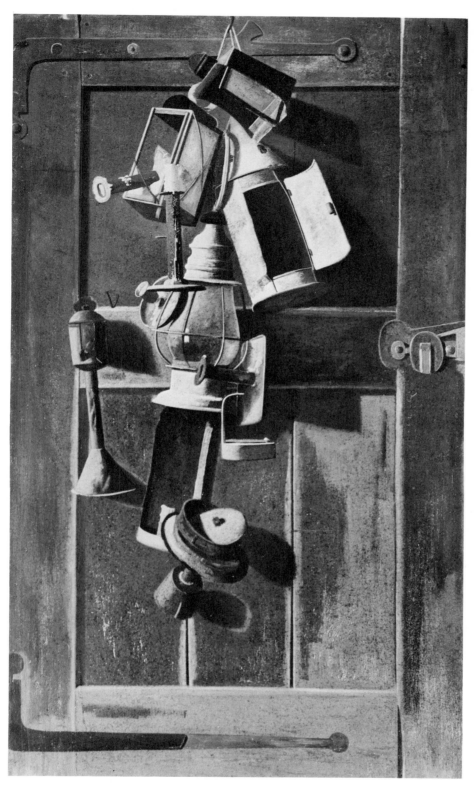

89

John Frederick Peto
Still Life with Lanterns after 1890 (50 x 30)
Brooklyn Museum, Brooklyn, New York

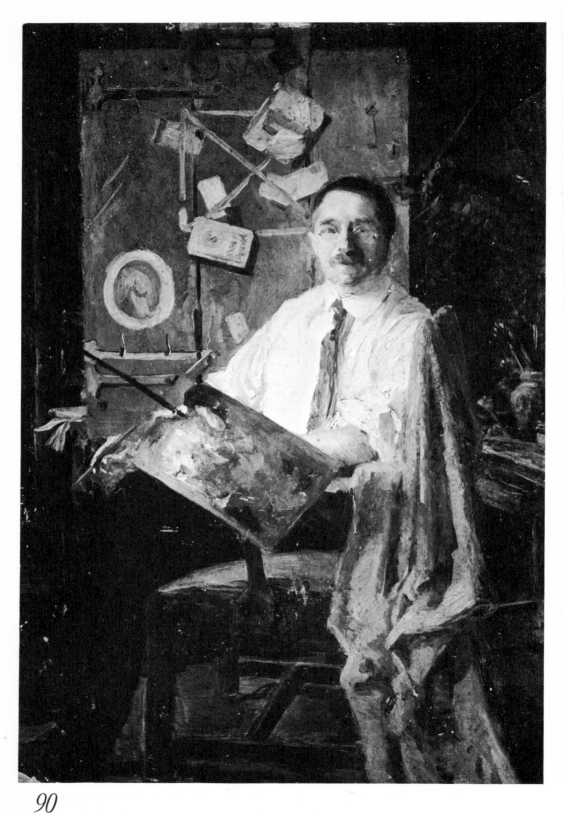

90

John Frederick Peto
Self-Portrait with Rack Picture 1904 (18¾ x 12½)
Mrs. Jose Bejarano, Rochester, New York

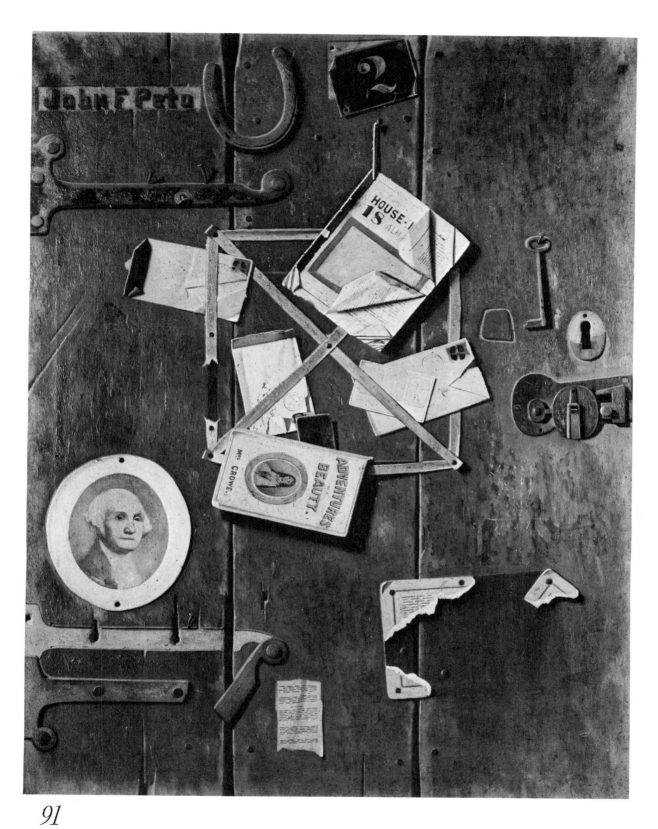

91

John Frederick Peto
A Closet Door 1906 (40 x 30)
Private collection, New York

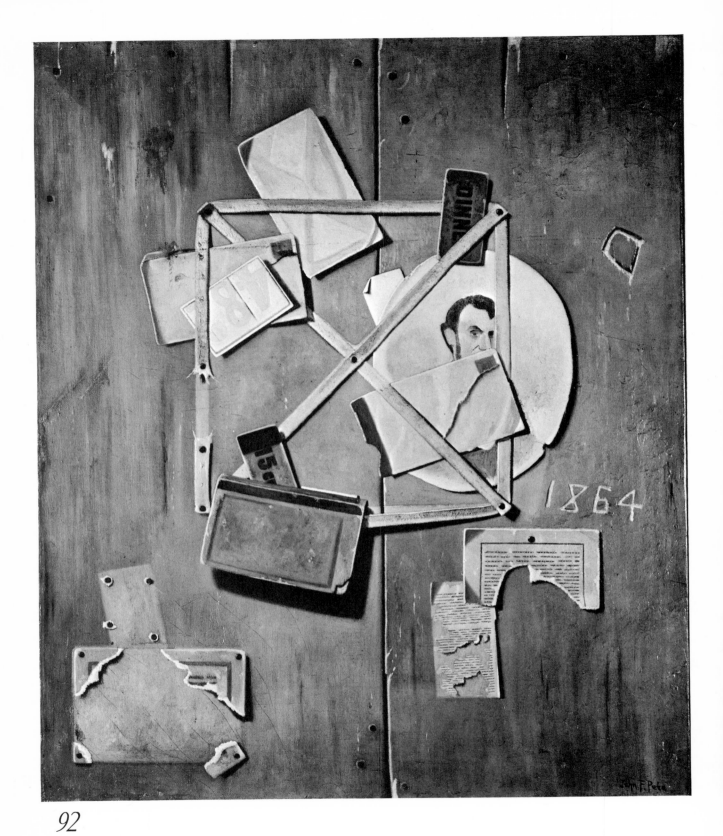

92

John Frederick Peto
Rack Picture with Portrait of Lincoln after 1890 (30 x 25)
Mrs. William Wood, Morrisville, Pennsylvania

*Y*ET IN MIND and person he was a survival of the 1500's . . . In mere time he was a lost soul that had strayed by chance into the twentieth century and forgotten where it came from."

So Henry Adams, in his *Education,* describes his good friend, Augustus Saint-Gaudens. Many another American artist has likewise stood apart from his time, and none more markedly than those discussed in this book. The case of John Frederick Peto, however, is peculiarly complicated, for Peto was not only half a century behind his era but also a quarter-century ahead of it.

Materials for a biography of John Frederick Peto are even more meager than those for a biography of William Michael Harnett. Peto spent the greater part of his working life at a distance from art centers, in the seaside village of Island Heights, New Jersey. He was seldom in the public eye; he received little notice from the press; and not a single letter of his is known to exist. Such information about him as we have comes from the recollections of his daughter, Mrs. George Smiley, from city directories, a few scattered entries in exhibition catalogues, the scraps of documentation preserved in his house at Island Heights (where Mrs. Smiley still lives), and the evidence of his works themselves.

John Frederick Peto was born in Philadelphia on May 21, 1854, and died in Island Heights on November 23, 1907. (These dates are taken from his tombstone in the Protestant cemetery at Toms River, about two miles from Island Heights.) He came of an old Philadelphia family whose name, despite its Latin ring, is actually English and of some antiquity: it is borne by the lieutenant of Sir John Falstaff's regiment in Shakespeare's *King Henry IV.*

The artist was one of the four children of Thomas Hope Peto and his wife, Catherine. Although both parents were alive throughout the greater part of his life and his mother actually survived him, he was brought up from childhood by his maternal grandmother, Mrs. Hoffman Hamm, and her four unmarried daughters, Margaret, Maria, Helen, and Louise. The artist's relations with his father seem always to have been very friendly, however, and a postcard

sent by Thomas Hope Peto to his son, John Frederick, on September 7, 1894, was, as we have seen, a major document in unraveling the Harnett-Peto mystery.

Thomas Hope Peto first appears in the Philadelphia City Directory for 1853, and is listed as a gilder for ten years after that, except in 1860, when he is listed as a dealer in picture frames. Gilding and picture framing were closely related professions in those days; if Thomas Hope Peto was a picture framer, he must have had pictures to frame, and his son probably saw some of them.

The elder Peto ran a restaurant in Philadelphia for several years in the mid-1860's; then, for the last quarter-century of his life, he engaged in a business to which he may have been led by his previous experience as a gilder: he sold fire engines, hose, and other types of fire-fighting equipment. Fire engines were superbly gaudy things in those days, and more than one American artist, like John Quidor, began his career by painting them. It is not inconceivable that John Frederick Peto began in the same way. It is also not inconceivable that the spit, polish, and band-music that accompanied the activities of the Philadelphia Fire Department, of which the elder Peto was a proud honorary member, had something to do with the fact that the younger Peto played the cornet from his earliest childhood. At all events, John Frederick Peto's abilities as a cornetist had a decisive influence upon his career as an artist.

John Frederick Peto is first listed in the Philadelphia City Directory for 1876. He is called a painter, and his home address is given as 245 Spruce Street, which had been the address of the Hamm family since 1858. He remains listed as a resident of the house at 245 Spruce Street through the issue of 1891 although it is known that he moved to Island Heights, New Jersey, in 1889; as already emphasized, there is a lag of at least a year between the listings in nineteenth-century city directories and the movements they reflect, and Peto may have wished to keep up his Philadelphia contacts for a time after he had left.

Peto apparently worked at home for four years before he rented an independent studio, since he has no studio address in the Philadelphia City Directory

*Arbitrary Juxtapositions,
Unrelated Objects*

until the issue of 1880. His studio addresses are of some importance, for he often inscribed them, with his name, on the backs of his canvases, and these inscriptions, in the absence of other evidence, are of value in dating his paintings. Pictures bearing addresses which correspond to the city directory listings given below are, of course, to be dated a year earlier than the listings themselves, with certain exceptions that are readily apparent.

1880–1881: 1123 Chestnut Street
1882–1883: 1020 Chestnut Street
 1884: 1113 Spring Garden Street
 1885: 1420 Chestnut Street
 1886: 703 Chestnut Street
 1887: 1020 Chestnut Street
 1888: 1108 Chestnut Street

Peto's devotion to Chestnut Street, especially in the vicinity of Tenth and Eleventh, was not by any means accidental, for that was the artists' neighborhood in those days. The building at 1123 Chestnut was owned by Janentzky and Weber (later known as F. Weber and Company), then the leading Philadelphia firm of dealers in artists' materials. Janentzky and Weber had its store there, and rented out studios and exhibition rooms in other parts of the establishment. The well-known Haseltine Galleries were at 1123 Chestnut, and Dennis Gale, whose name and address are inscribed on a letter in a Harnett still life of 1879, sold pictures next door at 1125. Earle's Galleries, which handled works of Harnett and Peto for many years, were down Chestnut Street at 816.

Except for the brief periods when Peto lived in Cincinnati and its suburb, Lerado, Ohio, he seems to have bought all his materials at Weber's, and this is important in establishing the approximate dates of numerous pictures by him to which there are no other chronological clues. According to Mr. E. G. Weber, present president of the firm, the organization was known as Janentzky and Weber from the early 1870's until 1887, when Mr. Janentzky retired, whereupon the name was changed to F. Weber and Company. It remained F. Weber and Company until Frederick Weber's death in 1920, when it assumed its present name, the F. Weber Company.

Obviously, a picture on a piece of canvas or academy board bearing the name of Janentzky and Weber (there are several such in Peto's house at Island Heights) was, in all probability, painted before 1887, while any picture on canvas or board with the name F. Weber and Company (Petos of this kind are extremely frequent) could not possibly have been done until after 1887. Most of Peto's known canvases are tacked to stretchers of the kind known as the Pfleger Patent. This stretcher—with its light, blond wood and its characteristic ridge or beading around its outer edges—was (and still is) manufactured in Chicago. It was patented in 1886, but it does not appear in Weber's catalogue until 1890. No dated Peto earlier than 1890 has been found on a Pfleger stretcher, and we may therefore conclude that any picture by this artist which is tacked to the Pfleger Patent was created at some time during the last seventeen years of his life.

There are also a few Petos on pieces of academy board bearing the label of the Cincinnati firm of Traxel and Maas. These apparently date from the painter's sojourn in Lerado in the latter part of 1894. Peto was also in Cincinnati in 1887, but probably did not remain long enough to do much painting.

II

EDUCATIONAL INFLUENCES on Peto are almost impossible to trace. In the catalogue of the annual exhibitions at the Pennsylvania Academy of the Fine Arts, to which he contributed irregularly between 1879 and 1886, he is designated as "self-taught," yet the same Academy lists him as a pupil in its school in 1878, two years after his first mention as a painter in the Philadelphia City Directory and three years later than his earliest known dated picture. Obviously, Peto could not have studied at the Academy for any great length of time, and even if he had, it would be difficult to determine what he learned there. As shown in the section on Harnett, details concerning instruction at the Pennsylvania Academy of the Fine Arts in the 1870's are very hard to come by; and to judge from the catalogues, there was no special emphasis upon still life in the Pennsylvania Academy exhibitions of that era.

Arbitrary Juxtapositions, Unrelated Objects

The strongest influence upon Peto's career, without much question, was William Michael Harnett. Harnett and Peto knew each other, apparently quite well, before Harnett left Philadelphia to go to Europe in 1880. A photograph of both, said to have been taken in one of Peto's Philadelphia studios, still exists at Island Heights. Harnett's burlesque monogram for his colleague, which indicates that there was more than a casual acquaintance between them, and to which William Ignatius Blemly assigns the extraordinarily early date of 1872, has already been described.

According to Peto's daughter, her father talked about Harnett constantly, invoking his name as the standard of perfection in still life. Peto painted many mug-and-pipe pictures, many writing-table still lifes, and many still lifes of money, of books on shelves and on packing cases, of violins, guns, and plucked fowl hanging against doors. All these are eminently Harnettian motifs, and some—notably the mug-and-pipe and the writing table—seem to be Harnettian inventions. At all events, there exists no dated Peto on any of these themes which is not later, and often considerably later, than Harnett's earliest known example of the same subject. In using the card-rack formula, however, Peto seems to have led the way, if only by an exceedingly narrow margin: as we have seen, Peto's earliest known rack picture (plate 45) is dated June, 1879, and the only known rack by Harnett appears to be dated August 26 in the same year. Even in this department, however, Peto eventually took over some ideas from the other artist.

Although he was strongly influenced by Harnett in certain matters of iconography, Peto is no mere Harnett imitator. His style—drawing, use of color, and application of paint—is poles apart from Harnett's at every point in his career, and he also had his own world of subjects which Harnett never entered. He took over many of Harnett's motifs, but not the compositional mannerisms with which they are associated in the older painter's work. For example, he never uses Harnett's dark recess and carved wood paneling in the backgrounds of his mug-and-pipe pictures, although he occasionally uses them in other pictorial contexts. Peto painted many table-top still lifes, but in only one is he known to have arranged his objects, Harnett-wise, in a receding pyramid above the table line with a triangular counterthrust of newspaper or sheet music below.[1] To be sure, Peto, like Harnett, will often dangle a torn-off book cover, suspended precariously by a single thread, over the edge of a table top. The prototype of this device can be found in a seventeenth-century still life by the Dutch master, Hubert van Ravesteyn (plate 75); its route to the nineteenth-century Philadelphians lies through entirely unknown territory.

III

PETO'S PROFESSIONAL career falls into two chronological divisions—the Philadelphia years, from 1875 to 1889, and the Island Heights era, from 1889 to the artist's death in 1907. The Philadelphia period seems to have been more varied in its activities and is far better documented, but comparatively few pictures of that time survive. In his Philadelphia days, Peto made bids for recognition through the usual channels, and some was accorded him, but not enough. That, clearly, is why he went to Island Heights to make his living (or part of it) playing the cornet for camp meetings. At Island Heights he gradually lost interest in the art world and contact with it, and he was almost completely forgotten long before he died. Consequently it was easy to forge the name of Harnett—whose reputation increased throughout his career and continued for at least a decade after his death—to Peto's canvases.

Although invitations to exhibit in the annual exhibitions at the Pennsylvania Academy of the Fine Arts came each year to Peto at Island Heights, he contributed to those shows only during his residence in Philadelphia. His exhibition record at the Academy is as follows:

1879—*Any Ornaments for Your Mantelpiece?* ($150)
1880—*Still Life.* ($40)
 The Poor Man's Store. ($200)
1881—*Still Life.* ($75)
1885—*Your Choice.* ($100)

[1] The picture in question is lost. It appears on the easel in an old photograph of Peto which is preserved at Island Heights.

Arbitrary Juxtapositions, Unrelated Objects

1886—*Fish House Door.* (No price given)
1887—*For a Leisure Moment.* (No price given)

Your Choice may be one of two known Petos: the painting of a box of books, once ascribed to Harnett but signed and dated by Peto in 1884, which is now in the collection of Alfred H. Barr, Jr., or the very similar work in the John Barnes collection which is signed and dated 1885 and bears on its back the inscribed title *Take Your Choice.* (This is the picture, discussed in the first section of this book, which, most problematically, yielded up a spurious Harnett signature after it had been cleaned.) The rest of the pictures shown at the Academy cannot be identified with any Petos now known, but there are others presumably much like two of those in the above exhibition list. Peto frequently repeated his subjects, often with little change: a *Poor Man's Store* of 1885 is now on loan to the Museum of Fine Arts in Boston (plate 84), and several versions of the *Fish House Door* can be found at Island Heights and elsewhere (plate 73). It is worth noting, by the way, that Harnett exhibited a picture called *Materials for a Leisure Hour* at the Pennsylvania Academy annual of 1881, six years before Peto paraphrased its title; this Harnett, with its Pennsylvania Academy label of 1881 still intact on the back of its frame, turned up in 1948 in St. Louis.

Except for passing mention among the also-rans, only one of Peto's Pennsylvania Academy pictures received any notice from the press, and the reason for that one notice becomes obvious when one reads the following paragraph from the Philadelphia *Record:*

Mr. John F. Peto contributes to the present annual exhibition of the Pennsylvania Academy of the Fine Arts a study of still life, entitled *The Poor Man's Store,* which cleverly illustrates a familiar phase of our street life, and presents upon canvas one of the most prominent of Philadelphia's distinctive features. A rough, ill-constructed board shelf holds the "Poor Man's Store"—a half-dozen rosy cheeked apples, some antique gingerbread, a few jars of cheap confectionery "Gibraltars" and the like, and, to give all a proper finish and lend naturalness to the decorative surroundings of the goods, a copy of *The Record* has been spread beneath. Mr. Peto's work has been well done, and is no less attractive from its artistic merit than for its fidelity to truth. The picture is No. 159 in Gallery F.

Peto also sent pictures to distant cities during his Philadelphia years. He had three paintings in the art show held in connection with the St. Louis Exposition of 1881—*Card Rack* ($35), *Still Life* ($25) and *Help Yourself* ($25). None of these pictures was singled out in the reviews. (*Help Yourself* is also the title of a painting by Joseph Decker, and the same title was used by John Haberle as well. All the American still life painters of the Harnett-Peto era helped themselves liberally to each other's titles, and that is one of the things that makes the study of them so wildly confusing.)

If the few tattered clippings preserved at Island Heights are any criterion, the only extended newspaper notice Peto ever received was in *L'Abeille de la Nouvelle-Orléans* for "Dimanche, 30 mai, 1886." This review, entitled "A Painter's Freak," is signed by L. Placide Canonge. A translation follows:

We call attention to an art-object now on view at Uter's on Royal Street. This thing is exceedingly difficult to describe, but we shall nevertheless attempt to give you an idea of it.

Imagine a canvas representing one of those cluttered boards which one often sees hung on a wall or on the sides of a desk or counter. The objects attached to it are quite unpretentious; in fact, they are exceedingly common.

Almost at the center of the board is a trellis formed of rose-colored strips of tape, held by tacks; into the meshes of this a copy of the *Picayune,* some letters in their slashed-open envelopes and a crumpled postal card have been negligently tossed. Lower down is a match-case from which emerged several matches with their purple heads, etc., etc.

At the left is a coarse string hanging from a nail, and beneath this can be read the figures of a mathematical computation; figures in the most ordinary kind of hand.

On one strip of the trellis, in the manner we have indicated, the artist has also placed an almanac whose color reveals its antiquity, a chromo, and, at the side of the old almanac, a blue envelope with its letter, as well as a photograph of a woman and some cards arranged on top of each other rather in the form of an open fan.

At the right of the board are some tatters of paper, the remains of some printed matter, pasted there long ago; one is tempted to pick at them, although one would never be able to remove them completely. The paper seems encrusted in the board; one would have to wash it off in order to be sure it is not. And some, indeed, have already fallen into the trap and attempted to do so!

Here and there, straight or bent, are nails, all covered with rust; they stand out all over the board like ancient teeth in their gums.

Arbitrary Juxtapositions,
Unrelated Objects

What name is to be given to such an assemblage of diverse, banal objects? Probably none at all. And we do not recommend this work for its subject matter, but for its execution.

The imagination plays no part here. It is all realism, and realism in the extreme; but we insist that the artist has produced delightful results with his experiment.

The rendition is strikingly correct; this is a relief for the hand, if we may put it in that way. One reaches out to touch the canvas in spite of one's self. Yes, in looking at that strange composition—if it *is* a composition—the eye is deceived throughout.

One passes one's hands over the trellised tapes and among the three letters, which are so truly and individually distinct from each other; one is tempted—and yielded to the temptation—to pick out the matches, which protrude from their case. That photograph, so exact in its color, and that chromo, the twin of a real chromo, would come off if you touched them. The hand itches to play with that string, which seems to move and flutter. One would like to unfold and read that copy of the *Picayune*. One is seized with the notion of extracting those stumpy nails, of denuding the picture of its objects.

In short, if you put this board in the right light, its illusion is complete. The drawing and color are beautifully done; and we repeat, more than once, that in examining this assemblage one believes that reality is here mingled with art, as in the exhibition-setting for a panoramic picture. If tangible nature is not there, it is counterfeited to the life on this canvas.

The artist, Mr. Peto of Philadelphia, intended this original freak of the brush for our Exposition. Unfortunately it arrived too late to take its place there, but the painter is nevertheless having his inning by exhibiting his work at Uter's. See it; it is quite curious and extremely striking in its realism.

This review combines two attitudes commonly taken toward the work of Harnett and Peto in their own time. These conflicting points of view are seldom expressed in the same article, as they are here. One is the layman's delight in accurate representation for its own sake. The other is the professional's scorn for mere "realism." M. Canonge also shows his bewilderment at the "banal" character of Peto's subject matter. Loops of string, dog-eared books, and tatters of paper were not regarded as fit subjects for an artist's attention. Harnett, as has been shown, often went in for "objects of intrinsic beauty"; that is one of the main reasons for his success in his lifetime, although today it is regarded as his principal shortcoming. Peto clung to his "banal" subjects throughout his span as an artist, and that is one of the main reasons for his failure to attract buyers while he was alive, but today it is regarded as one of his major virtues. Modern painters like Kurt Schwitters and Robert Rauschenberg have taught us the fantasticality of the commonplace and the pathos of the discarded, and Peto is one of the great masters in this realm of artistic expression.

IV

On June 16, 1887, Peto married Christine Pearl Smith of Lerado, Ohio (or Logtown, as it was known until 1890[2]). According to their daughter, her parents met when her father went to Cincinnati to paint a picture for the celebrated Stag Saloon of that city, although the documents suggest that the episode of the Stag Saloon took place seven or eight years later. If Peto did not go to Cincinnati in 1887 because of his commission from the Stag, the reason for his visit at that time remains unknown.

Throughout his Philadelphia years, Peto clearly experienced economic difficulties. This is shown by a number of things, the most interesting of which is his extensive series of "office boards"—rack or patch pictures obviously made to hang in business and professional establishments. Most of these have disappeared, but a few survive. The Metropolitan has a rack painted in 1888 for Dr. B. M. Goldberg, a Chestnut Street chiropodist of that era. Mrs. John Barnes has one made in 1881 for Christian Faser, who sold mirrors and picture frames on Arch Street (plate 83). At Island Heights is a photograph of a lost patch picture of 1888, painted for Eli Keen's Sons, dealers in hats, caps, and straw goods, with offices at 62 North Second Street. There are also racks and patch pictures of the Philadelphia days bearing Peto's own name and his various studio addresses, but the most amusing picture of this series known to exist is the rack painted in 1882 for Wil-

[2] According to a local tradition, the name of Logtown seemed extremely prosaic to its citizens, and they decided to change the designation of their village to something romantic. They settled on the racy-sounding name of Laredo, after the city in Texas, but were somewhat shaky in their spelling.

Arbitrary Juxtapositions, Unrelated Objects

liam Malcolm Bunn, editor of the Philadelphia *Sunday Transcript* (New York: Louis Stein).

William Malcolm Bunn was a celebrated *bon vivant,* humorous poet, and politician of Philadelphia; he was also one of the founders of the Clover Club. He was a perennial candidate for public office, and Peto's rack, with its obscure allusions, may have something to do with one of his political campaigns.

At the top of the rack is a photograph of Bunn, below it is a folded copy of his newspaper, beneath this are letters and a postcard addressed to that gentleman and to the editor of the *Sunday Transcript,* and at the bottom of the painting, tucked behind a letter addressed to "Garibaldi McFod" at the office of the newspaper, is a wild caricature of Bunn labeled "McFod to the Fore." Unfortunately no copies of the *Sunday Transcript* for this period seem to exist in any library, and so it is impossible to check upon "Garibaldi McFod." Conceivably, this was a pseudonym under which Bunn wrote comic copy for his journal.

Two rather interesting references to Peto's office boards are preserved among the clippings at Island Heights. One, dated March 27, 1885, speaks of a picture "in the window of Jacob Reed's Sons, Nos. 920 and 922 Chestnut Street. It is but a bit of red tape forming a rack for some small articles, but *The Record* almanac looks as though it could be opened; one feels inclined to lay hold of the copy of the Philadelphia *Record;* the postal card seems ready to mail, and the photograph must certainly be one. The whole is the work of John F. Peto of No. 1420 Chestnut Street."

Four years later, one of the Philadelphia papers carried an advertisement concerning the auction of a collection of paintings belonging to one I. S. Isaacs, to be held on March 4, 1889. Only one work is singled out for mention in this announcement: "Among the many very fine pictures to be sold in this sale is one, the subject 'Our Office Board,' containing an admirable and truthful portrait of William M. Singerly, Esq. This picture is equal to any painted by Harnett. This is a genuine work of art."

William Miskey Singerly was owner of the Philadelphia *Record* from 1879 to his death in 1898, and it is therefore by no means unlikely that both clippings refer to the same painting. It seems quite probable that Peto painted it with the hope of selling it to Singerly, but was unable to do so. Observe that the auctioneers who sold the Isaacs collection did not consider Peto's name sufficiently important to mention; observe, likewise, the standard of comparison they use in trying to sell his work, and their assumption that this standard of comparison would be readily and widely known.

Office boards obviously produced insufficient revenue, and Peto therefore tried his hand at other things. According to his daughter, he painted some portraits, none of which can be found today, and did some portrait photography. He is said, also, to have executed some sculpture for Rittenhouse Square. If so, it has long since been taken down and destroyed.

V

ABOUT THE time of his marriage, Peto started going to Island Heights to play the cornet at camp meetings. The village had been founded by the Island Heights Camp Meeting Association as a place in which to hold religious revivals, and a cornet player with considerable lung-power was needed to lead the singing. Peto, who had apparently earned some reputation as a virtuoso with the Third Regiment Band of Philadelphia, was chosen for the job; for two or three years he shuttled back and forth between Philadelphia and the Jersey shore, but in 1889 he built his house at "the Heights," and there he remained for the rest of his life. The camp meetings were ultimately taken elsewhere, but the town remained, and still remains, one of the few bone-dry spots among the many resort communities in the vicinity of Barnegat Bay. Consequently it became a favorite vacation spot for sober and genteel families, and little Mr. Peto, the artist of Island Heights, became a legend among them. He seems to have sold quite a few pictures to these summer visitors, some of whom boarded in his own house, and these vacation souvenirs are now scattered all over the eastern seaboard.

So far as anyone knows, Peto made only one ex-

Arbitrary Juxtapositions, Unrelated Objects

cursion away from Island Heights from 1889 to the day of his death. That was in 1894, the greater part of which he spent with his wife and daughter in Lerado. In all probability, he stayed there while painting his picture for the Stag Saloon in nearby Cincinnati.

Among Peto's papers at Island Heights is an undated clipping to the effect that Tony Honing and Eddie Baylis had reopened their Stag Saloon, newly furnished, five years after its original opening, with numerous paintings, including one by Peto. "The Stag," owned by Honing and Baylis, first appears in the Cincinnati City Directory for 1890 as a "billiard and sample room." In 1891, it is "The Stag, liquors and billiards," and so it remains to 1896, when it becomes "The Stag Saloon." If we put all these dates back one year, as we probably should, it seems that the Stag became a liquor dispensary in 1890 and was reopened in 1895. Peto's commission for a painting to adorn its refurbished walls might very well account for his being in Lerado in 1894.

A photograph which Mrs. Smiley believes to be of Peto's Stag Saloon picture still exists. It is of the type of the *Fish House Door* (plate 73), with a boathook hanging from a hinge, an oilskin coat, fishing tackle, a pistol, a beer mug, a slate, a photograph of a barn in the snow, and a portrait of a fatuously smiling boy; the whole is adorned with yards and yards of the fish net which also appears as one of the accessories of Peto's cluttered studio in a photograph of him said to have been taken in Philadelphia.

This painting, like all those of the *Fish House Door* series, is adapted from Harnett's *After the Hunt*, fourth version, which had hung in Theodore Stewart's saloon since 1886. Honing and Baylis obviously wished to turn their Stag into a carbon copy of Stewart's, and that undoubtedly is why Peto was engaged to paint an adaptation of *After the Hunt*—a commission which might well have gone to Harnett himself if he had been alive. Peto may have come to the attention of Honing and Baylis through his wife's relatives in Cincinnati or through pictures exhibited at the Cincinnati Exposition. Unfortunately only a scattered few copies of the Cincinnati Exposition art catalogues can be located today, and Peto's name does not appear in any of them, but we know he contributed, or intended to contribute, to

the exposition art shows in St. Louis and New Orleans, and it is very likely that he was represented at other expositions as well.

As previously emphasized, the saloon was second only to the exposition as an outlet for art in America in the 1880's and 1890's. This was the saloon era in American painting, and especially in American still life painting. Saloon keepers were the best customers for mug-and-pipe pictures, for pictures of dollar bills, and for such tricky things as the five-dollar gold piece which Jefferson David Chalfant painted on the top of a bar in Wilmington, to the great delight of the barflies who witnessed the efforts of their more deeply gone companions to pick it up. More luxurious paintings were also demanded, for, as the writer of Peto's story about the Stag observed, "There is an indefinable something that makes a homely bit of bread and cheese and a glass of beer more acceptable when properly served in the midst of congenial surroundings."

The "congenial surroundings" at the Stag involved

a masterpiece from the brush of Lucien Berthault, [which] once hung, an admired treasure, in the Paris Salon. . . . It is called *Les Sirènes*, or *The Sirens*, the artist depicting the escape of the hero of the Odyssey from the wiles of the fatal sisters while on his voyage so famed in mythology. The languorous, enticing beauty of the undraped sirens is powerful, even upon the canvas, and keeps the viewer enraptured before it. Other famous painters are represented. Farny's bit of Indian life, *An Early Start*, is there. John Hauser contributes an Indian study. Atherton, Furlong, Delort, Rossi, Walker, Peto, Knauss and Groleron are all there. Antique armor and objects of art relieve the searching eye along the tinted wall.

There are a few other clippings relating to Peto's days in Lerado; in one of them we find the first mention of the Lincoln motif that was to become one of the artist's prime preoccupations. The Lerado correspondent of a Cincinnati newspaper, probably the *Commercial Gazette*, wrote an account of a visit to Peto's studio in which he describes a rack picture containing a copy of that publication, letters, a postal card, and an engraving of the Civil War president; this painting must have been much like the Peto at the Museum of Modern Art in New York, which was painted at about the same time and was once widely reproduced as a Harnett. The Lerado cor-

respondent also spoke of "a handsome oil painting" which represented "a rooster hanging on an old door; the chicken has been picked and presents a very natural appearance." Another clipping, apparently from a newspaper called *The Democrat,* published in Toms River, New Jersey, near Island Heights, speaks of the rooster picture in precisely the same words, adding that it had just been painted and was on view in C. B. Mathis' drugstore on Main Street. This painting of a plucked fowl, or one much like it, is now in Howard Keyser's collection in Philadelphia. It is dated December 15, 1893, and bears on its back the title *For Sunday Dinner.* Harnett had painted a picture with the same title, and of an almost identical subject, five years earlier.

At some time during his years in Island Heights, Peto called upon the editor of *The Democrat* of Toms River to borrow a photograph of that gentleman. Three months later he showed up with a painting on which the photograph had been reproduced, together with a copy of the paper and an envelope, all tacked to a board. "Ye editor," as he calls himself, praises the realism of the painting and adds, perhaps significantly, that it is to be seen at the Mathis drugstore.

VI

FROM THIS point onward there are no more documents relating to Peto's life, but the story can be filled in from the recollections of his daughter and from the evidence of the paintings left in his studio.

As already pointed out, Peto was brought up by his maternal grandmother and her four unmarried daughters, and lived in their home at 245 Spruce Street, Philadelphia, until his removal to Island Heights. Two of his maiden aunts followed him to Island Heights, moved into his house, and apparently tried to run his life for him. According to his daughter, they prevented his going to Europe to study, and their presence created friction between the artist and his wife. One of them became senile in her last years, and had to be confined to her room, where she would stand for hours rattling her

locked door, while her nephew, within earshot in the studio below, tried to paint still lifes. One of his great-aunts, Caroline Hamm, died under mysterious circumstances at Tivoli, New York, in 1899. There were quarrels and lawsuits over her property which dragged through the courts for many years, and Peto represented his mother and her sisters in this futile, time-wasting litigation.

In view of all this, it is not surprising that the work of Peto's last years is exceedingly uneven in quality, and that much of it is unfinished. He had almost no reputation in the art world, and he painted countless small pictures to sell for whatever they would bring. (Some of these, bearing price marks of three and four dollars in Peto's own handwriting, are still at Island Heights.) Over and over again he would tackle a larger canvas, only to leave it unfinished, and would often return to the same subject, with little or no change, leaving the second, third, or sixth attempt incomplete as well. He repeatedly reëmployed his old canvases without scraping them down; X ray has revealed as many as three separate pictures on one support. Sometimes he failed to remove the titles and dates originally inscribed on the backs of these canvases, and this adds much confusion to the analysis of his work. For example, there are six or seven pictures at Island Heights—mug-and-pipe still lifes, fruit pieces, and one picture (plate 87) of Peto's beloved Lincoln engraving tacked across the Pfleger stretcher—which bear on their backs the title *The Old Mill.* This title also appears on several landscapes representing a mill, and it is very likely that X ray would bring out different versions of that landscape on the canvases just cited.

These things, obviously, are evidences of isolation and failure—and exasperation, if not something worse, seems clearly apparent in Peto's selling an immense stack of his paintings, in varying stages of completion, to one of his neighbors, James Bryant, who had a summer place at Island Heights. (These paintings are now in the homes of Bryant's son-in-law, Howard Keyser, Jr., of Red Bank, New Jersey, and of Mr. Keyser's children, Howard, Cheston, and James Keyser, and Mrs. William Wood, in Island Heights and Philadelphia.) But it would be a mistake to assume that Peto disintegrated or that his skill or the quality of his painting deteriorated

in his last years. An astonishing number of his finished pictures, including some of his finest works, are dated 1904, which must have been an exceedingly active year for him, and at Island Heights there is a very good landscape of Harpers Ferry made in 1907, the last year of his life.

VII

AT EVERY stage in the study of Peto's work new difficulties emerge. The majority of his known canvases are unfinished, unsigned, and undated, and many are in exceedingly bad condition. Many others have been lost or destroyed. Harnett's work can be documented with dated paintings from every year of his career, and a reasonable, progressive survey of his achievement can be made; in the case of Peto, however, we are presented with a disorderly heap of pictures, most of them painted after his removal to Island Heights in 1889.

Most of Peto's recurrent motifs have been described. In addition to the rack and patch picture, he specialized in still lifes of mugs and pipes (plate 86), worn old lamps (plate 89), books (plates 17, 18, and 88), musical instruments, pistols and powder horns (plates 14 and 15), and five-dollar bills. He took great delight in the most ordinary objects— torn envelopes, a latch that fell off his own gate (plates 14, 15, and 91), burnt matches and cigarettes, dog-eared dinner checks, bookmaker's tickets, broken hinges, cracked slates, rusty horseshoes, and engravings ripped from magazines. There is also a marked rustic quality in much of Peto's work. He never tired of painting a farmer's large, worn, straw hat, along with a market basket or a carpet bag and a huge, ancient umbrella (plate 85), and, quite unlike the completely urban Harnett, he often painted rural landscape.

There are also many paintings by Peto—notably the racks—which are fantastic in the extreme. These run a gamut from the wise-cracking journalistic humor of "Garibaldi McFod" to an expression which is as tragic as it is bizarre, disturbing, and from a literal-minded point of view, incomprehensible

(plate 92). Furthermore, Peto used certain motifs, especially the torn-off label, metal number plates, and portraits of Lincoln, to an obsessive degree. I am very wary of the psychoanalysis of artists on the basis of their iconography, but I suspect that the Lincoln portrait was allied in the artist's unconscious mind with recollections of his father. The older Peto had served in the Civil War and had told his son many tales of his experiences at that time. At Island Heights there is still a bowie knife which, according to family tradition, Thomas Hope Peto picked up on the battlefield at Gettysburg, and which bears dark stains said to be blood. The son who never lived with his father often used this for a model, sometimes dangling ominously above the Lincoln engraving.

It does not take a Freudian psychologist to perceive that Peto's concern with used-up, discarded, and rejected things parallels his own life. This has gently poetic implications which are perhaps most obvious when one studies Peto's rack pictures as an isolated group.

Peto is especially the master of the rack. Only Harnett, among his contemporaries, seems to have dealt with this motif at all, and Harnett could not have produced more than a few examples of it. Peto, however, painted innumerable canvases of this type, with their "arbitrary juxtapositions of unrelated objects."

As already indicated, Peto's early rack pictures seem to have been turned out as office boards for the adornment of specific places of business. These works—the known examples date between 1879 and 1885—all employ very elaborate racks, sometimes involving as many as twelve tapes in a highly complex grid. Flat papers are laced through the tapes in the most careless and offhand fashion. Some of these papers are letters and postcards addressed to the artist himself, but more often the "mail" is addressed to the people for whom the pictures were painted. There are also, very often, photographs of these people, as well as their business cards, letterheads, calendars, or placards, and, if they are newspaper proprietors, the mastheads of their publications. Running throughout the early rack pictures are certain persistent motifs which have no apparent relationship to the particular offices for

Arbitrary Juxtapositions, Unrelated Objects

which the paintings were created. All show the torn-off label, and many show ragged, tattered newspaper clippings, tacked or pasted to the board in the free space outside the rack itself. In the free space one may frequently see loops of string, as in the only known example of this pictorial species by Harnett. A little green pamphlet, always folded but always inscribed with enough visible lettering to indicate that it is the annual report of some society or corporation, appears often in the meshes of Peto's early racks, and a copy of the *Public Ledger Almanac* is frequently suspended from a nail (plate 83); the report booklet and the almanac vary in date according to the year in which the picture was painted. An envelope, bright tan in color and printed with the legend "Important Information Inside," is a frequent member of the pictorial cast (plates 19, 45, and 83); so are a little green ticket reading "Dinner Check" and certain greeting cards decorated with floral designs—a card with a wide black border and small white or pink flowers, one with a gray border and a rose, and one with a bright blue border and a spotted lily. This constant repetition of a few pictorial ideas seems at first rather odd, but as one studies the field with which this book is concerned, one realizes that repetition of motif is a prime characteristic of the still life painter's mentality, whether that painter be Velvet Breughel, Claesz, Heda, Kalf, Colyer, Chardin, Peale, Francis, Harnett, Peto, Haberle, Goodwin, or Pope. Perpetual rearrangement of the same few models is a major part of the still life game. One comes at length to expect it as perfectly natural and to be unhappy if it is not exhibited, for it is of the essence of the great tradition.

The early rack pictures by Peto (plates 19, 45, and 83) are quite specific in their description; postage stamps, business and greeting cards, and the exceedingly fancy cover of the almanac are all set down in full and complete detail. Except for the torn-off labels, a broken tape here and there, and an occasional dog-eared envelope, there is relatively little dilapidation.

No Peto rack pictures dated between 1885 and 1894 are known to exist. When the theme is picked up again after the nine-year hiatus it has changed markedly (plates 4–7). The rack itself has been reduced from a complex grid to the much simpler form of the X inside a square which Harnett had used in his painting of August 26, 1879 (plate 46), and the tapes are much broader and more powerful in their linear design. It is very likely that Peto is indebted to Harnett for this development. As we have seen, Peto owned a photograph of the Harnett which he may have taken himself; I found the negative for it in his studio in Island Heights two years before Harnett's actual canvas came to light. The Harnett contains an envelope inscribed "To the lad[y o?]f the house," while the Peto patch picture of 1897, now in the Wadsworth Atheneum, exhibits, in addition to its bowie knife threatening to decapitate Abe Lincoln, an envelope inscribed ". . . of the House." It is difficult to believe that Peto carried that phrase in his head for eighteen years before setting it down on a canvas of his own. It is more likely that he became acquainted with the Harnett, and took his photograph of it, more than a decade after it was painted.

In some of the late rack pictures by Peto, the door, which in earlier paintings has shown no metal work of any kind, bears fancy iron hinges, rather like those in Harnett's door pictures of the middle 1880's and later. These hinges, again like those of Harnett, are always rusty and broken; unlike those of the older painter, they have frequently rotted out of their moorings and have shifted upward or downward, leaving ghostly impressions of themselves on the wood. There is one quite astonishing work (Red Bank, N.J.: Howard Keyser, Jr.) wherein the tapes are tacked to a hinged door which is set within a door frame; at the top of the door is a horseshoe in the "bad luck" position which Harnett favored but which Peto usually avoided, and before it, standing on a ledge, are a pewter-lidded jar and a big book. Peto, in other words, has been studying Harnett's *Old Models.*

There are no specific references in these later rack pictures. They are not office boards. In place of business or greeting cards Peto now uses a Jack of Hearts and a bookmaker's ticket sometimes inscribed with a name like "Farmers' Club" under which the betting brokers carried on their illegal

Arbitrary Juxtapositions,
Unrelated Objects

trade.[3] Rather than portraits of merchants, chiropodists, and editors, the racks now consistently show portraits of Lincoln—especially (plates 4 and 92) the nicked, oval engraving by Buttre after Mathew Brady—but in one (the last known rack painting, plate 91), Washington takes the place of Lincoln. Very few of the envelopes in Peto's later rack pictures are addressed to anyone, and most of the books have blank covers. Considerably more attention is now paid to the free space on the door surrounding the tapes. This contains many more torn-off labels than formerly, and they are larger, more dramatic and more prominent. The envelopes are almost always torn and crumpled, and the books badly worn. The whole—this applies to Peto's later patch pictures as well as to his racks [4]—is likely to be a symphony of tatters, scuffs, frayings, and tears, fabulous in its precarious, asymmetrical design and highly mysterious, but generally quite somber in its emotional tone.

VIII

It is impossible to discuss a painter's technique as a thing apart, without reference to his subject matter and compositional predilections; nevertheless it is clear that Peto's craftsmanship underwent a long development in which one may distinguish at least two and possibly three distinct stages. These merge gradually with each other, but in the later stages there are lapses due to haste and carelessness. As a result of these lapses the story of Peto's stylistic evolution is not so clear as that of Harnett, who never had to use a canvas more than once, who sold practically everything he painted, and was never forced to turn out anything like the dim Peto of a sign-

board, reading "Hoogenstyne for Shoes," which Cheston Keyser properly keeps concealed from view in his house at Island Heights.

M. Canonge and other critics to the contrary notwithstanding, Peto was never essentially concerned with *trompe l'oeil*. He often achieved it, but mainly as a by-product of other interests. His earlier works are relatively loose and stringy; in his earliest known canvas, a still life of fruit, a vase, and a statuette on a table top dated 1875 (Philadelphia: James Keyser) the drawing is lopsided and the white highlights are loaded on in a fashion that can only be described as amateurish. The subject matter of this picture is extremely conventional, of a type which any ordinary nineteenth-century still life painter might have chosen, and its composition is haphazard. In subject matter and composition, the office boards and book pictures of the early 1880's are far more individual, but there is a slapdash quality to them which sets them quite apart from Peto's later achievements on the same themes. As we have seen, an effort was made at one time to defend the Harnett ascription of the Peto forgeries by employing early Petos as a standard of comparison, but this line of reasoning breaks down when one looks at Peto's work as a whole.

The most striking characteristic of Peto's mature style—one for which Harnett, mistakenly, received much praise—appears fitfully in pictures painted as early as 1880, but it does not emerge in its fullest manifestation until the following decade. That is the extraordinary muted radiance of his color; it has a soft, powdery kind of texture which has caused more than one critic to invoke the name of Vermeer. This Vermeer-like texture appears uniformly throughout the entire canvas; leather, metal, paper, porcelain—all are approached and rendered in the same way. Texture provides one of the crucial distinctions between Peto and Harnett, "whose brass *is* brass, whose wood *is* wood," and whose paintings are masterpieces of realistic tactile differentiation. By the same token, Peto is much less interested in describing specific details than is Harnett, except in his early office boards. As Sheldon Keck has pointed out, the books in Peto's still lifes are all untitled, while Harnett's books usually display their names.

[3] The Farmers' Club was actually one of the oldest, most highly respected social organizations in Philadelphia. Professional gamblers apparently adopted its name as a kind of ironical mask.

[4] The slight and not too meaningful distinction between "rack" and "patch" picture has already been given, but it might be worth giving again. A patch picture is a rack picture without a rack; in other words, it is a painting in which the flat objects depicted are pasted directly to a board or door. Peto himself seems to have invented this terminology.

Arbitrary Juxtapositions, Unrelated Objects

Similarly, the edges and contours of the objects in Peto's paintings are likely to be a little heavy, or "woolly," as Lloyd Goodrich puts it, and the placement of the objects in space is likely to be somewhat ambiguous. The flow of air around and behind objects is always very precisely rendered by Harnett except in a few of his earliest pictures; to reiterate, perhaps unduly, one always knows precisely where a thing *is* when Harnett paints it, and how it relates to the other things represented. It took Peto a long time to master space in this fashion, but he ultimately did master it, as in the Smith College *Discarded Treasures* (plate 17), which, I am convinced, was not painted until well after the turn of the present century, even though its subject matter is imitated from Harnett's *Job Lot Cheap* of 1878 (plate 3).

Peto, in other words, is much less a realist than Harnett, and, as Mr. Goodrich has observed, his work is closer to modern painting.

In general [says Mr. Goodrich, in the *Art Bulletin* for March, 1949], Harnett seems to belong to an older tradition than Peto—the tradition of the Peales and of mid-century naturalism, with the object paramount, everything conceived in the full round and in three dimensions, the vision precise, the technique sure and firm.

Peto belongs to a somewhat later school. He thought a good deal more about light than Harnett did, and about the decorative quality of light and shade. His light is usually more direct and concentrated, generally from a single source, as if from one window, sometimes even resembling modified sunlight, and his shadows have sharper edges than Harnett's. He made a good deal of play with dramatic contrasts of light and shade. There were certain pronounced mannerisms in his handling of light. He liked to have light catch one side or edge of an object, contrasting strongly with the shadow over the rest of the object and with the dark background. He made his light simplify objects, dividing them into broad areas of light and shade, with a relatively sharp dividing line and little halftone. Upright objects, such as vases, mugs, candles and candlesticks have a strong light down one side and a deep shadow down the other, the light going out to the edge and silhouetting the whole light side of the object and at the same time unifying it. The whole lighted side tends to be somewhat flat, and the lightest light is often near the outer edge.

Mr. Goodrich's observations, like those of Mr. Keck (see p. 18), were written at a time when the differential diagnosis between Peto and Harnett was a matter of paramount concern. The question of the

forgeries having been settled, attention was turned toward Peto himself as a figure of much interest and importance in his own right, and he was given his first one-man show, forty-three years after his death, at Smith College, the Brooklyn Museum, and the California Palace of the Legion of Honor in the spring of 1950. At that time many of his works passed through the hands of John I. H. Baur, then curator of painting and sculpture at the Brooklyn Museum, who was moved to write a critical appreciation of Peto *per se* for the *Magazine of Art* (May, 1950). Many of Mr. Baur's remarks are well worth reprinting here.

From early in his career, Peto was sensitive to the new impressionist vision which was gradually seeping into American painting at about this time. We do not know what contacts he may have had with this, but its influence is quite apparent in most of his work, as several critics have already pointed out. It caused him to relax that intensity of observation which the *trompe l'oeil* group had used to create a sense of preternatural significance, and to abandon the exact description of texture, weight and density. The object, with Peto, is no longer paramount; it is bathed in palpable light and atmosphere, half lost in shadow and wholly transformed by the conditions of seeing. The forms are softer, nearly blurred, the brushwork freer and looser. Texture, as Mr. Frankenstein points out, tends to become uniform throughout. The degree to which Peto accepted the new visual realism varied greatly, however. At the conservative extreme are a few pictures like the *Pipe, Mug and Newspaper* [plate 86] cited above, at the other is the extraordinary *Self-Portrait with Rack Painting* [plate 90] broadly brushed with much broken color, like the touches of pink, yellow, green and blue in the folds of the white shirt. Needless to say, these are both atypical; the majority of Peto's works explored a rather wide middle range between. . . .

But it was in respect to design, space and color that Peto departed most radically from the tradition in which he had been raised. His instinctive feeling for strongly marked, abstract patterns of simple volumes, subtly related, has been remarked by everyone who has had an opportunity to study his work as a whole. While he was uneven in this, as in most other respects, his best work has a closely knit architectural quality quite unusual for its time and quite different from the more casual compositions of his contemporaries. This is most apparent in certain rectilinear, almost geometrical designs, such as that of the Minneapolis Institute's *Reminiscences of 1865,* but it also underlies his most fluid and non-geometrical pictures like *Lincoln and the Star of David.* Though these are entirely different in the character of their shapes, they show Peto's abiding preference for asymmetrical arrangements brought into balance by an innate feeling for

III

Arbitrary Juxtapositions, Unrelated Objects

the poetry of intervals and formal relations. Doubtless it was his fascination with this kind of flat design that led him to paint so many "rack" and "patch" pictures.

Even when Peto turned to three-dimensional subjects, he often preferred to compress them into virtually flat compositions. It then became necessary to destroy the carefully defined space of the *trompe l'oeil* tradition, and this he did ruthlessly in a number of ways. In *Lamps of Other Days* for instance, the eye-level is exactly that of the shelf, so that only the edge of the latter and none of its retreating surface is seen. Light emphasizes the abbreviated depth thus created. It plays strongly on the front surfaces of the objects, while receding forms are deep in shadow. The retreating wall at the left is also shadowed, its juncture with the back wall nearly invisible. The elaborate flat design is almost freed from the objects, utilizing only a little of this one, a part of that, and setting up a strong tension between its independent flatness and the suppressed illusion of depth. While this picture is typical of many Petos, it is not so of all, for the artist occasionally returned to a more traditional handling of space. . . .

In general Peto used three rather different color systems. One, a rich harmony of many hues, was closest to the *trompe l'oeil* tradition and is often found (though not always) in those pictures, such as *Old Scraps, Discarded Treasures* or Mrs. Smiley's *Books on a Table,* which are also closest to that tradition in composition and use of space. In his flat designs, however, the artist frequently limited his palette to different shades of a single color or, more usually, two colors, thus emphasizing the formal structure—somewhat as the cubists were to do later. Brown and green was a favorite combination, sometimes with white and gray added; *Reminiscences of 1865, Lamps of Other Days, Lincoln and the Star of David* and *The Cup We All Race 4* are duochromatic studies in this range. Finally, as if impatient with the relative severity of his two-color harmonies, Peto occasionally disrupted them with sudden loud color chords like the adjacent red label and blue book which ring so effectively against the subdued background of the *Bowie Knife, Keyed Bugle and Canteen.* Pictures of this sort are rarer but must be counted among his most original efforts.

It is plain, then, that Peto, while working within the general limits of our native *trompe l'oeil* tradition, broke with it eventually in nearly every important respect except perhaps that of iconography. His revolt was partly a reflection of large forces then transforming American art in many fields, but to a greater extent it seems to have sprung from a personal vision quite remarkably in advance of its time—a vision which found delight in building both the simplest and the most complex relations of form and color.

The *Self-Portrait with Rack Painting* which Mr. Baur singles out because of its "broadly brushed . . . broken color" and its "touches of pink, yellow, green and blue in the folds of the white shirt" is, so far as anyone knows, the most strongly impressionistic picture which Peto ever painted. I have a private, highly speculative theory to explain its unique character.

The self-portrait is signed and dated 1904. It shows the artist seated on a chair before an easel on which is a rack picture employing an oval portrait of Washington. This work, as it appears in the self-portrait, is in the same free, vibrant style as the rest of that painting, but appears very decidedly to be unfinished; it is, in fact, scarcely more than a sketch or blocking-out. After Mr. Baur's article was published, a dealer discovered a painting (plate 91), now in the collection of Nelson A. Rockefeller, which seems to be the very picture that stands on the easel in the self-portrait. This canvas, signed and dated 1906, is obviously finished and bears no trace of impressionism or free brushwork, but is in the artist's Vermeer-like manner, with all traces of the brush carefully concealed.

Of course, we cannot be sure that Mr. Rockefeller's picture is actually the one which appears in the background of the earlier painting; Peto turned out many near replicas, and we may be dealing here with one of them. But if the rack picture shown in the self-portrait of 1904 is really the same as the one in Mr. Rockefeller's possession, it is by no means inconceivable that its sketchy condition at that time may have determined the character of the self-portrait as a whole. If so, Peto's self-portrait provides us with a most interesting definition of the impressionistic process as seen from a vantage point on the New Jersey shore.

Entirely with the Brush and with the Naked Eye

JOHN HABERLE

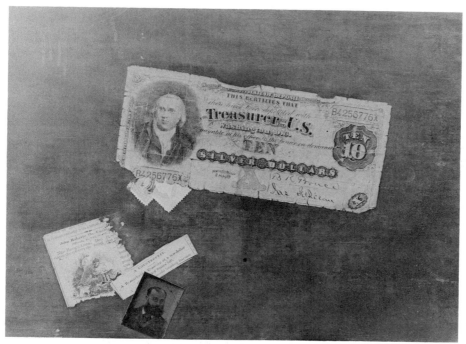

93

John Haberle
Reproduction circa 1888 (9½ x 13)
Formerly collection G. G. Wade, Cleveland

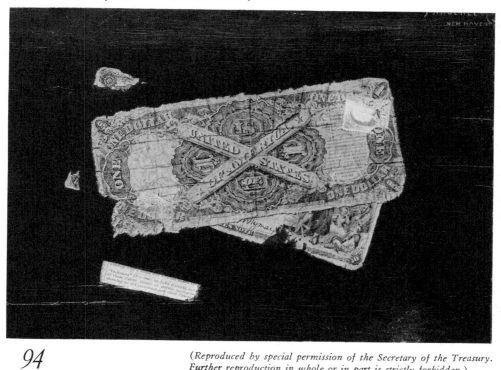

94

John Haberle
U.S.A. 1889 (8½ x 13)
Marvin Preston, Detroit

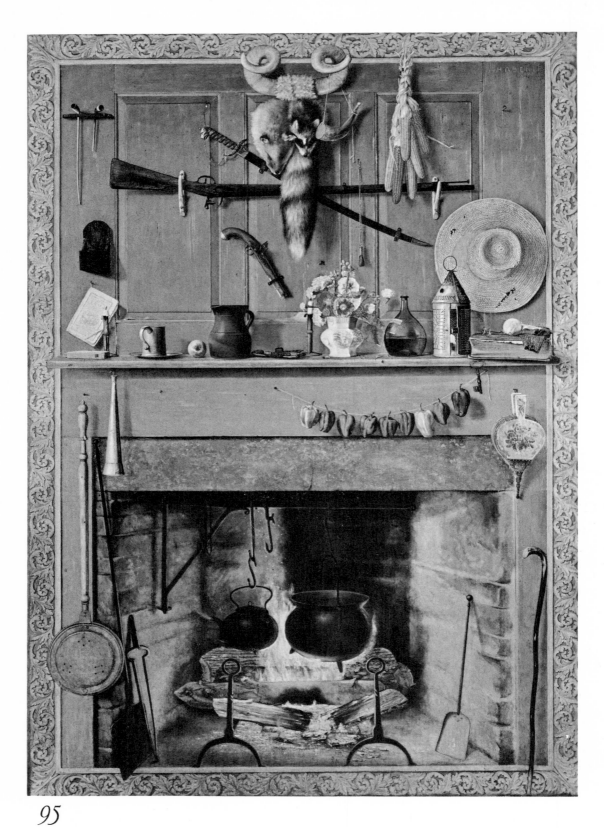

95

John Haberle
Grandma's Hearthstone 1890 (96 x 66)
Detroit Institute of Arts, Detroit, Michigan

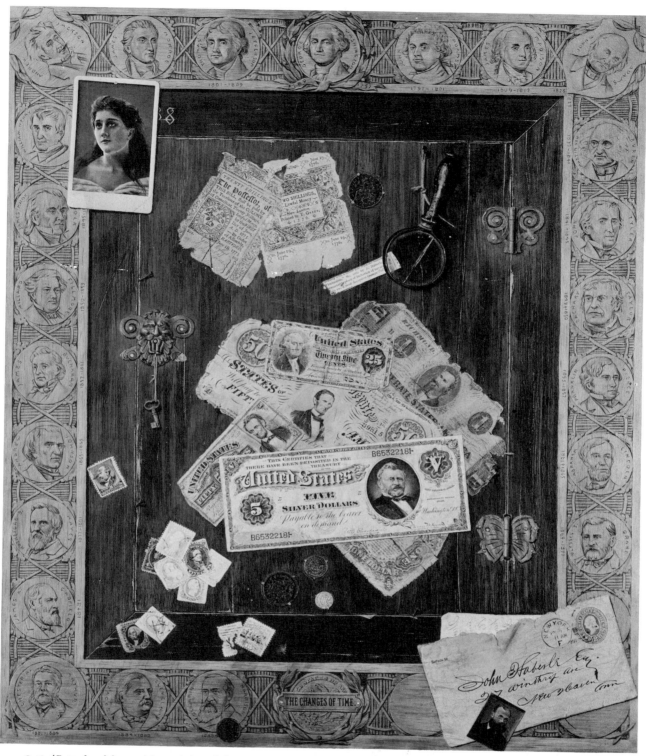

96

John Haberle
The Changes of Time 1888 (23¾ x 15¾)
Marvin Preston, Detroit

97

John Haberle
Torn in Transit (14½ x 20¼)
Formerly collection Edwin Hewitt, New York

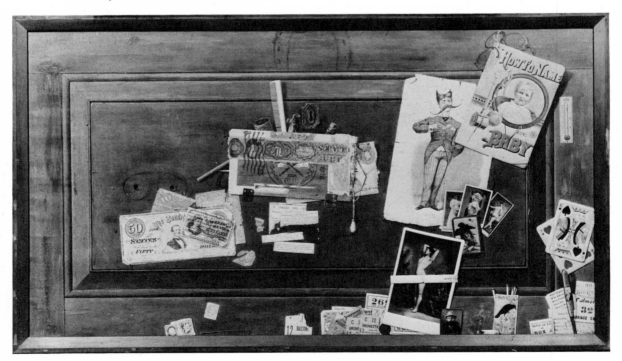

98

John Haberle
A Bachelor's Drawer 1890–1894 (20 x 36)
Mr. and Mrs. J. William Middendorf, New York

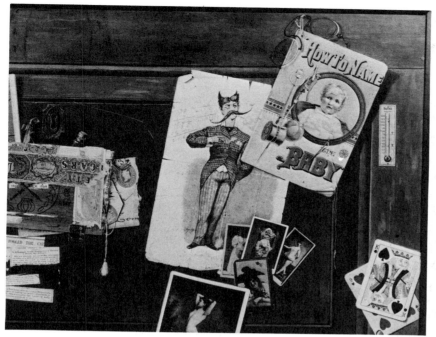

99

John Haberle
Detail of *A Bachelor's Drawer*

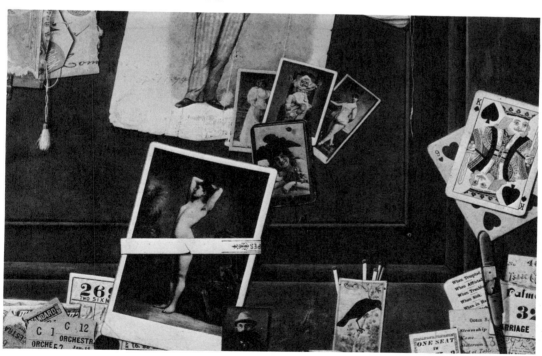

100

John Haberle
Detail of *A Bachelor's Drawer*

101

John Haberle
Clock (26 x 15⅜ x 3¾)
Hirschl and Adler Galleries,
New York

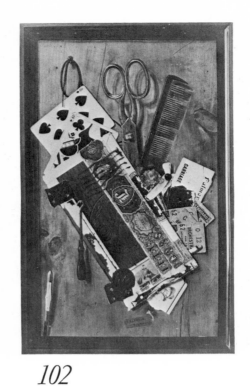

102

John Haberle
Conglomeration
(photograph of lost painting)
1889

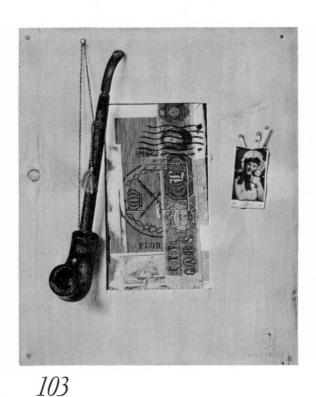

103

John Haberle
A Favorite circa 1890 (14½ x 11½)
Museum of Fine Arts,
Springfield, Massachusetts

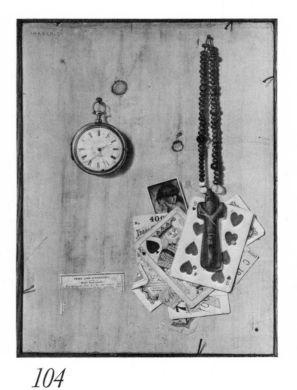

104

John Haberle
Time and Eternity (14 x 10)
Art Museum of the New Britain Institute,
New Britain, Connecticut

\mathscr{S}URREALISM is the first word that comes to people's lips when you show them paintings by John Haberle. This reaction is instantaneous, automatic, and almost invariable, but it is not altogether correct. For surrealism, by definition, is concerned with mysterious congruities beyond the incongruous, and Haberle's game is to bestow fantastic consequence on the inconsequential. Where some of his contemporaries fling their bold artistic challenge in the face of the vast grandeurs of the Rockies, Haberle fishes a comb, a ticket stub, or a canceled stamp out of his own side pocket and bids us marvel at *that*. In this respect he is somewhat akin to Peto, but there is a major difference between the two. Peto is romantically moved by the pathos of used-up things. Haberle is wry and wacky, full of bravado, self-congratulating virtuosity, and a kind of sly flamboyance.

Until the present writer's work began, Harberle was known to the art world solely through two small *trompe l'oeil* paintings in the Springfield Museum of Fine Arts, where they were catalogued as works of "J. Haberle, XIX Century, American." The list of his known pictures can now be expanded from two to forty-odd—unquestionably a small fraction of his output, but enough to serve as the basis for a preliminary sketch, especially when pieced out with the seven works which survive in photographs and with the scant but not hopelessly meager documentation I was able to find.

No one knew where Haberle had lived, and if it were not for the fact that the Art Institute of Chicago keeps its exhibition records in the form of a card-index file, Haberle might have remained as mysterious as Dubreuil or F. Danton, Jr., but in searching the Chicago records for the name of Harnett (which was not to be found there), I accidentally turned up a nearby card on which was written "John Haberle, 27 Winthrop Avenue, New Haven, Connecticut," and the titles of three pictures by this artist which Chicago had seen in 1888, 1889, and 1890. I proceeded eventually to New Haven, and in the files of the *Register* of that city I found an obituary notice stating that John Haberle had been born in New Haven in 1856 and had died there, at 81 Cove Street, on February 3, 1933. The obituary went on to say that Haberle had studied at the National Academy of Design in New York, had been employed for a time by Othniel Charles Marsh, the famous Yale paleontologist, and was survived by two daughters, Vera Haberle and Mrs. Anthony M. Fresneda.

The New Haven telephone directory then current showed that Mrs. Anthony M. Fresneda was still living at 81 Cove Street—and then the fun began. For Mrs. Fresneda and Miss Haberle were most kind, and the Cove Street house was full of paintings, clippings, and other memorabilia. The clippings were the springboard for exploratory expeditions to Detroit, Cleveland, Chicago, and Boston, and the total result was a reasonably full and accurate picture of what Haberle had done.

II

Trompe l'oeil still lifes in painted line, with a minimum of modeling and no exploitation of color or tone except for purposes of strictly local description, appear very early in the history of illusionistic art. They are usually executed in watercolor, and their subject matter is largely confined to flat or extremely shallow objects flung all over a two-dimensional picture space in a spirit of high comedy. Although Haberle worked in oil rather than watercolor, he is the greatest American master of this tradition, which is poles apart from Harnett's sumptuosity, careful balances, well-modeled volumes, and great concern for three-dimensional space relationships. It is equally far from Peto's sensitivity in the matter of color. Among the very few American paintings which anticipate Haberle's manner are Raphaelle Peale's patch picture for Dr. Physick (plate 43) and the rack by Goldsborough Bruff, but Haberle brings to the style a grandeur of exaggeration, an all-out fanaticism, that are unique among its practitioners.

An article about Haberle published in the *Illustrated American* for December 30, 1898, informs us that as a student he was unable to afford models and therefore trained himself by making sketches of his

own hands, arms, and legs; that he worked for Marsh before he began to paint; that he exhibited for the first time at the National Academy of Design in 1887; and that the picture he sent to the National Academy show was bought by Thomas B. Clarke.

A beautifully correct drawing labeled *Haberle's Left Hand,* dated 1882, is preserved in New Haven. The next bit of evidence of the artist's activity is a listing in the catalogue of the autumn exhibition held at the National Academy in 1887: "No. 362, *Imitation,* by John Haberle." Now, in 1887 Haberle was thirty-one years old, and since he is said to have come from a poor family, he must have been earning his own living for some years. Marsh was at the height of his career in the late 1870's and early 1880's, and it is very likely that Haberle worked for him at this period. One is tempted to trace the minute precision of Haberle's achievement as an artist to an early discipline in scientific illustration (just as one traces at least some part of Harnett's precisionism to his youthful training as a silver engraver), but although many of the drawings published with Marsh's books and articles are credited to the artists who made them, Haberle's name is completely absent from those pages. He seems actually to have been employed by Marsh as a "preparator"—i.e., a craftsman who cleaned fossils, mounted skeletons, made plaster casts of bones, and did other work of that kind.

Haberle's National Academy picture of 1887 is described in the catalogue prepared for the exhibition of the Thomas B. Clarke collection at the Pennsylvania Academy of the Fine Arts in the fall of 1891:

John Haberle: *Imitation.* An assortment of familiar objects—bank notes, fractional currency, coins, postage stamps, etc.—painted with microscopic detail and descriptive imitativeness of observation and skill. Signed as a printed label at the bottom.

The high importance of the bank note as a motif in nineteenth-century American still life has already been indicated. As we have seen, the bank-note picture has been interpreted as evidence of the American love of filthy lucre, but we have also seen that this interpretation is quite untenable. Haberle,

in all probability, was devoted to this subject because he was infuriated by its illegal status.

In 1888 Haberle exhibited a painting called *Reproduction* at the Art Institute of Chicago. This work (plate 93), now in the collection of G. Garretson Wade of Cleveland, shows a ten-dollar bill, two postage stamps, the tintype self-portrait which this artist often used by way of signature, and two newspaper clippings. The more significant of these clippings is painted as if badly torn and little of it can be read, but that little is quite revealing.

It consists of the last two lines of a news story followed by an ornamental rule; then come the heading and the first lines of another story illustrated with a little half-column cut. The lines above the mark of division read: "of work of the kind yet . . ." and "it is done entirely with a brush." Below the dividing-line is the following fragment: "John Haberle the Counter . . . / (Special to the World) / New Haven, Conn., Dec. 12— . . . / ceives the eye into the belief that the . . ." Underneath this is the cut, showing a man with a black beard like Haberle's working at a table by the light of a lamp, with a ludicrously criminal pistol and dagger hanging on the wall over his head.

The second clipping is slightly different, typographically speaking, and therefore suggests a different source. It consists of three lines of heading and one line of story: "A Counterfeit. / A Remarkable Painting of a ten-dollar / sil . . . ited States' Bill. / A . . . would humbug Barnum."

All the newspaper clippings in the paintings of Haberle, like those of Chalfant but quite unlike those of Harnett and Peto, are legible; furthermore, Chalfant's and Haberle's clippings are always in praise of the artist. The originals of the clippings in every known painting of Haberle but this are preserved in the Cove Street house, carefully pasted to cardboard mounts. Here, the painted clipping date-lined December 12 plainly imitates the typographical style which the New York *World* followed between 1883 and 1888; but the *World* did not use half-column cuts at that time, and, what is much more important, no such story was ever printed by that newspaper. This, of course, is as it should be. A newspaper story about painted counterfeits ought itself to be a counterfeit, but there was obviously something other

*Entirely with the Brush
and with the Naked Eye*

than a mere pleasantry behind this fabrication.

In all probability, what lay behind it was Harnett's notorious, widely publicized arrest for counterfeiting in the winter of 1886. Haberle himself seems to have had the same kind of trouble. One of the clippings preserved in his house states that "the artist painted bank bills so accurately that the Secret Service men compelled him to desist"; the search for Jim the Penman, we may be sure, was not limited to Manhattan Island.

Harnett, apparently, painted no more money after the Treasury Department told him to stop. Haberle's similar warning seems only to have goaded him to produce more and better pictorial taunts. In 1889 Haberle sent to the Chicago annual a painting (plate 94) which bore the magnificently scornful and sarcastic title, *U.S.A.* Marvin Preston of Detroit now owns this canvas. It represents a dollar bill, frayed portions of a ten-dollar bill, a one-cent stamp, and a few lines in praise of *Imitation* which had appeared in a New York newspaper when that work had been exhibited at the National Academy. The dollar bill is seen face down, so that it flaunts, by way of a public announcement of unrepentance, the full and complete text of the official warning against the imitation of Federal currency which was then printed on the backs of all United States notes: "Counterfeiting, or altering this note, or passing any counterfeit or alteration of it, or having in possession any false or counterfeit plate or impression of it, or any paper made in imitation of the paper on which it is printed, is punishable by $5000 fine or 15 years at hard labor or both."

The Art Institute of Chicago, unlike the establishment kept by Theodore Stewart in New York, was not a favorite hangout for agents of the Secret Service. That, perhaps, is why Haberle experienced no legal difficulties so far as *U.S.A.* was concerned, but this picture landed him in an altogether different kind of trouble, stirred up by one of the Art Institute's habitués. *U.S.A.* had not been hanging long in Chicago when the art critic of the *Inter-Ocean* expressed himself as follows:

There is a fraud hanging on the Institute walls concerning which it is not pleasant to speak. It is that alleged still life by Haberle, supposed by some to be a painting of money. A $1 bill and the fragments of a $10 note have been pasted on canvas, covered by a thin scumble of paint, and further manipulated to give it a painty appearance. A glass has been put over the "painting" since the writer of this picked loose the edge of the bill. That the management of the Art Institute should hang this kind of "art" even though it were genuine, is to be regretted, but to lend itself to such a fraud, whether unwittingly or not, is shameful.

Haberle heard about this newspaper story, presumably through his relatives in Chicago, and took the first train west, with blood in his eye. On July 3, 1889, the Chicago *Daily News,* the *Inter-Ocean's* rival in the afternoon field, gleefully reported that the painting had been examined by experts in the presence of the artist and his accuser. "The lens was used, the paint was rubbed off, and the whole ingenious design proved really a work of imitative art, and a most excellent one. Both bills were painted, the stamp was painted, and the newspaper clipping was painted."

Four days later the critic of the *Inter-Ocean* handsomely ate his dish of crow, and called upon an unexpectedly high authority to join him in his confusion:

Just how the writer of the notice came to be deceived in the matter is of no particular moment, for he recognizes the fact that he has no business to be affected by the statements of others, and he has nothing to plead in justification. The deception, however, does not appear strange when one has seen the painting. A record of the disputes over the genuineness of Mr. Haberle's paintings would prove amusing reading. Better informed and more astute men than the writer of the notice have been taken in, notably Eastman Johnson, the dean of American figure and genre painters, who had a very serious time proving to himself that Mr. Haberle's paintings were what they purported to be.

(Many years later, as we have already seen, Marcel Duchamp, master of collage, "had a very serious time proving to himself" that the sheet music in a painting by Chalfant was *not* what it purported to be.)

III

HABERLE'S MOST ambitious money picture is *The Changes of Time* (plate 96), for which he asked the

Entirely with the Brush
and with the Naked Eye

exceptionally high price of $2,200 when it was shown at the Pennsylvania Academy of the Fine Arts in 1890. Along with *U.S.A.* and several other Haberles, this work came shortly into the possession of a Detroit business man, Marvin Preston, whose like-named grandson has his collection today. To a light gray door are pasted many types of American currency, from a Connecticut Colony twenty-shilling note of 1773 through various types of Federal greenbacks and Confederate notes down to a five-dollar bill of the series of 1886. There is a similar progression of coins and postage stamps, including one from Canada, and some of the stamps are pasted across the bottom crack of the door. There is also a hair-raisingly problematical key escutcheon in the form of a grinning brass satyr head which is firmly nailed across the crack at the left. Balancing the key escutcheon, at the right, are two brass hinges, one in the form of a butterfly and the other in the form of two scrolls, back to back. Toward the top of the door a cracked magnifying glass with a worn black handle rests on still another (carefully edited) notice of the National Academy picture: "entirely with the brush and with the naked . . e / 'Imitation,' No. 362, by J. Haberle . . . a / . emarkable piece of imitation of natura . ob- / . ects and a most deceptive *trompe l'oil.*" (This is a pastiche of at least two different notices. The last line, with its misspelled French word, appeared as follows in the New York *Evening Post:* " 'Imitation,' No. 362, by J. Haberle, a small canvas which, without being in any sense a work of art, is a remarkable piece of imitation of natural objects and a most deceptive *trompe l'oil.*") [1]

The door has its own frame, and on it, at the upper left, is a "cigarette picture" of a woman covering part of the date, 1888, which has been painted as if it were incised in the wood. At the bottom, in the crack between the door and its frame, a small piece of paper protrudes.

The frame around the entire picture is painted and is an integral part of the canvas. The faces of all the presidents from Washington to Benjamin Harrison, identified by their names and dates of administration, appear on it as if carved in wooden medallions, but in a very curious order. Washington is in the center at the top, flanked by Jefferson and Adams, and the subsequent presidents alternate, left and right across the top bar of the frame and criss-cross from one side bar to the other, until we get to Hayes, when they proceed in direct succession to Benjamin Harrison, who had just entered on his term of office at the time the picture was completed. There is a small coin over the lower part of the Harrison medallion. It has slipped from the place where it was originally tacked, just below and to the right of the cluster of six stamps on the lower part of the door, and there it has left a ghost image of itself.

The four medallions at the lower right corner are empty. They are partly covered by a violet-colored envelope addressed to Haberle in New Haven and postmarked in New York with the date, " '88." On top of this is the tintype self-portrait. The small corner of the letter which protrudes from the envelope is one of Haberle's most delicious feats of virtuosity; one can almost hear him chuckle with delighted self-approval as one studies it. No complete words are legible, but it is none the less apparent that the more boldly stroked letters are in mirror writing, while the interlined fainter letters are not. In other words, the paper is quite thin, the mirror writing is on the reverse side of its first sheet, and the fainter letters are on the obverse side of a sheet beneath. "Entirely with the brush and with the naked eye!"

Beside *The Changes of Time* and *U.S.A.,* the elder Marvin Preston owned a painting by Haberle of a palette, some brushes, and a palette knife, as well as a delightfully whimsical little picture of a thermometer, eternally registering a balmy 68 degrees, set in a frame painted to suggest very simple relief carving in wood, with naked children climbing vines, a flying bird, and a smiling, benevolent sun.

Preston managed a famous, handsomely furnished saloon known as Churchill's, which was the Detroit version of Theodore Stewart's. All his pictures hung there, but they were dwarfed by the Churchillian equivalent for *After the Hunt*—an immense work

[1] Observe that the *Post* critic goes out of his way to state the opinion that Haberle's picture is not a work of art, just as the critic of the *Inter-Ocean* had deplored the fact that such things, even if actually painted, were accepted by the Art Institute of Chicago. These criticisms, of course, reveal the professional distrust and dislike of *trompe l'oeil* which we have seen throughout this entire story.

Entirely with the Brush
and with the Naked Eye

of Haberle's that belonged to the proprietor of the establishment, Mr. Churchill himself, and in 1950 was presented by his daughter, Mrs. J. Q. Goudie, to the Detroit Institute of Arts. This painting (plate 95), eight feet high and five and a half feet wide, is the largest example of *trompe l'oeil* it has ever been my pleasure to see. It is called *Grandma's Hearthstone,* and it was produced on a commission from James T. Abbe of Holyoke, Massachusetts, under conditions of bravura described in the section of this book devoted to Harnett.[2] It was completed in 1890 after two solid years of work.

Unlike most of the known Haberles, *Grandma's Hearthstone* uses much tone and modeling. It represents a stone fireplace, with logs burning and kettles boiling, a mantel-shelf covered with pitchers, candlesticks, wine bottles, vases, lamps, a Bible on which rests an unfinished piece of knitting, a string of varicolored peppers, an apple, a crude toy flute, and similar objects, to say nothing of several crawling flies. Above the mantel hang guns, a sword, pipes, a salt box, a straw hat, coon skins, a string of dried corn, and so on. As in *The Changes of Time, The Palette,* and a lost picture of a little Japanese doll, known through a photograph, which likewise once belonged to Abbe, Haberle here makes much of a painted frame that participates in the pictorial action. A crooked old cane stands against this frame, a bed warmer and a coal shovel protrude from the fireplace and partly cover it, while the string of corn hangs from its upper horizontal bar.

IV

ABBE WAS not the only patron whom Haberle permitted to choose his own subject. Preserved at New Haven is the photograph (plate 102) of a lost painting which bears on its back the inscription, "With compliments, truly yours, Walter D. Jones. By order of Walter D. Jones, who designed same." And in Haberle's hand, "*Conglomeration,* 1889."

Conglomeration is the perfect title for it. The lid of a cigar box is held to a door with two crude leather hinges. A buttonhook hangs from this box top, and a pearl-handled knife sticks upright before the painted frame. Protruding from behind the box top is a jumble of things, including playing cards, a shoelace, a pair of scissors, a cigarette, a comb, and numerous theater tickets, while a small bouquet of flowers appears behind the ribbon which is tacked at one end to the box lid and at the other to the door and keeps the whole assemblage from falling apart.

The cigar-box lid of *Conglomeration,* with its studiously painted labels, canceled revenue stamps and burnt-in trademarks, reappears in Haberle's picture called *A Favorite* (plate 103). This time, however, it is not held to a door with hinges on one side and a ribbon on the other; it hangs, slightly askew, inside an oblong hole which has been cut in a broad white board, and it is held perilously in place by a single, slipping toothpick inserted in its edge at the right. A kind of trapdoor has been cut into the box lid; it is held at its top with a leather hinge, while at its bottom is a little loop of string with which to pull it open. To the left of the box lid dangles a richly colored meerschaum pipe. At the right-hand side of the board is a "cigarette picture" tacked down to act as a match holder, and several matches appear in this improvised case; on the board above their heads is clear evidence of match-scratching. The board as a whole is held down (presumably to the wall behind it) with screws at three of its four corners, but the screw that was once at the upper right has fallen out and the one at the upper left is obviously loose. The signature is not the usual tintype self-portrait but a crude, childish self-caricature of a kind Haberle sometimes employs. These Haberle caricatures, by the way, are startlingly similar to the little scrawly drawings which are part of a painting, *The Dead Cock,* by the seventeenth-century Dutchman, Melchior de Hondecoeter.[3] Folk art, as its chroniclers often remind us, stands apart from the influences of place and time, and children scribble in much the same way whether they be in Amsterdam, 1680, or in New Haven, 1880—but how many trained profes-

[2] See above, p. 83.

[3] Reproduced in Wolfgang Born, *Still-Life Painting in America,* plate 2.

sional painters before our own time could or would care to draw in childish style so sympathetically and so effectively as these two virtuosi of sophisticated literal realism?

A Favorite is one of many pictures Haberle is known to have sold at James Gill's art gallery in Springfield, Massachusetts. It was purchased in 1891 by Charles and Emilie Shean and formed part of the famous collection of *trompe l'oeil* pictures which the Sheans displayed for many years in the lobby of their Hotel Charles, and which came eventually to the Springfield Museum of Fine Arts.

One of the most curious of the Haberle documents in New Haven is a newspaper advertisement or handbill: "Policemen and firemen will be interested in the free exhibition of Haberle's famous realistic paintings which will be opened to the public on Monday, June 29, at Conway & Co's., 48 School Street, Boston. This exhibition is the private collection of Mr. Frederick McGrath and cost $10,000. The exhibition will continue several days."

Conway's was a liquor store, and Frederick Mc-Grath became its owner in 1889. Why he thought Haberle's pictures would be particularly appealing to policemen and firemen is far from instantly apparent. McGrath's assets, including his pictures, were ultimately taken over by liquor companies which went out of business with Prohibition, and their records no longer exist. Newspaper clippings show, however, that the McGrath collection included the inevitable Haberles of paper money, paintings of a pipe and a sack of tobacco, of one of the keys to Libby Prison, of a jumping jack, and *The Challenge*—"a duelling pistol of the old style and a belligerent note demanding satisfaction, which has been tacked up on the wall and used for a target." [4]

Other Haberles known only through the literature include a picture of a violin, painted for August Gemunder, a New York violin maker, using one of Gemunder's instruments as a model; *The Editorial Board,* exhibited at the National Academy of Design in 1889; *Can You Break a Five?,* shown at the Pennsylvania Academy of the Fine Arts in the same year; *Realistic,* which once belonged to James T. Ellsworth of Chicago; and a painting of a "marble bust of Washington surrounded by a screen on which are small pictures and letters": this last was owned for some years by Charles Scholl of New Haven.

V

IN THE Haberle house on Cove Street were three utterly incredible pictures. One is *The Bachelor's Drawer* (plates 98, 99, and 100), which is dated 1890–1894, and is one of the maddest paintings that has ever been created by the hand of man. It involves an indescribable chaos of theater stubs, stamps, old bank notes, bookmaker's tickets, cigarette pictures, playing cards, the cigar-box lid, a photograph of a nude woman modestly draped with a paper band from a package of envelopes, a caricature of a moustachioed man torn from a magazine and covered with painted doodles, a comb, a corncob pipe, some matches, a burned-out cigarette, a pocket knife, an old letter, the tintype self-portrait, and, to top it all off, a slip from a Gideon Bible and a large, fancy

[4] Two Haberles came to light in an antique shop on a highway near Boston in the summer of 1951. One of these represents a long-stemmed clay pipe and a sack of tobacco hanging against a door, and is, presumably, one of the pictures that belonged to Frederick Mc-Grath. The other painting (plate 104) is highly irreverent in subject matter, and if McGrath possessed it, he would scarcely have advertised that fact, especially to the police of Boston. Its background is a worn pine board. On this, at the upper left, is a watch. Below the watch is a newspaper clipping with the headline "Time and Eternity" and the subhead "Bob Ingersoll." Two lines of the news story are indicated; they read, "Providence, July 4—In the county jail . . . awaiting trial . . ." Hanging from a nail at the right of the picture is a string of rosary beads terminating in a worn, primitive-looking crucifix. The crucifix lies on top of a conglomeration of papers, including play-

ing cards, a cigarette picture, a theater ticket, a bookmaker's ticket, part of an insurance policy, and a receipt issued by a pawnbroker whose first name was Isaac.

Philip Claflin of New York tells me that during his student days at Harvard, in the 1920's, he saw a table-top still life by Haberle in the window of an antique shop in Boston. Mr. Claflin took his friend, Bernard Faÿ ("later head of the Bibliothèque Nationale, and later still imprisoned for life for collaboration with the enemy and no longer a friend"), to see it. M. Faÿ wished to take it back to Paris with him as a present for Picasso or for Gertrude Stein, but the transaction somehow fell through.

In the Boston Public Library Mr. Claflin found a story to the effect that "intimates of Grover Cleveland, in the spirit of practical joking, persuaded Haberle to paint a five-dollar bill on a library table at the White House. When the President happened to pass, he, of course, tried to pick it up." Another version of this folk tale—the one about J. D. Chalfant and his five-dollar gold piece painted on the top of the bar in Wilmington—has already been cited in our section on Peto.

Entirely with the Brush
and with the Naked Eye

book entitled *How to Name the Baby*. There are also the usual newspaper clippings, including one headed "It Fooled the Cat" the original of which appeared in the New Haven *Evening Leader* in 1893 and told how, when *Grandma's Hearthstone* was first put on view at Churchill's, the house cat curled up in front of it as before a real fireplace— a new version of a folk tale which is as old as painting itself.[5] (The same folk tale, but with a most amusing and subtle twist, is the subject of plate 135, although I must confess to having invented the title which is given there, the painting itself having no title inscribed upon it.)

A Bachelor's Drawer was Haberle's last painting of this type, and it sums up all his characteristic iconography. The other two pictures from the Cove Street house exhibit less bravura but are consider-ably more subtle. One is a picture of a clock (plate 101) which stands about four feet high and is not nailed to an ordinary stretcher but to a boxlike affair some four inches deep, so that the canvas turns back to that depth on all four sides and creates the effect of a palpable, three-dimensional object. This picture stands, or did stand, on a dark shelf above the stairway in Haberle's house and I passed it by three or four times before I even faintly suspected that it was not an actual clock.

The face of this timepiece is executed in a meticulously realistic manner, but beneath the face is a landscape in the very cheap and commonplace style one associates with paintings on glass made to be inserted in the doors which give access to the mechanism of old-fashioned clocks. In other words, much of the illusionistic effect produced by this painting arises from the fact that a good part of it is *not* illusionistically painted. Cove Street provides an even more extreme example of the same thing, and another extreme instance of it is to be found in a picture once in the collection of Edwin Hewitt in New York (plate 97). In both of these works the effect is that a painted landscape—in one a view of a town seen from the water and in the other a cottage on a neck of woodland between a lake and a stream— has been shipped in a paper wrapping which has been torn open in transit. In each, most of the canvas is taken up with the landscape, which, in the nature of the game, had to be done in a broad, free, splashy style. The wrapping paper, the string, and the shipping labels are, of course, illusionistic, but they occupy a minimum of space. And when one arrives at the point at which the nonillusionistic elements in a work of *trompe l'oeil* occupy nearly all the space, one can go no further; this is the end of the line.

VI

IN 1893, when *A Bachelor's Drawer* was first exhibited, Haberle was quoted in the press as saying that his eyes had gone bad from the strain he had placed on them and that he would do no more "imitative" painting. This statement is repeated in

[5] Another version of this yarn, told by E. T. Snow and others, is that a dog once leaped at and tried to carry off the *Side of Spring Lamb* which Harnett is known to have painted. Virgil Barker (*American Painting*, p. 372) tells precisely the same tale concerning an inn sign depicting fish, game, and meats painted by the Philadelphia artist, John A. Woodside, about 1820. These dog and cat stories are, of course, descended from the classic story of Zeuxis, the ancient Greek artist who produced painted cherries at which the birds came to peck. But Zeuxis, it will be recalled, was outdone by his rival, Parrhasios, who brought him a picture covered with a veil. Zeuxis tried to remove the veil, only to discover that this was the picture itself.

The Parrhasian side of the legend also has its latter-day descendants. One such appears in the Blemly scrapbook in the form of a clipping from a newspaper identified as the *Mail and Express*. The writer of this declared that not long before he had seen, in an unnamed artist's studio, "an ordinary drawing-board, eloquent of long and hard usage. There were pencil sketches on it. Three or four cancelled stamps were stuck here and there, and a photograph of an actress, such as is given away with a package of cigarettes, ornamented a corner of the board. Someone had cut his initials into it, and the knife had not been very sharp; and someone else had struck a match across it." The writer goes on to say that the artist told him he proposed to paint an exact copy of that drawing board, and that when he had finished he was going to paint the things on the other side. The writer then stepped to the board, turned it around, and discovered, of course, that it was no drawing board at all, but a painting.

The *Mail and Express* story then quotes the unnamed artist as saying that Harnett often did things of that kind, which indicates clearly that the artist in question was not Harnett himself. The picture described by the *Mail and Express* reporter has a distinctly Haberlean ring, and the identification of the unknown painter with Haberle is underlined by a story printed in the *Evening Leader* of New Haven on May 15, 1894; this time a visitor to Haberle's studio is said to have stood before *A Bachelor's Drawer* and asked the artist when he was going to start painting that conglomeration of objects.

I suspect that, Parrhasios or no Parrhasios, both these stories go back to some single incident which actually occurred in Haberle's studio. I should have called them fabrications if, as reported in the main body of the text, I had not myself been fooled by one of Haberle's paintings.

Entirely with the Brush
and with the Naked Eye

several clippings bearing later dates, yet in 1898 Haberle came out with *A Japanese Corner,* photographs of which survive, and which appears to be an ultra-ultra-ultra realistic tribute to the Nipponese craze satirized by Gilbert and Sullivan in *The Mikado.* A Japanese screen creates a cozy nook in which are displayed an open parasol, a lantern, a kakemono, a piece of embroidered silk, a cloisonné vase full of chrysanthemums, a small bamboo table, painted fans, and a doll. The only visible touch of the endearing Haberle humor in *A Japanese Corner* is the label reading "Do Not Touch" which appears at its left-hand edge. The work as a whole seems to modern taste a depressing example of misapplied dexterity, and with it Haberle's "imitative" career seems actually to have closed. This means that that portion of his productive life which interests us to-day lasted only eleven years, and the more important part of it, for all we know to the contrary, only seven years.

As early as 1889 Haberle had painted a picture called *Attacking a Still Life,* which shows a mouse eating an apple, and after 1898 he produced a string of such things—small, sentimental paintings of kittens and puppies, as well as some flower and fruit pieces, and a little sculpture of animals. It is perfectly clear that his eyes were not what they had been; and if one had not found these later works in his house one could not believe they had been painted by the same masterly hand and hell-on-wheels spirit that had created *The Changes of Time, A Bachelor's Drawer,* the clock, and the thermometer. In 1923, when his son-in-law graduated from Yale, he signalized the occasion with a tiny painting of a schoolboy's slate in which the old fire flickers for a brief moment; but it never really revived.

He was more than a technical trickster. If he had done only works like *A Japanese Corner,* he would have no place in this book. He was, rather, a prestidigitator of art, and in the enormous hyperbole of his best achievement there is something akin to the nineteenth-century American spirit that found its most famous outlet in Mark Twain. Of all the American still life painters at work in his time, he is the most curious, the most piquant, and the one least likely to be confused with any other.

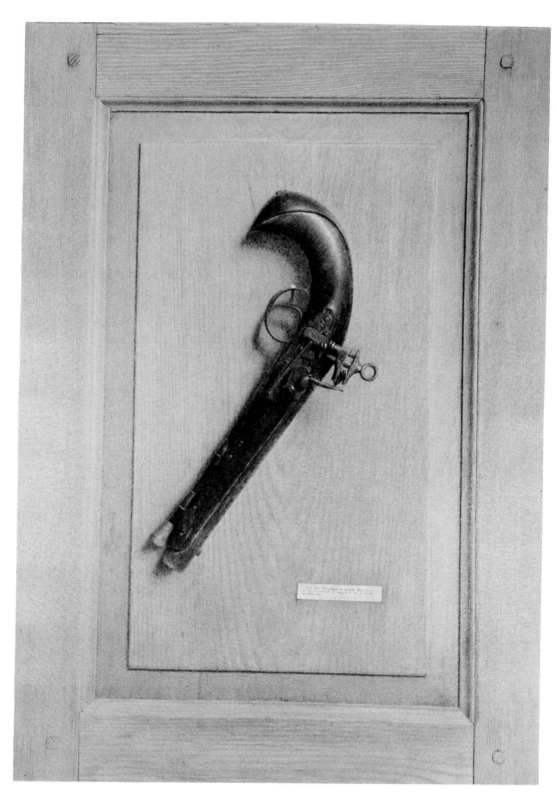

105

J. D. Chalfant
The Old Flintlock circa 1898 (25 x 17)
Mrs. J. David Chalfant, Wilmington, Delaware

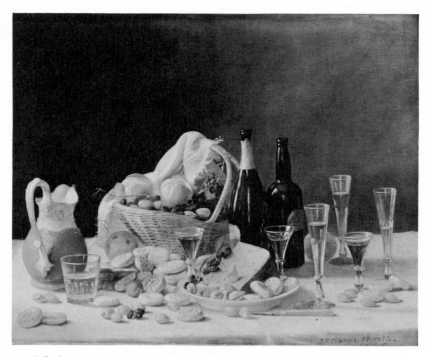

106

John F. Francis
Still Life 1867 (25 x 30)
Museum of Fine Arts, Boston

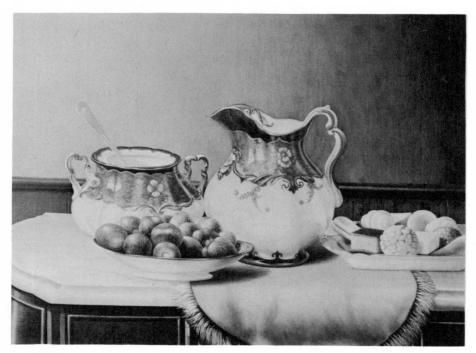

107

George Cope
Still Life 1911 (11 x 14)
Mrs. Andrew Gibbons, Titusville, Florida

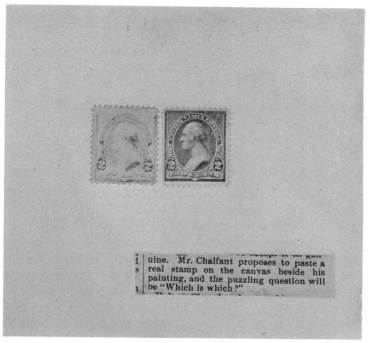

108

J. D. Chalfant
Which Is Which? (5 x 7)
Ernest Jarvis, Fort Lauderdale, Florida

109

George Cope
Still Life 1902 (21½ x 17½)
Formerly collection Joseph Starr
West Chester, Pennsylvania

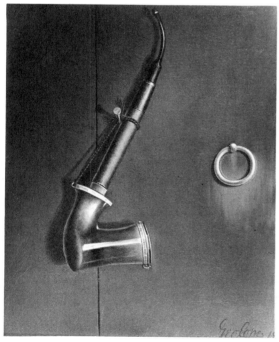

110

George Cope
Professor Hunter Worrell's Pipe 1911
(14 x 10) (cf. plate 65)
Mrs. John Barnes, New York

111

John F. Francis
Iris and Snowballs (17½ x 15)
Formerly collection Mrs. C. L. Sturtevant,
Wilmington, Delaware

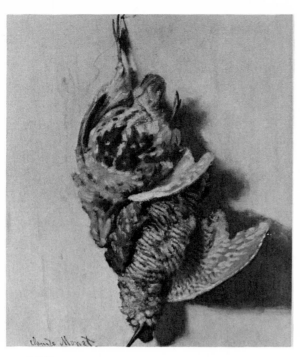

112

Claude Monet
A Partridge and a Woodcock (24 x 20)
Mrs. Charles Henschel, New York

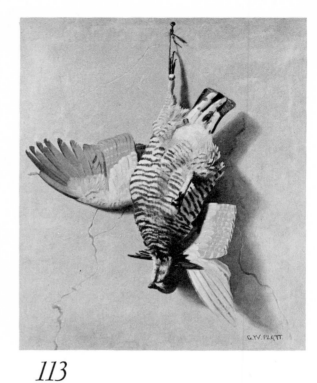

113

George W. Platt
Quail (29 x 24½)
Eldon P. Harvey, El Paso, Texas

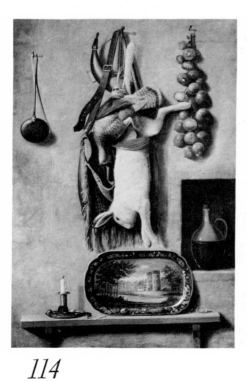

114

Richard LaBarre Goodwin
Kitchen Piece 1890 (56 x 35¾)
Stanford University Museum,
Stanford, California

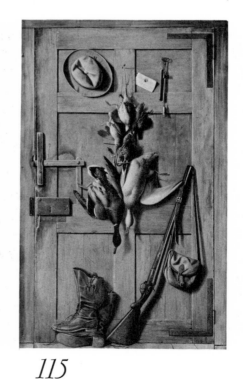

115

Richard LaBarre Goodwin
Hunter's Cabin Door 1890 (81¼ x 42)
Museum of Fine Arts, Springfield, Massachusetts

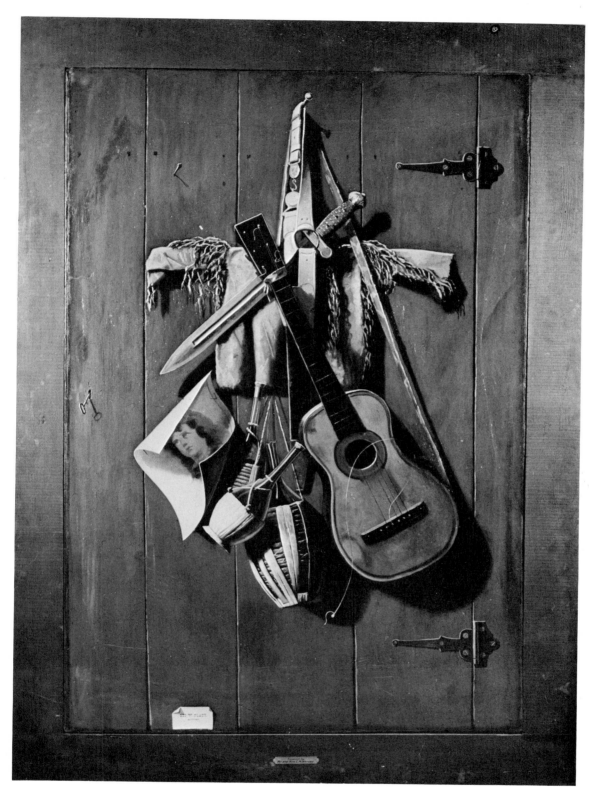

116

George W. Platt
Relics of a Den (50 x 40)
Eldon P. Harvey, El Paso, Texas

117

Alexander Pope
Pups in Transit (21 x 26)
Leonard K. Firestone, Pebble Beach, California

118

Alexander Pope
Still Life (15 x 18)
Formerly collection Edwin Hewitt, New York

The Second Circle

JEFFERSON DAVID CHALFANT, GEORGE W. PLATT,
RICHARD LABARRE GOODWIN, JOHN F. FRANCIS,
GEORGE COPE, ALEXANDER POPE

\mathcal{I}N 1941, SHORTLY AFTER the California Palace of the Legion of Honor had acquired Harnett's *After the Hunt,* Robert Neuhaus, who was then in charge of educational activities for that museum, conducted a gallery tour in which the work of Harnett was discussed. A few days later Mr. Neuhaus received a letter from an old gentleman in Oakland named A. A. Flitz, who had been a member of the gallery-touring party. In the 1880's he was in the leather business, and had dealt extensively with a leather manufacturer in Wilmington, Delaware, whose name was H. Wood Sullivan. According to Mr. Flitz, Mr. Sullivan was a friend and patron of Harnett and had bought many pictures from him, including a large canvas like *After the Hunt,* "also door work showing a violin, bow, and music sheet and other details. Also copies of money and all in minute details fit for the glass." Mr. Flitz had met the artist in Mr. Sullivan's home.

Mr. Neuhaus kept this letter in his files, and when, in 1946, he learned that I proposed to write a book about Harnett, turned it over to me. Because of it, I went to Wilmington and looked for the will of H. Wood Sullivan, but failed to find it. All the old-timers in the local tanneries remembered him; they were unanimous in saying he had left Wilmington many years before, but no one could say where he had gone. Mr. John Blatz, president of the Amalgamated Leather Companies, was good enough to institute a search through the files of the *Shoe and Leather Reporter,* and eventually found that H. Wood Sullivan had died in Brooklyn in 1903.

Meanwhile I went to Cincinnati in search of Harnettiana, and there I discovered an exceedingly interesting thing. In the catalogue of the art show held in connection with the Cincinnati Industrial Exposition of 1886 (the show at which Harnett had sold *The Old Violin* to Frank Tuchfarber) I found a cut of a painting, strikingly like *After the Hunt* in iconography and composition, but called *After a Day's Sport—Game Prices,* and attributed to J. D. Chalfant, whose name I had never run across before. At this time I knew nothing at all about the long string of imitations and adaptations which *After the Hunt* had bred, and was quite ignorant of Peto,

Platt, Goodwin, and all the other secondary artists involved in this book; I was therefore considerably more amazed by this discovery than I should have been at a later stage in my research. Who, I had to know, was J. D. Chalfant? For the first, last, and only time in all my work, the answer was provided by one of the official publications of the art world.

The encyclopedic dragnet of Thieme and Becker's *Allgemeines Lexikon der Bildenen Künstler* had gathered Chalfant into its meshes. According to this work, Jefferson David Chalfant had been born in Pennsylvania in 1856 and lived in Wilmington, Delaware. The date of his death was not given, but the *Lexikon* stated that one of his paintings, entitled *A Perfect Counterfeit,* was in the Brooklyn Museum. Harnett, I had long since learned from the Blemly scrapbook, had once painted a picture called *A Bad Counterfeit.* Clearly this Chalfant was a man to be investigated.

The Brooklyn Museum had a record of the picture. It had been acquired by gift from one H. Wood Sullivan on May 31, 1902. Its title was indeed *A Perfect Counterfeit;* it measured 17½ x 24½ inches, and bore the acquisition number 396–A1.82—but the museum had presented it in June, 1935, to Judge Vincent J. Sweeney of Manhattan.

This was news to Judge Sweeney. In response to my inquiry, the judge declared he had never received a gift of any kind from the Brooklyn Museum; he added, however, that in the summer of 1935, some paintings had been stolen from that institution and photographs of these had been sent to the New York City Detective Bureau, which he then commanded. Judge Sweeney felt that the Brooklyn record must refer to this incident, not to any gift of an actual canvas. Mr. Frank D. Doyle, secretary of the New York Police Department, searched the records of the Detective Bureau at my request and reported that the name of J. D. Chalfant was absent from the list of paintings stolen from the Brooklyn Museum (and, incidentally, never recovered). The Brooklyn Museum then renewed its assertion that it had given the picture to Judge Sweeney, Judge Sweeney renewed his denial of its ownership, and that is the end of the Case of the Missing Counterfeit.

While correspondence concerning all this was

going on, I returned to Wilmington, to visit J. David Chalfant, the artist's son, whose name I had found in the Wilmington directory, in the old house on Ashley Place where the Chalfants have lived for many years. There on an easel I saw the only Chalfant still life left in the family's possession (plate 105)—a flintlock pistol hanging against a light gray door, obviously inspired by Harnett's *Faithful Colt* (plate 1). I also saw some of the artist's genre pictures, and a whole drawerful of letters which Chalfant had received from H. Wood Sullivan. It was obvious that Mr. Flitz had been wrong in his recollection of the artist whom Sullivan had patronized. Sullivan had been wholeheartedly devoted to Chalfant, had bought much from him, and had tried to act as his business manager—engineering sales, advising the artist of opportunities for exhibition, and urging him to compete for this prize and that. I ultimately located Sullivan's will in the files of the Probate Court in Brooklyn, and through it I found his daughters; but they told me that their father's collection had long since been dispersed.

According to Chalfant's son, his father was born in Lancaster, Pennsylvania, on November 6, 1856, and died in Wilmington on February 3, 1931. He began his career as a cabinetmaker, a trade in which his own father was engaged, and both the Chalfants came to Wilmington between 1875 and 1880 to execute cabinet work for railroad cars. Jefferson David Chalfant started painting landscapes as avocation, without training; he launched himself as a professional artist around 1880 and turned out most of his still lifes in the following ten years, although at this period he also produced many genre scenes. In 1890, the New York art patron, Alfred Corning Clark, sent him to Paris to study with Bouguereau and Jules Lefèvre. His European studies, which lasted two years, seem to have done him neither harm nor good; his style had been fully formed long before he went abroad, and there is no evidence to show that he was affected in the slightest by his experience in Paris. During the last thirty years of his life, Chalfant devoted himself largely to portraiture; all his portraits seem to be in private homes in Wilmington, and I have not seen any of them.

Stylistically speaking, Chalfant is closer to Harnett than any other painter. To be sure, his color is drier than Harnett's and lighter in tonality, his textures are less sharply differentiated, his draftsmanship is smaller boned, and he lacks Harnett's virtuosity as a composer; whether the subject be still life or genre, he is much at his best in very simple arrangements, and his more ambitious compositional efforts do not come off. Nevertheless, a painting by him could pass for a work of the Philadelphian much more plausibly than a painting by anyone else. Perhaps pictures by Chalfant bearing forged Harnett signatures have been accepted as Harnetts but I rather doubt it. For one thing, the documents seem to show that Chalfant painted only about a dozen still lifes in his entire career, and the actual canvases, old photographs, or descriptions provided by contemporary catalogues and newspaper clippings account for nearly all of them.

But there can be no doubt that Chalfant sat in Wilmington, observed what Harnett was doing, and often proceeded to do something very similar. The newspapers of Wilmington, New York, and Philadelphia, where he frequently exhibited, constantly bracketed him with Harnett, and he seems to have been quite pleased at the comparison, but there is also evidence to show that he was also a little uneasy about it, at least once.

Chalfant kept a scrapbook, and in it is a document, dated in Wilmington on February 5, 1886, that reads: "This painting of a gunner's outfit and game (still life) is entirely original and painted by me from the objects placed in the position as shown on the canvass [*sic*]."

The paper is signed by Chalfant, countersigned by Henry Braunstein (apparently the brother of Katherine Braunstein, whom Chalfant married in 1903) and by one C. H. Maguire, who added the observation, "I witnessed from day to day the drawing and painting from the outlines to the varnishing." It is undoubtedly significant that this document was found in Chalfant's scrapbook folded around a clipping of the long article on Harnett's *After the Hunt* written by the unknown scientific analyst whose observations have been dealt with at some length in our chapter on the older painter.

Chalfant's scruples about following Harnett had vanished entirely by 1888, when he produced a larger and closer adaptation of *After the Hunt* than

The Second Circle

the painting of the gunner's outfit and game; for this he even appropriated Harnett's own title. (The 1888 version survives in a photograph reproduced as plate 67.) According to an obviously well-informed article about Chalfant signed with the name of Caroline Rudolph and published, according to a notation in the artist's scrapbook, in a Wilmington newspaper in 1895, Chalfant's *After the Hunt* hung in the Auditorium Hotel in Chicago during the World's Fair of 1893; and an entry in the artist's handwriting in one of the old catalogues he preserved states that this picture was sold to the Chicago millionaire, Leander McCormick, although there is no trace of it in the existing records of the McCormick collection.

Chalfant was also represented at the Chicago fair itself; his *Perfect Counterfeit,* the picture Sullivan ultimately gave to the Brooklyn Museum, was exhibited in the Delaware building. This painting had been done in 1888, and in that year it was refused a showing at Earle's Galleries in Philadelphia because of the fuss the Secret Service had made about Harnett's money pictures in 1886.

Chalfant is known to have painted three still lifes of violins. One of these is the work, now in the Delaware Art Center at Wilmington, which caused M. Duchamp so much concern (plate 61). It was clearly inspired by Harnett's *The Old Violin* (plate 60), which preceded it by two years, but is considerably simpler in its total effect. Harnett places his violin against a green door and frames it in the long arms of two rusty hinges. The bow, the fingerboard, and strings, and the long crack in the door establish a pattern of elegant verticals against which the hinges, the newspaper clipping, the letter, and the sheet of music provide horizontal and diagonal counterpoints. Over all is an exceedingly subtle play of light, of shadows, and of reflections from the paper, from the painted and varnished woods, and from the metal, whether bright or rusted. That Harnett differentiates every texture to the utmost goes without saying, and he carefully avoids monotony of texture in the broad expanse of the door by means of cracks, splinters, and nailholes, fresh and rusty nailheads, and fresh and rusty rivets in the hinges. One rivet in the top hinge has fallen out, and part of the lower hinge has been cracked away to reveal

the unpainted wood beneath. In other words, Harnett eschews mechanical repetition, provides something of unique local interest at every point, and unifies it all with a strikingly original design. Chalfant, on the other hand, gives us simply a violin, a bow, and a sheet of music, painstakingly and perfectly described, but composed in a rather haphazard fashion. His background is merely a white rectangle painted as uniformly and flatly as if it had been done by a house painter, although with the passage of time it has acquired a crackle which gives it some texture. But Chalfant relieves the blankness of his wall, to the right of the violin, with an exquisitely painted pair of steel-rimmed spectacles.

The literature also mentions a Chalfant still life of an egg falling through empty space, and much astonishment is expressed at the fact that the downward movement is somehow indicated—but unsupported eggs seldom stand still and even less frequently rise.

Miss Rudolph speaks of Chalfant's *Which Is Which?* but says nothing about his flintlock pistol; this work is undated, but was clearly painted after 1895, when Miss Rudolph's article was written. The flintlock picture bears a painted clipping which reads, "For the first time in nearly ten years, J. D. Chalfant is engaged on a study in still life." Since the latest of Chalfant's dated still lifes was created in 1888, the flintlock must have been produced about 1897, and it seems to be the artist's final work in this department.

Which Is Which? (plate 108) is a little masterpiece. A real two-cent stamp has been pasted to a piece of white-enameled copper (Chalfant favored white or light gray backgrounds) and the artist has painted a two-cent stamp beside it, while beneath he has painted a newspaper clipping defying the beholder to tell the difference. In the sixty-odd years since this was done, the real stamp has faded almost into unrecognizability, but the painted stamp is as good today as it ever was. The owner of the picture, Mr. Ernest Jarvis of New York, who is an ardent philatelist, once wrote me that he expected to remove the faded stamp and replace it with one of the same issue from his collection. If Mr. Jarvis ever does so, he will promptly be murdered with a flintlock pistol by the writer of these lines, for there exists no

more perfect demonstration of the relative permanence of reality and illusion than *Which Is Which?* as it has been affected by "the changes of time."

Chalfant's work as a genre painter is of relatively little interest and is not likely to be revived, even though it is stylistically identical with his work in still life. His kind of precisionism confers pictorial life upon mechanical objects like flintlock pistols, violins, and steel-rimmed spectacles, but it is powerless to confer pictorial life upon living subjects. Many artists have been equally great in still life and genre, but none have been devotees of *trompe l'oeil*. A plum by Chardin is a minuet for strings, an apple by Cézanne is an epic canto, and a Bible by van Gogh is the Sermon on the Mount; but neither the plum, the apple, nor the Bible has ever been fingered to determine if it is "real." Once again a basic principle asserts itself: "realism" in art is a form of pure abstraction; and those who try to warm it with the color of the human anecdote simply do not understand.

II

THE WORK from which this book emerged involved many tangled and curious chains of research; the resurrection of George W. Platt, however, tops them all. At times the Platt investigation verged on the out-and-out detective story, which is, of course, a form of slapstick comedy: if the records of a mental hospital in Colorado, crossed with the letter column of a newspaper in Iowa, had not led to a casual conversation between two women at a grocery counter in Texas—but let us begin at the beginning.

The beginning, as usual, is William Ignatius Blemly's scrapbook of Harnettiana, which has a Harnett obituary notice, published in the New York *Recorder,* containing the following statement:

Four years ago he [Harnett] exhibited a painting at the St. Louis Exposition which created a sensation. Hung upon an old door were the saddle, sombrero, rifle, and all the equipments of a first-class cowboy outfit. Sticking straight in the woodwork was a bowie knife, which had been flung there. In order to prevent the public from touching the

canvas to allay their doubts concerning the identity of the picture, a fence had to be erected around it.

No such painting by Harnett was known to exist, but it seemed very likely that there would be some record of it in St. Louis. There was, and it showed that the *Recorder*'s obituary editor knew what he was talking about—up to a certain point.

The picture had indeed created a sensation at the St. Louis Exposition of 1888, and there was scarcely a day during the six weeks of that fair when the local newspapers did not refer to it. On September 11, the St. Louis *Republic* described it as follows:

One of the points of interest now is the trick picture exhibited in the hall east of the main entrance to the art gallery. It is called *Vanishing Glories,* and was painted for exhibition at the Exposition by G. W. Platt of Chicago. It represents an old barn door with rusty hinges and hasp, while from a peg is suspended the outfit of a typical cowboy of the West. A huge buffalo skull forms the centrepiece, and around it are carelessly hanging a Colt's revolver, bright in its blue steel finish, and a Winchester rifle on which the marks of hard usage are plainly visible in its rusty appearance. There is also a Mexican spur, a quirt with a horn handle, a plaited lariat, a cartridge-belt and deerskin jacket, while a bowie knife is carelessly stuck in the wood or canvas.

Other newspaper accounts added that the artist had secretly arranged to have the catalogue number 70 assigned to his picture and had painted his own number label. A great controversy arose, and the St. Louis press delighted in it: was that label real or not? Was the door real wood or its counterfeit on canvas? Bets were made, the director of the art show was driven half out of his mind with questions, and the reporters made much of an enigmatic Woman in Black who visited the painting every night, just before closing, when the crowd was thin. So famous did the picture become that, in the final days of the exposition, the management headed its advertisements with the phrase "Vanishing Glories."

There can be no doubt whatever as to the authorship of this picture. All the newspaper accounts gave it to George W. Platt of Chicago, and so did the official catalogue, while, according to all available evidence, Harnett had nothing in the show at all. In other words, the furore over Platt's *Vanishing Glories* was, after a lapse of four years and at a distance of a thousand miles, confused with the

The Second Circle

nearly contemporary furore over Harnett's *After the Hunt.* A very similar thing also happened to Platt himself.

I went to Chicago to look for traces of George W. Platt. The archives of the Art Institute showed that he had exhibited there repeatedly for nearly twenty years; in the 1880's he had lived in Chicago itself, but in the '90's he had resided in Denver. I dropped a line to the clerk of the Probate Court in Denver to ask if there were any records in the name of this artist. What came forth was the most voluminous thing of its kind with which I have ever dealt.

Platt had died in Denver on September 16, 1899, and his wife had been appointed administratrix of his meager estate. Two years later, Mrs. Platt was committed to a mental hospital, where she died in 1929, and her husband's brother, Walter Platt, was appointed conservator. For more than a quarter of a century, Walter Platt sold the paintings left by his brother, which belonged, of course, to Mrs. Platt, in order to pay what he could of his sister-in-law's expenses. Each transaction had to be reported to the clerk of the Probate Court in Denver, and the entire heart-breaking record of this affair was dumped into my lap. Walter Platt was required to report only the sums—miserably small—he had realized from his sales, not the titles of the pictures or the names of the buyers, but the file showed that he had lived in Muscatine, Iowa, throughout the period of his correspondence with the clerk of the court in Denver. Extensive searches by Otto Karl Bach of the Denver Art Museum and by Mrs. Alys Freeze of the Department of Western History at the Denver Public Library failed to turn up even as much as a single canvas bearing George Platt's name in Denver. The trail—if there was a trail—clearly led to Muscatine.

Walter Russell, managing editor of the Muscatine *Journal,* was kind enough to publish a story in his columns to the effect that I was coming to town to look for pictures by George W. Platt, especially one called *Vanishing Glories.* When I arrived a week later, Mr. Russell had lined up five Platts for me to see, and had also received a highly significant letter that touched upon my search.

Most of the Platts in Muscatine were fruit and flower pieces of no interest at all, but there was one very striking and unusual still life of the quail, gun, and cabin-door variety. This work, in the collection of Eugene Boynton, is a very large painting in the general iconographic tradition of *After the Hunt,* but very individual in treatment. The artist had successfully achieved something bordering on the impossible—effects of *trompe l'oeil* with free brushwork. To be sure, the brushwork was not as splashy and pyrotechnical as that of Chase—Platt, I eventually learned, had been a fellow student of Chase at the Munich Academy in the late 1870's—but it was far from the tight, concealed, illusionistic brushwork of a Harnett. Furthermore, Platt had restricted himself to an exceedingly narrow palette, using little but close, subtle tones of gray and brown. Although Platt at his worst was negligible, Platt at his best was by no means an unimportant artist.

Mr. Russell told me that, according to local tradition, people in Denver had tried to raise money to buy the Boynton canvas from Platt himself and present it to Theodore Roosevelt, who was then campaigning in Colorado, but they had been unable to meet Platt's price—four thousand dollars—and so the project had been dropped. Wolfgang Born tells an almost identical story about Richard LaBarre Goodwin, and I have since run across it in other connections. Abandoned projects to present paintings to Theodore Roosevelt are as much a part of the folklore of American still life as arrests for counterfeiting because of pictures of money. (One of the Platts in Iowa, by the way, is a very nice dollar bill.) The story happens to be true of Goodwin: an effort *was* made to buy a cabin-door picture from that artist and present it to Roosevelt the First.

The letter which Mr. Russell had received as a result of his published announcement of my forthcoming visit to Muscatine came from Miami, Florida, and was signed by H. C. Platt, son of Walter Platt, and therefore the artist's nephew. It read as follows:

An article in the *Muscatine Journal* was brought to my attention regarding a picture, *Vanishing Glories,* by George W. Platt.

I sold a number of his pictures to an art dealer in El Paso, Texas, and I think that was one of them.

I think the dealer sold that one to the First National Bank of El Paso, which failed some years ago. However, you may

The Second Circle

get trace of it through whoever took over their assets. I don't remember the art dealer's name. That was about 1914.

To trace a painting by a forgotten artist through the receivers of a defunct bank struck me as being about as hopeless a project as any on which I had ever engaged. Nevertheless, just to see if anything would develop, I wrote to the El Paso Public Library, explaining the whole situation. To my intense surprise, Miss Erin Humphrey of the El Paso Public Library replied at once to say that the pictures formerly in the First National Bank of El Paso were all stored in the museum of the Texas College of Mines and Metallurgy, which is in the same city, and that I could undoubtedly obtain the information I wanted from President D. M. Wiggins of that institution.

President Wiggins confirmed the fact that his college possessed the paintings from the First National Bank, but felt unable to comply with my request to open the four unwieldy crates in which they were contained and rummage among their contents for *Vanishing Glories;* however, he granted me permission to do so myself if I should visit El Paso.

President Wiggins had a secretary named Frances Stevens who took an interest in the cranky communications that crossed her employer's desk. Shortly after the exchange of letters just cited, Mrs. Stevens met an artist-friend in a grocery store and asked her if she had ever heard of any paintings by George W. Platt in El Paso. The artist had; in fact, she had just finished cleaning four paintings by George W. Platt in the home of Mr. and Mrs. C. M. Harvey on Elm Street. A few minutes later, Mrs. Stevens encountered Mrs. Harvey: Yes, they had four paintings by George W. Platt. The title of one was *Vanishing Glories.*

As soon as I received this information, I wrote to Mr. Harvey. He replied on his business letterhead, and part of the problem was solved. He was president of the El Paso National Bank, a distinctly going concern with a name which might easily be confused with that of the First National Bank of El Paso, now deceased. Mr. Harvey stated that he had bought the Platts from an El Paso dealer who in turn had obtained them from a relative of the artist, and that they had hung in his office for some years before he took them to his home. (I eventually found that the pictures stored in the museum of the Texas College of Mines and Metallurgy were all horrible oil murals by an artist with a Scandinavian name which has fortunately disappeared from my files.)

Mr. Harvey had his Platts photographed, and when I received the prints, I had a new problem. Mr. Harvey's *Vanishing Glories* wasn't *Vanishing Glories,* but a varied repetition of the same idea, signed and dated six years later (plate 71). In place of the buffalo skull was the head of a mountain sheep. There were, to be sure, a "faithful Colt" and a rifle, but no lariat, sombrero, or other pieces of cowboy equipment; in their place were the hunting tools of an Indian: a bow, two quivers of arrows, a war club, a spherical basket, and a ceremonial rattle. The whole thing was a Wild West adaptation of *After the Hunt,* and an exceedingly good one. Its title actually is *Wild West;* it is so listed in the inventory of the artist's estate.

There was another photograph of a large Platt—*Relics of a Den* (plate 116)—which was equally good; it showed wine bottles, a guitar, a short sword, a fringed buckskin jacket, and a photograph of a girl hanging against a door. What was especially interesting, not to say astonishing about this picture —and, to a slightly lesser degree, about *Wild West* as well—was that, to judge from the photograph, its style was very similar to that of John Frederick Peto. This was surprising, but not quite so much so as it seemed on first glance, for, according to evidence discovered later, Platt had been a student at the Pennsylvania Academy of the Fine Arts in 1876. Harnett was studying there at the same time, and Peto was in the neighborhood, if not enrolled in the school. So Platt could well have known them both and been subjected to the same educational influences.

Examining Mr. Harvey's pictures at first hand confirmed and deepened the impression I had carried away from the Boynton picture in Muscatine. The photographs had not misrepresented Platt's use of a softly radiant, Peto-like texture. Once again his palette was limited almost entirely to browns and grays, very subtly harmonized, and once again

there was a remarkable combination of realistic illusionism and free brushwork. In one of the Harvey paintings, a picture of a dead quail (plate 113), the freely handled brush and the rigidly limited color scheme had carried Platt quite outside the area of *trompe l'oeil* to produce a picture one might mistake for an early Claude Monet (plate 112). Three years later John I. H. Baur was to note Peto's frequent use of brown and gray monochrome, which Mr. Baur likens to the similarly subdued color of the early cubists, as well as Peto's "sensitivity to the new impressionist vision" that was creeping into American art in his time. Mr. Baur expresses wonder at the appearance of these things in the paintings of an obscure cornet player in a seaside village in New Jersey. He might well express equal wonder at their appearance in the work of an obscure art teacher in the Rocky Mountains, even though the art teacher and the cornet player may have been fellow students twenty years before.

Biographical information about George W. Platt comes from his scrapbook of clippings, which Mr. Harvey acquired at the same time as his paintings; from the artist's niece, Mrs. William Johnson of Santa Monica, California, whom Walter Russell, the Muscatine editor, eventually located; and from obituary notices published in the Denver newspapers. He was born in Rochester, New York, on July 16, 1839. His father, like Peto's, was a picture-framer; he had nine brothers and sisters, one of whom, Helen, taught art for many years in Boston and had some local reputation as a landscape painter. He was graduated from the University of Rochester and then spent some time on the Western plains and in the Rockies as official draftsman with John Wesley Powell's geological survey expeditions. He returned to the East and studied for five years at the Pennsylvania Academy of Fine Arts, after which he polished off his training in Munich and in Italy. The only date on which all this can be hung is that on his record card at the Pennsylvania Academy— 1876, when Platt was thirty-seven years old.[1]

His professional career could not have begun

much before 1880. He is said to have set up a studio in New York on his return from Europe, but he could not have remained in New York for very long. All his clippings are from Chicago and Denver; those from Chicago date from the 1880's and those from Denver from the following decade. Alone among the artists studied in this book, he held salaried positions as a teacher—at the University of Denver and elsewhere. He was also active on the Chautauqua circuit, and seems to have delivered a lecture called *Illusions in Art* as often as Russell H. Conwell gave his *Acres of Diamonds*. He painted many fruit and flower still lifes of dubious merit, many game and barn-door pictures of high quality, some landscapes, and numerous portraits, mostly of Colorado dignitaries. He died in Denver and is buried very close to Muscatine, in Rock Island, Illinois, a town to which his parents had removed at some undiscoverable time.

Where, by the way, is *Vanishing Glories?*

III

SOMEWHERE BEHIND each of the mystery men of American art lie a clutch of documents and a dusty stack of paintings which, in time, will answer all the questions. I am convinced that there is no one whose records are utterly lost, although finding the key to the records may not be easy. The key to Richard LaBarre Goodwin, however, lay in plain sight for years; the mystery is simply why no one bothered to pick it up.

Wolfgang Born, who knew Goodwin only through two pictures, observes in his book that "with the exception of an inaccurate obituary of a few lines in *Art News*, not a single word seems to have been printed about him in books on art or in art magazines, and he was so completely forgotten when the Museum of Modern Art exhibited one of his pictures in 1939 that except for the obituary in *Art News*, no biographical data was available for the catalogue."

The death-notice in *Art News* was printed on December 17, 1910, and stated that Goodwin had

[1] The only record of students which the Pennsylvania Academy has preserved from the nineteenth century is a series of cards each inscribed merely with the student's name and a single date, probably the date of his last contact with that institution. The card for Harnett is dated 1876 and the one for Peto 1878.

The Second Circle

died just a week earlier in Orange, New Jersey. Born searched further in the libraries, found a Goodwin obituary in one of the New York newspapers, and with this he pieced out his material. This trail could lead no farther, but there was another. On file in Orange are the artist's will and death certificate, which lead straight to his son, Judge Clarence Goodwin of Washington, D.C., to his daughter, Miss Claribel Goodwin of New York, to two housefuls of Goodwin documents, and, finally, to dozens of Goodwin's paintings, most of them in the Manhattan Storage Warehouse, about two blocks from the Museum of Modern Art.

Still life painting is a sedentary occupation and most still life painters are reasonably settled people. Goodwin, however, was a wanderer, and as a result, his pictures are likely to turn up anywhere and everywhere. But, although he never remained in one place for any great length of time, he did remain remarkably devoted to a single still life subject. If Peto is the master of the rack and Harnett the master of the table top, Goodwin is the master of the hunting-cabin door.

Richard LaBarre Goodwin was born in Albany, New York, on March 26, 1840. His father, Edwin Wyburn Goodwin, was a painter who left a frightening list of no less than 806 pictures produced by his own hand in a span of fifteen years. Most of these were portraits of political notables, including Martin Van Buren, Thurlow Weed, DeWitt Clinton, and William H. Seward, who was his particular friend and patron. The elder Goodwin died when his son was five years old. Richard studied with various obscure teachers, apparently in New York City, and took up the trade of itinerant portrait painter in 1862; he had enlisted with a regiment of New York volunteers at the outbreak of the Civil War, had been wounded at the first battle of Bull Run, and been mustered out for disability. For a full quarter century Richard Goodwin traveled the roads of western New York State painting portraits. He is known to have lived in Ithaca, Seneca Falls, Clifton Springs, Penn Yan, Rochester, and Syracuse; his first settled studio of any consequence seems to have been established in Syracuse in the 1880's, and there his earliest known still lifes were painted.

Goodwin was in Washington between 1890 and 1893, and was exceedingly successful there, especially with the California delegation; he painted one of his best cabin-door pictures for Senator George Hearst and sold no less than eight canvases to Senator Leland Stanford. (I found six of these stored in the basement of "the family's" museum on the campus of Stanford University.) He went to Chicago at the time of the World's Fair in 1893, and remained there seven years. Colorado Springs was the next stop, 1900–1902; after that, Los Angeles, and then San Francisco. Four years of Goodwin's work were burned up in the San Francisco fire of 1906. He went on to Portland, remained there two years, returned to Rochester in 1908, and had just settled in Orange, where his younger son, Charles, was employed in the Edison laboratories, when he died.

Although Goodwin established residences in the various cities mentioned, one should not infer that he became even a temporary fixture in any of these places. He was perpetually on the move, wandering through the Sierra, fishing in Florida, exploring the Willamette country, or packing into the wilderness in Maine. He was not an urban personality like Harnett, and he had none of Peto's rustic domesticity. It is not surprising that he painted comparatively few fruit and flower still lifes, and I have yet to see a work of his in which a book appears. He painted portraits for a living and landscapes for love, but above all he delighted in the hunter's cabin door.

It is quite impossible even to estimate how many cabin-door pictures Goodwin produced; I should not be surprised if his total output ran to a hundred. Eighteen are known to me, either in the actual canvas or in old photographs preserved by the artist's daughter. All can be dated by internal or external evidence of one kind or another: the earliest is one in the Stanford collection, painted in 1889, and the others follow over a period of nearly twenty years. There is nothing to show that Goodwin painted any of his cabin doors before Harnett returned from Europe with *After the Hunt* in 1886, and there is much to suggest that he could not have done so. Goodwin, who is known to have visited New York City repeatedly during his days in Rochester and Syracuse, seems to have taken over certain motifs—the most striking and obvious of them is

the soft hat—directly from *After the Hunt,* and perhaps certain devices of arrangement as well. Furthermore, some of Goodwin's cabin doors are adorned with letters and postcards addressed to the artist in French, with dated Paris postmarks, which immediately suggest the letter from Paris in Harnett's *Old Violin,* which, after 1887, was known all over the country, thanks to the Tuchfarber chromo. As early as 1881, Goodwin is known to have painted small pictures of dead ducks hanging against plain backgrounds, and he continued to produce minor works of this kind for the rest of his life. It clearly seems that *After the Hunt* showed him how additional interest, as well as size and impressiveness, could be added to this extremely limited theme, and he thereupon proceeded to ring innumerable changes upon it.

Harnett's essential romanticism is beautifully shown when one compares the iconography of *After the Hunt* (frontispiece) with that in any of Goodwin's pictures on the same subject (plate 115). Harnett's rich green door has huge, magnificent, rusty hinges and a superb brass key escutcheon in the form of a medieval warrior; Goodwin's doors are plain, battered, unpainted things, with the most unpretentious kind of mail-order hardware. Harnett's gun is a rare, carved, and pearl-studded museum piece, carefully dated on its stock, "Trient, 1740"; Goodwin's guns are businesslike modern instruments for killing ducks. Harnett makes much of a grandiose old hunting horn; Goodwin gives us a little pocket whistle instead. Harnett places an ivory-handled sword in his assemblage; Goodwin rests a pair of old shoes against the door.

Those old shoes do not, to be sure, appear invariably; as observed above, Goodwin plays with the subject in countless ways. His most extreme variation is a picture in the Stanford collection dated 1890 (plate 114). Here a rabbit, a quail, and hunting equipment hang against a plaster wall along with a big brass ladle and a string of onions; below these is a shelf on which are a candlestick and candle snuffer, a match, a pair of steel-rimmed spectacles, and a large blue platter adorned with a landscape of a castle by a stream, while a big wine crock stands in a niche nearby. The kitchen piece is much favored by European artists, but this is one of the few such works I have seen by American masters of *trompe l'oeil.*

Goodwin seldom goes as far afield as his kitchen piece. Ordinarily he sticks to the hunting-cabin door, sometimes making a great deal of the flat, rectilinear, Mondrianesque pattern produced by its reinforcement boards and draw bars. A door and game are his only consistent motifs, although he generally works in a rifle as well. Sometimes he uses game bags, powder horns, and other objects already mentioned, and sometimes not. His game is usually a string of ducks, but it may also be a fox, and in one handsome painting it is a turkey. His composition is never so elaborate as Harnett's in *After the Hunt,* and is not spread so widely over the board. He tends to cluster his objects in a long, columnlike arrangement which ascends through the middle of the painting, leaving much broad, free space on either side. This central column has its base in the stock of the gun, which stands on the ground before the door; as the column goes upward, it broadens out into a rotating, erupting tangle of bird forms, and then narrows off to the spear point of the strings from which the birds are suspended. The whole thing is like a rocket in flight, although there is none of the nervous free brushwork commonly associated with such expressions of energy.

Goodwin has a little of Harnett's fascination with varied textures, but only a little. He has none of Peto's sensuous surface or of Platt's monochrome. What distinguished him most, stylistically speaking, is the drastic, powerful, almost monumental simplification of his bird and animal forms. This may proceed from nothing more than inability to render the skeleton beneath the skin; if so, Goodwin certainly made a virtue of his limitations. If Harnett's books predict abstraction, if Peto and Platt foresaw impressionism and Haberle was a protosurrealist, Goodwin may be credited with seeing in the creatures of nature the proverbial cylinder and cone.

One aspect of Goodwin's method is, so far as I know, unique, and its results are well worth looking for, if there are any on the market. His cabin-door pictures are, of course, exceedingly large, but he had a way of preparing for them in completely finished oil sketches not more than two feet high. These

The Second Circle

miniaturistic cabin doors are sometimes even better than the big ones. There is a kind of magic about their small size; it is *trompe l'oeil* seen through the wrong end of a telescope, and it is all the more charming for that.

Without much question, the most famous painting of Goodwin's life was one he produced in Portland, Oregon, in 1905 (plate 69). At that time Portland was celebrating the centennial of the Lewis and Clark expedition. One of the exhibits on the fairgrounds was the door of a cabin in which Theodore Roosevelt had lived while ranching in the Dakotas in 1890. It was a cabin door like any other; Goodwin had painted dozens like it, and he proceeded to use it as a model for a typical still life in his usual style. The gun depicted is said to be one which General Phil Sheridan had used while serving in the army in Oregon, and this may be true. The hat is said to be Teddy Roosevelt's hat, but this is *not* true; it is the hat Goodwin had shown in the Stanford picture of 1889 and several times later. Some Portlanders wanted to present this painting to Roosevelt himself, but the chairman of the committee appointed to raise the necessary $2,500 died suddenly before the transaction was completed. He had kept no books, no one knew how much money had been collected or where it was, and so the whole thing fell through. Goodwin took the picture with him and later made mild capital of its Rooseveltian connections; it was reproduced, for instance, in a gigantic full-page cut in the Rochester *Herald* for January 10, 1909. The painting was in the possession of Claribel Goodwin for many years.

Born knew the Portland story—which, as we have seen, has gone into the folklore of American still life and has been applied to several different painters—but he was acquainted with only two pictures by Goodwin, and he had no idea that that artist had made a life work of this one subject. Born therefore identified the Goodwin cabin-door picture at the Springfield Museum of Fine Arts (plate 115) as a "second version" of the "lost" Portland painting of 1905 (plate 69). To be sure, the Springfield canvas displays a postcard with a postmark of August 8, 1890, but Born had an explanation for this: the postmark must refer not to the date of the painting but to the date of Roosevelt's sojourn in the

Dakotas. It was an ingenious theory, and Born was so delighted with it that he committed one of his few genuine errors in scholarship: he failed to check the history of the work in Springfield. If he had done so, he would have found that it was purchased in 1890 by Charles and Emilie Shean from the Springfield dealer, James Gill, hung for many years as part of the Sheans' famous Hotel Charles collection, and came from there to its present location.

It makes me feel like a quarrelsome German professor constantly to correct Born; I especially dislike doing this because Born is dead and cannot defend himself. However, print confers authority on words, and in the course of my investigation I have found that Born's book is frequently accepted as gospel. Attributions have been made, museum records altered, and purchases concluded on the basis of information derived from it; but that information is sometimes a dubious guide. Born was a devoted scholar, and his inadequacies lay less in his method than in his materials; he was the first to enter a totally unexplored territory. I can only hope that this book contains as few and as unimportant shortcomings as his.

One error of my own should be corrected here. Some years ago the New York market was enriched with a painting, bearing a forged Harnett signature, that I immediately attributed to Goodwin. The picture was purchased by a gentleman named Edward Wallace, who may since have disposed of it. It shows four ducks, two hanging against a wooden door, two lying on a table before the door. Behind the hanging ducks is a large net-covered game bag. There is a horseshoe in "bad luck" position at the top of the picture, and propped behind the ducks on the table are two leather cases of the kind used for the separate parts of demountable rifles. Fuller acquaintance with Goodwin's work convinces me that this canvas is not his. It is much too slick and glassy, and the ducks are quite without his formal qualities. I suspect that it is a relatively recent production; at all events, its Harnett signature cannot for a moment be taken seriously. On the other hand, there is a picture with no visible signature of any kind which was shown me as a Harnett at the Ferargil Galleries in the spring of 1947 but which rings true for Goodwin in every particular. It shows

The Second Circle

a group of game birds hanging to a door whose re-inforcement boards are in the shape of a gigantic Z. At the left are a powder horn and a combination handle and door latch; a horseshoe nestles in the apex of the triangle between the diagonal arm of the Z and its bottom horizontal; to the right of this is a loose feather, and at the extreme right a shot pouch with two nipples. If anyone has acquired this as a Harnett, he may console himself with the thought that he actually owns an excellent work by one of Harnett's ablest contemporaries.

IV

JOHN F. FRANCIS belonged to an older generation than the other painters considered in the present study, but he seems to have influenced Harnett, and at least one work of his, adorned with a forged Harnett signature, has been accepted as a work by the younger artist;[2] consequently he should be discussed here.

Wolfgang Born records only nine pictures by Francis in his *Still-Life Painting in America,* and his biographical notes on this artist are very meager. When the Museum of Fine Arts in Boston received three of his pictures with the Karolik Collection, members of the staff were able to find only that he had been represented at the Artist's Fund exhibition in Philadelphia in 1840 and at the annual exhibitions of the Pennsylvania Academy of the Fine Arts in 1854, 1855, and 1858; the Pennsylvania Academy catalogues showed that he had been living in Harrisburg on the first occasion, near Wilmington, Delaware, on the second, and in Phoenixville, Pennsylvania, on the third. According to Mantle Fielding's *Dictionary of American Painters, Sculptors and Engravers,* Francis was born at an unspecified place in 1810 and died in Montgomery County, Pennsylvania, in 1885, but the staff at the Museum of Fine Arts seemed disinclined to accept this assertion without corroborating evidence.

Fielding was very nearly right, however; Francis died, at the age of 78, in Jeffersonville, Montgomery

County, Pennsylvania, on November 15, 1886; and he lies buried in the Morris Cemetery at Phoenixville. This information was obtained from the papers filed with his will, a copy of which I discovered in the archives of the Orphans' Court in Philadelphia, where Francis had owned two houses at the time of his death. Finding the heirs mentioned in the will proved to be very easy, and within forty-eight hours I had rounded up thirty-one hitherto unknown paintings by John F. Francis, all belonging to members of one family in or near Washington, D.C. In addition to those recorded by Born and a number of others which have since turned up elsewhere, there is now a corpus of eighty-odd pictures by this artist with which to work, and several more are known through photographs. To be sure, these eighty-odd pictures represent only a small fraction of Francis' total output, but they span more than thirty years of his career and so provide a reliable index to his stylistic development. The discovery of Francis' will led, moreover, to certain contemporary documents. The most important of these are the obituary notices and a letter of reminiscence published in the *Herald and Free Press* of Norristown, hard by Jeffersonville; a manuscript catalogue of his portraits which the artist kept for many years, and the Francis family Bible.

The will itself is an interesting bit of literature. It shows that Francis was very well to do at the time of his death, and that he was an intensely religious man. Three provisions of the will are especially revealing.

Francis left two thousand dollars to the Hospital of the Protestant Episcopal Church in Philadelphia "to be invested and the income to be applied in procuring and supplying necessaries and delicacies for the indigent female patients, such as shall be proper in their feeble condition." (Francis' two children, and perhaps his wife as well, had died in a cholera epidemic in the summer of 1856; it is easy to see in this a reflection of that tragedy.) He left five hundred dollars to each of his nephews, "Willie, Hubert and Preston King . . . subject to the condition that if any of said children degrade their manhood by crime or the sin of intemperance they shall forfeit absolutely all benefits given by this paragraph of my will—my object, before God, being to distribute

2 See p. 183.

a blessing and not a curse." (The distinguished subsequent careers of the Kings of Washington show that their Uncle John did, indeed, distribute a blessing.) Francis bequeathed a third of his residuary estate to the Protestant Episcopal Diocese of Pennsylvania "for the relief of the worthy and deserving poor . . . preference to be given to the poor of the County of Montgomery and the counties adjoining . . . My object is to reach and assist, if it be possible, such worthy poor people as, through feelings of delicacy, are unwilling to publicly or openly ask for help."

According to Francis' obituaries, he had been born in Philadelphia, the son of French Catholic parents, and had lived in many parts of Pennsylvania, especially Phoenixville and Jeffersonville; in the latter city for more than twenty years. A few days after his death the *Herald and Free Press* (December 6, 1886) published a letter from Charles Collins, minister of the Presbyterian Church at Jeffersonville, which mentions Francis' "eccentricity," his "persistency in living entirely alone," his "exceedingly nervous temperament," his "spells of chronic despondency and unrest," and the "misanthropic turn of his mind," all of which Dr. Collins ascribed to "the bereavements of past years"; this may explain why we possess no paintings by Francis dated later than 1879.

According to Dr. Collins, Francis "frequently unburdened his heart" to him, and "spoke with pride of his former associations among the opulent and distinguished of society."

Forty or fifty years ago [the minister continues], "he ranked himself among the then well known Philadelphia portrait painters, Sully, Darly [*sic*], Brewster, etc. As an artist in those years, Mr. Francis had some reputation; painting portraits in Philadelphia, Washington, Nashville, and later in Lewisburg, Bellefonte, and other parts of central Pennsylvania. Especially in fruit painting, Mr. Francis seemed to excel. The imitative faculty with him was a gift, so that many of his oil paintings often is received [*sic*] with public commendation.

Portraiture lies outside the scope of this book, and therefore Francis' catalogue of his own works in this field need not be given here. (It was printed in full in *The Magazine Antiques* for May, 1951.) It accounts for a large number of portraits painted in Harrisburg, Pottsville, Northumberland, Sunbury, and other Pennsylvania towns, as well as "fancy *Signs, Banners, and Scarfes* for the Different Societies" of Sunbury. Surviving examples show that Francis was an excellent portrait painter, far superior in quality to many of his contemporaries to whom much attention has been paid.

Francis unfortunately left no catalogue of his still lifes, or if he did, it has not been preserved. Of the fifty-nine paintings by him which are known to exist, twenty are portraits and one is a picture of a house in Jeffersonville, probably his own. Of the remaining thirty-eight canvases, one is a still life of flowers and one includes a meat pie. The rest is all dessert.

His simplest still lifes are small studies of a few peaches or oranges on a table. His most elaborate are grandly orchestrated affairs depicting all manner of fruits, as well as nuts, cake, wine, cheese and the little round biscuits that go with it, and containers appropriate to all these things—china pitchers, plates, and footed dishes; wine bottles, glasses, and an occasional knife or spoon. His heaviest artillery is provided by a huge, weighty, roughly split watermelon. Whenever the watermelon appears in the Francis still lifes known to me, it leads the artist on to the grandest effort of all—the table and its big assemblage of objects is placed before a wall in which there is a window, and a stretch of landscape is seen outside.

To be sure, the landscape may appear without the watermelon, but whenever it is used it fills about a quarter of the background, invariably on the right-hand side, and there is usually a vine or some other foliage twining about the window-frame. This is only one of Francis' many fixed habits. His wine bottles are always very dark; they usually come in pairs, and one always has a collar of tinfoil. His chinaware is always light in tone (often blue and white, with gold ornamentation), and is usually rather florid in design; his china pitchers are usually placed at the extreme left-hand side of the painting; and they make the most of their arching handles. His fruit baskets are almost invariably draped with fringed napkins; sometimes their handles are adorned with ribbons.

This is a complete index of Francis' still life

iconography in his known paintings. He exploits the smallest repertoire of any important American still life painter. Harnett's repertoire seems encyclopedic by comparison, although it seems small enough when one's sights are trained exclusively upon it.

Francis is an intermediate link between Raphaelle Peale and Harnett, but he lacks their fanatical interest in varied textures and produces no effects of *trompe l'oeil*. Nothing painted by Francis will ever be mistaken for the real thing, which is a weakness or a virtue according to one's prejudices. His prime virtue lies in his ordering of shapes, especially in those pictures which are not too cluttered and which employ bottles and wine-glasses; the glasses, tall and narrow, short and squat, and of intermediate size and shape, distribute themselves about the canvas in delightful rhythmic patterns, and one can almost hear the bright, high notes they would chime if struck (plate 106).

Francis also has his virtues as a colorist, although his color is generally rather bland. Born notes that

Francis' colors are neither the local colors of the Peales nor the tonal values of an Ord. They rather reflect a study of relative values suggested by the combination of objects of different color and texture. As a result, novel shades of pink, blue, green and yellow determine the effect of Francis' mature paintings. Evidently the interest in texture is subordinated to the study of volumes and colors under a given light —a principle that in the sphere of the great art of the world was suggested by the landscapes of Corot's Italian period and was not carried through to its last consequences until later on in Cézanne's work.

Born also points out that the evolution of Francis' style is marked "by an increasing freedom in his handwriting"; [3] this is strongly underlined by the twelve dated still lifes by Francis of which I am aware (they range from 1854 to 1879), and it is a rather remarkable fact. The work of Harnett, Peto, and the other painters with whom we have been concerned, exhibits progression—changes in treatment, in taste, and in subject matter—but not "increasing freedom in handwriting." Francis, on the other hand, although his draftsmanship and application of paint grow steadily more vibrant, exhibits no changes in subject matter at all. It must

be pointed out, however, that Francis had a way of producing replicas, nearly exact in treatment as well as subject, many years apart, and this gives one pause when it comes to establishing criteria for differences in his style in each decade. Nevertheless it is true that, in general, the drawing in his earlier still lifes is tighter and firmer than that in his later pictures, and that the brushwork is hidden in these earlier achievements. As the years progress, outlines grow softer, and free, palpable brushwork plays a larger and larger part in the artist's scheme of things. This, as Virgil Barker observes in the course of his brief remarks on Francis in his *American Painting,* "gives any painter more freedom of touch," but in Francis it was also associated at times with rather dull or overelaborated compositions. Once, however, it led to a minor masterpiece—his one known flower picture (plate 111) which is as subtle and sensitive an example of "painterly" painting as American still life affords.

V

IN THE spring of 1936 the Art Centre of West Chester, Pennsylvania, was host to an exhibition called *Yesterday in Chester County Art.* In connection with this, the Chester County Art Association published a remarkable pamphlet containing articles on "Benjamin West in His Historical Significance," "Philip Derrick, Printer and Artist," "Thomas Buchanan Read, the Odyssey of an Artist," "Bayard Taylor's Artistic Side," "William Marshall Swayne, Chester County's Sculptor of Lincoln," "Wilmer Worthington Thomson, Editor and Painter," "A Quaker Illustrator, William T. Smedley," and, finally, "Our Own George Cope."

One does not write about "Our Own Benjamin West." If for slightly different reasons, that would be as out of line as writing about "Our Own Salvador Dali." But "Our Own George Cope" perfectly fits the attractive if relatively minor figure of the present story.

Throughout nearly all of his long life, George Cope remained in West Chester, painting pictures,

[3] The word "handwriting" as used here refers, of course, to the artist's brushwork.

mostly still lifes, that were bought by his friends and neighbors. Large numbers of these pictures are still there, and many have never been moved from the walls on which they were originally hung—the homes of Jay and C. Rodney Jefferis, the Starrs, Mrs. William Marvel, and Dr. Henry Pleasants, Jr., author of the article on Cope in the Art Association's pamphlet. None of these households seem to contain fewer than eight Copes, and Dr. Pleasants had sixteen—there are Copes all over Chester County, and they spill out into adjoining counties as well. Some have reached New York and one has reached a museum, the Wadsworth Atheneum in Hartford, Connecticut; by and large, however, Cope remains a provincial figure, and the art world is as little aware of him as it is of George W. Platt.

Dr. Pleasants' able article provides the main outlines of George Cope's career. He was born on a farm near West Chester in 1855 and studied painting with one Harral Herzog in Philadelphia. He went wandering in the Far West in 1876 and painted landscapes on the plains and along the Pacific coast for four years. He was back in West Chester by 1880, and there he remained until he died, on January 15, 1929. In the middle '80's he taught in a local school. In the '90's his reputation was more than merely local, and he received commissions from wealthy collectors in Philadelphia and elsewhere; but after the turn of the century, when his type of painting was regarded as outmoded, he was gradually forgotten, and he died poor and neglected.

Dr. Pleasants' article can be supplemented with material from the Cope file preserved by the Chester County Historical Society. This consists of clippings, all from the *Daily Local News* of West Chester. The squibs and stories involved were published between 1879 and 1897; it is significant that there is nothing from the twentieth century except the report of a speech given by Dr. Pleasants himself just before the Cope revival—such as it has been—was launched by the exhibition at the West Chester Art Centre.

The earlier newspaper items—those from the late '70's and early '80's—all refer to landscapes: "a passing storm off the Falls of the Turnchuck River, Washington Territory"; "a spur of the Sierra Nevada Mountains with the Truckee River, Indian huts, and portion of the sage deseret in the back-

ground"; "the old Episcopal Church and surroundings at Rock Spring, Harford County, Maryland." After the artist's return to West Chester, new influences begin to appear in his work. Witness the *Daily Local News* for October 20, 1890:

Mr. George Cope has just completed to order a very excellent canvas for a Philadelphia party. It is 16 x 22 inches, and represents an old grandfather's clock with a brass candlestick, box of matches, tobacco, pipe, a copy of *Harper's Weekly,* several wartime envelopes and a horseshoe, while the background represents some knotty pine boards.

A few weeks later (January 1, 1891):

When I Was A Boy is the title given by Artist George Cope to his latest canvas, which . . . represents a hunter's outfit, composed of a game-bag, powder-horn, shot-pouch, etc. In the bag is a rabbit and a gray squirrel, while hanging from the old shutter, which serves as background, is a meadowlark, beautiful in color and true to life in its many features.

August 29, 1891:

Mr. George Cope, our gifted artist, will exhibit this evening in Mr. D. M. McFarland's office his latest and perhaps his best canvas . . . The grouping of beer-mug, pretzel, cheese, cane, old books, matches, tobacco pipe and bag, keys and old envelopes, is done with such regard to and knowledge of nature as to deceive the eye of the looker-on.

On June 20, 1894, comes a climax:

Mr. George Cope is now fairly enlisted in a work that promises to be the greatest production from his highly artistic brush. It is seven feet by four and one-half feet and the subject is the hunting jacket, rifles, hat, lariat, etc. of Buffalo Bill.

Six months later:

George Cope's large painting of Colonel W. F. Cody's (Buffalo Bill) outfit is now on exhibition at the Hoffman House, in New York City, where it was placed in position yesterday. It is already attracting much attention, and has the most conspicuous place in the house.

The *Daily Local News* never displays the slightest awareness of the fact that Cope belonged to a great, highly specialized tradition, and to this day there are those in West Chester who seem to believe that he invented all this by himself. Its source is obvious enough. *Buffalo Bill's Traps* (which is lost, but is known through a photograph, plate 68) is a rather disorganized version of *After the Hunt;* a considerably better version by Cope, *Major Levi McCauley's*

Uniform, is preserved in the American Legion hall at West Chester. Cope's painting of Professor Hunter Worrell's pipe (plate 110) directly follows Harnett's hanging meerschaums, and the same predecessor is also suggested by Cope's picture of keys and a letter on a board. Cope's table-top still lifes (plates 107 and 109) sometimes reflect Harnett and sometimes Francis, but his line and his textures are much harder than those of either. The perspective and proportions are sometimes obviously faulty in Cope's table-top pictures, and for this reason Born includes him with the primitives, but by virtue of their very defects these works have distinct character and charm. The spectator always seems much closer to the objects than in the table tops by Harnett and Francis, (plate 109), and is much more clearly aware of the fact that he is seeing only an end or a corner of the table; by the same token, Cope's table-top compositions are considerably less complex than those of the older artists.

If Francis' artistic "handwriting" shows increasing freedom with the years, Cope's "handwriting" displays exactly the opposite development. Dr. Pleasants' article may provide the explanation for this: "The greatest delight of the aging artist was to find someone in whom the appeal of detail in art had not been stifled by the wave of enthusiasm for modernistic interpretation." Cope, one must bear in mind, continued to employ the style of the 1880's well into the 1920's. It may very well be that as his own time receded, and as he found himself more and more hopelessly isolated in a world whose artistic tendencies emphasized an expressive fluency with which he could not sympathize, he returned to his canvas more than ever determined to cherish the ideal of "correct" drawing and rendering in which he had been trained. At all events, his last still lifes are almost macabre in their staring, frozen, rigid exactitude; his earlier still lifes, with their slips and "errors" in draftsmanship, are considerably more pliant and vivid.

At the same time, some of Cope's last landscapes are exceedingly interesting. He seems always to have loved and respected the greens of foliage, the grays of wood and stone, and the blues of water and sky. In painting these, he never drives his color too far, as he sometimes does in still life. His relatively mild landscape palette, coupled with his devotion to precise objective statement, led to something startlingly like the *Neue Sachlichkeit* which was at one time so popular among the Germans and has its contemporary counterparts elsewhere. Cope's landscapes would be at home in an exhibition of pictures by Malcolm Morley. Once again, the forgotten old-timer has the last laugh.

VI

THE MURRAY Hill Hotel in New York has long since been torn down and so is seldom mentioned any more, but there was a time when anyone interested in *trompe l'oeil* was constantly being informed of a painting in its lobby which represented five puppies in a crate (plate 117). The crate was open on the side facing the spectator, and the puppies were held in by a piece of chicken wire. The wood was done in a reasonably illusionistic style, and bore a Petoesque torn label. The picture was signed with a delivery ticket giving the artist's name and address as consignee: "Alexander Pope, 23 Irvington Street, Boston."

The rest was easy, for Pope had been a famous man. The files of Boston newspapers were crammed with clippings about him, and through these I had no difficulty in locating his son, Samuel Downer Pope of Melvin Village, New Hampshire, who had the invariable scrapbook and stack of old photographs, although he had very few of his father's pictures. Alexander Pope had not left many unsold paintings. He was much too successful for that. He seems to have been one of those back-slapping, club-going, sportsman-artists who can practice with equal ease in half a dozen different styles at once, and whose reputations, high during their lifetimes, seldom last very long. But Pope left some things worth reviving.

He was primarily a painter of animals—of celebrated race horses, champion dogs, and blooded cattle. He had shown his predilection for animals as subjects from the beginning of his career, and his first work was a long series of lithographs of birds

of which many copies still exist. (They are signed A. Pope, Jr.; his later works are signed with his full name, minus the "Jr.") Born in Dorchester, Massachusetts, on March 25, 1849, he had studied sculpture for a short time with William Rimmer, but sculpture did not appeal to him as strongly as painting, in which he was entirely self-taught.

Pope seems to have spent all his life in and around Boston, and he died in the Boston suburb of Hingham on September 9, 1924. Countless works of his are, or were, to be found in private homes, theaters, clubs, and hotels throughout New England and elsewhere; the Czar of Russia owned two Popes, and so did many another exalted personage in the artist's time. No doubt his most celebrated work is one still to be met with occasionally in saloons: a lithograph of a lion set deep in a frame with black wooden rods all across its front to simulate the bars of a cage.

Animal painters sometimes paint dead animals, and then they become still life painters. As the Boston *Herald* put it in a feature story about this artist published on October 5, 1902, "It is one of his favorite pastimes to paint birds, rabbits, etc., hanging to a wall and cause them to stand out so as to deceive the sight and to cause many to desire to see the other side in order to be convinced that they are not real instead of painted objects." These hanging-game still lifes by Pope are very numerous, but they represent a tiresome tradition with which very little can be done. At least once, however, Pope worked a sensational variation on the theme— a picture of a huge white swan magnificently spread on a large green door. On November 2, 1902, the Boston *Post* was moved by the verisimilitude of this painting to approach something close to journalistic ecstasy: "If a person wishes to be startled out of his ordinary complacency and to almost believe the days of sorcery have returned, he has but to visit Alexander Pope's studio in this city and to look at a recent painting titled *The Wild Swan.*" Many years later the owner of this work, tired of its sorcery, presented it to the most inappropriate institution he could find—the Massachusetts Society for the Prevention of Cruelty to Animals—which was doubtless happy to pass it on to the Metropolitan, where it is today.

As one would naturally expect, Pope did many versions of *After the Hunt,* including the military version—the study of a soldier's uniform and equipment hanging to a door, as in the example by Cope previously mentioned. Pope's one known example of this—known, that is, through a photograph in his son's possession—has a hair-raisingly original touch, for its central motif is nothing less than a pair of pants hanging upside down in a large V, suspended from a pair of antlers.

To judge by the photographs at Melvin Village, Pope produced quite a few examples of *After the Hunt* in its more orthodox form. These are his best works by far. Unfortunately only three are known to exist in the actual canvas—one in the Graves Art Gallery in Sheffield, England, which acquired it and Harnett's *Old Cupboard Door* by gift from H. H. Andrew, one in the Poland Springs Hotel at Poland Springs, Maine, and one, in the collection of Mrs. A. Perley Chase in Medford, Massachusetts (plate 72).

Like Goodwin, Pope alters the theme a great deal from canvas to canvas, but there are, nevertheless, certain constants in his treatment of it. Rather oddly, he makes relatively little of the dead animals. His attention is directed more toward the hunter's equipment and the antlers; the latter is a motif which Goodwin never uses but which Pope never omits. Often they are the huge, intensely heavy antlers of a moose. Whether of moose or deer, they are always used as a rack, either for guns or for fishing rods partly wrapped in their canvas coverings. The door seldom shows hinges or fittings of any kind, and never its top or bottom; the objects, we are given to understand, are displayed in the middle of the door. The center of the picture is usually occupied by a big X, usually provided by crossed rifles, sometimes by crossed knives. Scattered here and there are such things as pistols, sheath knives, leashes, canteens, pipes, fishing reels, fishing flies, binoculars, and game bags; a frequent motif is an ace of hearts which has been used for a target and shows holes where it has been hit. (The same device appears in Cope's Buffalo Bill picture.) The arrangement is often very ingenious; the composition is more aerated than Harnett's and full of interesting contrasts and balances of shape and move-

The Second Circle

ment. Where Harnett studies contrasting textures, Pope studies relative weights, densities, and degrees of hardness, and he draws and applies paint in genuine virtuoso style.

At the opposite extreme, in certain respects, is the Pope still life formerly in the Hewitt collection, which shows bottled wine, olives, sardine cans, and a crock, all standing before a champagne crate topped with a cigar box (plate 118). This is a study in relative transparencies. The whole painting is soft-edged; its point is the light shining through the liquid in the bottles and the brilliant, splashy highlights reflected from the glass, the stoneware, and the tin. If it were not signed with the same name in the same type of block lettering as that used in other works of Pope, one would not believe it had been produced by the same hand. It has nothing of the *trompe l'oeil* style. It suggests Sargent. It also suggests that there may be a great deal more to Pope than has been indicated here.

The Third Circle

\mathcal{W}ILLIAM MICHAEL HARNETT, John Frederick Peto, and John Haberle appear, in the light of present knowledge, to be the outstanding figures in the story of illusionistic American still life between 1870 and 1900. Jefferson David Chalfant, John F. Francis, George Cope, Richard LaBarre Goodwin, George W. Platt, and Alexander Pope are secondary figures whose work has been recovered in some quantity and concerning whom sufficient biographical information is obtainable to provide a reasonably well-rounded picture. The "third circle" consists of still life painters of the same era—all of them provably or presumably Americans—who, for one reason or another, must be classified as minor figures. Some of these, notably William Keane, may well have been major talents, but so little of their work has come to light, and so little is known about them, that no trustworthy estimate of their importance can be attempted. Others, like Claude Raguet Hirst, are certainly minor talents, but minor talents that must not be overlooked.

The "third circle" itself has three rings. First to be considered are thirteen painters who demand relatively extended treatment. Next is a group of four who, like most of the preceding thirteen, can be assigned a more or less definite place in the total picture but who do not call for more than a paragraph or two. Last of all is a group of nineteen people known solely because their names are signed to one or two pictures in the tradition of *trompe l'oeil*.

* * * * *

HENRY ALEXANDER was the victim of a chain of tragedies. He died, very suddenly, at the age of thirty-three, before his career had fairly started. Eleven years later, his family, preparing a memorial exhibition, gathered together a large number of his paintings, and all of these—the core of his brief life's work—were destroyed in the San Francisco fire of 1906. Consequently all that remains of the work of this gifted and interesting artist is a scattering of pictures here and there: one in the Metropolitan Museum, one in the M. H. de Young Memorial Museum, and a few in private hands in the San Francisco area.

Alexander was born in San Francisco in 1862 and was sent to Munich to study at the age of fourteen. He returned to his native city in the early '80's and remained there until 1887, when he went to New York, where he occupied quarters in the famous old Tenth Street Studios. He died in New York in 1895.

Alexander was primarily a genre painter, but a genre painter of a special and rather curious kind. His figures are neither very well portrayed nor very interesting in their action, but they are likely to be surrounded with an endless storehouse of still life objects painted in brilliant style. Without much question, his best pictures are those which represent people at work in the laboratory of Thomas Price, the California state mineralogist and assayer (plate 123). Here, at one stroke, Alexander created a unique department in American art—the still life of scientific equipment.

No cubist could have surpassed Alexander when it came to the forms of retorts, beakers, test tubes, bottles, burners, funnels, flasks, microscopes, balances, and the thousand-and-one fantastic shapes into which chemical glass is blown. In addition to the litter of Price's work tables, Alexander makes remarkable cubist patterns with the windows and wood panels, the cabinets, racks, and other large rectilinear shapes of the laboratory, to say nothing of his play with the sparkling blues, reds, greens, and yellows of the chemical solutions contained within the glassware.

Some of Alexander's pictures of old-fashioned business offices are almost equally interesting, thanks to their magnificent chaos of papers, pens, inkwells, chessmen, and similar objects, and to their glimpses of narrow downtown streets outside. At least once he applied his encyclopedic method to the inside of a taxidermist's shop, with its tools and barrels and boxes and with an amazing scatter of dead animals in every conceivable stage of mounting. An interior of a cobbler's shop provides a complete inventory of lasts, dozens upon dozens of lasts, each slightly different in shape from the others, and all arranged on shelves behind the cobbler's head. The old shoemaker, however, is playing a shaky tune on his violin as he sits at his bench, a little colored boy has stopped at the door to listen—and the sentimentality

of the figures kills the mathematics of the still life.

Alexander was also fond of painting the interiors of the gloomy, oppressively ornate, overcarved, overgilded, overembroidered, overstained-glass-windowed Chinese restaurants that existed in San Francisco in his time. Some of these works, however, are at least partly redeemed by their vases, cups, and teapots. For the rest, he did some soldier-monk-and-tavern-table pictures in typical Düsseldorf style, some costume genre pictures in the inescapable tradition of Meissonier, and some humorous genre pictures that might be worth reviving. His painting of an artist in an almost bare studio, contemplating the worn-out sole of his shoe while snow settles on the Tenth Street buildings outside, reminds one of Louis Moeller and other New York genre painters of that era who have been unjustly neglected in the art historians' concern with the rural genre specialists of an earlier period.

Toward the end of his life, Alexander seems to have been especially fascinated with painting artificially patinated glassware. Some of these works are quite charming, but some are crude and harsh. His performance as a whole was extremely inconsistent, but perhaps it would have leveled off on a more even keel if he had lived longer and decided just what it was that he wanted to do. No doubt, also, we should have a better idea of his achievement if so much of it had not been wiped out of existence. As it is, so little of Alexander is left that one can reconstruct only a patchwork, but a patchwork of no inconsiderable interest.

* * * * *

ONE REALLY should have one's spies everywhere. If a girl named Lillian Holmes who worked for a radio station in San Francisco with which I was at one time connected had not gone to spend her vacation with her parents in Fargo, North Dakota, the baffling case of a presumed Harnett in Youngstown, Ohio, might never have been solved.

The Butler Art Institute at Youngstown has a picture of a violin which it purchased as a Harnett in 1917. This work bears no Harnett signature, and it is by no means uninteresting that at that time it was identified and sold as one of his paintings, for Harnett is supposed to have had no reputation whatever in the earlier years of the present century; nevertheless, as we have seen, Harnett's *Old Violin* was never really forgotten in Cincinnati and other Ohio towns.

I saw the Youngstown painting quite early in my search. It is of the same general type as the Harnett in Cincinnati, but with certain signal differences. The violin hangs against a wall with a sheet of music behind it. The music, *Auld Lang Syne,* is not the music of the Cincinnati picture, but it is placed in exactly the same diagonal position and has the same folds and tears. There are no hinges or rings on the door, and there is a table below the violin on which are a piccolo, a paper-bound copy of *Great Expectations,* more sheet music, and a letter addressed to "H. H. Baker, General Post Office, New York." At the time I saw this work, I did not know that Harnett never left a completed canvas unsigned, nor did I know that the Baker inscription was not in his handwriting. Harnett might have addressed a painted letter to a friend or buyer, and H. H. Baker, I thought, was someone who might eventually fit into my story. The style of the Youngstown picture, however, was curious. It had little of Harnett's superb virtuoso treatment. To be sure, it gave off a general air of competence, but when one examined details it failed to come off, at least as a Harnett. Its violin was too flat and imperfect in proportion; it even suggested convexity where it should have been concave. The bow was too heavy, the edges of the sheet music too jittery, and the painted notes too staringly black. The postmark on the letter was covered by the violin bow and neither its date nor place of origin could be read. I filed the Youngstown picture among the questions to be answered.

In July, 1947, Mrs. Anton Erickson of Fargo, North Dakota, presented a copy of the Tuchfarber chromo of Harnett's *Old Violin* to the YWCA in that town. The YWCA wrote to the Frick Art Reference Library to find out what it was, and accordingly received its correct identification. It was discussed in the Fargo *Forum* for July 20, and Lillian Holmes sent me a copy of this story.

Then, on August 3, the *Forum* published a letter from Mrs. Charles Ira Gross of Oakes, North Dakota:

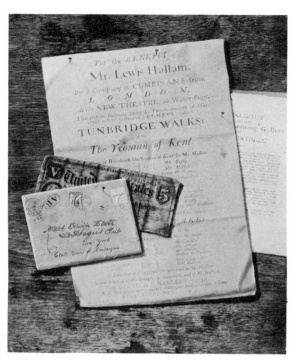

119

N. A. Brooks, attributed to W. M. Harnett
To Edwin Booth (25 x 19) Formerly
collection A. Conger Goodyear, New York

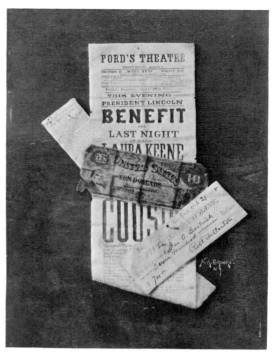

120

N. A. Brooks
Still Life with Playbill 1888 (20½ x 15¾)
Oberlin College, Oberlin, Ohio

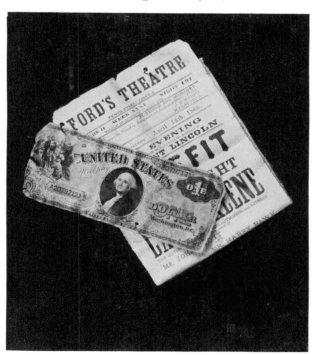

121

Ascribed to W. M. Harnett
Dollar Bill and Playbill (14 x 12)
(photographed before laboratory examination)
Franklin D. Roosevelt Library, Hyde Park,
New York

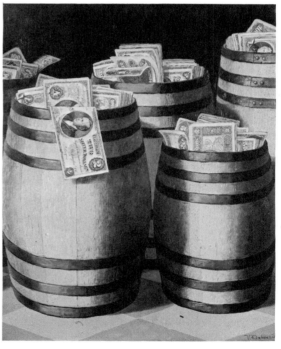

122

V. Dubreuil
Barrels of Money (24 x 20)

123

Henry Alexander
The Laboratory of Thomas Price (21½ x 27)
Formerly collection James Alexander, San Francisco

124

Joseph Decker
A Hard Lot (12 x 22)
Formerly collection Henry Rogers Benjamin, New York

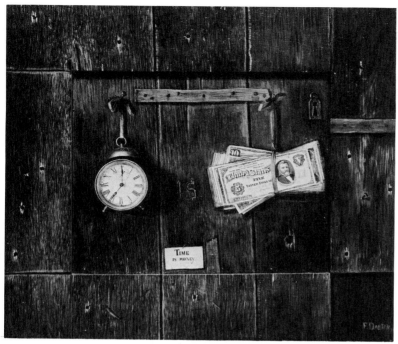

125 *(Reproduced by special permission of the Secretary of the Treasury. Further reproduction in whole or in part is strictly forbidden.)*

F. Danton, Jr.
Time Is Money 1894 (17 x 21)
Wadsworth **Atheneum,** Hartford, Connecticut

126

Claude Raguet Hirst
An Interesting Book (watercolor, 10¾ x 15)
Francis C. Hutchens, San Francisco

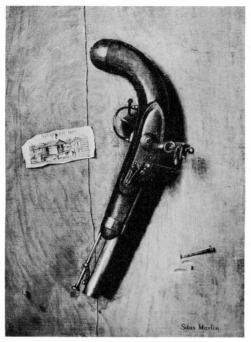

127

Silas Martin
Flintlock circa 1890 (19½ x 13½)
Formerly collection Mrs. A. W.
McKillop, Walnut Creek, California

128

C. A. Meurer
The Pen Is Mightier than the Sword 1948
(40 x 32) Formerly collection
C. A. Meurer, Terrace Park, Ohio

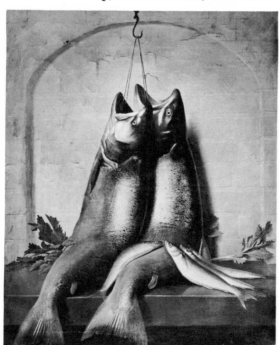

129

Samuel Marsden Brookes
Salmon Trout and Smelt (40 x 32)
M. H. de Young Memorial Museum,
San Francisco, California

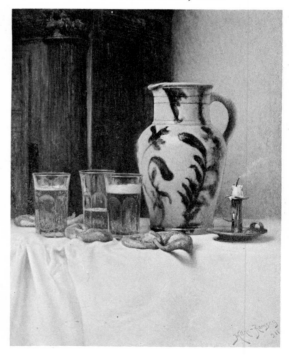

130

Milne Ramsey
Still Life 1911 (30 x 24)
Dr. K. C. Slagle,
West Chester, Pennsylvania

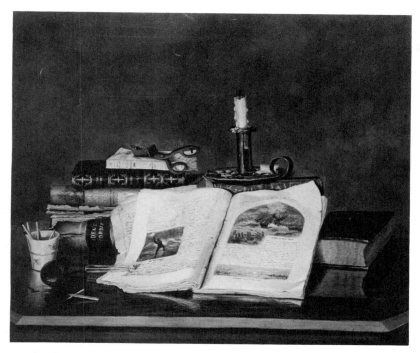

131

E. N. Griffith
Still Life 1894 (12 x 14)
Mr. and Mrs. George A. Stern, New York

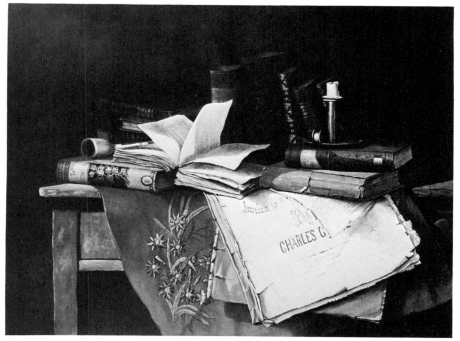

132

Ascribed to W. M. Harnett
The Bachelor's Friends (20 x 26)
Addison Gallery of American Art, Phillips Academy,
Andover, Massachusetts

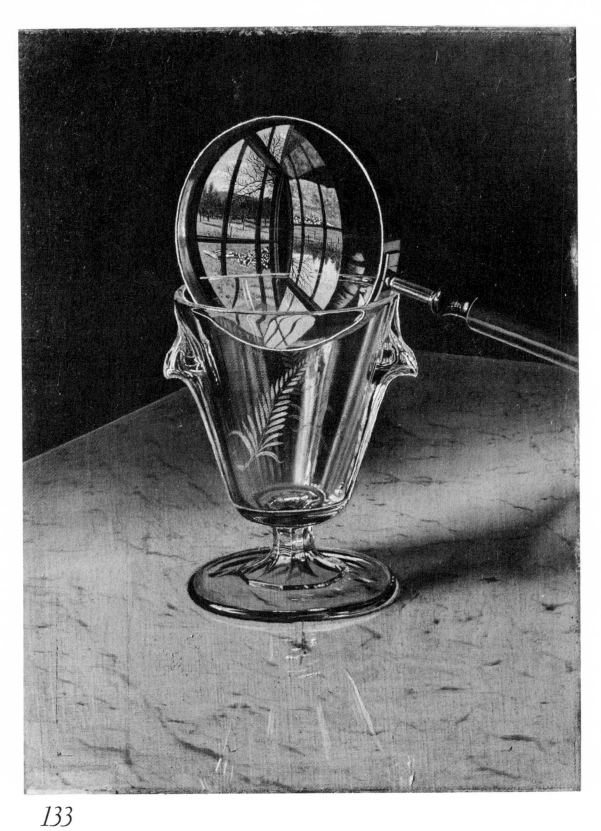

133

Edwin Romanzo Elmer
Magic Glasses circa 1890 (14 x 10½)
Formerly collection Maude V. Elmer, Seattle

134
William Keane
Still Life (40 x 24)
Formerly collection Charles Jackson, Orford, New Hampshire

135

Unknown artist
The Fish Is on the Other Side (18½ x 22)
Formerly collection Edwin Hewitt, New York

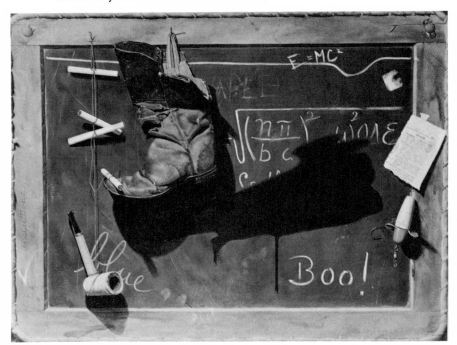

136

Kenneth Davies
The Blackboard 1951 (20 x 26)
Joseph Verner Reed, New York

The Third Circle

In Sunday's Fargo *Forum* I noticed a picture of *The Old Violin*. Well, I have a copy of the painting in oil, have had it for over fifty-seven years . . . *The Old Violin* was painted by a friend of mine. He copied it from the original and I have never framed it, but it has hung upon the wall all of my married life, which is fifty-six years.

Miss Holmes used her scissors again, and I used the air mail. Back came a letter from Mrs. Gross:

The gentleman who copied the painting has passed away. His name was Harry H. Baker. His family and mine came from England. We lived in St. Paul for a number of years. Our families were close friends . . . Harry went to Minneapolis and it was there he painted *The Old Violin*. He painted two of them, giving one to his uncle, a Mr. John Walker, who also has passed away. Harry Baker had two brothers and a sister, Nellie, who married a Mr. Will Drake. I think they lived in California in the last years of their lives. Harry went to England to study art. I think when he returned from England he painted something in a Masonic temple before the earthquake.

A few days later I received a photograph of Mrs. Gross' painting. It is a close copy of Harnett's *Old Violin* except that it substitutes *Columbia, the Gem of the Ocean* for Harnett's music. Its letter is addressed to "H. H. Baker, Minneapolis, Minn., 2820 22 ave., South," and is postmarked in St. Paul on December 9, 1887, shortly after the Tuchfarber chromo was published. The handwriting on this painted envelope is identical with that on the envelope addressed to H. H. Baker in the picture at the Butler Art Institute; it is a bold hand with highly pronounced and unmistakable characteristics, such as the use of a capital "K" in the middle of the artist's last name.

The Youngstown painting is probably not the second version of Baker's Minneapolis copy to which Mrs. Gross refers in her letter. It is considerably more skillful than the Gross version and so was probably made later, perhaps after the artist had returned from his studies in England. Nothing else of Baker's has so far turned up, and we have no further information about him, but this little incident put me on the lookout for oil copies of the Harnett chromo, and of such, as we now know, large numbers exist.

* * * * *

SOME YEARS ago, at the Brooklyn Museum, John I. H. Baur called my attention to a very handsome still life of fish which that institution had just acquired. It was signed S. M. Brookes, a name that meant nothing to Mr. Baur or to me, but I was one up on him when it came to the marks on the back. The canvas was old and rubbed, but one could still read on it the words "Kearny Street," the name of the thoroughfare in San Francisco where many dealers in artists' materials have their shops to this day.

It was the old story: I had been running after nineteenth-century still life painters in Philadelphia, New York, Chicago, New Haven, Denver, and everywhere else but in my own bailiwick, and I had to go to Brooklyn to become aware of a San Francisco artist. To be sure, Samuel Marsden Brookes did not turn out to be a great master of *trompe l'oeil*, but he is far from a totally negligible figure.

According to the notes on Brookes in the catalogue of the permanent collection of the San Francisco Art Association published in 1905, his career was unusual in one respect: he had been born in England (on May 8, 1816) and grew to full maturity there, but he studied art in Chicago, in the early 1840's, and then returned to England to practice. He came back to this country in 1847 and settled in Milwaukee. In 1862 he went to San Francisco, where he remained until his death on January 31, 1892. He was one of the founders of the Bohemian Club of San Francisco, which still displays some of his works, and there are pictures by him in the M. H. de Young Memorial Museum, in the E. B. Crocker Art Gallery in Sacramento, at the University of California, and in private hands in the San Francisco Bay Region. (His San Francisco Art Association picture, a peacock, has disappeared.) That his reputation was not entirely local is indicated by the fact that he was represented at the Philadelphia Centennial; the picture shown in Philadelphia was lent by Albert Bierstadt, the enormously successful painter of Western scenery.

Brookes was primarily a highly skilled painter of wet, gleaming, glistening fish (plate 129), but he was by no means solely devoted to this subject. The Art Association catalogue of 1905 speaks of his portraits "in the rooms of the State Historical Society

The Third Circle

of Wisconsin," [1] and I have seen some beautifully painted, miniaturistic flower-pieces from his brush. The San Francisco *Chronicle* of February 8, 1892, records a Brookes of a fox with its foot in a trap which "readily suggests the San Francisco Stock Exchange." The Brookes at the Crocker Art Gallery is a large affair of fish, game, and vegetables on a stone ledge, distinctly recalling the Flemish masters of gory opulence. This work is dated 1862, the year of Brookes' arrival in California, and is considerably more subtly brushed than any of his later pictures known to me.

An interesting sidelight on Brookes and on critical appreciation in the '70's is to be found in the following observations by the anonymous critic of the *Overland Monthly* published on December 7, 1873. It is part of a review of the San Francisco Art Association's annual show:

> In the department of still life, S. M. Brookes stands alone. His recent studies of Sonoma fruit—including, separately, pomegranates, apples, and Flaming Tokay grapes—are among the best things he has done in that line—literal transcripts of nature. He takes a branch of a tree or vine, with all its fruit and leaves upon it, and paints that—nothing more—charming one with the mockery of reality. Such work is very honest, and the technical skill it shows is very great; but why will this able artist always fasten his cunning branches against bits of stuccoed brick work, and never compose his beautiful studies into a picture? Mr. Brookes also exhibits one of his best fish studies—a couple of splendid salmon hanging against a wall above a marble table—fresh, moist, full-bodied, palpable, and bright in their silvery sheen. Less worthy of the labor is the clever imitative talent bestowed on the picture of an open Bible, with spectacles on the page, as though some aged reader had just laid them down, under the soft pale light of a kerosene lamp.

Observe that Brookes was doing the open book and the glasses in 1873, before Harnett's career had started, and, in all probability, before Claude Raguet Hirst had even begun her artistic studies.

* * * * *

N. A. BROOKS is, of all the artists in this book, the one who has most successfully resisted research. He is the actual author of two paintings to which someone later added Harnett signatures, and which were sold as Harnetts—*To Edwin Booth,* in the collection of A. Conger Goodyear (plate 119), and *Dollar Bill and Playbill,* which Nelson A. Rockefeller presented (as a Harnett) to President F. D. Roosevelt; this is now in the Franklin D. Roosevelt Library at Hyde Park, New York (plate 121).

Careful and extended searches have turned up only two facts about N. A. Brooks: his first name was Nicholas, and he is listed, as "artist" or "portrait painter" in some issues of the New York City Directory printed between 1880 and 1904. He seems never to have joined any art societies, never to have exhibited at the National Academy of Design or at any other institution which held annual shows in his time, and to have been utterly ignored by the press. There is no record of his death in any of the five boroughs of New York City, and for all I know he may still be alive somewhere, like John Wilkes Booth or Billy the Kid. A number of table-top still lifes by him, obviously inspired by Harnett but of no great quality, have appeared on the New York market in recent years, and the Detroit dealer, W. H. Thomson, has found a painting by him of a ten-dollar bill and a newspaper clipping.

In the first section of the present book is the story of how the Goodyear picture (plate 119) was identified as a forgery through its iconography. The picture, it will be recalled, was signed "W. M. Harnett, 1879." It represented an eighteenth-century Philadelphia playbill on top of which were a five-dollar note and a letter addressed to Edwin Booth at the Players Club, New York; partly hidden behind the playbill was the first page of the catalogue prepared for the sale of an art-collection which had belonged to a man named Leaming. The five-dollar bill was clearly inscribed as belonging to the series of 1880; the Players Club, it turned out, had been founded in 1888, and the Leaming sale had been held on April 4, 5, and 6, 1893, following the death of Dr. James R. Leaming on December 5, 1892. (Harnett, remember, died on October 29, 1892.) The Harnett signature on this painting was a farce: its perpetrator had not even bothered to imitate Harnett's invariable monogram, but had written out a capital "W" and a capital "M" on the same line as the capital "H" (plate 16, bottom of left-hand column).

Returning to this panel after a preliminary check

[1] For reproductions of these see Porter Butts, *Art in Wisconsin.* Madison, 1936.

of its subject matter, I noted several other things of interest. First of all, coming up through the underpaint on the Booth letter, brought out by time and repeated cleanings, was a second address: "219 Third Avenue." There were other inscriptions in the underpaint, but they remained illegible; clearly, however, the whole Booth address was a late addition. Furthermore, someone had used sandpaper to remove the dates from the postmarks on that letter, and sandpaper had also been used to efface something on the painted page of the Leaming catalogue. Comparison with the actual page as preserved in the New York Public Library revealed what had been taken away: the name of Robert Fullerton, the dealer who had been in charge of the Leaming sale. Robert Fullerton was the proprietor of an antique store called the Old Curiosity Shop. Its address was 219 Third Avenue.

In the Dudley Peter Allen Art Museum at Oberlin College is a picture (plate 120), on the same type of mahogany panel as Mr. Goodyear's *Edwin Booth,* which is signed "N. A. Brooks, N.Y." It represents the so-called "Brown Reprint" of the playbill at Ford's Theater on the night of Lincoln's assassination, across which lie a ten-dollar bill and a check for seven hundred dollars drawn on the Fifth National Bank of New York on February 21, 1888; to the order of James A. Bostwick. The check is signed by Robert Fullerton. (Bostwick was a photographer on Sixth Avenue. What he had to do with Fullerton I have never been able to discover.) In one corner of this picture is a painted newspaper clipping headed "Gen. Robert Fullerton's Old Curiosity Shop." Not much of this clipping is legible, but the opening lines are, "When the artist Chas Muller made a sketch of Gen. Robert Fullerton's Old English Curiosity Shop; and afterwards put on canvas the picture that attracted the eye of millionaire Mitchell of Milwaukee; it increased his reputation and put the snug sum of $250 in his pocket." The clipping has no bearing on our story at all, and I mention it for only one reason: just a week before these notes on Brooks were written, John Barnes, the New York collector of *trompe l'oeil,* sent me a photograph of his latest find, a picture of a dollar bill signed "C. Muller."

The Roosevelt picture (plate 121) is on the same

kind of panel as the other two. As in the Goodyear painting, its "Harnett" signature is obviously fraudulent. Like the signed Brooks at Oberlin, it represents the "Brown Reprint," this time with a dollar bill lying across it; the playbill and the dollar bill were all the naked eye could see at the time this painting entered the President's collection.

Stylistically and iconographically, all three of these pictures clearly belonged together, and they were further linked by the mahogany on which they were painted. The Goodyear and Roosevelt pictures were sent to Sheldon Keck for laboratory exploration. Nothing at all was found on the Goodyear; it may have had a Brooks signature that was sanded off at the same time as the dates on the postmarks and the name of Fullerton, but of this we cannot be sure. The Roosevelt picture yielded up two things to Mr. Keck's analysis. One was a passage of overpainted lettering, now illegible, to be sure, but into which the signature of N. A. Brooks could easily be fitted. The other thing was a newspaper clipping which had been part of the original painting but which had been chipped and scraped before it was painted over. Only one fully legible word was left on that clipping: "Robert."

Just what Robert Fullerton was doing with these pictures, why they were made, why Brooks made them, and why they were tampered with, no one knows. Fullerton died on March 20, 1904, and his obituary notices mentioned, among other things, his friendship with the late Dr. Leaming and his extensive collection of rare old playbills. The "Brown Reprint" was not particularly rare, but the playbill of the *Edwin Booth* picture certainly was: some years after Fullerton's death a copy of it was sold at auction in New York and was reproduced in the catalogue of that sale along with the statement that no other copy was known to exist.

This whole story is rendered all the more mysterious by an undated clipping in the Blemly scrapbook which is headed "Last of the Grewsome Old Curiosity Club." The clipping has to do with the disbanding of "a company of jolly art lovers" who had gathered each week at Fullerton's Old Curiosity Shop: eight of the eleven members had died suddenly within a period of three years, so that the remaining three members decided that their society

was a jinx. The names of all eleven "jolly art lovers" are given. Brooks was not among them. Fullerton was one of the survivors. William Michael Harnett was one of the dead. The others do not matter.

So the Blemly scrapbook links Harnett with Fullerton, but in order to use this story as evidence that Harnett painted *To Edwin Booth*—on which, after all, no Brooks signature has been found—one will have to prove that in 1879 Harnett knew that a new series of bills was to be printed in 1880; that the Players Club was to be founded nine years later; that Dr. Leaming was to die five weeks after his own death; and that the Leaming sale was to be held four months after that. This may prove to be a difficult assignment.

* * * * *

JOSEPH DECKER is a name I first ran across in studying the manuscript catalogue of the Thomas B. Clarke collection which is preserved at the Whitney Museum of American Art. Clarke, as we have seen, had a Harnett and a Haberle, and he had several still lifes by Joseph Decker as well. Later I found that Decker had repeatedly exhibited still life at the National Academy of Design in the 1880's and 1890's, and in the reviews of these exhibitions his name was constantly bracketed with those of men in whom I was interested, notably Harnett and Chalfant. Decker had lived at various addresses in Brooklyn all during the period of his contributions to the National Academy annuals. I was never able to find any trace of his will or death-certificate, or of an obituary notice.

According to the catalogue of the Clarke exhibition held at the Pennsylvania Academy of the Fine Arts in 1891, Decker had been born in Würtemburg in 1853, had come to the United States in 1867, had studied at the National Academy of Design and in Munich, and was a painter of "landscapes, cattle, still life and portraits." One of the Clarke Deckers, purchased at the National Academy show and entitled *A Hard Lot,* was described in that catalogue as "Nuts, a nutcracker, a scale, measure, etc., noteworthy for its close rendition of color, texture and substance."

In March, 1949, I mentioned my interest in Decker, of whose work, up to then, I had not seen a single example, in the course of an interview on a New York radio program. The broadcast was not over before I received two telephone calls, one from Henry Rogers Benjamin of Manhattan, who said he had a Decker, and one from Dr. Paul B. Engel of Brooklyn, who said he had many.

Mr. Benjamin, it turned out, had Thomas B. Clarke's *Hard Lot,* and a very good work it is (plate 124). It employs deeper space and more uniformly distributed light than Harnett would have used, so that its effect is somewhat photographic; nevertheless it is a distinguished contribution to the goober-and-tin-can tradition, which is a distinctly American variety of still life.

Dr. Engel had a houseful of large landscapes more or less in the manner of George Inness, who, Dr. Engel informed me, had been Decker's ideal in landscape painting. Decker had been a close friend of the doctor's father, and had left him not only the landscapes on the walls but numerous small still lifes which were taken from cabinets for my inspection. They all seemed much weaker than Mr. Benjamin's picture, and as Dr. Engel continued to bring forth paintings and talk animatedly about them and about the artist, there came over me an indescribable, hair-raising sensation that was next door to panic: Dr. Engel's Joseph Decker and Mr. Benjamin's Joseph Decker were probably not the same man, yet their biographies were almost identical. Dr. Engel's Joseph Decker had been born in Germany in 1852—either the Clarke catalogue or the doctor himself could easily be wrong by one year—and had come to this country as a young man. He had begun his career by painting pictures of small boys (the gamin picture beloved of all nineteenth-century genre painters) and he had also done many small still lifes, especially of fruit and nuts. He had lived in Brooklyn most of his life and had died there in 1920. He had at one time been employed by Thomas B. Clarke to restore damaged Oriental vases, but, according to Dr. Engel, he had never exhibited at the National Academy of Design.

I have never been able to decide whether or not I had run across the trail of one Joseph Decker or two. It is not impossible that two men bearing the same far from uncommon name were born in Germany within a year of each other, that both became

artists in Brooklyn, and that both came into the orbit of Thomas B. Clarke. Perhaps something might have been determined if we could have taken Mr. Benjamin's picture to Dr. Engel's house, but this comparison could not have settled very much, for there was only the one lone canvas by *the* Joseph Decker to go on, and the road to hell is paved not only with good intentions but with the broken necks of art historians and other scholars and scientists who have generalized from insufficient evidence.

Since that time another painting by Joseph Decker has come to light and has been bought by Joseph Katz of Baltimore. To judge from the photographs, it is a very spirited and skillful work far superior to anything I saw at Dr. Engel's home. To be sure, it is not demonstrably similar in style to *A Hard Lot,* but that may be due to the fact that its subject is completely different. It is a painting of a group of small boys.

* * * * *

V. DUBREUIL must have had a merry time in his life, which I trust was long and spent amid pleasant surroundings. He apparently never went to jail, although one of his pictures did; that painting may very well be the only work of art ever held behind steel bars in the United States of America.

Dubreuil—whoever he was—seems to have done nothing but paint pictures of United States currency. I have seen six of his works, and have been told of two more. All are signed. None is dated. All represent bills issued during the 1880's and 1890's. Unfortunately the records of the serial numbers printed on Federal currency at that period no longer exist, and so it is impossible to check on the place of issue of the notes in Dubreuil's pictures and thereby discover where he lived. That would be the only possible point of attack for solving the mystery of this artist, for his name is completely absent from the archives and publications of the art world, nor is there any record of him in the files of the Secret Service, which has a complete dossier on Harnett's embroilment with the law over paintings of money. The Secret Service did confiscate one of Dubreuil's canvases—a large one, with twenty-dollar bills spilling out of barrels—and it was held for years under lock and key in Secret Service headquarters at the Treasury in Washington, although it was recently destroyed. No matter; there is another Dubreuil of that type in existence, but I shall not say where (plate 122).

Dubreuils have come to light in Providence, Washington, New York, and Cleveland, but the artist's name is absent from the directories of those cities for the period in which he was presumably at work. Most of his pictures show the bills tacked to boards; sometimes there is only one bill and sometimes there are several, arranged in interesting patterns. In one highly amusing variation, a stack of ten-dollar notes, held together with a strip of paper and a pin, dangles free in space at the end of a ribbon, while beneath is the title, *Take One.* Dubreuil's style is rather rough and ready. He was not a great illusionist but he was a blithe spirit, and the spirit of his works is all the blither for their mocking refusal to yield up even so much as a single scrap of evidence concerning the man who made them.[2]

* * * * *

EDWIN ROMANZO ELMER first came to the attention of the art world in the summer of 1950, when an utterly charming genre picture of his, *A Lady of Baptist Corner, Ashfield, Massachusetts,* made a great hit in the exhibition called *American Processional* at the Corcoran Gallery of Art. A little earlier, his niece, Maude V. Elmer of Greenfield, Massachusetts, had visited the Peto exhibition at Smith College, bringing with her photographs of several paintings by her uncle. One of them was an incredible primitive picture. It showed a large, old-fashioned house, set far back on a lawn but nevertheless painted with obsessive photographic attention to every minute detail. A man with a derby hat and handlebar moustaches sat in a chair on the grass, and a woman sat near him. In the foreground were a doll buggy, a cat, and a little girl, standing and fondling a lamb. The little girl, Miss Elmer said, was painted with the lamb to show she was dead.[3]

[2] For some additional information on Dubreuil, see Preface to the Revised Edition.

[3] This and other paintings by Elmer will be found reproduced in the *Magazine of Art* for October, 1952.

Another picture of which Miss Elmer had brought a photograph was the *Lady of Baptist Corner,* which belonged to E. Porter Dickinson, librarian, Amherst College. This is actually a portrait of Elmer's wife working at a machine for the weaving of whip-snaps which the artist himself had invented. It exhibits much greater sophistication than the family group, but no less minute and exacting a technique. Maude Elmer, who had been superintendent of art instruction in the public schools of Seattle for many years and possessed ample background for her enthusiasm about her uncle's work, said that there were many portraits, still lifes, and genre scenes by Elmer in Greenfield and nearby towns, but it was some time before enough of them could be rounded up to obtain a fair idea of what Elmer had accomplished.

Elmer was born in Ashfield in 1850 and died there in 1923. He spent his childhood on a Massachusetts farm, went to a country school, invented his whipsnap machine, a mechanical churn, a machine for shingling houses, and other devices; he also made his living for some years turning out enlarged crayon copies of photographic portraits. In 1895 or thereabouts, he went to New York and studied at the National Academy of Design with that great panjandrum of rumble-bumble, Benjamin Wells Champney. He returned to Ashfield after a year in New York, and painted there until his death.

To judge by the few examples of his painting which I have seen, it is far from unlikely that Elmer is to be ranked with William Sidney Mount and similar painters of American rural life; his work, however, has a character all its own, and demonstrates a progression from primitivism to a rich and by no means unsophisticated handling. His still lifes sometimes remind one of Raphaelle Peale's powerful simplicity, and one of them is, so far as I know, unprecedented in American art.

This work (plate 113) represents a magnifying glass set in the wide mouth of a glass vase on the top of a marble table. The polished magnifier reflects the landscape seen through two windows behind the spectator's back. The view through each window is bent and distorted by the convex surface, and one of them is inverted as well.

Similarly distorted exterior and interior scenes as reflected in drinking glasses, crystal balls, and curved metal surfaces are, of course, exceedingly common in sixteenth-century Dutch genre and still life, but I do not recall any other American example of this device. Even among the Dutch, the reflected image is usually verified, not to say identified, by its repetition in large elsewhere in the canvas. To present the reflected image of a scene entirely outside the spectator's line of vision is unusual. To present two such images is even more unusual, and to turn one of them upside down is, in all probability, altogether unique.

* * * * *

OFTEN IN studying Harnett forgeries a bell rings at once. The style of the canvas before you fits together with a known style as perfectly as the two images of a stereopticon, and you know you have a Peto, a Meurer, a Goodwin, a Hirst, or a Francis. Just as often, however, the bell is completely silent. Then all you can say is that the picture in question is not a Harnett, but you cannot link it to anyone else. The most annoying cases are those in which the manners of known artists are suggested but are not convincingly demonstrated. *Raspberries and Ice Cream,*[3] is close to Cope, but not close enough. The table-top still life once owned by Louis Stern of New York reminds one of Waas, but the reminiscence is faint. The big catch of fish in the collection of S. H. Meilachowitz of Philadelphia, a work which has the unique distinction of exhibiting two spurious Harnett signatures, could be a Brookes, and then again it might not. The still life with apples and a pitcher of cider once shown me by the New York dealer, J. B. Neumann, has a hint of Ramsey, but no more than a hint.

One of the most curious problems of all was provided by a table-top still life called *The Bachelor's Friends* in the Addison Gallery of American Art at Andover, Massachusetts (plate 132). This came within hailing distance of not one but two or three different painters and had, to boot, a Harnett signature which was an exceedingly clever piece of counterfeiting. There was a smidgin of Peto in the wood of the table, a touch of Hirst in the books, an intimation of Harnett himself in the skillfully managed

light falling across the front of the entire composition and creating deep shadow at the back; but nothing really dovetailed anywhere. The picture's whole approach was too linear, and the canvas was too full of little nervous zigs and zags. Worst of all was the bright blue drape painted with still brighter green leaves and yellow flowers; this was not only hectically out of key with itself and with the rest of the painting, but equally out of key with the entire period of the artists under discussion.

At length the Harry Shaw Newman gallery in New York turned up a still life, signed E. N. Griffith, which depicted several of the same books and the same candlestick as *The Bachelor's Friends* and treated them in exactly the same way. The bell rang, the two halves of the stereopticon image meshed without overlapping, and, as Sheldon Keck put it, "that mysterious picture (*The Bachelor's Friends*) is certainly solved—if you can solve a picture." The solution, however, is as tantalizing as the problem, for E. N. Griffith is a name to which nothing else can be attached. The Newman painting is dated " '94"—and that is what we know about E. N. Griffith.

* * * * *

EXCEPT FOR a scattering of brief, insignificant obituary notices, the entire literature on Claude Raguet Hirst seems to be contained in a single paragraph, preserved in a yellowed clipping sent me by Francis C. Hutchens of Berkeley, California:

Claude Raguet Hirst, the painter, is said to be unexcelled in her particular métier—that of painting old books and pipes. Many years ago Miss Hirst lent her studio to W. C. Fitler, the landscape artist, who left the studio cluttered with pipes and books. Miss Hirst was inspired to paint a group of the untidy landscapist's belongings, which sold immediately. Since the sale of that picture Miss Hirst has painted nothing but old books and pipes, and always on an eight-by-ten-inch canvas. Because of the detail in her work she has been called the female Harnett. Two years after the sale of her first meerschaum-book still life, Miss Hirst married the owner of the pipe.

There are several remarkable things about this story, and by no means the least remarkable is its presumed source and date. According to Mr. Hutchens, whose family has owned a Hirst still life for many years, it was published in the San Francisco *Argonaut* about 1920.[4] If so, Claude Hirst's reputation extended much farther in area, and Harnett's reputation much further in time, than anyone has previously suspected.

Miss Hirst seems to have spent all her life in New York, where she died on May 2, 1942, at the age of eighty-seven, and there is little to suggest that she exhibited her pictures elsewhere. That she confined herself to an eight-by-ten-inch canvas is an absurd statement, but the statement that she married William C. Fitler is unassailably correct; it is proven by Fitler's will, which was filed in New York on December 29, 1911, and by her own death certificate. It may be true that Miss Hirst was inspired to paint pipes and books because Fitler had littered her studio with such objects, but there is evidence to suggest that the idea came from a totally different William.

Miss Hirst first appears in the catalogues of the National Academy of Design in 1884. She exhibited four pictures in that year and three in the year following; their titles show clearly that they were all still lifes of flowers or fruit. Miss Hirst's name does not recur in the National Academy catalogues until 1890, and now her titles—*A Bachelor's Solace, Crumbs of Comfort, Some Well-Worn Volumes*—indicate that she has taken up the book and pipe. Perhaps her friendship with Fitler developed between 1884 and 1890, but . . .

In 1886, Harnett, returning from Europe, set up shop at 28 East Fourteenth Street, and there he remained until 1889. Throughout the 1880's and well into the '90's, Miss Hirst's studio address was 30 or 32 East Fourteenth. (These two addresses probably refer to one and the same building.) And when, in 1891, Harnett sends the National Academy a picture called *A Bachelor's Friend* while his erstwhile next-door neighbor sends *Delights of a Bachelor,* one wonders just who has been watching whom.

This question might have been answered, and perhaps much Harnettiana might have been recovered, if Claude Hirst's trail had come to light in time. She died in abject poverty, was buried at the expense of an artists' society to which she had belonged, and her few possessions seem to have been

[4] It is in the typographical style employed by the *Argonaut* between 1902 and 1929.

scattered among casual acquaintances of her old age who cannot be located today.

Miss Hirst was particularly adept at painting old books (plate 126). In this one motif, her work might be mistaken for Harnett's. She had none of Harnett's command over textures, however, and never seems to have undertaken compositions as varied or complex as his. She had great trouble with her pipe stems; their rubber bits are utterly unmanageable and often curve forward or remain straight instead of bending backward. Her "bachelor's still lifes" are small—but not invariably confined to an eight-by-ten inch canvas—and usually depict a pipe, a book or two, a sack of tobacco, a few matches, sometimes a pair of steel-rimmed spectacles, and usually a vase or vessel of some kind. A favorite Hirstian model is a brass candlestick in the form of a winged lion. Many of her works are in watercolor; she is the only artist considered in this book who habitually employed that medium.

A Hirst with a forged Harnett signature has been shown me by two Western dealers both of whom obtained it on consignment from one of their colleagues in New York. Very curiously, a highly typical *Peto,* with no signature of any kind, was reproduced in the magazine *Panorama* for December, 1949, with an ascription to Claude Hirst; why this ascription was made, I have never been able to discover.

* * * * *

MRS. A. M. McKILLOP of Walnut Creek, California, sent me a photograph of a delightful still life, in her own collection, which represented an old flintlock pistol hanging against a door (plate 127). It contained one disturbing detail: next to the pistol was a painted clipping of a crude newspaper cut showing a farmer at work at a cider-press, and this was dated "November, 1837." If this picture actually was painted in 1837—which, to judge by its style, seemed highly unlikely—Harnett's *Faithful Colt* (plate 1) was by no means so original a work as it had seemed.

The picture was signed "Silas Martin," and inscribed on its back was the address, "85 North High Street, Columbus, Ohio." Martin, it turned out, was very well remembered in Columbus, for he had been

professor of art at Ohio State University for many years. He was the first teacher of George Bellows, who returned to sit at Martin's bedside during his last illness. He painted landscapes, still lifes, and portraits, many of which are preserved today at the Columbus Gallery of Fine Arts, at Ohio State University, and in the Ohio capitol; I have found other works of his scattered from Oakland, California, to Windsor, Connecticut.

Martin was born in Columbus on November 20, 1841, and died there on September 2, 1906. He was very largely self-taught. From the examples of his still life which I have seen, it is evident that he developed a style characterized by exceedingly skillful modeling and dexterous gradations of tone. He was not interested in *trompe l'oeil,* and even his flintlock has no trace of that manner, but the subject of that picture is such as to demand its mention in this book. (According to the artist's daughter, Miss Mabel Martin of Columbus, it was painted about 1895, three years after Harnett's death.) Furthermore, if Martin climbed aboard the Harnettian bandwagon once, he may have done so more than once, and more Martin still lifes on subjects reminiscent of the Philadelphia school may be expected to emerge.

* * * * *

WITH THE death of Charles Meurer, on March 14, 1955, the last link with the great days of American *trompe l'oeil* was severed. Works of Meurer's are scattered from coast to coast and often turn up in highly unexpected places. At least one has been sold as a painting by Alfred Henry Maurer. Most of his pictures were painted in Terrace Park, Ohio, a suburb of Cincinnati, where the artist spent the greater part of his long life.

Meurer was born in Germany, of American parents, in 1865. He grew up in Clarksville, Tennessee, studied art with Duveneck and others in Cincinnati, and with various masters in Paris and Lyon. According to his own statement, he was converted to *trompe l'oeil* when he saw the Harnetts, including *The Old Violin,* exhibited at the Cincinnati Industrial Exposition of 1886, and he also recalls seeing rack pictures by Peto in Cincinnati art galleries in the early 1890's, but he never met either artist.

The Third Circle

During Meurer's early days in Tennessee, there was a rising young editor of Chattanooga who commissioned him to paint a still life representing the first page of that gentleman's paper, the Chattanooga *Times,* placed on a table and surrounded with books and other symbols of editorial wisdom. Meurer was to do many such newspaper pictures later, and quite a few of the men involved in them —like the Tafts and James M. Cox—later rose to eminence in politics. But the Chattanoogan, whose name was Adolph Ochs, stuck to mere journalism, and, although he later acquired another daily called the *Times* in a distant city, he was never a governor, ambassador, senator, or president. His descendants may console themselves with the thought that he was, in all probability, the originator of the editorial-sanctum still life, a very distinct form of art practiced by numerous American painters up to a fairly recent period. The editorial-sanctum still life is not to be confused with Harnett's mug-pipe-and-newspaper motif or with Peto's office board. It emphasizes authority (books), industry (pens and ink-well), and respectability (five-dollar bills); and the front page of the newspaper is usually set forth in great detail. Such pictures are still to be found in many journalistic offices throughout the country.

Meurer's business card said that he was a specialist in "Streets, Pastoral, Garden Scenes, Portraits, Still Life and Flowers," but his work is of special interest in the semifinal department. He has done *After the Hunt* in the military form (plate 74). He has produced many pictures of money, and in the days of the secret search for Jim the Penman he ran into the usual trouble over them. (A Meurer of a two-dollar bill has recently been found bearing on the back of its canvas-stretcher a ticket showing that it was at one time seized as evidence by government agents.) A Meurer with a forged Harnett signature belonged to Dr. Emerick Friedman of Albany, New York, and in view of the pronounced Harnettian inspiration of Meurer's work, this is not surprising. His style, however, (see plate 128) is very crude and naïve and not at all likely to be confused with that of his Philadelphia predecessor.

* * * * *

WILLIAM B. BEMENT, whose picture catalogue of 1884 is discussed in some detail in our section on Harnett, owned a still life by Milne Ramsey, whom the catalogue identified as a contemporary Philadelphia painter. The picture was reproduced in that volume: it was a rather conventional affair of an Oriental vase and fruit on a table draped with velvet, but it seemed to have a soft, powdery texture quite reminiscent of Peto, and so Ramsey, I felt, should be investigated.

He had sunk into complete obscurity, but the almost unfailing combination of will and death-certificate worked as usual, and led to the artist's daughter, Dorothy Ramsey, of West Chester, who still had many of her father's paintings.

Milne Ramsey was born in Philadelphia in 1846 and died there on March 15, 1915. He studied at the Pennsylvania Academy of the Fine Arts and in Paris, but with whom is not known. He certainly came under the influence of Meissonier, for he produced many small costume genre pictures in that artist's manner. The diffused, sensitive surface which is characteristic of so many of his existing still lifes does not seem to come from any Parisian example, but whether or not he had any direct contacts with Peto cannot be determined. He dated his pictures in the same way as Peto—thus "2.08" for February, 1908. But Miss Ramsey had never heard of the Island Heights painter, and Peto's daughter was equally ignorant of Ramsey. A photograph of Ramsey as a young man in his studio shows him surrounded with costume genre scenes and still lifes in a hard, precisionistic style, one of them composed *à la* Harnett with a pyramid of objects on a table and a drape descending; yet the picture with the Peto-like surface which first attracted my attention must have been painted prior to 1884, when the Bement catalogue was compiled.

Ramsey's existing still lifes are exceedingly competent from a technical point of view, but they are often spoiled for modern taste by their extravagantly large size and their overelaborate subject matter. He delighted in painting Turkish and Arabian metal-work with its exuberance of filagree and repoussé ornamentation, and many of his other still life subjects represent late Victorian taste in its richest and dullest form. But he knew how to draw, how to

build a volume, how to place objects in space, how to distribute weights and accents over a canvas, and his effects of surface are often quite beautiful. When he limited himself to a few simple objects (plate 130), he produced works that should not be forgotten. There are, one hopes, many Ramseys of this kind to be brought forth from neglected corners in Philadelphia and New York.

* * * * *

SOME YEARS ago the New York art-dealer, George Guerry, found a very good adaptation of Harnett's *After the Hunt* in an antique shop in Mount Vernon, New York (plate 70). It was signed "J. M. Shinn," and was dated 1927. It was the most recent work of its type which has so far come to light, and as such it interested me greatly. It was exhibited at the California Palace of the Legion of Honor, along with other adapted versions of Harnett's big picture, but it was necessary to state in the catalogue that nothing was known about J. M. Shinn.

As it happens, Shinn had a nephew in San Francisco, who was heard from almost immediately. The artist's daughter, Mrs. L. Brewster Smith of Mount Vernon, and his son, John M. C. Shinn of Fords, New Jersey, then provided biographical data and photographs of other works by their father.

John Marion Shinn was born in Dubuque, Iowa, on October 25, 1849, and died in Mount Vernon on October 15, 1936. He studied art at the Polytechnic Institute in St. Louis and went to New York in 1872 to finish his art studies at Cooper Union and the National Academy of Design. He must have attended the latter school at the same time as Harnett, whose work very clearly influenced his own. Shinn, however, left the business of art before he was fairly engaged in it, taught school in Pelham Manor, took a law degree, and was active in politics and journalism in Westchester County for the rest of his life.

He continued to paint as an amateur for many years. One of his still lifes preserved at Fords is an excellent, eminently Harnettian picture of a flute, candlestick, books, sheet music rolled and flat, and a pipe whose spilled-out ashes are burning a hole in a newspaper. Mrs. Smith had a most delightful painting that represented a tattered etching by Sir Edward Landseer (the interior of a stable) tacked to a wall, with a letter tucked behind it. Similar painted still lifes of prints and engravings are very frequent in European art of the seventeenth and eighteenth centuries, but are quite rarely produced in this country. Other paintings by Shinn—fruit-and-flower pieces—are known to exist.

He was an amateur only because he wanted to be. He had a certain humor and a sense of the personality of the still life object which the masters of the idiom, especially Harnett and Peto, possessed to a superlative degree, but which is seldom met with among the minor figures.

II

JACOB ATKINSON (1864–1938) was a Philadelphia letter carrier for whom painting was an avocation. He is mentioned here because the one work of his with which I am acquainted—it belonged to his daughter, Carrie Atkinson of Philadelphia—is an exceptionally skillful affair. It represents letters, postcards, a postage stamp, and a dollar bill pasted to boards. Nearly all the postal motifs relate in one way or another to the Chicago fair of 1893, and the picture is signed by Atkinson in that year. If the artist had not overdriven the painted grain of his wood, this picture might well pass as a work by one of the major figures in American *trompe l'oeil*. It may have been a flash in the pan, and it may not have been; at all events, it seems very likely that other paintings by Jacob Atkinson are to be found in the Philadelphia region.

* * * * *

A. D. M. COOPER was an eccentric artist who lived in the town of San Jose, California, and produced one of the most extraordinary still lifes in the history of American art. In 1898 he was engaged by Mrs. Leland Stanford to paint a picture of her jewels; Mrs. Stanford was contemplating the sale of her collection to raise money for the university which her late husband had founded in memory of their

son, and she desired to retain a pictorial record of her treasures.[5] Consequently her tiaras, necklaces, pins, brooches, diamond-encrusted miniatures, and whatnot now sparkle in imperishable impasto in the basement of the Stanford Museum. They are shown spread flat on a plum-colored background. The canvas is about seven feet long and five feet high, and it creates the effect of an unimaginably gigantic plush-lined tray in a jewelry store. Cooper later made a replica of this picture and exhibited it in a saloon in San Jose. The lady was not amused.

Cooper is also the author of a hunting-cabin still life, signed and dated 1906, in the Rancho Nicasio at Nicasio, California. His best work, however, is the undated still life of a buffalo head, Indian weapons, and photographs of Buffalo Bill and other Western notables which hangs at the head of the staircase in the Hotel Irma at Cody, Wyoming. All the paintings at the Hotel Irma came from Buffalo Bill's collection, and this one was doubtless executed expressly for that famous man. Its iconography suggests that Cooper was acquainted with Platt's *Wild West* (plate 71), perhaps even with the same artist's *Vanishing Glories*.

* * * * *

M. LEE GRANBERY is the only artist considered in this book whose work I have never seen. Throughout the late 1880's and early 1890's, the catalogues of the annual exhibitions at the National Academy of Design are full of this painter's name, always associated with titles like *Results of a Day's Sport*. A whole tribe of painting Granberys were showing at the National Academy at that time, first from Wissahickon, Pennsylvania, later from New York, but M. Lee is the only one of them whose titles suggest the school with which we are concerned.

Virginia Granbery taught art in the New York schools for many years. Her will, filed on September 6, 1921, shows that the "M" in M. Lee Granbery stood for "Mollie," and that Mollie Lee Granbery was then the wife of a man named William Chapman who lived in Machias, Maine. Inquiries in Machias failed to produce any trace of her, however.

[5] See Bertha Berner, *Mrs. Leland Stanford*. Stanford Univ. Press, 1934, pp. 105–107.

Without doubt, works of hers will some day appear on the New York market. Whether or not they are worth putting on the market I have no way of knowing.

* * * * *

MORRIS ABRAHAM WAAS (1843–1927) was a Philadelphia dentist and amateur painter who, according to his daughter, Miss Carrie Waas of Kingston, Jamaica, was a friend of Harnett's. He certainly exhibits that fact in his work. The known paintings of Waas are mug-pipe-and-newspaper still lifes obviously inspired by Harnett's example. He also did some more elaborate table-top pieces and at least one violin hanging on a wall. His draftsmanship is faulty but his color is pleasant. I have been told that paintings by Waas have been forged as Harnett, but I have not seen any such canvases.

III

BEN AUSTRIAN: This name, with the address, 1252 Perkiomen Street, Reading, Pennsylvania, appears on a tattered envelope with an undated Reading postmark in an amusing painting reproduced in *The Old Print Shop Portfolio* for August-September, 1952. The background is the upper corner of a paneled door. Attached to it by a single nail, in addition to the envelope, are some newspaper clippings, a photograph of a woman, and a short-stemmed German-style meerschaum pipe. The notes published with this reproduction inform us that Austrian was born in Reading in 1870 and died in Kempton, Pennsylvania, in 1921, and that he created two famous nineteenth-century trademarks, the Victor dog and the Corticelli kitten. However, according to a well-documented article in *Life* for November 17, 1952, the Victor dog was originated by an English artist named Francis Barraud.

L. BLOCK: Painter of a beautifully illusionistic if slightly dry and linear still life of books, a quill pen, and an Egyptian statuette which hung for years in the office of the late Randolph Adams, librarian of the Clements Library at the University

of Michigan. A second signed Block, in the same very able style but richer in color, recently came to light in Los Angeles: it represents books, engravings, an hourglass, and a globe on a table top. Neither picture is dated. Both are in watercolor. The Los Angeles picture had originally been purchased in London, but whether the artist was English, American, or a Continental European cannot be determined. All his books are Renaissance tomes in Latin.

J. HENRY BURNETT: Undated still life of a feather duster hanging against a door. (New York: formerly in the collection of Edwin Hewitt.)

JOHN CALIFANO: Dollar bill, formerly in Hewitt's collection. A still life like Harnett's *The Old Violin,* signed "J. Califano," is in the catalogue of the annual exhibition of the Society of Independent Artists for 1923, but for some inexplicable reason the artist is listed as "Frank Califano." (Frank Califano is also credited with a *Return from the Hunt* in the Independents' catalogue for 1922.) John I. H. Baur has interested himself in this artist and regards him as "a kind of missing link between the Harnett tradition and the work of such modern painters as Ivan Albright and his brother."[6]

BEN COHEN: Mrs. Samuel Chertok of Coatesville, Pennsylvania, owned a table-top still life by this artist, and Dr. Pleasants of nearby West Chester had a rack picture of his showing letters and a copy of the West Chester journal called the *Daily Local News.* Dr. Pleasants' canvas is dated 1888. Cohen is said to have been a well-known character in West Chester and to have been a friend and follower of George Cope, whose work is strongly reflected in the Chertok still life.

DARIUS COBB: In his time one of the most celebrated figures in the artistic life of Boston, where he was born in 1834 and where he died in 1919. His once-famous portraits and historical costume pictures are totally forgotten today, but his reputation has been slightly revived because of an exquisitely executed chromolithograph which he created in 1888 for the Old Army Friends Publishing Company. This shows a battered cap, canteen, and knapsack hanging against a door; toward the lower left is a

piece of paper adorned with a crude drawing of a tin cup and the inscription "Dipper missing."

F. DANTON, JR.: Author of an absolute masterpiece of pictorial impudence, signed and dated " '94." (Hartford, Connecticut: Wadsworth Atheneum, plate 125.) An alarm clock and a stack of ten-dollar bills hang by ribbons from nails in a door. Between them, painted as if incised in the door, is the word "IS." Below, so that no one can possibly miss the point, is a painted ticket inscribed "Time is Money." The wide frame is painted to continue the grain and the cracks of the door painted on the canvas. The frame projects about a half inch ahead of the canvas on all four sides and therefore casts shadows upon it. At the lower right-hand corner of the frame, at the point where the picture is signed, is a square area *painted* with cast shadows which create the illusion that that square is recessed to the same depth as the canvas. The frame is punctured with nail holes, some real and some painted, but the real nail holes have painted splinters around their rims precisely like those around the rims of the simulated ones.

S. S. DAVID: Peanuts in a kind of square recess in a board, covered with a broken glass. At the upper right is a card reading "Free Sample, Take One." No date. (Portland, Oregon: Portland Art Museum.)

DE SCOTT EVANS: Two small still lifes of fruit, one representing two pears and one an enormous apple. In both the fruit hangs by strings against wooden doors or walls and in one the artist's name and place of residence—New York—are inscribed on a card tacked to the wood. Both are undated. (New York: Victor Spark.)

M. A. GOUY: An insouciant soul, to judge by the two pictures by him which are known to me. One is a table-top still life with a riot of books and letters and with a tall cabinet in the background. The letters are testimonials to Mr. Gouy of New York and praise the excellence of his paintings. This picture was found by Louis Pappas in a San Francisco junk shop. The second Gouy, which, like the first, is signed but not dated, was picked up by Mrs. Charles J. Fuess of Utica, New York. It represents a whisk-broom hanging against a door.

B. J. HARNETT: This disturbing name is signed to

[6] For further discussion of Califano see John I. H. Baur, *Revolution and Tradition in Modern American Art*, p. 100.

two mediocre pictures I have seen—a landscape (North Andover, Massachusetts: F. Leslie Frisbee) and a marine (New York: Dr. S. J. Marder). It is possible that this otherwise unknown artist is also the creator of the landscape attributed to William Harnett owned by Norman Bonter in Manhattan. (B. J. Harnett painted no still lifes, so far as is known, but is mentioned here for obvious reasons. For further information, see the Preface to the Revised Edition.)

C. R. HURLBUT: Author of a rather curious painting reproduced in the catalogue of Sale No. 1409 held at the Parke-Bernet Galleries in New York on February 13 and 14, 1953. The catalogue describes it as follows:

A violin and bow standing on an open music book and fastened to a gray wall beside a felt hat and a sheet of music; on a wooden shelf beside the book, the photograph of a violinist, a piece of rosin, a corncob pipe and tobacco. Signed, and dated '92.

WILLIAM KEANE: Frederick S. Jackson of Malaga, New Jersey, has found three still lifes by this painter, who is said to have lived in Camden in the 1880's and 1890's, but of whom I can locate no record. All three are door pictures. Two are quite small; one represents a trowel, a hatchet, and a newspaper clipping and the other, two fish and a key. The third known Keane is a large, magnificently executed painting (plate 134) which, in the absence of a signature, one would be tempted to ascribe to Haberle. In subject matter it is closely related to two Harnetts —*The Old Violin* and *After the Hunt*—and it may have been intended as a satire on those immensely popular pictures.

At the left-hand side a huge banjo hangs upside down against the door, and beneath it is a sheet of music placed on the diagonal. (It is a jiggy piece in A major so covered by the drum of the banjo that one can read only the last word in its title: *Barn*. It was "arr. for banjo by Walter Burke" and "Copyright mdccclxxxix by T. B. Harms & Co.") At the lower left corner is a draftsman's compass, and above that is a series of three concentric circles which the compass has pricked out in the wood. At the upper right-hand corner of the painting a striped collar hangs by a nail with a factory-tied four-in-hand dangling from it. Below the necktie is a torn-off

label and below this a large soft hat. At the lower right corner two "cigarette pictures" (one of a young woman and one of two Negro boys boxing under the supervision of an adult white referee) are tucked behind a ribbon. A peacock feather has been tacked to the door and extends in a long flattened curve from a point below the hat at the right almost to the left edge of the painting, thereby tying the composition together, if rather crudely.

G. KEIL: An amusing picture, dated 1890, of a horseshoe in "bad luck" position and two broken pieces of a hinge, all nailed to a door. Apparently adapted from Harnett's *Colossal Luck*. (New York: Mrs. John Barnes.)

M. J. LAWLER: Two doves hanging by their feet from a string against a barn door whose hinges are festooned with wisps of hay. Signed on a painted piece of paper tacked to the door at the lower left. This picture was discovered in Pittsburgh in 1952 by John O'Connor, Associate Director of the Art Department of the Carnegie Institute.

HELENA MAGUIRE: This artist produced a large number of hanging-game pictures which were reproduced by lithography and were at one time widely circulated. Her work is of no interest whatever and would not be mentioned here if it were not for one fact: Miss Maguire often signed her pictures with a monogram—an "H" and an "M" so intertwined that, with sufficient determination, it can be read as "W. M. H." But there is no evidence to show that W. M. Harnett ever did a lithograph or permitted one of his hanging ducks to be reproduced in that fashion. Besides which, Harnett's style and Miss Maguire's style do not exist in the same world.

JOHN MOONEY: Just as this book was going to press, word came of the discovery, in Richmond, Virginia, of a number of *trompe l'oeil* still lifes by this hitherto unknown artist. One gathers that these pictures, now preserved at the Valentine Museum in Richmond, are mostly flower, fruit, and game pieces. Mooney, we are informed, was born in New York State in 1843, served in the Confederate army during the Civil War, and was active as an artist in Washington and Richmond, where he died in 1918.

THOMAS POPE: Grapes, a letter, and a newspaper

clipping on a board, providing a rather curious combination of the fruit piece and the patch picture. This work, in the New York State Museum at Albany, is unsigned, but the postmark on the letter is dated "Aug. 3, 1889." According to Carl E. Guthe, director of the museum, it came to his institution along with several landscapes signed "T. B. Pope"; the donor declared that all these pictures were by the same hand and that the artist's first name was Thomas. To find a Thomas Pope in one's files is not altogether conducive to peace of mind when one is already concerned with a Thomas Hope (albeit an uninteresting artist whom I shall not mention further), an Alexander Pope, a George Cope, and a Thomas Hope Peto.

W. S. REYNOLDS: A superb, eminently Harnettian still life.[7] A big book entitled *Critical, Doctrinal and Homiletical Commentary* lies on its side on a table. On top of the book is a cigar box, and on top of that are a lighted cigar and an alarm clock. Standing at the left-hand side is a small bottle of whiskey. At the table's edge, in dead center, is a card, lying flat, and inscribed "Time, Religion and Politics." Signed and dated, " '94." (New York: M. Knoedler and Company.) Block, Cobb, Keane, and Reynolds are the most professional of all these unknowns.

[7] Reproduced in Wolfgang Born, *Still-Life Painting in America,* plate 92.

William Michael Harnett: A Critical Catalogue

This catalogue falls into two parts. The first part lists all the works of Harnett known to the present writer, including those known only in the form of photographs; small pencil sketches, however, are omitted. The second part of the catalogue is devoted to forgeries and misattributed pictures.

In the first edition, published in 1953, the catalogue accounted for 126 genuine Harnetts—102 extant paintings, three drawings, and twenty-one lost paintings which had survived in photographs. The present catalogue lists 153 extant paintings, five drawings, one piece of sculpture, and sixteen paintings known only through photographs. The tally of forged and misattributed pictures has grown from sixty-nine to seventy-nine. They are by at least thirty-five different artists, eleven of them identifiable by name.

The catalogue numbers assigned to the 126 works in our edition of 1953 have become reference points for dealers, collectors, and museum people. We have therefore not changed them, but have assigned combinations of numbers and letters to the newly discovered works: 4A, 4B, 4C, and so on. The genuine Harnetts are listed chronologically by year. We possess clues to the detailed, day-to-day chronology of Harnett's work for part of 1880 and most of 1888, and all such clues are followed. Other entries under the year headings were made in alphabetical order in 1953 and these entries remain as they were; the new entries, however, have been made with an eye to grouping related works regardless of their titles.

Pictures are described below if they are not illustrated in the present volume. Pictures which we reproduce are entered in the catalogue only by title and plate number, plus a symbol, to be explained in a moment, to indicate the location of the signature and date, since this detail is often illegible in the cuts; data regarding the ownership and dimensions of these paintings will be found in the legends beneath the plates. Text references to all the pictures discussed in this book, those listed in the catalogue and all others as well, will be found assembled under their titles in the index.

Whenever the artist's original title for a painting is known, that title is employed here and is given in full-sized capitals. Titles applied by dealers and owners are in small capitals and those invented by the present writer in italics.

With a few extremely rare exceptions of which note is taken, all genuine Harnetts are signed and dated. Signature and date almost invariably appear at the bottom, either right or left. Consequently the symbol *R* is used to show that a Harnett is signed and dated at its lower right and the symbol *L* that it is signed and dated at the lower left.

The word "Photograph" in parentheses preceding a title indicates that, to the best of the writer's knowledge, the painting in question exists only in that form. Several paintings known only as photographs in 1953 have since come to light and have, of course, been assigned the catalogue numbers previously given them as photos.

Certain Harnett models reappear with great frequency, and they are therefore identified in the catalogue by name, without further description. Harnett's flute, with its cracked ivory head, its black rosewood body, and its silver keys and rings, appears in plate 37. The same plate also shows the Arnold ink bottle, which is conical in shape, made of light brown speckled stoneware, and adorned with a bright yellow label ornamented with a border of repeated capital A's. The Dutch jar and the blue tobacco box are shown especially well in plate 76, the pewter tankard in plate 56, and the Roman lamp in plate 63. The Caporal tobacco package, which appears mainly in the little mug-and-pipe pictures of Harnett's early years, is not illustrated; it is a small paper parcel, of the same general shape and dimensions as the oblong package in the bowl at the right in plate 33. It is light blue in color, bears a white band imprinted with the phrase "1 Kilo Tabac Caporal," and is usually torn open toward its right-hand end. Harnett uses many different meerschaum pipes, but they are all of the same general type—with a richly stained bowl, a long cherrywood stem, a rubber bit, and bright brass fittings.

Harnett employs three different conventions in representing the tops of the tables or cabinets which serve as support for his still life objects. In many of the early paintings he follows the tradition of Raphaelle Peale (plate 22) in showing no corners at all; this convention is symbolized below with the phrase "central segment" of a table or cabinet top. In the paintings of his later years, Harnett shifts the table in such a fashion as to bring a front corner into view; the phrase "right corner" or "left corner" implies this. Sometimes in his earlier works Harnett will show a back corner but not a front corner; no special note is made of this, and in the absence of comment to the contrary, it may be assumed that this is the convention employed.

Some Harnetts and pseudo-Harnetts not reproduced in the present volume are reproduced elsewhere, and, when they are not too ephemeral (as on calendars and Christmas cards), references to these reproductions are provided. References are also given for color reproductions of paintings which we present in black and white. In this connection certain publications are cited sufficiently often to justify our using abbreviations for them in the catalogue. These abbreviations and their meanings are as follows:

RO = The Reminiscent Object, catalogue of an exhibition held at the La Jolla Museum of Art and the Santa Barbara Museum of Art in the summer of 1965. This exhibition, devoted to Harnett, Peto, and Haberle, was the best show of late nineteenth-century American still life ever held anywhere, and its catalogue is the best illustrated document, after the present volume, so far as all three artists are concerned.

Born = Wolfgang Born, *Still-Life Painting in America,* Oxford University Press, 1947.

William Michael Harnett: A Critical Catalogue

MC = *American Paintings and Drawings from Michigan Collections,* catalogue of an exhibition at the Detroit Institute of Arts, April 10 to May 6, 1962.

Birch catalogue = handbook of the sale of Harnett's models, paintings, and other effects held for the benefit of his estate at Thomas Birch's Philadelphia auction rooms, February 23 and 24, 1893.

Unless otherwise specified, it may be assumed that all paintings listed below are in oil on canvas. All measurements are given in inches, height preceding width.

It has proved impossible to keep continuous, accurate check on the ownership of all the paintings listed here, and in some cases up-to-date information on this point was impossible to obtain. Ownership information which is not reasonably recent is designated as such with an asterisk.

WORKS OF WILLIAM MICHAEL HARNETT
Undated

1. *Still Life for William Ignatius Blemly.* Center segment of a marble table top. On it, left to right, two hazel nuts, a tall vase of greenish glass with a wide band and floral decorations in gold, and an orange with a section of its peel removed; fragments of nutshell here and there. *R.,* but no date visible. 11½ x 7½. Undoubtedly a very early work, probably 1874 or 1875.

* Mount Vernon, New York, William Aloysius Blemly.

2. (Photograph.) An exceedingly complicated rack picture full of torn envelopes and small cards, with rectangular splotches (apparently newpaper clippings and torn labels) on the free space of the background outside the rack itself. The photograph, one copy of which was preserved by Ella Harnett and one by William I. Blemly in his scrapbook, is extremely fuzzy and out of focus. No inscriptions are legible on it and it is impossible to interpret; it may be a photograph of real objects, a model for a rack picture and not a painting.

3. An unfinished replica of No. 46, unsigned and undated. 8 x 10.

Berkeley, California, University Art Museum.

3A. *Iris.* A full-blown flower and a bud of iris, each on a separate stem with two leaves. Pencil and India ink wash. Signed vertically on the stem of the full-blown flower. 8¾ x 6¾.

New York, Ferdinand Davis.

1871

3B. KEY OF COLOR. Overlapping circles of color all inscribed within a large circle, in total effect like a geometrized flower. Watercolor, 8⅛ x 8¼. Signed *L,* "Wᵐ M Harnett/July 71." This student exercise, along with Numbers 6 and 10 below, were framed together by E. Taylor Snow. Below the "key of color" was a card inscribed in Harnett's handwriting: "Compliments of/Wᵐ M Harnett to Friend/E. T. Snow/my first paintings in oil." (Referring, of course, to Numbers 6 and 10.) On the back was a

typewritten statement signed by E. T. Snow: "This 'Key of Color' is the first thing ever attempted by William M. Harnett, and was executed in 1871. The other two objects in oil were the first paintings in still life, in oil color, that he ever attempted, this being in 1874. They were presented to the writer in 1877."

* New York, Downtown Gallery.

1873

4. *Discus Thrower. R.* Plate 27.

4A. DANTE IN HIS STUDY. Dante apparently seated within a painted window frame studying a large book propped against two other books at the extreme right. The poet's face is in profile looking at the large book, and his right hand, extended across his chest, holds its pages open. His left hand rests on another book lying open and flat on the lower edge of the window frame. *R.* Watercolor, 7¾ x 7¾. This painting is copied from a fresco by Luca Signorelli in the cathedral of Orvieto. For a color plate of the original, see R. T. Holbrook, *Portraits of Dante from Giotto to Raffael* (New York, 1911), opposite Page 192.

New York, Kennedy Galleries.

4B. *Dante.* Head of Dante, wearing the traditional cap and laurel wreath, in profile looking toward the spectator's left. Bronze relief, 2⅝ inches high, mounted on black painted wood panel, 7½ x 5. *R.* The back of the relief is inscribed, in incised letters and numerals, "Dante/Alighieri./[signed with the familiar Harnett monogram] 1873." Harnett's only known piece of sculpture.

Reproduced: *Dante in Art,* catalogue of exhibition at the Museum of Art, University of Oregon, Eugene, February 2 to March 14, 1965.

Philadelphia, Harold Hays.

4C. STUDY OF PLUM BOUGH. A branch containing three plums and seven leaves against a wall, with strong illumination from the left throwing shadows toward the right. Pencil and charcoal, 13½ x 9. *R.* The earliest known instance of an effect on which Harnett was to rely very heavily in later years—the modeling and deployment of shadows whereby the objects depicted seem to protrude into the spectator's space.

New York, private collection.

1874

5. (Photograph.) *Cupid.* A painting of a plaster cast. A naked Cupid, sculptured in high relief against a stele, stands leaning on his quiver and gazing upward. The stele is broken along its left-hand edge. *R.*

6. *Glass Object on a Table Top.* A glass jar or candy dish, ornamented in gold, on the top of a table. Signed, *L.,* "Harnett, Oct. 74." 4⅛ x 4.

* New York, Downtown Gallery.

7. (Photograph.) *Head of Minerva. R.* Plate 26.

8. Oil sketch. Dated but unsigned. Plate 25.

9. Oil sketch. A slice of watermelon, a cantaloupe, and

William Michael Harnett: A Critical Catalogue

a pear. Dated at upper right, "Sept. 9—74." Unsigned. 12¼ x 7½.

Reproduced: *Magazine of Art,* February, 1951, p. 64.

San Francisco, Alfred Frankenstein.

10. *Paint Tube and Grapes.* A paint tube labeled "Emerald" and a bunch of Concord grapes lying on the lid of a cigar box labeled "Conchas." Signed, *L.,* "Sep. 1874—Harnett." c. 4¼ x 4.

* New York, Downtown Gallery.

11. *Perfume Bottle.* A drop-shaped bottle of green glass with a brass stopper standing on a dark brown, diagonally slanted area implying the top of a table. The maroon background is unfinished. Dated, *L.,* "Nov. 74." Unsigned. 8⅝ x 6½.

San Francisco, Alfred Frankenstein.

1875

12. View from the artist's window, 104 East Eleventh Street, New York. Unfinished, unsigned, undated. Plate 28.

12A. *Fruit and Asparagus.* A marble table top. On it, left to right, a red banana lying on a yellow one, a coconut, a bunch of asparagus, a Chinese ginger jar standing on a wooden box, and six oranges on a newspaper which drops over the table's edge. *L.* 18 x 24.

Birmingham, Michigan, Jess Pavey.

12B. STILL LIFE. A wooden table top. On it the same basket as in A WOODEN BASKET OF CATAWBA GRAPES, plate 32, and in precisely the same position. More of the table top shows to the left of the basket, however, and on it are three apples, two little bunches of grapes, and a plum. The basket itself is full of fruits of various kinds, and an orange rests on the table top at the extreme right. *L.* 18 x 26½.

Reading, Pennsylvania, Public Museum and Art Gallery.

1876

13. MORTALITY AND IMMORTALITY. *R.* Plate 31.

14. A WOODEN BASKET OF CATAWBA GRAPES. *R.* Plate 32.

14A. BOHEMIAN LUNCH. A wooden table top partly covered by an irregularly torn piece of newspaper with a heading which implies the words *STAATS-ZEITUNG;* this is placed on the table top at an angle and part of it falls over the table's edge. On the newspaper, left to right, a beer stein, a table knife, an irregularly shaped loaf of bread, and a heel of head cheese or some similar sausage-like meat held in a skin. Fragments of pretzel on the bare portion of the table top to extreme left and right. Fragments of meat and bread on either side of the knife blade. *L.* 14 x 17.

Winston-Salem, N.C., Mrs. H. Frank Forsyth.

14B. *Still Life.* A veined marble table top covered with a red flowered cloth for a little more than half its width, starting at the left-hand end. On it, left to right, a banana; two apples; a coconut; a gray, stained crock with a vaguely floral decoration in blue; two oranges; a folded newspaper which projects over the table's edge at the point of juncture between the red cloth and the bare marble; a round wooden cheese box with its lid cocked toward the right; a tall vase decorated with a Greek meander pattern; two more oranges; a lemon; and, at the extreme right, a pile of four books lying on their sides. *R.* 20 x 28.

* Stockton, California, Mrs. Robert C. Clark.

1877

15. AFTER LUNCH. Center segment of a black marble table top, heavily veined. On it, at left, half a peach, with its stone; at right, a whole peach. Flies on both. Peach leaves and stem. Drops of water on the cut-open peach and on the edge of the table before it. *L.* 6 x 8.

New York, Kennedy Galleries.

16. *After Lunch II.* Identical with No. 15 except that there are no flies and no drops of water. *L.* 6 x 8.

New York, Donald S. Stralem.

17. *After Lunch III.* Center segment of a black marble table top. On it, left to right, a bunch of grapes, a peach, and a peach leaf. *R.* 6 x 9.

New York, Jerome Zipkin.

18. *The Banker's Table.* A black marble table top. On it, at extreme left, a small coin. To the right of this is a pile of two books lying on their sides and surmounted by a squat stoneware ink bottle and a quill pen. Jutting over the table's edge from under the lower book is an envelope addressed to ". . . le/ . . . r Street/ . . . ew York City." At the extreme right are a large coin near the table's edge and, farther back, a stack of coins in a torn-open paper wrapping resting on a folded wad of paper money. *R.* 8 x 12.

New York, Metropolitan Museum of Art.

19. *The Chinese Vase.* A white marble table top. On it, left to right, a single grape, an apple, a large bunch of grapes, a pear, a small bunch of grapes, and a peach. Directly behind the small bunch of grapes is a tall cylindrical vase with a bright green collar. The body of the vase is gray and is covered with Chinese characters in gold; there are also white panels, vertical and horizontal, on the vase, with Chinese characters in black and large bull's eye circles with ideographs in white. Grape leaves and stem in the left background. A single grape leaf hangs over the table's edge directly beneath the pear. *L.* 14 x 12.

North Salem, New York, Hammond Museum.

20. *Five-Dollar Bill.* A frayed five-dollar note of the series of 1869, bearing the serial number K9555624. The note is adorned at its left with a portrait of a man in an oval, and in its center with a vignette of a pioneering scene: a roughly dressed man stands with an axe in his hand while a dog peers over the fallen log on which the man has been working and a woman sits in the background before a summarily sketched house. Panel, signed and dated at upper left. 8 x 12.

Reproduced: *RO,* No. 4.

Philadelphia Museum of Art.

21. FOR A PIPE SMOKER. A brown wooden table top. On it, a meerschaum pipe lying across the entire width of the painting at the table's edge. Behind it, at right, a can of tobacco with its lid removed and resting against its left-hand side. The label on the can reads "Magnoli . . . Smokin . . . Manufactured by Jo . . . Richmond. . . ." Five matches, burnt and fresh; crumbs of tobacco and ashes. *L.* 8 x 10.

* New York, Gifford Cochran.

21A. *Smoking Scene.* A bare wooden table top. On it, at left, the tobacco can of No. 21, but turned around; where in No. 21 the label faces toward the right, here it faces toward the left, and on it one may read ". . . OLIA/ . . . acco/ . . . & Co./ . . . MOND, VA." The lid of the can rests against its right-hand side. The meerschaum pipe of No. 21 here rests on a folded newspaper. It has a live spark of tobacco inside, part of which has spilled out and is burning the paper. Only the letter "O" is visible on the masthead of the newspaper. Beneath this is a dateline on which one may read ". . . ULY." At the extreme right is a terra cotta match container holding seven matches, one of them upside down. Matches and crumbs of tobacco on the table top. *L.* 8 x 12.

San Francisco, Edwin Hewitt, on loan to the California Palace of the Legion of Honor.

21B. *Smoking Scene II.* A variation of the foregoing. The ceramic match container and its seven matches are now at the extreme left; the folded newspaper, the pipe, and the burning sparks are the same; the tobacco can is at the extreme right, with its lid resting against its left-hand side. The decoration of the tobacco can is quite different, however, from that of Nos. 21 and 21A; here one may read the words "EIGHT OUNCES" on the revenue stamp around the top of the can, and the label, only partially visible at the left of the can, implies a human figure of some sort. Matches here and there. *L.* 9 x 12.

New York, Walter P. Chrysler, Jr.

22. *Fruit Piece.* A brown wooden table top. On it, at extreme left, a plum and two grapes. In the center, well back from the table's edge, a cantaloupe from which a large slice has been taken, revealing seeds and pulp at its heart. To the right of this, a conical vase of green glass ornamented with a band and drops of gold and with more gold around its scalloped rim. Directly before the vase is a red and yellow apple; in the flesh of the apple is the blade of a table knife whose cracked ivory handle rests on the table. Before the knife-handle, hanging over the table's edge, is a bunch of grapes. At extreme right, a single grape. *R.* 14 x 12.

Reproduced: Born, plate 82.

* New York, Downtown Gallery.

22A. *Olive Piece.* A variation of the foregoing wherein the strong vertical on the right-hand side, instead of being a tall glass vase, is a tall, narrow bottle of stuffed olives sealed with foil at its top. To the left of the olive bottle is a cantaloupe, almost identical with that in No. 22, but lying back at an angle. The red and yellow apple of No. 22 now appears at the extreme left. Grapes and grape leaves here and there. *L.* 16 x 12.

Reproduced: *Still-Life Movement,* catalogue of exhibition at Schweitzer Galleries, New York, October 10–31, 1966, cover.

New York, private collection.

23. JAKE'S SOLACE(?). A light wooden packing-case. The top of the lid and part of the front side are shown; in the front side are two square-headed nails, pounded deep into the wood. The lid reveals, at extreme left, some rather smearily painted lettering: an "E" and "ue." Resting on the lid are a meerschaum pipe with an exceptionally large number of brass fittings in its relatively short stem, a piece of Bologna sausage, a loaf of French bread, and a gray-and-blue beer stein. Three fresh matches at extreme right; a stub of a burnt match at extreme left. *R.,* but this signature and date may not be authentic; an authentic Harnett monogram, however, is on the back of the canvas in black paint. 12 x 10.

Mamaroneck, New York, Cresson Pugh.

23A. *Jake's Second Solace.* A very close paraphrase of the foregoing. The most readily describable difference is that the pipe, the sausage, the bread, and the beer stein rest, not on a packing case, but on the top of a wooden table. There is a drawer under the shelving table-top at the left; it is partly open and a loop of string emerges from it. The unusual pipe is identical in both pictures and lies in precisely the same place on the edge of the packing case or table top. There are slight, indescribable differences between the sausages, loaves of bread, and beer steins in both pictures, but in both they stand in precisely the same relationship to each other and to the pipe. There are six fresh matches at the right in No. 23A as opposed to three in No. 23. *R.* 12 x 10.

New York, William Selnick.

24. A MAN'S TABLE. Center segment of a brown wooden table top. A meerschaum pipe lies at its edge across the entire width of the picture. Behind this is a folded copy of the New York *Sun* dated ". . . er 17, 1877," and a beer stein, gray and blue. Three matches, and, at extreme right, a hard, round biscuit and crumbs. *L.* 12 x 10.

Princeton, New Jersey, Millard Meiss.

24A. *A Man's Table Reversed.* Nearly a mirror image of the foregoing. The beer stein is to the left and its handle is to its own left. Below it, on the table top, are two round, hard biscuits and fragments of a third. The bowl of the meerschaum pipe is to the right, and the stem fills nearly the entire width of the painting along the table's edge. Behind the bowl of the pipe, with the shadow of the beer stein falling across it, is a folded copy of a newspaper on which one may read the masthead, ". . . OR" and the date ". . . May 1 . . ." *L.* 12 x 10.

New York, Amanda Berls.

25. *Pipe and Tobacco.* Center segment of a brown wooden table top. On it, a briar pipe with an exceptionally large bowl, a curved rubber stem, a gold rim around the bowl and a perforated gold collar at the end of its shank, resting against a sack of tobacco bearing a revenue stamp on which one may read the word "Four." These objects lie on a folded newspaper with a masthead ". . . W YO . . ." and the date "Friday, March . . ." Two matches protrude from under the tobacco sack. *L.* 7 x 9.

* Philadelphia, Charles Coiner.

26. *Staats-Zeitung and Pretzel.* Center segment of a brown wooden table top. On it, left to right, the Caporal tobacco package, the briar pipe of No. 25, a folded newspaper with a masthead reading ". . . taats-Ze. . . .", a beer stein, and at the extreme right, a piece of a pretzel curling over the edge of the table. Three matches, burnt and fresh; crumbs and grains of salt. *L.* 12 x 10.

* Marblehead, Massachusetts, Mrs. Herbert D. Ashley.

27. *Still Life. R.* Plate 23.

27A. *Two Ounces.* A variant of No. 27. The principal differences are that the pipe (identical with the one in No. 27) rests against the Caporal tobacco package, torn open to reveal tobacco at its right-hand end, and bearing a revenue stamp on which one may read "Two Ounces." A beer stein provides a vertical accent at the right, and it rests on a folded newspaper on which one may read only the letters "YO" in the masthead. A small round biscuit lies on the newspaper to the left of the beer stein, immediately below the slash in the tobacco package. *L.* 12 x 10.

Present whereabouts unknown.

27B. *A Smoke Backstage.* A wooden table top. On it, the Caporal tobacco package torn open at its right-hand end to reveal tobacco and bearing the usual label, "Kilo Tabac . . . poral," as well as a revenue stamp, "Two Ounces." A clay pipe rests against this, with its stained bowl on the table to the left. The Caporal package rests on a folded theatrical poster full of large, sensational-looking type in which one may read ". . . STN / . . . TRE / . . . IN BOOTH!!! / . . . OF DENMARK." *L.* 7 x 8⅛.

Honolulu Academy of Arts.

27C. *Alas, Poor Yorick.* See Preface to the Revised Edition.

27D. THE PIPE RACK. A meerschaum pipe with a short cherry wood stem and an amber bit hanging from a nail by means of a brightly colored string. *R.* 7¼ x 7¾.

New York, Miriam Bloch.

28. *Writing Table.* A black marble table top, heavily veined. At extreme left, silver and copper coins. Behind these, lying on its side and extending three-quarters across the width of the picture, a light tan book with a red label reading "U.S. Gazetteer" and a black label reading "Vol. II." (Both labels lettered in gold.) On top of the book a yellow envelope with a blue stamp, and on top of this an Arnold ink bottle. At the right, a folded letter reading "received you . . . / early part of last mo . . . / and was

extremely glad / to hear that . . . u had succe- / ful reflecting . . ." Lying before the letter is a rolled-up five-dollar bill, its end projecting over the edge of the table. A quill pen rests between the yellow envelope and the topmost edge of the folded letter. *R.* 8 x 12.

Reproduced: Born, plate 78. Also, in color, *Living for Young Homemakers,* Spring, 1948, p. 102.

Philadelphia Museum of Art.

1878

29. AMERICAN EXCHANGE. Center segment of a bare brown table top. On it, left to right, a rolled bill with the serial number K6607521*, a folded letter, a gold coin, and a book ("Universal Gazetteer, Vol. V") on which stand a yellow envelope and the Arnold ink bottle. Inserted between the book and the table, and hanging over the table's edge, is another bill, serial number K651231716. The letter reads "New York / Dec. 5 / Mr. Stevenson / I believe you / have been waiting to hear / from me for some time, but . . ." *R.* 8 x 12.

Reproduced: *RO,* No. 6.

Detroit Institute of Arts.

29A. *Still Life with Illegible Letter.* A black marble table top. On it, left to right, the Arnold ink bottle with a wooden pen holder behind it, a gold coin, a roll of bills, and a frayed leather book with two labels, the upper reading "Universal Gazetteer" and the lower "Vol. IV." On this are a slashed-open envelope and a folded letter. A half sheet of the letter, covered with bold longhand, is visible, but only an occasional word can be read on it, such as "in regard" in the fifth line and "therefore" in the last. *R.* c. 8 x 12.

New York, Kennedy Galleries.

29B. *Still Life with Letter.* Central segment of a black marble table top. On it, left to right, the Arnold ink bottle, a gold coin, a roll of bills, a letter written in blue ink with a yellow envelope, and a brown leather book with two labels on its spine. The upper one, in red, reads "Gazetteer," the lower, in black, "Vol. I." The letter reads ". . . it was well known / . . . with the publication . . . / tinned if you still . . . work, although it will / . . . I will / mail —I would like to have." *R.* 8½ x 10.

New York, Donald S. Stralem.

29C. *Still Life with Letter to William Taggart.* A bare brown table top. On it, at left, two brown books lying, one above the other, on a five-dollar bill a corner of which curls over the table's edge. The lower book has two labels, the upper one, in red, reading "Gazetteer" and the lower one, in black, "Vol. II." The books are surmounted by the squat Arnold ink bottle. To the right of the books, at the table's edge, is a coin. At extreme right is a folded letter lying on a yellow envelope with a green stamp addressed to "Mr. William Taggart, Esq. / Ph . . ." The text of the letter is as follows: ". . . enclosed [smudge] letter you / the order for those. . . . / I promised to send you I w . . . / send the rest of them as soon / . . . receive them. If you are not

. . . / a hurry for them I would like / to detain [smudge] for a few days." *R.* 8 x 11⅞.

Los Angeles, Mr. and Mrs. Murry G. McClung.

30. *Argus.* A brown wooden table top. On it, left to right, the Caporal tobacco package, a meerschaum pipe, a gray beer stein, and a small round biscuit. Behind the pipe, a folded newspaper with masthead reading "Argu . . . / . . . rnin . . . ruary 21, 1878." *R.* 12 x 10.

Clinton, New York, Richard E. Schmidt.

31. *The Blue Tobacco Box.* Center segment of a brown wooden table top. On it, left to right, a meerschaum pipe resting on a folded newspaper and a blue tobacco box with its lid removed and cocked over the left end of the box itself. Shredded tobacco inside the box; matches, burnt and fresh. The newspaper masthead, in the typography of the New York *Herald,* reads ". . . RK/ . . . 6, 1878." *R.* 8 x 10.

* New York, J. W. Rosenberg.

31A. *Herald.* Central segment of a bare wooden table top. On it, left to right, the Caporal tobacco package torn open at its right-hand end and bearing the label "1 Kilo Tabac Capo . . ."; the propped-up front page of a newspaper on which one may read ". . R . . . HERAL . . ." and a dateline, ". AY 3, 18 . ."; a meerschaum pipe standing up straight against the Caporal package and the newspaper; a beer stein, and, at extreme right, a small round biscuit. Matches, crumbs, ashes. *R.* 12¼ x 10¼.

New York, Kennedy Galleries.

31B. *Ledger.* Nearly a replica of the foregoing except that the labels and revenue stamps appear only on the left-hand end of the Caporal package and the newspaper masthead reads "LEDG . .", with the date of ". . . ch 20, 1878." *R.* c. 12 x 10.

Present location unknown.

31C. THE PHILADELPHIA LEDGER. A draped table top. On it, left to right, a meerschaum pipe lying at the table's edge and spilling out its ashes; a folded, propped-up copy of a newspaper with the masthead ". . . EDGER" and the dateline ". . . 8 . . . TWO"; a long, rectangular tobacco package with the words "HAVANA TOBACCO" on its top and cut open at its right-hand end; a small package with a sailing ship at the top of its label and below this the words "T.A. DAILY/WATERPROOF/ MATCHES"; a stoneware beer stein, and a match. *R.* 11¾ x 16.

New York, Miriam Bloch.

32. (Photograph.) FRONT FACE. Signed and dated at upper left. Plate 52.

33. JOB LOT, CHEAP. *R.* Plate 3.

34. MUSIC AND LITERATURE. *R.* Plate 37. Full-scale color reproduction published by the Niagara Lithograph Company, 1949.

35. *Old North Carolina.* Center segment of a brown wooden table top. On it, left to right, a meerschaum pipe

with a scalloped gold collar at the end of its shank resting against a long, narrow sack of coarsely woven cloth, and, at extreme right, behind the sack, a terra cotta matchholder filled with matches. The sack bears a label reading ". . . ld/ . . . orth Carolina/ . . . obac . . ." The label is further adorned with a crude figure of an animal (dog, opossum, or cat) smoking a pipe against a landscape background. A burnt match near the table's edge. Crumbs of tobacco and ashes. *L.* 8 x 10.

Evansville, Indiana, Museum of Arts and Sciences.

36. OLD SOUTH CAROLINA. Center segment of a brown wooden table top. On it, left to right, a meerschaum pipe, the sack described in No. 35, a folded copy of the New York *Times* dated ". . . ber 8, 1878," a tall, rather narrow beer stein, and a small, round biscuit. Matches, burnt and fresh, and biscuit crumbs. The label on the sack reads "Old/ . . . th Carolina/ . . . Tail Smo . . . / Tobacco," and has probably been misinterpreted in providing the picture with its title; in all probability, the brand name is "Old *North* Carolina," but the incorrect title is now too well established to be changed. The stem of the pipe lies across the middle of the label and obscures most of the figure it contains, but one may still make out the ears of the animal and part of the landscape background described in No. 35. *L.* 12 x 14.

Reproduced: *Art Digest,* February 15, 1944, p. 14.

San Juan Capistrano, California, Robert Honeyman.

36A. *Sack of Tobacco.* Central segment of a bare wooden table top. On it lies a fat sack of tobacco bearing a label on which one may read only the capital letter E followed by a quotation mark. A clay pipe with an amber bit lies across this, with its bowl to the left on the table top. The signature, *L.,* has been badly rubbed and the date effaced, but the picture is included at this point because of the resemblance of its tobacco sack to those of the two foregoing. 6 x 9.

Verona, New Jersey, Dr. Milton Luria.

37. *The Portrait by Raphael.* A table covered with a bright green cloth. On it, lying at the table's edge, are an open book, a violin and bow, and, at extreme right, a pile of three books lying on their sides. The neck of the violin and the upper part of the bow rest on the open book. Beneath the topmost book in the pile at the right is a slashed-open envelope bearing an address: "Folwell, / . . . dar st. / Philadelphia." In the center background, propped against books, is a copy of Raphael's portrait of Bindo Altoviti in a carved gold frame. A book lies against the lower right-hand corner of the frame, and resting against this is a bright tan Greek vase with ornamentation in gold and black. *L.* 28 x 34¼.

* New York, Mrs. Natalie Thomson.

38. SOLACE. Central segment of a bare table top. On it, at extreme left, the Caporal tobacco package with a meerschaum pipe resting against it. Behind the pipe, a folded copy of the New York *Herald* on which one may read the

date, ". . . ry 23." At right, a large beer stein. In extreme right corner, a small round biscuit. Matches, burnt and fresh, and crumbs of tobacco and biscuit. *L.* 12¼ x 10¼.

Reproduced: *Illusionism and Trompe l'Oeil*, exhibition catalogue published by the California Palace of the Legion of Honor, p. 31.

New York, Donald S. Stralem.

39. *Still Life.* Central segment of a bare wooden table top. On it, at extreme left, a large can of tobacco with its lid removed and placed on the table behind it. Resting on the edge of the tobacco can is a folded copy of the Philadelphia *Bulletin* dated ". . . 19, 1878." At the right, standing on a large book which lies on its side, is a stoneware vase with a rough ornamentation of impinging circles around its circumference. Across the entire width of the painting, lying at the table's edge, is a meerschaum pipe. Matches, burnt and fresh, and ashes. *L.* 19½ x 16½.

Harrisburg, Pennsylvania, George Reily.

40. *Still Life.* Central segment of a light brown table top. On it, left to right, a beer stein standing on a folded newspaper and the Caporal tobacco package with a meerschaum pipe leaning against it. Ashes and a fragment of burnt match at the extreme right. One of the very few works of Harnett with the main vertical (the beer stein) at the left.

Reproduced: *Antiques,* August, 1948, p. 68.

Boston, B. Bornstein.

41. *Still Life for Nathan Folwell.* A table covered entirely with a green cloth embroidered in reddish brown at its extreme left. On this, reading from the left to the center of the picture, are the Arnold ink bottle resting on a slashed-open envelope, a folded letter, a large bronze statuette of a greyhound, and three books of various sizes in various positions. To the right of the center is a pile of two books lying on their sides surmounted by a Greek vase adorned with human and supernatural figures, gold bands, and other ornamentation. The lower book of the pile juts forward, and on its jutting corner lies a large watch, its gold fob hanging over the table's edge by a black ribbon. The letter reads "What you reques . . . / however it can . . . / heard what it . . . / published the . . . / of New York whos . . . / all publications op . . . / can be obtained . . . / will attend to the . . ." *R.* 26 x 21.

Philadelphia, William Goldman.

42. STILL LIFE WITH BRIC-A-BRAC. *L.* Plate 35.

43. *Times.* Nearly identical with SOLACE (No. 38) except that the newspaper is the Philadelphia *Times* dated ". . . uary . . . 8," and there is no biscuit. The matches are also differently distributed. *R.* 11½ x 9½.

Reproduced: *RO,* No. 5.

New York, Martin Grossman.

44. A WRITER'S TABLE. Central segment of a table covered with a green cloth. On it, left to right, a small bronze bell on a vertical stand (this object has been identified as a reading lamp, but it is much too short to be such, and its clapper is plainly visible), a rolled-up bill, the Arnold ink

bottle with a quill pen emerging from its mouth standing on a slashed-open envelope, a wide-mouthed bronze vase, and a pile of two books lying on their sides and surmounted by a folded letter the handwriting of which is now illegible. The upper book bears a black label reading "Murray's Grammar" and the lower a red label reading "Universal Gazetteer." *L.* 14⅛ x 11⅞. The entire painting seems at one time to have been clumsily restored and otherwise tampered with, and the bronze vase may be an addition by another hand. (See below, Artist X, No. 3.)

New York, private collection.

44A. BARD OF AVON. A bisque or marble bust of Shakespeare standing on two books lying on their sides. The upper book is labeled "CO . . . SHAKESPEA . . ." The lower book, much larger than the upper, has two labels, one reading "Shakespeare's Tragedies" the other "Illustrated." A third book, fat and worn, leans against the other two; it is labeled "SHAKESPEARE'S SONNETS." A quill pen rests against the books supporting the bust. All this on a draped table. *R.* 29½ x 19½.

Reproduced: *Burlington Magazine,* March, 1967, p. xxxix.

Boston, Adelson Galleries.

1879

45. THE ARTIST'S CARD RACK. Signed and dated at upper left. Plate 46. Reproduced (in color): *RO,* No. 10.

46. *The Banker's Table II.* Central segment of a black marble table top. On it, left to right, a silver dollar, a pile of nine silver coins diminishing in size and resting on a wad of folded five-dollar bills, a gold coin, and a book on which rest a quill pen, a folded letter and the Arnold ink bottle. The only legible words in the letter are "interest on" in the first line. The five-dollar bills are probably unfinished and the signature and date, *R.,* may not be authentic; consequently the picture may be earlier or later than 1879. 8 x 12. (Cf. Nos. 3 and 18.)

Healdsburg, California, Mrs. S. D. Wattles, Sr.

47. *The Broker's Table.* Center segment of a black marble table top. On it, left to right, a folded letter, a pen in a wooden penholder, and two books lying on their sides surmounted by a squat stoneware ink bottle. The upper book is brown and bears the title "Algebra / I." The lower book, green in color, is entitled "Gazette / II." Protruding from under the green book is a corner of a bright yellow envelope addressed to ". . . son / . . . Street / . . . w York." The text of the folded letter is as follows: "p . . . osed to offer some / further shares for sale, / it is necessary for me to ex- / plain that the sale of these / shares is not urgent, al- / though it is desirable, be- / cause apart from the. . . ." *R.* 9 x 12.

New York, Donald S. Stralem.

47A. *The Philosopher's Table.* A marble table top. On it, at right, a pile of two books lying on their sides, the lower and larger one labeled "Shakespeare's Sonnets," the

upper and smaller "T . . . Betrot . . ." The Arnold ink bottle surmounts this pile. A slashed-open envelope juts from beneath the bottom book. A quill pen, stained with ink at its writing end, lies across nearly the entire width of the painting, its writing end on the table top, its feathered end on the topmost book. Behind this, at left, is a folded letter, upside down. The exposed sheet reads "howe . . . that may be to all those / . . . quainted with his writings, / . . . t will be unnecessary for me to / acknowledge, how greatly I am / indebted to him for several [smudged] of / the conclusions which I have / been led to form, or how closely / in many cases I have followed / up his views. For the manner . . ." L. 11¼ x 14¼.

Reproduced: *Kennedy Quarterly,* December, 1967, p. 285.

Grosse Pointe, Michigan, R. Manoogian.

48. THE BLUE CARAFE. A black marble table top. Left to right at the table's edge, a cracked walnut, an almond, a bunch of grapes, a cracked Brazil nut, and a whole walnut. Behind these, a partly peeled orange and two apples. Behind the orange, a conical wine glass, partly filled. Behind the apples, a large glass ewer or carafe etched with dia-mond-shaped ornamentation and also partly filled with wine. L. 22 x 18.

San Juan Capistrano, California, Robert Honeyman.

49. MATERIALS FOR A LEISURE HOUR. Central segment of a black marble table top. On it, left to right, a dented pewter mug with a small round biscuit wedged beneath it, a meerschaum pipe with a glowing ember in the depths of its bowl and a long wraith of smoke emerging there-from, a book ("Thaddeus of Warsaw"), a stoneware beer bottle with a torn collar of silver foil, and a terra cotta match holder containing five matches. Behind the beer bot-tle is a folded newspaper with a mysterious masthead read-ing "IN . . . ON / Chronicle / . . . ay 18, 1879 . . . by post 6½ d." L. 14½ x 19½.

Reproduced: *Art News,* September, 1949, p. 16.
St. Louis, Mrs. Lemoine Skinner.

50. ON NOVEMBER 2. Central segment of a table top cov-ered with a green cloth. On it, left to right, a meerschaum pipe with a glowing ember and a wraith of smoke, a folded copy of the New York *Times* for November 2, 1879, and a beer stein. Matches, burnt and fresh, and ashes. R. 14 x 12.
Bethesda, Maryland, Robert H. Smith.

51. THE SECRETARY'S TABLE. A light gray marble table top, veined. At the extreme left, a terra cotta inkwell with its brass lid standing open and with a quill pen emerging from it and slanting to the right. The inkwell rests on the topmost edge of a blue envelope with a red wax seal. Next, to the right, is a brown leather writing pad on which is a sheet of white paper bearing the inscription "June 28 / See Mr. Clarke / at St. George Hotel." A black pencil lies across the top of the writing-pad; behind it stands a letter-seal with a wooden handle and a spot of red wax on its metal tip. In the center of the picture is a green leather

letter case partly opened to reveal unused sheets of letter-paper of various light colors, all stamped with a device in the form of a circular Japanese fan adorned with a crane and stalks of bamboo. Before the letter case, and resting against it, is a brilliant red stick of sealing wax with a burned end. Inserted between the letter case and the table top, with its handle projecting over the table's edge, is an ivory-handled table knife. At the extreme left stands a heavy brass candlestick with a stump of a translucent candle and spots of red sealing wax. L. 14 x 20.

Reproduced: *RO,* No. 8.
Santa Barbara Museum of Art.

52. *Shinplaster.* Signed and dated at upper left. Plate 38.

53. *Shinplaster and Exhibition Label.* R. Plate 39.

54. THE SOCIAL CLUB. L. Plate 29.

Reproduced (in color): *American Paintings and His-torical Prints from the Middendorf Collection,* catalogue of exhibition at the Metropolitan Museum of Art, October 4 to November 26, 1967, p. 54.

55. *Still Life.* Identical with *Solace* (No. 38), except that the newspaper is dated ". . . y 3, 18 . . ." and displays a different part of its masthead: ". . . R . . . HERA . . ." R. 12 x 10.

Grosse Pointe, Michigan, Harold O. Love.

56. *Still Life.* Central segment of a black marble table top. On it, left to right, the Arnold ink bottle with a wooden penholder emerging from its mouth, a folded letter, a large book, and a folded copy of the London *Times* for July 17, 1879. Before the book, at the table's edge, is a pearl-handled pocket knife with one blade ex-tended. The letter, on ruled paper, reads "now if . . . / your favor . . . / let me hear from . . . / . . . ediately and while . . . / . . . gaged on that work the . . . / . . . that I would call . . . / . . . ular attention to, of . . ." L. 11 x 15.

Reproduced: *Kennedy Quarterly,* December, 1967, p. 284.
New York, Kennedy Galleries.

57. *Still Life with Letter to Dennis Gale.* A varied replica of the STILL LIFE WITH LETTER TO THOMAS B. CLARKE, plate 34. Here the envelope is addressed to "D. Gale / 1125 Chestnut St. / Philadelphia," the newspaper is the New York *Herald* for ". . ly 28, 1879," and the ink bottle is Arnold's familiar conical one, not the squat cylinder of the Clarke picture. The book titles, likewise, are different. The Gale picture presents "Hudibras" and "Wordsworth's Works," the Clarke "Whittier's Poems" and "Shake-speare." R. 11 x 15.

Reproduced: *RO,* No. 9.
New York, Oliver B. Jennings.

58. *Still Life with Letter to Mr. Lask.* A black marble table top, veined. On it, left to right, the Arnold ink bottle with a wooden penholder emerging from it, a rolled up bill, a gold coin, and a pile of two books lying on their

sides surmounted by a slashed-open envelope and a folded letter. Much of the writing on the letter has become illegible, but one can still decipher "say now, Mr. Lask, I would like / you to call upon . . . / and we will make arrangements (?) / to spend the . . . / in the Adirondacks if you . . ." *R.* 9 x 12.

Lake Bluff, Illinois, Paul MacAlister.

59. STILL LIFE WITH LETTER TO THOMAS B. CLARKE. *R.* Plate 34.

60. (Photograph.) THIEVES IN THE PANTRY. *L.* Plate 33. Inscribed on back, "$ Moehring, Frankfurt. 16 x 35 in."

60A. TO THIS FAVOUR. A draped table set before heavy masonry, with an arch providing a deep, dark recess at the right. On the table, left to right, a book lying on its side, a book fanned open, an hour glass, a book lying diagonally at the left-hand end of a large volume labeled "Shakespeare/Tragedies," a candlestick with a stump of translucent candle, and a small book. A white skull rests on top of "Shakespeare's Tragedies." Below the fanned-open book is one with a cover torn off and dangling by threads over the table's edge. On this book cover, in longhand, "Now get you to my lady's chamber and / tell her, let her paint an inch thick, to / this favour she must come." *R.* 24 x 32.

Cleveland Musem of Art.

1880

61. *New York Times, November 9, 1879.* (Dated 1880 at the signature.) Center segment of a bare wooden table top. On it, left to right, a folded copy of the New York *Times* with date as indicated, a meerschaum pipe, a porcelain beer stein adorned with a figure of a running dog in relief, and a terra cotta match holder containing six matches. Matches, burnt and fresh, on the table; ashes. *L.* 10 x 14. (Also known as HIS MUG AND HIS PIPE.)

New York, Oliver B. Jennings.

62. *New York Herald, January 9, 1880.* A brown wooden table top. On it, left to right, a meerschaum pipe, a copy of the New York *Herald* with date as indicated, a package of matches, a barrel-ribbed beer stein, and a small round biscuit. Matches, burnt and fresh, and crumbs. *R.* 12 x 16.

New York, Kennedy Galleries.

62A. *New York Herald, February 9, 1880.* Central segment of a bare wooden table top. On it, at the table's edge, a meerschaum pipe with a metal rim and a long amber bit stretches almost the total width of the painting. Behind the pipe is the terra cotta match container with nine matches, two without heads. Behind this a propped up copy of the *New York Herald* with date as indicated. At right, a gray stoneware jug. Matches and ashes on the table top. *L.* 7½ x 9¾.

Philadelphia, R. McNeil, Jr.

63. *London Daily Telegraph, February 10, 1880.* A black marble table top. On it, left to right, a meerschaum pipe with a glowing ember and wraith of smoke, a folded copy of the London *Daily Telegraph* with date as indicated, a cylindrical package of tobacco adorned with a Japanese fan and other ornamentation, a gray stoneware jar with blue ornamentation, and a box of wax matches. A green drape appears in the left background. *L.* 14⅛ x 20.

Reproduced: *RO,* No. 11.

Denver Art Museum.

64. *Philadelphia Public Ledger, March 2, 1880.* Central segment of a light brown wooden table top. On it, left to right, a small round biscuit, a folded copy of the Philadelphia *Public Ledger* with date as indicated, and a book lying on its side surmounted by a beer stein; a meerschaum pipe rests upside down, the rim of its bowl on the book, its bit on the table. Matches, burnt and fresh, and crumbs. A paneled background throughout the width of the canvas. *L.* 9¼ x 14.

Reproduced: Born, plate 81. (Incorrectly titled *New York Ledger.*)

Bethesda, Maryland, Robert H. Smith.

65. *New York Herald, March 10, 1880.* Central segment of a bare wooden table top. On it, left to right, a meerschaum pipe lying upside down, with the rim of its bowl against the table, a folded copy of the New York *Herald* with date as indicated, a rough stoneware beer stein, and a small round biscuit. Matches, burnt and fresh, and crumbs. A wall of simple rectilinear paneling extends throughout the width of the canvas in the background. *L.* 14 x 12.

* London, England, Robert Frank.

66. *Le Mot d'Or(dre?), March 27, 1880.* A wooden table top, left corner showing, and covered at its left-hand end with an elaborately embroidered floral drape. In the background to the left is another floral drape, and, to the right, an elaborately paneled wall. On the table top, left to right, a cigar box labeled "Conchas 50" with a paper-bound book wedged beneath it, a wine glass partly filled with wine, a pile of three books lying on their sides, and a glass carafe of wine with an exceptionally tall, narrow, neck terminating in a ball-shaped stopper. Before the carafe lies a stub of a cigar in a curved ivory holder. The right-hand end of the cigar box and the cigar in its holder lie on a folded newspaper which hangs over the table's edge so that its masthead is upside down. This masthead reads "LE MOT D'OR . . . ," and above it, in smaller type, is this line: "No. 82 Lundi 27 Mars 1880 PARIS: 10 CENTIMES—DEPART . . ." Panel, *R.* 7 x 6.

San Francisco, Mrs. M. H. Crowe.

67. *London Times, April 9, 1880. R.* Plate 53.

68. *New York Herald, July 11, 1880.* A bare wooden table top, left corner showing. On it, left to right, a meerschaum pipe lying on its side and spilling ashes, a folded copy of the New York *Herald* with date as indicated, and

a book lying on its side surmounted by a stoneware jug. A deep, dark recess in the background at the extreme right. The remainder of the background is a paneled wall. *R.* 5¼ x 7.

New York, Miriam Bloch.

69. *New York Herald, July 26, 1880.* A brown wooden table top almost entirely covered with a drape of light raspberry red. On it, left to right, a paper-covered book, a meerschaum pipe, a copper candlestick with a translucent candle, a folded copy of the New York *Herald* with date as indicated, an open can of tobacco with a bright yellow label reading ". . . al leaf / . . . ginia tobacco," and a leather-covered book on which rests a gray stoneware jar ornamented in blue. A tightly folded newspaper is wedged between the bottom of the jar and the book. Matches, burnt and fresh, and ashes. The extreme right-hand corner of the table is shown, and is its only bare spot. The background at the extreme right is a dark, empty space. The remainder of the background is a wide stretch of paneled wall. *R.* 7½ x 9½.

Reproduced (in color): Philadelphia *Inquirer Magazine,* August 10, 1952, p. 11.

Philadelphia, Private collection.

70. SEARCHING THE SCRIPTURES, *L.* Plate 49.

71. *Still Life with Three Castles Tobacco.* A light brown wooden table top. On it, left to right, a cylindrical stoneware ink bottle lying on its side with a trail of dried ink pouring from its mouth and staining the table before it, an open can of Three Castles tobacco, a meerschaum pipe, and a stoneware vase or jug. Matches, burnt and fresh. *L.* 10¹³⁄₁₆ x 15.

Reproduced: *Saturday Review of Literature,* May 6, 1950, p. 66.

Brooklyn Museum.

71A. *Figaro.* Central segment of a bare table top. A meerschaum pipe (cherrywood stem, rubber bit) lies at the table's edge across most of the width of the painting. Behind it, a folded copy of *Le Figaro,* undated and with its masthead upside down. At right, a large, fat, stoneware jug with dark bands around its collar and foot and floral decoration at its left-hand bulge. Behind this, at extreme right, lying on the table, a can labeled "LATAKIA TABAC." The background is a paneled wall with the usual dark recess at the right; the recess contains a cabinet on which stands a carafe, and a portion of a framed picture is visible above its stopper. *L.* 7 x 6.

Omaha, Joslyn Art Museum.

71B. *Latakia.* A table top, left corner showing and draped; the drapery extends across three-fourths of the width of the table top as shown. On it, left to right, a meerschaum pipe; a stoneware jug with floral decoration on its left-hand bulge, with a brass collar and a brass rim around its mouth joined by a handle of the same metal; a can labeled "LATAKIA TABAC" lying on its side, its left-hand end on a folded newspaper, its right-hand end

open and pouring tobacco onto a newspaper with the masthead "THE NEW YOR . . ." and the date "Wednesday, July . . ."; a large paper-bound book behind the tobacco can; behind that a pile of three books lying on their sides, the topmost paper-bound and dog-eared; a glass mug of wine or cider propped on the large paper-bound book; a match; and a small round biscuit. A drape in the background at the left extends to the middle of the painting. Then paneling and a deep, dark recess at the extreme right. Match-ends here and there. *R.* 7¼ x 9¼.

Detroit, Bert Smokler.

71C. *Latakia II.* Central segment of a bare wooden table top. On it, left to right, a worn, leather-bound book labeled "SCOTTISH CHIEFS" on which stands a fat, round, gray beer stein adorned with decorative bands top and bottom, starting at the points of juncture of its handle. Behind this is a newspaper whose masthead reads (upside down) ". . . O . . . ALD." Before this, a large, open tobacco can with a yellow label reading "LATAKIA TABAC." At right, a briar pipe with gold rim and collar and a rubber bit, upside down on the table top. The background is a paneled wall. Matches, burnt and fresh, and ashes. In this painting, alone among the known works of Harnett, the signature and date are separated. The signature is at the lower left and the date at the lower right. The last digit of the date has been rubbed by a frame and is illegible, but the use of the Latakia can suggests 1880. 11 x 15.

Montecito, California, Private collection.

1881

72. *Frankfurter Zeitung.* A wooden table top covered at its left-hand corner with a flowered rug. The background at the left is a flowered drape, and, at the right, a paneled wall. On the top of the table, left to right, a cigar box, labeled "Conchas Regalia," with a wine glass behind it, a plum in front of it, and a bunch of grapes lying on its top at the right-hand end. Next right is an apple behind which stand a pile of books and a bronze plaque. To the right of the apple is a glass wine bottle, partly filled with wine, and with a long, narrow neck terminating in a glass stopper. At the extreme right, more grapes and a stump of a cigar in an ivory holder. Beneath the apple and the wine bottle, hanging over the edge of the table, is an undated copy of the *Frankfurter Zeitung.* Signed and dated at upper left. 7⅛ x 6⅛.

Reproduced: *Realism, an American Heritage,* catalogue of exhibition in galleries of the International Business Machines Corporation, January 14–February 1, 1963.

New York, International Business Machines Corporation.

73. HEAD OF A GERMAN GIRL. *L.* Plate 51.

74. (Photograph.) REMINISCENCES OF OLDEN TIME. Center segment of a table entirely covered with a flowered cloth or rug. On it, left to right, a Greek vase lying with its lip on the top of a small mother-of-pearl card

case, a sword, and a large book on which stand a guffawing medieval helmet and a porcelain beer stein with no perceptible handle. Behind the stein is a bronze plaque. The background is a plaster wall. Reproduction in the Birch catalogue. No signature or date visible. According to the Birch catalogue listing, this work was painted in Munich in 1880, but Harnett probably did not go to Munich until the following year.

This painting and No. 76 (plate 54) are closely related. Both are known only through reproductions in the Birch catalogue, and both represent the same book, the same helmet, and the same sword, composed together in very similar ways. The Greek vases, bronze plaques, and mother-of-pearl card cases used in both pictures are much alike but not identical. (The sword, incidentally, appears unsheathed in AFTER THE HUNT, frontispiece.)

75. STUDY OF AN ITALIAN PEASANT (?). Also known as TYROLEAN. Head of a young man with long black hair, clean-shaven, collarless, with a rough wool coat and a conically shaped hat. *L.* Charcoal on paper, 19½ x 15½.
* New York, Downtown Gallery.

76. (Photograph.) YE KNIGHTS OF OLD. Plate 54. See notes on No. 74.

76A. *Münchener Bote.* A bare table top, left corner showing, set against a smooth plaster wall with the usual dark recess at the right. On the table top, left to right, four turnips, a glass of wine, a hard roll, a pile of two books lying on their sides, a stoneware jug adorned with bands at collar and foot and with floral motifs on its left-hand bulge, and a meerschaum pipe. All this is held together compositionally by a copy of the *Münchener Bote* lying diagonally across the table top from deep left and hanging over the table's edge at right. On the wall at left is a pair of clock weights hanging by chains and, to to right, a horn hanging by a strap. In the dark recess at extreme right one may see a portion of a cabinet with a bottle on it and a portion of a plate standing upright against the wall. *L.* 5⅛ x 7.
New Haven, Connecticut, Josephine Setze.

76B. *The Egyptian Vase.* An elaborately paneled cabinet with hinged doors and a marble top, left corner showing. On the marble top, left to right, an apple, a large bunch of grapes with its leaves and tendrils and hanging over the edge of the cabinet, a dark vase adorned with geometric and floral motifs in Egyptian style, and a peach. Detached grapes here and there. Signed *L.,* but, as in No. 76D, vertically rather than horizontally. Another signature and date are on the back of the stretcher. This painting is unique among those of Harnett because of its extremely small size. 3¾ x 2¾.
New York, Donald S. Stralem.

76C. *Egyptian Vase No. II.* A very close paraphrase of the foregoing. The same apple, grapes, peach, and Egyptian vase, in the same relationship, but an additional apple has been introduced to the right of and behind the first

one. Furthermore the paneling of the cabinet is different; there is also less of it, and, correspondingly, there is more free space for the objects on its top. This painting, also, is horizontal rather than vertical, is on panel, and is larger than No. 76B. Signed on back only. 7¾ x 5¼.
Ripon, Wisconsin, Mrs. James Bowditch.

76D. *Still Life with Two Signatures.* See Preface to the Revised Edition.

76E. *Lobster and New York Herald.* Central segment of a paneled cabinet with a marble top, draped at the left with a cloth containing a floral motif. The dark recess which appears so commonly at the extreme right in the backgrounds of Harnett's still lifes of the 1880's here appears at the extreme left. On the table top, left to right, a bunch of red grapes; a half-opened wooden box labeled "FIGS" and containing such; an apple, and a bright red lobster at the table's edge, lying on a copy of the New York *Herald* dated ". . . 22, 1881." Behind the lobster are another apple, a bunch of green grapes, a blue Chinese ginger jar, and a tall, dark champagne bottle, with foil wrappings around its neck and its handsome, egg-shaped cork. To the right of the champagne bottle are a peeled orange wrapped in tissue paper, a cigar box, and a single grape. *L.* 10 x 8.
Boston, Adelson Galleries.

1882

76F. *Lobster and Figaro.* A paraphrase of the foregoing. The drape has been removed from the table top and the dark recess has been returned to its usual place at the extreme right, where it takes the form of an arch in a masonry wall. The cigar box and the small bunch of green grapes are now at the extreme left. Next comes the champagne bottle, showing a bit of its label at its left. Directly before this is the lobster on a copy of *Le Figaro* which hangs over the table's edge. The green grapes, and the half-opened fig box lie behind the lobster. The fig box is now stenciled "ELEME FIGS." At the right, before the arch, two apples, a lemon, four grapes, and the Chinese ginger jar. *L.* 11½ x 9.
Reproduced: *Kennedy Quarterly,* December, 1967, p. 282.
Detroit, Mrs. May Morrison Becker.

76G. *Still Life with Lobster.* A variation of No. 76F. The objects on the table top are, with exceptions to be noted, identical with those in 76F, and they are composed in precisely the same relationships. The differences between the two pictures are as follows: The table top is heavily draped rather than bare. The drapery has a floral design on the right-hand side; on the left it has no design but lies in deep folds. The background is a plain plaster wall and the recess at the extreme right is simply vertical, not arch-shaped. There is no newspaper. A sprig of cherries with their leaves protrudes from under the lobster and over the table's edge. The foil wrapping around the neck

of the champagne bottle is a little less deep than in 76F. *R.* 11½ x 9.

Reproduced: *MC*, p. 23.

Washington, Admiral E. P. Moore.

76H. *Lobster and Figaro No. II.* The composition has been shifted from vertical to horizontal, and a drape is back on the table at its left-hand end. The blue Chinese ginger jar is now at the extreme left with a small bunch of green grapes at its feet and two red grapes below it. Next right are two yellow spotted apples, a bunch of red grapes, and the half-opened Eleme fig box with its fruit. The lobster lies on a copy of *Le Figaro,* along with grape leaves, as in Nos. 76F and 76I. Behind the lobster are a lemon, a small dark liqueur bottle with gold foil around its neck and cork (a dwarfed relative of the champagne bottle in the three preceding paintings). The vertical accent for the picture is provided by a tall bottle, with a metal cap and the word "BLANC" on a white label around its neck, containing preserved fruits of many colors and various sizes and shapes. At the extreme right are the cigar box and the peeled orange wrapped in tissue paper. *R.* 10 x 14.

Reproduced (in color): *Kennedy Quarterly,* January, 1965, cover.

New York, private collection.

76I. *Lobster and Pester Lloyd.* An extremely close variation on the foregoing. The deep recess remains at the left. The table remains undraped but has been given a black marble top. The ginger jar, the grapes, the apples, the fig box, the lobster, the liqueur bottle, the tall bottle of preserved fruits, the cigar box, and the orange wrapped in tissue paper are all the same as in No. 76H. There are, however, these noteworthy differences: at the extreme left a bone-handled knife lies near the table's edge and three grapes lie directly before it; the newspaper is the *Pester Lloyd* dated *Dienstag 7 Febr.;* the label on the neck of the bottle of preserved fruits reads "MELANGE"; there is a small bunch of grapes on the top of the cigar box, much in the shadow of the bottle of preserved fruits; and the back wall, instead of being plain plaster, as in Nos. 76E and 76G, or a masonry wall as in 76F, splits the difference and becomes plaster painted to simulate masonry. *R.* 13½ x 16½.

Detroit, Dr. Irving F. Levitt.

77. *Deutsche Presse. L.* Plate 55.

78. PLUCKED CLEAN. A dead rooster, bereft of all but his tail feathers, hanging by his left foot on a string against a plain wooden door. Feathers and down here and there. *L.* 34½ x 20¼.

* New York, H. Turner.

79. STUDY OF AN ITALIAN BRIGAND (?). Head of a young man with abundant dark hair and a dark moustache. His wide soft collar is open and is drawn in detail, in white, but his shoulders and chest are suggested only with a few dark lines. *R.* Charcoal and white crayon on paper. 19½ x 15½.

Reproduced: *MC*, p. 31.

Detroit, Dr. Irving F. Burton.

80. A STUDY TABLE. *L.* Plate 56.

Reproduced: *RO*, No. 12.

80A. THE OLD MUNICH MODEL. Head and shoulders of an elderly man with deeply lined face, sunken cheeks, and a small, bristling moustache. He wears a brown fur hat and a somewhat frayed, knitted scarf, rose-colored. His coat is olive-green with a collar of a deeper green. The lapels of the coat are secured with translucent bone buttons, white, flecked with brown. The background is brown shading to black. Original title identified by an old exhibition label pasted to the stretcher. *R.* 17½ x 14½.

Hamilton, Massachusetts, J. L. Gardner.

80B. MUNICH STILL LIFE. A bare wooden table top, left corner showing. On it, left to right, two large turnips; a box of matches partly opened; a light brown tobacco package opened at its right-hand end and held together with a bright red seal; and a bone-handled knife with metal fittings whose blade lies under the matchbox and props it slightly toward the left. Behind the tobacco package is a glass of red wine. To the right of it is another turnip partly hidden behind a tall, vase-like beer stein with a metal lid and decoration mostly in blue on its gray body. At the foot of the beer stein a meerschaum pipe rests, upside down; at right, hidden in the shadow of the stein, is a fourth turnip, and directly behind the pipe is half a loaf of rye bread. The knife, the tobacco package, the beer stein, and the pipe all rest on the front page of a newspaper whose masthead reads . . . "NACHRICHTEN / und / . . euer Anzeiger. Mittwoch, 2 August, 1882." Behind all this is a very dark plaster wall with an even darker recess at the right. On the portion of the wall directly behind the glass of wine is a caricature in line of a man holding a beer stein; there is a rough *graffito* over the man's head in which one may decipher the letters "TERR . . ." At the upper left-hand corner of the painting are two theatrical announcements, one large, in blue, with a fragment of another poster on its surface, the other white. The blue poster reads ". . . . ARTZ. / Wien / . . . CERT / . . . Uhr. / Entree 50 pf." The white one reads ". . . PSCHIFF / ARIA." *L.* 24⅝ x 30¼.

Reproduced: *75 Masterworks, an Exhibition in Honor of the Seventy-fifth Anniversary of the Portland Art Association.* Portland, Oregon, December 12, 1967–January 21, 1968.

Dallas Museum of Fine Arts.

1883

81. AFTER THE HUNT, first version. *L.* Plate 58.

81A. AFTER THE HUNT, second version. Nearly

identical with the preceding. The large dead duck at the lower right, seen in No. 81 in a ventral view and with its wings spread, is here shown in a dorsal view and with its wings held closer to its body. There are also slight differences between the two pictures in the small game birds and the iron work; the hinges are shorter in 81A than in 81, and they and the key plate are more heavily ornamented. The hat in this version is more informally dented than in 81. *L*. 52 x 33½.
New York, private collection.

82. MALLARD DUCK. A mallard hanging against a wall by a string attached to its left foot. *R*. 34 x 20½.
Ottawa, National Gallery of Canada.

83. MERGANSER. A duck hanging against a wall by a string attached to its left foot. *R*. 34 x 20½.
Youngstown, Ohio, Butler Institute of American Art.

84. *Sporting Still Life*. A wooden cabinet with a shelving marble top, set before a much larger and taller cabinet, elaborately paneled; the shelving top of the smaller cabinet is covered with an embroidered cloth at its right-hand side, and the background at the right is a deep, dark recess. On the top of the smaller cabinet, at the extreme left, is a lighted cigarette with a trail of smoke. To the right of this is a bottle of champagne set in a large metal tub. Before the tub are a peeled orange, wrapped in tissue paper, and four apples. To the left and right of the tub are clusters of grapes; behind it are a tall wine glass and a lidded jar. Just to the right of the center of the picture, standing on the left-hand edge of the embroidered cloth, is the pewter tankard. To the right of this are an unlabeled cigar box, an apple, and a package of cigarettes. Panel. *R*. 8¼ x 10¾.
Franklin, Michigan, Paul Zuckerman.

85. STILL LIFE. A wooden cabinet with a shelving top set before a plaster wall with a deep, dark recess at the extreme right. The cabinet is covered with a rug at its left-hand corner. On it, left to right, are a closed wooden fig box, a stoneware Curaçao bottle, a champagne bottle lying nearly on its side, a copper jug with its lid partly open, a pearl-handled table knife, and a cigar box labeled "Colorado / Maduro / 100." On top of this cigar box stand an open Chinese ginger jar propped toward the right by its own lid, and an apple. Before the cigar box is an orange, almost entirely peeled, and at the extreme right is a completely peeled orange wrapped in tissue paper. A long segment of grapevine, with many tendrils and a few grapes, winds in and out throughout the entire painting. Panel. *R*. 6½ x 8½.
Columbus, Ohio, Gallery of Fine Arts.

85A. *Still Life*. An almost exact replica of the foregoing. The principal differences are that the rug draping the table at the left has a different pattern, with stylized flowers, although it is arranged in precisely the same folds. The fig box now has the word "Eleme" stenciled on the end immediately behind the Curaçao bottle. The cigar box is labeled "La Matilde / Claro / 50." There are two grapes on the bare table top immediately before the wrapped orange. Panel. *R*. 8¼ x 10¾.
Franklin, Michigan, Paul Zuckerman.

86. (Photograph.) *Still Life with Bust of Dante*. A cabinet with a shelving top and with an Oriental rug draped over its left-hand corner set before a much larger cabinet adorned with carving, fancy hinges, and an heraldic eagle and castle in the paneling of its door. A dark recess appears at the left-hand side of the picture. On the top of the smaller cabinet is a complex jumble of objects including a sheet of music entitled "Rosamunde," eleven books, a keyed bugle, a small bronze bust of Dante, and a medieval helmet. Sheets of music and a book-cover hang over the edge of the lower cabinet. In its body, below the shelving top at the right, is a door with a key escutcheon in the form of a little boy. *R*. Inscribed on back: "Munich 1883 / $ to Neustadt of New York / 10½ x 14 inches, 26 x 35 cent."

87. (Photograph.) *Still Life with Bust of Socrates*. A table, draped with a rug at its left-hand corner, set before a large paneled cabinet; a deep, dark niche is in the background at the extreme right. On the table, seven books of various kinds, the pewter tankard, a violin and bow, a bronze bust of Socrates, and a roll of music. Sheet music and a music-cover hang over the edge of the table. Signature at upper left. Inscribed on back: "Munich 1883 / $ Carmer of N.Y. / 7 x 9 in. / 19 x 23 cent."

88. (Photograph.) *Still Life with Clarinet*. A table, draped with a plain cloth at its right-hand corner, set before a large cabinet with paneled doors and brass key escutcheons. A dark recess extends along the left-hand side of the picture. On the table, seven books, an old-style clarinet, the pewter tankard, and a snuff box. Sheet music hangs over the table's edge. *L*. Inscribed on back: "München 1883 / $ Carmer of N.Y. / 7 x 8½ in. / 17 x 21 cent."

89. (Photograph.) *Still Life with Hard Roll*. A cabinet with a shelving top, its left corner showing, set near a junction of two walls. On it, a hard roll with a split top, four books, a cylindrical paper package of tobacco, a meerschaum pipe, a porcelain beer stein with a pewter lid, a candlestick with a stump of candle, and a turnip. Over the edge, a newspaper with the masthead, "Zeitung." *R*. Inscribed on back: "Munich 1883 / $ to Rothschild of New York / 15 x 19 cent / 6 x 7¾ in."

90. (Photograph.) *Still Life with Horn*. A cabinet with a shelving top, right corner showing, set before a plaster wall, with a dark recess at the extreme right. Hanging on the wall, the horn of AFTER THE HUNT, first version (plate 58), and a gun. On the top of the cabinet, left to right, three large turnips or rutabagas, two small radishes, a bone-handled knife, a glass of wine or dark beer, a pile of two books lying on their sides and surmounted by a folded newspaper, an open snuff box, a stoneware jar with a pewter lid, and, at the extreme right, another turnip or

rutabaga. In the body of the cabinet, supporting the shelving top, is a drawer with two brass knobs. *L.* Inscribed on back: "Munich 1883 / $ Carmer of N.Y. / 6½ x ½ / 16 x 21 cent."

91. Through a misreading of its date, the painting now catalogued as No. 76G was assigned to the year 1883 in the first edition of this catalogue and was given the number 91. Since this was incorrect, and since we wish, for reasons explained in the introduction to the present catalogue, to disturb the original numbering as little as possible, we simply void No. 91 in this edition.

92. (Photograph.) *Still Life with Turnips.* A cabinet with a shelving top, right corner showing, set before large cabinet elaborately paneled; a deep, dark recess at the extreme right. On the top of the smaller cabinet, three large turnips, a porcelain beer stein with a pewter lid, a bone-handled knife, three books, a cigar box on which rests a folded newspaper with the masthead, "Zeitung," and a stump of a cigar. Signed at the upper left. Inscribed on back: "Munich 1883 / $ to Rothschild of New York / 14 x 18 cent / 5¾ x 7¼ in."

92A. STILL LIFE: HELMET, BOOKS, TRUMPET, AND SHEET MUSIC. A paneled cabinet with a shelving marble top set before a much larger cabinet with elaborate hinges and paneling; a deep, dark recess at the extreme right. At its left-hand end, the smaller cabinet is covered with a rug. On it are twelve books of various shapes and sizes, all lying on their sides or resting diagonally against other books. A roll of music in its cover, bound around with a string, lies on a fair-sized book at the extreme left. In the center of the composition is a keyed bugle; directly behind its bell is a helmet from a suit of armor, its visor closed. At the right, half hidden by books, is a bronze bust of Dante. A book at the left, with a cover torn off and dangling over the table's edge, is a Dante dated 1506. The paper-bound book immediately above this bears the title "JULIETTE." Panel. *R.* 10¼ x 13¾.

Reproduced: *Masterpieces in the High Museum of Art,* 1965, p. 38. Also in *The Triumph of Realism,* catalogue of exhibition held at Brooklyn Museum, Virginia Museum of the Fine Arts, and California Palace of the Legion of Honor, 1967–68, p. 180.

Atlanta, High Museum of Art.

1884

92B. *Still Life.* A variation on Nos. 85 and 85A, suggesting that those pictures were painted at the end of 1883 and this one at the start of 1884. The dark recess is at the left. The table is draped with a velvet cloth at its left-hand end. The cigar box and the half-peeled orange are on the table-top at the extreme left; the cigar box is propped toward the right by an apple underneath it; the cigar box is labeled "La Intimidad / Habana," and the Chinese ginger jar rests on top of it. The Curaçao bottle stands in the center of the picture, with green grapes behind it.

The copper tankard is next right and provides the major vertical. Before it the champagne bottle lies against the fig box, now with one board in its top slightly opened and labeled, on the end presented to the spectator, "Eleme Figs / in La . . ." The knife lies at the table's edge, its blade in the shadow of the Curaçao bottle. Before the champagne bottle are two apples and a small bunch of red grapes; another apple and three more grapes stand before the fig box. *R.* 9½ x 12½.

Reproduced: *RO,* No. 13, but incorrectly dated 1882.

Flint, Michigan, Institute of Art.

92C. *Literary Still Life.* A paraphrase of No. 87. A cabinet with shelving top set before a much larger cabinet with paneling and elaborate hinges. The smaller cabinet is draped at its left-hand end with a cloth, old and stained. At the extreme left on the cabinet-top a large book, labeled "Dante / Purgatorio," lies on its side with a torn-off cover dangling over the table's edge. On this book stands the pewter tankard, now treated with twisted fluting. Behind this tankard are three books, one lying on its side, the others propped toward the right. In the center of the picture, lying on the cabinet-top, is a violin, its bow extending diagonally toward the left across the body of the tankard. Behind the violin are a candlestick with a stump of candle, propped toward the right, a large book lying on its side, and a roll of music on which one may read "ROSAMUNDE / par . . . / VIOLIN (sic!) ET . . ." Behind this is a bust of Socrates, the lower part of its face obscured by the roll of music, which lies diagonally across it. At the extreme right is a vellum-bound book with a cross on its exposed right cover; the spine reveals that this is a copy of Tasso's *Gerusalemme Liberata* dated "Roma, 1560." * Below the violin, a music cover, on which one may read "LA TRAVIATA / SOLO," falls over the table's edge. Beneath this is a piece of music in A major, ⅜ time; it is an unidentified tune which Harnett uses in other paintings as well. It has nothing to do with Verdi's *La Traviata. L.* 14½ x 12.

Newark Museum.

93. (Photograph.) *George Fryer's Still Life.* Signature not visible. Inscribed on back: "Munich 1884 / $ London Geo. Fryer / 115 x 140 cent / 46 x 56 in." Plate 57.

94. (Photograph.) *Still Life with Dutch Jar and Bust of Dante.* A cabinet with a shelving top before a larger cabinet, elaborately paneled; a dark niche at the right. The top of the smaller cabinet is covered with a plain drape at its left-hand corner. On it are six books, the Dutch jar, a violin and bow, a candlestick with a stump of candle, and a bronze bust of Dante. The torn-off cover of one book, with an elaborate metal hasp, hangs by a single thread over the edge of the cabinet top at the left; sheet music also hangs over. Inscribed on back: "Munich 1884 / to Fryer,

Gerusalemme Liberata was not published until 1580. Such predating of vellum-bound books is an old Harnettian trick. See supra, p. 65.

London / with pewter tankard to Columbus, Ohio / 31 x 38 cent / 12½ x 15 in / $ in London."

94A. AFTER THE HUNT, third version. Nearly identical in subject matter with the celebrated fourth version (No. 95; frontispiece), but quite different in composition; furthermore, the objects represented, while repeated in No. 95, are generally somewhat larger, which gives them a relatively heavy feeling; the composition, also, lacks the spacious elegance of No. 95. Other differences to be noted between the two versions are that in 94A the bell and mouthpiece of the horn point upward rather than down; that the powder horn hangs in the middle of the circle provided by the horn; that the alpenstock hangs diagonally from upper left to lower right rather than the other way around; that the gunstock is incised with a decorative star instead of the mother-of-pearl used in No. 95; that the sword is at the left rather than the right and the lion's head of its hilt looks upward rather than down; and that the two hanging, dead game birds in 94A are of different species from those of 95 and their wings and legs are differently disposed. There are also differences in the two key plates, although both of them are in the form of an antique warrior with a battle axe, and differences in the shapes and curlicues of the hinges. In No. 94A the horn is held by one prong of the antlers at the left; in No. 95 the antlers are above the horn. The two hats are much alike, but are differently punched in, and the one of 94A has a feather in its band. The horseshoe, the pistol, the key, and the canteen of 95 are absent from 94A. *L.* 55 x 40.

Reproduced: *RO.* No. 15.

Youngstown, Ohio, Butler Institute of American Art.

1885

95. AFTER THE HUNT, fourth version. *L.* Frontispiece.

96. (Photograph.) *George Richmond's Still Life.* A paneled cabinet with a shelving top (left corner showing) and a plain drape at its right-hand side set before a considerably larger cabinet, also paneled; a dark recess extends along the left-hand edge of the painting. On the top of the lower cabinet are eight books of various sizes and with various types of binding; a roll of music; a flute; a vase with a light body and dark neck; the Roman lamp; and the Arnold ink bottle with a quill pen emerging from it. Sheets of music, one in Gregorian neumes and one in modern notation, hang over the edge of the lower cabinet. No signature visible. Inscribed on back: "Paris, 1885, 10½ x 14 inches. / $ in Royal Acad. London Geo. Richmond."

Reproduced: *Magazine of Art,* February, 1951, p. 66.

97. *Still Life with Tankard.* Panel. *R.* Plate 63.

98. THE TROPHY OF THE HUNT. A dead rabbit hanging by its left foot on a string looped over a nail at the top of a green door. At the top and bottom of the door are long, rusty hinges extending from right to left across the entire width of the picture. These hinges are held on by fresh and rusty rivets; they have vertical arms as well as horizontal, but the lower vertical arm of the top hinge has been broken off and reveals the unpainted wood and the hole where its final rivet had been. Between the vertical arms at the right-hand edge of the painting is a large, free rivet; this is balanced by a metal ring at the left-hand edge. *L.* 42½ x 22.

Reproduced: *Life,* April 14, 1941, p. 74 (in color). Also Born, plate 87, and *Magazine of Art,* October, 1946, p. 253.

Pittsburgh, Carnegie Institute.

1886

99. COLOSSAL LUCK. Nearly identical with GOLDEN HORSESHOE (No. 99A; Plate 64). The main difference is that the newspaper clipping is square and is pasted over the wide crack that runs from top to bottom in both pictures. There are also a few more nails, scratches, and nail holes in 99 than in 99A. *L.* 26⅛ x 22¼.

* New York, Edith Gregor Halpert.

99A. GOLDEN HORSESHOE. *R.* Plate 64.

100. *Meerschaum Pipe. L.* Plate 65.

101. *Meerschaum Pipe II.* Nearly identical with the foregoing except that there is no newspaper clipping, no nail, and the cracks and smudges on the door are slightly different. *R.* 17⅝ x 12¾.

Allen Memorial Art Museum, Oberlin College, Oberlin, Ohio.

102. THE OLD VIOLIN. Signed as address on the letter, *L.;* dated on postmark. Plate 60.

Full-scale color reproduction published by F. Tuchfarber, Cincinnati, 1887. Another edition, but date unchanged, published by Donaldson Sign Company, Covington, Kentucky. A somewhat reduced version published by New York Graphic Society. The best of the recent color plates, however, is in John Canaday, *Metropolitan Seminars in Art, Portfolio 2: Realism* (New York, 1958).

103. *Clarinet and Candlestick.* A brown wooden table with a mottled brown marble top. On it, at left, three books falling successively toward the right. The first book is seen from the top and has a brown binding. The second is vellum-bound and is inscribed on its spine: "Purgat / orio / Divina / Com / Dante / Alighieri / Firenze / 1490." The third book is a blue paperback lying entirely on its side. All three books are on a blue music cover. Next right is a brass candlestick with a white stump of candle. Lying diagonally behind this, supported by the books at its lower end, is an E-flat clarinet with ivory rings around its joints; its mouthpiece rests on the table top with its reed toward the spectator. On the table top, directly before the mouthpiece of the clarinet, is a single rose petal. Behind the clarinet, left to right, are a blue vase containing a rose, a bronze bust of a woman, a brown-bound book on the

table, and a roll of music. Hanging over the table top is a stained sheet of music containing a melody entitled *Cantique.* Behind this, also hanging over the table's edge, is the title page of a piece of music on which one may read ". . . DIES. . . ETS / . . . RE . . . / G." A drape, deep olive-green in color, fills the entire vertical space at the extreme left. At its right-hand end, the table is covered with a somewhat similar velvet cloth, but grayer in tone. The background behind the table is a paneled wall. *R.* 17 x 21.

San Juan Capistrano, California, Robert Honeyman.

104. STILL LIFE WITH VIOLIN. Identical with No. 105, plate 66, except for four details: the top of the table is wood rather than marble; the vellum-covered book, a Dante dated 1503, stands at the extreme right rather than the extreme left and has nothing resting upon it; at the extreme left is a pile of two books resting on their sides; and the newspaper hanging over the edge of the table is the Philadelphia *Times* for "Wednesday morning, October 20, 1886," instead of the Toledo *Blade* for Friday, September 17 of that year. (The newspapers in the two paintings are folded in exactly the same way, however, and are even slightly torn at the same spots.) *L.* 20¼ x 24.

Reproduced: *A Century of American Still Life Painting, 1813–1913,* catalogue of exhibition circulated by the American Federation of Arts, 1966, No. 23, but incorrectly titled *The Philadelphia Ledger.*

New Britain, Connecticut, Museum of American Art.

105. *Toledo Blade. L.* Plate 66. Inscribed on back: "Painted to order / for I. N. Reed / of Toledo / Ohio / 1886. / Wm. M. Harnett."

105A. THE LAST ROSE OF SUMMER. A table with a marble top, left corner showing, but covered with a plain drape toward the right. On the table top, left to right, a book lying on its side, a roll of music burrowing back into the hangings that fill the left-hand side of the canvas, a brass candlestick with a stump of candle propped toward the right by the book, a brass candle snuffer, a vase with roses in deep shadow at the back, a tall metal ewer with a human figure playing a double pipe formed in repoussé on its body, and a vellum-bound book inscribed on its spine "DIVINA / COM / PURGAT/ DANTE / ALIGHIERI / FIRENZE / 1405." Two books are propped against this, leaning toward the left; one of them is bound in paper. Behind these two books is a very large one in the "astride" position. In the center of the composition, with the brass candlestick, the candle snuffer, and the Dante resting on it, is a music cover on which one may read "TRANSCRI . . . / INGRA" Two pieces of music hang over the table's edge. The lower one, of which relatively little may be seen, is in Gregorian neumes. The upper one is in modern notation and contains two melodies. The lower one is headed "(LA DERNIÈRE ROSE D'ETE)" and contains that melody, in E major, distin-

guished at its beginning as "No. 7." Signed vertically on the table-leg, lower left. 24 x 20⅛.

Cincinnati Art Museum.

1887

106. (Photograph.) EASE. A table covered with a velvet drape with an embroidered border; a plain velvet drape also fills the entire left-hand side of the painting. On the top of the table, left to right, an irregularly formed pile of five books lying on their sides with a sixth book leaning against them, a table lamp, an envelope, a chased metal ewer filled with daisies, a glass vase containing two roses standing on a book, and, at extreme right, a second pile of six books against which lean a violin and a palm leaf fan. A flute lies across the books in the middle of the painting, and to the right of its head is a chased metal cup. Sheets which appear blank in the photograph hang over the table's edge; on one of them lies a lighted cigar. *L.*

107. LA FLÛTE ENCHANTÉE. A bare brown table top, left corner showing, covered at its extreme right with a worn, patch drape, olive drab in color. The table stands before a paneled wall. On it, at the extreme left, is a large vellumbound book inscribed on its spine "Divina / Com / et / Purgat / orio / Dante / Firenze / 1503." Behind this is an even larger book standing "astride" on the edges of its cover. In the center is the Roman lamp. At the base of the lamp is a book with an illegible title. At the right is the Dutch jar with a meerschaum pipe lying at its foot. At extreme right, part of another book. The flute runs diagonally throughout almost the entire width of the painting, its head lying on the book "astride" and its end on the table top near the mouthpiece of the pipe. Over the table's edge at the center hang three large sheets. The topmost, light blue in color, is a music cover reading "Opera / La Tra . . . / aria." The second sheet, with water-stained edges, is in Gregorian neumes, with Latin text. The third is entitled "La Flûte Enchantée / Chanson de Friseleur / Mozart / allegretto / No. 37." (The melody on this sheet is that of Papageno's song, "Der Vogelfänger bin ich, ja," actually No. 2 of Mozart's opera, *Die Zauberflöte.*) *L.* Panel, 14 x 12.

* Detroit, J. S. Newberry.

108. *Still Life. L.* Plate 77.

A larger and clearer reproduction in *RO,* No. 20.

1888

109. MY GEMS. A bare wooden table top draped at its right-hand corner with an olive-drab cloth, patched and worn. On the table top, left to right, two books sliding off into the deep background; the Dutch jar standing on a large leather-bound book which lies on its side with a smaller, paper-bound book resting, partly rolled, against its right-hand end; the Roman lamp surrounded by three books of various sizes, one of them vellum-bound and entitled "Troil / & / Cres / W / Shakespeare / J. Condell /

London / 1605"; and, at extreme right, the Arnold ink bottle with a quill pen emerging from it. A piccolo lies with its cracked ivory head on the paper-bound book and its end on the table, directly before the ink bottle. At the edge of the table is a small meerschaum pipe with a straight amber bit. This lies on a music cover inscribed "Rigoletto." Hanging over the edge of the table is a sheet of music presenting the full text of *Hélas, Quelle Douleur,* "Cantique." *L.* Panel, 14 x 18. Inscribed on back: "2 /88."

Reproduction (in color): Huntington Cairns and John Walker: *A Pageant of Painting from the National Gallery of Art* (New York and Washington, 1966), p. 487.

Washington, National Gallery of Art.

110. STILL LIFE. A bare wooden table top covered at its right-hand corner with an olive-drab drape, patched and worn. On the table, from extreme right to extreme left, six books. The book in the center is a large one in the "astride" position; all the others lie on their sides, some partly propped on others. To the left of the large book "astride" in the center is a vellum-bound volume entitled "King Richard / Romeo / & / Juliet / W /Shakespeare / London / 1603." To the left of this, standing on end but tipped toward the left, is a roll of music imprinted "RIGO-LET . . ." Before the vellum-bound book, at the table's edge, is a brass candlestick with a length of translucent candle. Also at the table's edge is a piccolo, lying horizontally, its head caught between the base of the candlestick and the volume of Shakespeare. At the right, the Dutch jar stands on a copy of *Don Quixote.* Two sheets of music hang over the table's edge in the center of the picture; the lower one displays the melody, *Hélas, Quelle Douleur. L.* 14 x 17.

This painting has been relined and no inscription is visible on its back, but pasted to the stretcher is a card inscribed "Painted to order / by / W. M. Harnett, / Studio 28 e. 14th st / New York / Finished March 27, 1888." In view of the marked similarity in subject matter between this work and No. 109, it is listed immediately after it.

New York, Metropolitan Museum of Art.

111. (Photograph.) A bare wooden table top, left corner showing. On it, left to right, a stoneware pitcher, a folded copy of a newspaper with illegible masthead, and a meerschaum pipe. Biscuits, crumbs, matches. *R.* Inscribed on front: "No. 5 / 88." On back: "$ John Hedges / Phila / No. 5 / 88 / 7½ x 9½ panel."

112. (Photograph.) A bare wooden table top, left corner showing. On it, left to right, the Dutch jar, a folded copy of the Philadelphia *Public Ledger,* and a meerschaum pipe; biscuits, crumbs, matches. *R.* Inscribed on front: "No. 6 / 88." On back: "8 x 10 panel / $ Earle & sons / Phila / No. 6 / 88."

113. *New York News.* A bare wooden table top, left corner showing. On it, left to right, a gray beer stein with two bluish bands of ornamentation, a folded copy of the New

York *News* for April 3, 1888, and a meerschaum pipe. Two small, hard, round biscuits; crumbs, matches, ashes, and flakes of tobacco. *R.* Panel, 5½ x 7½. Inscribed on back: "7 / 88."

This picture and the two preceding, constituting Nos. 5, 6, and 7 of 1888, were placed by Harnett on an easel and photographed together. The photograph is inscribed on front and back as indicated in the two preceding entries. No. 7, the only one of the three known to exist at the present time, is inscribed on the photograph with the number and dimensions given here and with the further information that it was "$ John Hedges / Phila."

New York, M. Knoedler and Company.

114. *Still Life.* A bare wooden table top, left corner showing. On it, left to right, the Dutch jar, a meerschaum pipe, the blue tobacco box with shredded tobacco emerging from under its partly opened lid, two books, and a brass candlestick with a stump of candles; matches, biscuits, crumbs. *L.* c. 6 x 10. Inscribed on back: "8 / 88."

Baltimore, Mrs. Bernard Trupp.

115. MUSIC AND GOOD LUCK. Signed on card, *R.;* dated on painted frame below and to the right of this. Inscribed on back: "10 / 88." Plate 79.

Full-scale color reproduction published by Triton Publications, New York, 1952. Small-scale color reproduction published by Metropolitan Museum of Art.

116. FOR SUNDAY'S DINNER. A plucked rooster with a slit throat hanging by its left foot on a string against a door. At the right-hand side of the door are rusty hinges from which several rivets have fallen out; two of these have been replaced by flat-headed wood screws. At the left-hand side of the door is a key escutcheon whose top rivet has disappeared; the escutcheon has therefore fallen toward the right, leaving an image of itself in unpainted wood around the keyhole. Down and pinfeathers here and there. *L.* 37¼ x 21¼. Inscribed on back: "14 / 88."

Reproduced: *RO,* No. 21.

Art Institute of Chicago.

117. *Cincinnati Enquirer, L.* Plate 76. The canvas is backed with cardboard which the writer was not permitted to remove; consequently the present or absence of the typical "serial number" for 1888 could not be established.

118. *Still Life.* Nearly identical with No. 108, plate 77. We reproduce the painting of the present entry alongside it as plate 78, in order to illustrate the variations which Harnett characteristically introduced when painting replicas, but since these variations are slight, some description of them is in order here.

The principal differences are that in No. 118 the background, rather than paneling, is a green velvet drape that fills the entire length of the canvas at the extreme left, the jar (Harnett's beloved Dutch jar converted into a flower vase by removing its handle and providing it with a flaring neck) is filled with daisies instead of straw flowers, and the

Oriental rug at the right, while draped over the edge of the cabinet at the same angle, is altogether different in pattern. All but one of the book titles in No. 108 are illegible, but in No. 118 the book leaning against the lamp is Tasso's "Jerusalem Liberata" [*sic*], and the book lying on its side at the extreme right is "Il et Odys / Homeri." In both pictures the vellum-bound book at the left bears on its spine the titles of several Shakespearean plays "Printed by / Condell / London / 1598." In both versions the cover of this book, dangling over the edge of the cabinet by a single thread, bears a heraldic device consisting of a lute (seen from the back) behind which a trumpet and a sword are crossed, but in No. 108 this cover is inscribed with the initials "M.R.," while in No. 118 it displays the legend "To / Ben / Jonson." Both dangling book-covers are inscribed with the date 1605, although the spine of the book from which they hang is dated 1598. In both pictures, the second sheet from the top among those hanging over the cabinet's edge is a corner of an engraving; in No. 108 this shows one sandaled human foot and the end of a sword below which, in the margin, is the word "Fecit," but in No. 118 one may see both the sandal-bearing feet and part of the cape of the man with the sword as well as one foot of another figure, and the inscription is ". . . uis pinx." In both pictures, the third sheet hanging over the edge of the table is in Gregorian neumes and is headed "Benedictio Fontis," while the fourth sheet exhibits the complete melody of a song by Servel entitled *Séparation. L.* Unlike most of the Harnetts of 1888, this painting has no "serial number" on its back, but both No. 108 and No. 118 bear the same canvas-maker's mark, that of Henry Leidel, 339 and 341 Fourth Avenue, New York. It is not inconceivable that both paintings were begun in 1887 and that No. 118 was completed early in the following year.

1889

119. THE OLD CUPBOARD DOOR. *L.* Plate 81.

1890

120. EMBLEMS OF PEACE. A bare brown table top, left corner showing. On it, at extreme left, a pile of two brown, leather-bound books lying on their sides, the upper one labeled "Poems / Longfellow" and the lower "Tasso." Behind this stands a huge book in the "astride" position. In the center of the painting stands the Dutch jar. Leaning against its left-hand side is a vellum-bound book inscribed on its spine "Maximilian / Valenta / Augsburg / 1503." At extreme right is a pile of two books, also lying on their sides, surmounted by a heavy brass candlestick with a stump of candle; the upper book in this pile is also vellumbound and is labeled "Dante / Alighieri / Roma / Libreria (?) / par (?) / Giordano (?) / 1533." A brass candle snuffer leans against this pile of books. Both piles are pulled together, compositionally speaking, by the long diagonal line of Harnett's flute, which lies propped between

them. In the center, at the table's edge, is the blue tobacco box with its lid removed and with shredded tobacco spilling out, and a meerschaum pipe which lies upside down dropping its burning embers of tobacco on a folded newspaper beneath. The newspaper, which has many charred spots, hangs over the table's edge. Below it, likewise hanging over, are a blue music cover and a piece of music of which enough bars are shown to indicate that it is (as in No. 109) Papageno's song, "Der Vogelfänger bin ich, ja," from Mozart's *Zauberflöte. L.* 27½ x 33¾.

Reproduced: (In color) Born, frontispiece. Same plate in *Life;* August 28, 1939, p. 25. (In black and white) *Handbook of the Springfield Museum of Fine Arts,* p. 40. Also *Magazine of Art,* October, 1946, p. 250, and *Illusionism and Trompe l'Oeil,* exhibition of catalogue published by the California Palace of the Legion of Honor, p. 27.

Springfield, Massachusetts, Museum of Fine Arts.

120A. *Still Life.* A miniaturized version of the foregoing. The table is the same and the paneled wall in the background is also the same. At extreme left on the table top is the same book as the one at the bottom of the pile in No. 120, but now there are no other books at that point. Instead, a brass candlestick stands on the book; it is much simpler and homelier than the one in No. 120, but it has precisely the same length of candle in it, with almost the same drippings on its sides and slightly inclined toward the right exactly the same way. Behind the book stands the Dutch jar. The blue tobacco box is propped on the book at its left-hand end; it contains shredded tobacco and its lid lies on it in precisely the manner of No. 120. The same meerschaum pipe as in No. 120 lies upside down at the table's edge, spilling ashes onto a sheet of music. Behind the pipe is a black piccolo with an ivory head; it lies diagonally, propped on a vellum-covered book. Behind the piccolo is a very large book "astride." A pile of two books lying on their sides completes the composition. Matches and ashes here and there. *L.* Panel, 7½ x 9½.

Pittsburgh, Miss Helen C. Frick.

121. AN EVENING'S COMFORT. A bare wooden table top, right corner showing. On the table top, left to right, are a stoneware beer stein with a pewter lid, a meerschaum pipe which rests upside down in a fold of a newspaper, and the blue tobacco box. The latter, as usual, is partly opened, is full of shredded tobacco, and spills some of its contents over its edge. The newspaper exhibits no masthead. The background throughout is a wall of rectilinear paneling. *L.* Panel, 6 x 8.

New York, Mrs. Norman Woolworth.

122. THE FAITHFUL COLT. *L.* Plate 1.

123. WITH THE STAATS ZEITUNG. Identical with No. 121 except that less of the table's support is shown, the still life objects on the table top have been reversed in their placement, and the newspaper has a masthead. The group of the pipe, newspaper, and blue tobacco box, composed in precisely the same fashion as in No. 121, now appears at the

left instead of the right, and the beer stein is at the right instead of the left. The newspaper masthead reads "Staats Zeitung"; beneath this are a date, "1890," and "Preis 3 Cents." *L.* 14 x 20½.

Reproduced: *Art Digest,* June 1, 1946, p. 9. Also *The Magazine Antiques,* September, 1946, p. 160.

St. Louis, City Art Museum.

1891

124. JUST DESSERT. A marble-topped table, left corner showing. On it, left to right, half a coconut, the pewter tankard, a wooden fig box labeled "Smyrna" on which stands a Chinese ginger jar with the cracked ivory handle of a table knife emerging from it, two bunches of grapes (one light green and translucent, one dark), a bottle partly covered with straw but bearing a paper label reading "Maraschino," and a stocky copper pitcher. At the extreme right, in deep shadow, a few more grapes. A long sprig of grape leaves emerges from the pitcher and extends toward the left. Bits of powdered cork on the green grapes and the table top. *R.* 22½ x 26½.

Reproduced: Born, plate 80. Full-scale color reproduction published by Triton Publications, New York, 1950.

Art Institute of Chicago.

125. THE PROFESSOR'S OLD FRIENDS. A bare wooden table top, right corner showing, set before a paneled wall. On it, at extreme left, a roll of music imprinted "Louis Soll (?) / for the / clarinet / with / piano." Behind this is the Roman lamp with two books propped against it at its left and one at its right. In the center of the picture, toward the back, is a pile of four books lying on their sides. To the right of this, a large, pot-bellied beer stein with a pewter lid; leaning against its left-hand side is a paper-bound book imprinted on its spine ". . . res / par / Alexandre / Dumas / Paris." At the extreme right is the Arnold ink bottle with a quill pen emerging from its mouth, standing on a paper-bound book. In the foreground, across practically the entire width of the painting, is a thirteen-keyed clarinet. It rests upon a vellum-bound book entitled "Comp . . . / Iuris / par Wilam / Bachy (?) / Frankfurt / 1503." Hanging over the table's edge is a sheet of music—an ornate virtuoso piece imprinted at its bottom "Verlag Joh. André, Offenbach." *L.* 26½ x 32.

Reproduced: Birch catalogue, No. 28. In the listing for this picture in that catalogue it is called "the next to the last painting that emanated from his [Harnett's] easel."

Rockland, Maine, Farnsworth Art Museum.

1892

126. OLD MODELS, *L.* Plate 82.

Color reproductions: *Life,* August 29, 1949, p. 60. Another, larger in size but less accurate in color and tone, *Vogue,* February 1, 1949, p. 179. A third color reproduction is published by the Museum of Fine Arts, Boston.

FORGERIES AND MISATTRIBUTED PICTURES

The symbols *L* and *R* are again used to indicate the location of Harnett signatures, and we now add the dates given with them. All such signatures mentioned in this section are, of course, spurious.

By Artist X

Artist X is the only deliberate Harnett forger known to the writer of this book. All the paintings listed under other headings below were honestly created as expressions of the people who brought them into being and were often signed by them, but they have been wrongly attributed to Harnett through a misreading of their subject matter and stylistic peculiarities and because of the fact that, in the great majority of instances, they bear forged Harnett signatures, the signatures of the actual painters, when originally present, having been painted over or otherwise removed. Artist X, however, was not an innocent victim of the unscrupulous individuals who, forty or fifty years ago, placed Harnett's name on pictures with which he had nothing to do. Artist X was obviously well acquainted with Harnett's work, and his forgeries are often copies of paintings by Harnett or pastiches of Harnettian motifs, some of which he did not fully understand. (See No. 3 below.) His drawing is crude and inaccurate, and his color, while sometimes plausible, is frequently dull, dark, and bituminous; at no time does he exhibit Harnett's characteristic mastery of varied, contrasting textures.

Many of the paintings of Artist X came from the collection of Harnett's closest friend, the Philadelphia painter, E. Taylor Snow; in fact, it is by no means inconceivable that E. Taylor Snow *was* Artist X. If so, he may have produced his copies and paraphrases of Harnett out of respect and as a means of improving his own far-from-perfect technique; but these pictures have come on the market as works of Harnett himself.

1. A BACHELOR'S COMFORT. (Title inscribed on a label on the back of the painting.) So far as subject matter and composition are concerned, an almost exact copy of the Harnett of 1878 known as OLD SOUTH CAROLINA. (Harnett catalogue No. 36, *q.v.*) The principal variation is in the rendering of the sack of tobacco, which here has a relatively narrow label with no legible lettering and is smooth in texture rather than rough. The newspaper, furthermore, exhibits no masthead. Panel. *L.,* no date. 10⅞ x 14¼.

New York, private collection.

2. BEER AND SMOKE. A meerschaum pipe, a folded newspaper, and a beer stein on the top of a bare wooden table. *L.,* no date. 8¼ x 8.

* New York, Downtown Gallery.

3. BUNCH OF ASPARAGUS. Stalks of asparagus, bound together with ribbons at top and bottom, placed on a bare wooden table. *L.,* 1890. 17 x 14. (This is apparently a copy of a lost Harnett listed in the Birch catalogue as *"Bunch*

William Michael Harnett: A Critical Catalogue

of Asparagus, painted 1890, at New York." The signature here is adapted from the type which Harnett employed when he wished to create the effect that his name had been whittled into a door—with diamond-shaped loops in the "8" and "9" and a diamond-shaped "O." Most of this signature, however, is "whittled" into the empty space at the left of the table, although the two "T"s at the end of the name and the "O" of the date appear against the support of the table top. Not only is this nonsense descriptively speaking, but it is most un-Harnettian nonsense from an esthetic point of view. Harnett never spread his signature over two separate elements of his pictorial composition. To do so emphasizes the picture plane at the expense of the objects represented upon it and destroys the representational illusion.)

* New York, Downtown Gallery.

4. THE EMPTY STEIN. A bare wooden table top. On it, left to right, a beer stein, a pile of two books lying on their sides with a meerschaum pipe resting against them, a wide-mouthed brass vase, an Arnold ink bottle with a quill pen emerging from its mouth standing on an envelope, and a small bronze bell. No signature or date, but inscribed on its back "William M. Harnett, Philadelphia, 1877." 11¼ x 15½. (One of the most bituminous works of Artist X, apparently adapted from the Harnett of 1878 known as A WRITER'S TABLE [Harnett catalogue No. 44] with which Artist X himself may have tampered.)

* New York, Downtown Gallery.

5. AN EVENING'S PLEASURE. A bare wooden table top. On it, at extreme left, a beer stein. At the far right is a Caporal tobacco package with a meerschaum pipe leaning against it as well as a portion of a disjointed flute. This last is placed at an extremely sharp angle, so that its ivory head comes to rest on the table's edge immediately below the handle of the stein. At the extreme right, behind the tobacco package, is the separated lower joint of the flute, lying on the table. In the background, behind the main portion of the flute, is a folded newspaper headed "Times" and dated ". . . uary 11, 1877." Matches, burnt and fresh, and ashes. *R., 1877.* 12 x 16½.

* New York, Jack Lawrence.

5A. *Another Evening's Pleasure.* An all-but-exact copy of the preceding. The principal differences are that the folded newspaper is a little narrower than the one in No. 5 and that the joints of the flute lying on the table do not rest so closely alongside the newspaper and the Caporal tobacco box; there are also differences in the rough stippling of the beer stein. *R.* 12½ x 16¼.

Mamaroneck, N.Y., private collection.

5B. *Times II.* An exact copy of *Times.* (Harnett catalogue No. 43.) The iconography is identical: the Caporal tobacco package, a meerschaum pipe resting against it, a folded copy of a newspaper with masthead reading "TIM . . ." and date "UARY . . . 8", a large beer stein at extreme right, matches and ashes. The general style of

the painting, however, is perceptibly softer than that of Harnett No. 43; the forms are less skillfully delineated, and the color is more golden in general tone and less specifically descriptive. *R.* c. 16 x 12.

Philadelphia, private collection.

6. THE MEERSCHAUM PIPE. A meerschaum pipe lying on a bare wooden table top. Behind it is an apparently empty tobacco can with its lid resting against its side. *L.,* 1878. 7¼ x 10.

Present location unknown.

7. PIPES ALL 'ROUND. A varied copy of Harnett's SOCIAL CLUB of 1879. (Harnett catalogue No. 54, plate 29.) The principal variants are that the table top is wood instead of marble, the match holder appears immediately to the left of the cigar box rather than at the extreme right, and there is an additional pipe inside the box. Here, furthermore, there is no shredded tobacco inside the box and no lettering on its lid, while the revenue stamp appears at its left-hand end rather than its right and the only lettering visible on its front side is "CON . . ." *L.,* 1879. 14 x 18.

* New York, Downtown Gallery.

8. PUBLIC LEDGER. A cabinet in which is a door, partly broken, with a large brass hinge. On the top of the cabinet, three turnips, a glass of wine, a hard roll, a wooden-handled knife, a snuffbox, and a Dutch jar with a windmill and other objects dimly painted on its side, but without a pewter lid. A copy of the Philadelphia *Public Ledger* hangs over the edge of the cabinet's top. *L.,* no date. 10 x 8¼. (The Dutch jar is, of course, a very common Harnett motif. The turnips and roll seem to have been adapted from Harnett's Munich pictures of 1883, and the hinge over the large crack in the door is copied from Harnett's OLD MODELS of 1892, plate 82.)

* New York, Downtown Gallery.

9. *Still Life.* A bare wooden table top. On it, left to right, a beer stein, an Arnold ink bottle with a quill emerging from its mouth resting on an envelope, a pile of two books lying on their sides with a meerschaum pipe lying against them, and a wide-mouthed brass vase. *R.,* 1877. 12 x 16.

Present location unknown.

10. *Still Life.* A bare wooden table top. On it, left to right, a beer stein, a briar pipe lying upside down on the rim of its bowl and the curve of its bit, a folded newspaper with the masthead ". . . DGER," and two small, round biscuits, one partly broken. Matches, burnt and fresh. *L.,* no date. 10 x 12.

Pittsburgh, private collection.

11. STILL LIFE IN MINIATURE. A cabinet in which is a door with a large brass hinge at its left-hand side. On the top of the cabinet, left to right, an open snuffbox, a briar pipe resting as described in No. 10, a small, round biscuit, and a brass candlestick with a stump of candle before which are three matches, burnt and fresh. Behind all this, left to right, a pile of two books lying on their sides and

surmounted by a folded newspaper, and a large stoneware jug. *R.,* no date. 8 x 5. (Harnett signature largely effaced.) Present location unknown.

By Harry H. Baker

STILL LIFE, VIOLIN. A violin and bow hanging against a dark green door studded here and there with nails and nail holes. Behind the violin is a sheet of music headed *Auld Lang Syne.* In the foreground, below the violin, is a table on which are a piece of music without legible title, a paperbound book on the spine of which one may read "Great Expe . . . s—Dickens," and a piccolo. At the extreme right, propped against the door, with its lower edge resting on the table, is an envelope addressed to "H. H. Baker / General Post Office / New York." No Harnett signature, but the picture was purchased as a Harnett.
* Youngstown, Ohio, Butler Art Institute.

By H. Thomas Bromley

Duck. A dead duck hanging by a string attached to its left foot from a door or wooden fence full of rough splinters, nails pounded flat, and knotholes. At upper left is a stenciled inscription, "MAW & CO," at lower right, in longhand, "6 f ½ x 11." Above this is a ragged label reading "356." Harnett monogram on a bit of torn paper held by a nail at lower left. 22¹³⁄₁₆ x 18¼. The attribution to Bromley, who was active in Birmingham, Alabama, c. 1897, was made by letter from Charles C. Cunningham, director of the Art Institute of Chicago, to John Coolidge, then director of the Fogg Art Museum of Harvard University, April 18, 1967.
Cambridge, Massachusetts, Fogg Art Museum.

By N. A. Brooks

1. TO EDWIN BOOTH. Panel. Harnett signature and date, 1879, at the lower left-hand corner of the playbill. Plate 119.
2. DOLLAR BILL AND PLAYBILL. Panel. *L.* Plate 121.

By John F. Francis

THE DAILY TELEGRAPH. A table top draped throughout its width with a Turkish rug. On it, a large newspaper page with masthead, "The Daily Telegraph," spread to its full width and hanging over the table's edge. Resting on the newspaper are a dish containing two oranges, two tall, slender glasses filled with wine, three wine bottles (one labeled "Nektar" and two labeled "Creman ot [*sic*] Rose / Moet Chandon / Eperni"), three empty oyster shells, and a silver knife. Standing on the edge of the newspaper at the right, a jug with a pewter lid. In the background, to the left of this, a fancy box or jewel case. At extreme right, an apple. *R.,* no date. Panel, 10¼ x 8½.
* Detroit, Robert A. Tannahill.

By Richard Labarre Goodwin

Hunting Still Life. A barn door with reinforcement in the shape of a huge letter "Z." At the extreme left is a latch, and there is a deep, semicircular gash in the wood above it. Hanging from the top bar of the "Z" are a powder horn and a large swirl of dead ducks and other game birds. In the angle formed by the diagonal of the "Z" and its bottom bar is a horseshoe. At the right, hanging from a nail in the door, is a large, double-spouted shot pouch. A feather lies on the bottom bar of the "Z" just to the left of the topmost spout of the pouch. No signature. Shown to the writer as a Harnett, but obviously a magnificent work of Goodwin.
Present location unknown.

By E. N. Griffith

THE BACHELOR'S FRIENDS. *R.,* 1879. Plate 132.

By Claude Raguet Hirst

Still Life. A bare wooden table top. In the foreground, a meerschaum pipe lying on its side. Behind this, two books, both very worn and dog-eared, lying on their sides and surmounted with a pair of steel-rimmed spectacles. Behind this is a candlestick whose body is in the form of a winged griffin: the candlestick has a stump of candle. To the right of this, a sack of tobacco. Matches, burnt and fresh, ashes. *R.,* no date. 9¼ x 12. (Very similar to plate 126, although that painting is a watercolor and this one is an oil.)
Present location unknown.

By C. A. Meurer

Still Life. A semicircular table top covered with a tasseled drape which rises, somewhat ambiguously, to fill the upper left-hand corner of the painting. At the extreme left of the table top is a silver cup lying on its side; behind it is a wine glass. To the right of this is a jug with an exceptionally tall, narrow neck surmounted by a pewter lid. A clarinet lies across the table, its barrel joint at the foot of the jug, its bell extending over the table's edge at the extreme right. Lying across this, supported at the back on a pile of three books, is a violin, upside down, its neck and scroll protruding over the edge of the table. The bow lies to the left of the violin. Immediately below the bow, at the very edge of the table, is an ash tray containing a burning cigarette. Matches and crumbs. *L.,* " '81." 37 x 17.
* Albany, New York, Dr. Emerick Friedman.

By John Frederick Peto

1. AFTER NIGHT'S STUDY. A piled-up chaos of books on a draped table. One book, with a mottled cover, hangs over the table's edge at the left. At the extreme left corner of the table is a squat stoneware ink bottle, with the sharpened end of a quill pen lying before it. In the center of the picture is an iron candlestick with a stump of candle, a hook on its lip to the left, and a lever for the ejection of burned-out candles. The candlestick stands on top of a book, and another, spread open, leans against it at its back. In the background is a gray stoneware beer stein. Before it, on

top of a pile of four books, is a corncob pipe. *R.*, no date. 14 x 20.

Reproduced (as Harnett): Edgar P. Richardson, *American Romantic Painting*, plate 236. Also *Nature-Vivre* catalogue of exhibition at the Downtown Gallery, No. 10.

* Detroit, Robert A. Tannahill.

2. BOX OF BOOKS. Thirty-one books piled helter-skelter into a wooden box; the torn-off cover of one book hangs over the edge of the box toward the right. *R.*, 1881. 19¾ x 24.

New York, Mr. and Mrs. Alfred H. Barr, Jr.

3. BREAKFAST. Two soft buns, a coffee cup, and the wooden handle of a knife on a gray table top. *R.*, no date. Academy board, 6 x 9.

* New York, Mrs. C. N. Bliss.

4. CAREER'S END. A portion of a wooden wall or door with a long vertical crack between its two boards at the right. At upper left, a portion of a torn label and a nail. In the center and immediately below the center, torn newspaper clippings. At the lower right, a photograph of Lincoln which seems to be caught in the corner of the frame. *L.*, no date. Academy board, 9 x 6.

* Pittsburgh, Edgar Kaufmann.

5. DISCARDED TREASURES. *R.* Plate 17.

6. FOR SUNDAY DINNER. A dead chicken and a dead turkey suspended by their feet against a door on a string looped across a nail. The brown-feathered chicken is not plucked. The body of the turkey is plucked, but not its wings or the upper part of its neck. Two hinges hold the door at the left; at the right is an open hasp from which a padlock dangles on a chain. The undated Harnett signature is immediately below the padlock. 53 x 40.

Reproduced (as Harnett): Born, plate 86. Also *Magazine of Art*, October, 1946, p. 251, and (in color) Aimée Crane, *A Gallery of Great Paintings*, plate 49.

* New York, Downtown Gallery.

7. THE GRAY JUG. A gray beer stein on a table top. *R.*, no date. Panel, c. 4 x 4.

* New York, Morris Kantor.

8. THE MARKED PASSAGE. A brown book lying on its side on a table top. A smaller green book lies on the brown book, and inserted between its pages is a corncob pipe. Peto's "lard lamp" (cf. plates 2 and 13) stands in the background. *R.*, no date. Academy board, 6 x 9.

New York, Mr. and Mrs. Alfred H. Barr, Jr.

9. *Mug, Pipe, Newspaper, and Biscuits.* The newspaper is folded and is propped as background throughout practically the entire width of the picture. Before it stand, left to right, a gray stoneware beer stein with a hard, round biscuit wedged beneath it and tilting it toward the left, a meerschaum pipe with its stem protruding over the edge of the table, and, at extreme right, another biscuit. *R.*, no date. Panel, c. 5 x 7.

* Bel Air, California, Walter Reisch.

10. *Mug, Pipe, Newspaper, Book, and Candlestick.* A gray table top. The bowl of the pipe is at the extreme left and its long stem extends toward the right with the bit hooked around the right-hand side of the beer stein. The stein stands on a folded newspaper which, in turn, lies on a book. The candlestick, with its stump of candle, stands in the background at the left. *L.*, no date. Academy board, 6 x 9.

* Merion, Pennsylvania, Mrs. David Tendler.

11. NINE BOOKS. Nine books, five standing in normal position and four presenting their tops, on a shelf. A stretch of plaster wall with a nail in it fills the left-hand side of the painting. *R.*, no date. Academy board, 6 x 9.

* Chicago, Earle Ludgin.

12. OLD BOOKS. A gray table top. On it, a large, worn book supporting three smaller books toward its right-hand end; all are lying on their sides. An Arnold ink bottle with a stopper stands before the big book at the left. *R.*, no date.

Reproduced (as Harnett): *Nature-Vivre,* catalogue of exhibition at the Downtown Gallery, No. 3.

* New York, Nelson A. Rockefeller.

13. THE OLD CREMONA. A violin and bow hanging against a door. Behind the bow is a large blue book of music bearing the one word "VIOLIN." Rusty hinges at the left. At the right, a key hole with a rusty escutcheon, and above this, a nail. Cracks, rivets, nails, and nail-holes here and there. *R.*, no date. 16⅛ x 12⅛.

Reproduced (as Harnett): *The Magazine Antiques,* June, 1943, p. 260.

New York, Metropolitan Museum of Art.

14. OLD FRIENDS. *R.*, no date. Plate 2.

15. OLD SCRAPS. *R.*, no date. Plate 6.

16. OLD SOUVENIRS. *L.*, 1881. Plate 19.

17. OLD REMINISCENCES. *R.*, no date. Plate 4.

18. PROTECTION. Academy board. *R.* Plate 14.

19. RESEARCH. A gray table top. On it, at left, a squat stoneware ink bottle with a quill pen emerging from it and tilted toward the left. Behind this a large brown book leaning toward the right against a pile of three books of various sizes. At the right a book with a torn cover stands open with its back to the viewer, leaning against the two topmost books of the pile. *R.*, no date. Academy board, 9 x 11½.

* New York, Downtown Gallery.

20. SUSTENANCE. A bare brown table top. On it, left to right, two hard, round biscuits, a stoneware beer stein, and a meerschaum pipe propped against two brown books. A folded newspaper stands in the background. Matches, burnt and fresh. *R.*, no date. Academy board, 6 x 9.

* New York, Julian Levy.

21. THE WRITER'S TABLE. A table covered with a blue cloth. On it, at extreme left, a book lying on its side with

its lower cover dangling over the table's edge by two threads; this book cover displays a roughly penciled capital "M." On top of the book just described, another book, with a mottled cover, in the "astride" position. Next right is a tall brass candlestick, with a length of candle, leaning toward the left. In the center of the picture is a huge, worn, brass-bound book with heavy hasps. Before it stand an Arnold ink bottle with a stubby quill pen emerging from its mouth and an iron candle snuffer. At the right, tipped slightly backwards, is a dented pewter beer mug with its lid standing open. R., no date. 27 x 22.

Reproduced (as Harnett): *Gazette des Beaux-Arts*, January, 1947, p. 58. A detail also published under the title *A Student's Table* in *Art News*, October 1, 1944.

* New York, Edith Gregor Halpert.

By Cadurcis Plantagenet Ream

RASPBERRIES AND ICE CREAM. A white marble table top. On it, left to right, a dish of pink and white ice cream with a silver spoon sticking into it; a serving dish full of raspberries; a bunch of red grapes at the foot of the serving dish; at right, a piece of yellow cake with white frosting. The serving dish is all but indescribable. It is surrounded by a gold band with many small, ruby-like bosses, and loops of gold chain hang from it; it is has a tall, green foot like the heavy stems of German wine glasses which is adorned with a gold cincture around its top at the point where it joins the dish full of raspberries. The white marble table top is supported by wood carved in the form of V's and inverted V's; each V has a bright, ruby-like dot in its center. R., 1870. 12 x 10.

This is one of a series of dining room still lifes which Ream painted for L. Prang and Company, publishers of chromos. It is reproduced as such in *L. Prang and Company's Illustrated Catalogue of Art-Publications for Spring, 1876*, page 41, where it is given the title *Dessert No. IV*. Also reproduced as Harnett, Born, plate 77, and in *Vogue*, February 1, 1949, p. 181 (color).

* New York, Oliver B. Jennings.

By Unknown Artists

I. AFTER THE HAUL. Numerous fish of various sizes and species lying in a net supported on rocks and surrounded in the background and at the right by grasses and weeds. L., no date. 42 x 23½.

* Philadelphia, S. H. Meilachowitz.

2. *Apples and Cider*. A brown wooden table top. On it, at the left, apples in a brown bowl adorned with a fringed napkin. To the right of this, a glass pitcher of cider. Apples and a knife lie on the table. L., 1886. 18 x 24.

Present location unknown.

3. *Cantaloupe and Peaches*. A cantaloupe from which a large slice has been cut lying on a table top. To its left, three peaches. To its right, the slice taken from its main

body, and another peach. R., no date. 12 x 14½. (The style of this production is crudely impressionistic and altogether outside the tradition of the painters considered in this book.)

Present location unknown.

4. *Cards, Hookah, Stein*. A draped table. On it, at left, a shapeless jumble of books and playing cards, along with the box for the cards. In the center, two upstanding books ("Daughters / of / Genius / Parton" and "From / the Nile / to / Norway"). Before these books, a hookah; to its right, an ornately molded stein; behind the stein, a cigar box; in front of it, a meerschaum pipe. A newspaper with a cut of a bearded man hangs over the table's edge. No signature, but shown to the writer as a Harnett. 19½ x 23½. (Perhaps the crudest production with which the name of Harnett has ever been associated.)

Present location unknown.

5. *Cloisonné Vase*. A cloisonné vase containing a rose placed on an ambiguous expanse apparently intended as the top of a table. Leaning against its base is a small, round metal container with a chased lid. At right, a piece of lace, a corner of a wooden box with an ivory lining, and various bits of jewelry. At the extreme left, a small gold spoon. L., no date. 11½ x 6½.

New York, Norman Bonter.

6. *Confectioner's Still Life*. Two candy boxes on a bluish-gray tablecloth. The box to the left is open and filled with candy. The box to the right is wrapped in white paper and tied with a pink ribbon. Bon-bons, chocolates, and a bow of pink ribbon on the table before the boxes. Behind the box to the left is a brown glazed pitcher. At the upper right is the corner of a framed picture hanging on the green wall which extends all across the background. Signed, R., "Harnett," not "W. M. Harnett," but the left-hand vertical of the capital "H" is pulled around in a manner to suggest the reading "J. Harnett." Definitely not the signature of B. J. Harnett (for this artist see above, p. 158) nor that of the otherwise unspecified "Harnett" attached to the *Mountain Landscape*, No. 16 below. 13¾ x 17½.

* Wollaston, Massachusetts, Mrs. Peter Caliri.

7. *Ducks and Gun Cases*. A wooden wall. Hanging on it, a horseshoe and a large fringed game bag. Hanging from the horseshoe and against the game bag, two large ducks. Before the wall, at the bottom of the picture, is a bare wooden table top on which lie two more ducks and several feathers. At the far edge of the table, propped against the wall, are two leather gun cases. R., no date. (A very handsome painting, reminiscent of Goodwin but probably not by him.)

* New York, Edward Wallace.

8. FIRST OF THE SEASON. A basket of strawberries on a marble table top. Strawberries also on the table top itself, to the right and left of the basket. L., no date. 9 x 7.

* New York, Downtown Gallery.

9. *Five-Dollar Bill.* A five-dollar bill, creased and folded back on itself. Serial number A 514502. *R.*, no date. Panel, 7½ x 10.

* New York, William McKim.

10. *Fruit.* A cantaloupe surrounded by grapes, peaches, an apple, and two plums. In the foreground, a sprig of two raspberries. In the background, grape leaves. The Harnett signatures once present on this and the painting of the next entry have been removed by their present owner, who ascribes both pictures to John A. Woodside (1781–1852). 7⅞ x 10.

* New York, Victor D. Spark.

11. *Fruit and Basket.* At the extreme right, a large, rather shallow basket stands on its side. From it pour peaches, a pear, grapes, and plums. In the background, grape leaves. 7⅞ x 10.

* New York, Victor D. Spark.

12. *Fruit Piece.* A bunch of grapes, three peaches, and two plums. In the foreground, a sprig of five strawberries. In the background, grape leaves. *R.*, no date. 8 x 10. (This picture is apparently by the same hand as Nos. 10 and 11 and came onto the market from the same collection.)

Buffalo, New York, James Goodman Gallery.

13. HELMET AND SWORD. Two medieval helmets, the one to the left of dark metal, the other bright in tone, on a table top. Between them, in the background, the upper part of a chased metal vase. In the foreground, left to right, the grip and guard of a sword, an Egyptian statuette, a powder horn, and a book lying on its side surmounted by a broken fragment of a vase. *L.*, no date. 10½ x 12¾.

* New York, Downtown Gallery.

14. *Indianapolis News.* A heavily grained wooden table top. On it, left to right, an embroidered fez lying against a copy of the Indianapolis *News,* a cigarette box containing three cigarettes, an open box of pipe tobacco with a clay pipe leaning against it, a wine bottle, and a wine glass. In the foreground, matches, a pince-nez leaning against a stick of sealing wax, and a stack of playing cards surmounted by a burning cigarette; three playing cards have fallen loose from the stack toward the left. *R.*, 1878. 20 x 25. (Possibly by Daniel Lemon, an obscure painter of Indianapolis.)

* New York, L. Berman.

15. *Mandolin.* A mandolin hanging against a paneled door. Behind it, a piece of music headed "Diavolina, Polka, by R. Matini." *L.*, 1890. 30 x 25.

Reproduced (as Harnett): Born, plate 88.

* New York, Tania Whitman.

16. *Mountain Landscape.* A misty mountain in the background. In the right foreground, a river. Left foreground, a steep wooded bank and a rock on which are two deer. Signed, *L.*, "Harnett." (Not "W. M. Harnett.") 20¼ x 15⅛. (Possibly by B. J. Harnett.)

* New York, Dr. Philip Hussa.

17. NEWARK TIMES. A wooden packing case, much worn and cracked. On its front side, a torn label: "Southern Expres . . . / Company, / Winter Ha . . . Fl . . ." Lying on top of the packing case, a folded copy of the Newark *Times* for ". . . esday morn . . . 894." Before this, a clay pipe with ashes spilling from it and a package of tobacco lying upside down and labeled "Campbell & Co. / Fine Cut / Cavendish / Newark N.J." *R.*, no date. 6 x 8.

This picture may be by the New Jersey artist, Cyrus Durand Chapman. A similar painting, signed by him, presents a corncob pipe, a large open book, and a folded copy of the *Newark Evening News* for November 20, 1885, all lying on the top of a draped table. It hangs in the office of Richard Scudder, publisher of the newspaper depicted.

* New York, Henry Schnackenberg.

18. OFF TO THE OPERA. A hand holding an ivory-headed walking stick. *L.*, 1870. 9 x 7. (A fragment cut from a larger canvas.)

Reproduced (as Harnett): Born, plate 76.

* New York, Downtown Gallery.

19. *The Old Violin.* An oil copy of the Tuchfarber chromo after Harnett's *Old Violin.* c. 38 x 24.

* Seattle, Mr. and Mrs. Frank Hennessy.

20. *The Old Violin.* A copy of the Tuchfarber chromo, much cruder than the foregoing, with letter addressed to "Miss Julia Robb / 671 2nd Ave, / S. Brooklyn." No Harnett signature. 37½ x 27.

* New York, Mrs. Robert Freund.

21. *Parisian Street Scene.* A view down a narrow lane in which stands a figure of a woman. At the right, a wall beyond which is a garden or orchard. At left, a house with a steeply pitched roof. *L.*, no date. 9 x 12.

* New York, Cornelius Sheehan.

22. *The Portrait of Grieg.* A draped table set against a wall on which is tacked an engraved portrait of Grieg. On the table, a violin with a broken E string and a bow, both resting on a roll of music which in turn lies on a large bound volume and flat sheets of music. One sheet hangs over the table; it is an exact copy of the violin part of the Grieg sonata in G minor, Opus 13. The frog of the bow rests on a crumpled napkin with the monogram "G," which also hangs over the table's edge. At extreme left, a music cover imprinted ". . . vard Grieg" and a lump of rosin. *L.*, no date. 15 x 30. Possibly by J. D. Chalfant.

Princeton University Art Museum.

23. *Still Life.* Two clay pipes with long, beaded stems, two V-shaped wine glasses, and a dark liqueur bottle on a table draped with a white cloth. Harnett monogram at lower left. Charcoal on paper, 14 x 19.

Reproduced: *MC*, p. 23.

Detroit, Dr. Irving F. Burton.

24. *Still Life.* No photograph of this painting was provided, and this description of it must be taken from scattered notes. It involves a bare wooden table top, a beer stein with gray bands of ornamentation, a meerschaum pipe with

a pewter cover, a blue tobacco tin on which is the word "Mixture," a copy of "The Times" dated 1884, a match box, and matches. Harnett signature and date, 1882. Location of signature not noted. 16 x 24.

* Upper Darby, Pennsylvania, Hobson Pittman.

25. *Still Life.* A table covered with a green cloth along the lower edge of which is a looping, ornamental gold line. On the table, left to right, in the foreground, a dollar bill, three silver coins, a piece of blue notepaper, a torn-open envelope with illegible address, three dark-colored cigarettes or small cigars, two matches, and a pink ribbon. Behind these, left to right, a book placed at an angle, a conical stoneware ink bottle labeled ". . . old's / medal / . . . on ink / London," (not the customary Arnold label), a quill pen leaning against a pile of three books lying on their sides, and a folded letter. The second of the three books bears as title the word "Aldemus." R., no date. 12 x 17. An infra-red photograph of this painting taken by Sheldon Keck brought out a signature at its lower left: "J. M. Scherrah (?) / Philada 79."

Present location unknown.

26. *A Study Table II.* A weak, somewhat varied copy of Harnett No. 80, plate 56. c. 11½ x 14½. L., no date.

Philadelphia Museum of Art.

27. *Ten-Dollar Bill.* A ten-dollar bill of the series of 1880 with serial number A 156259. In the lower left corner of the bill is portrait of a man (Daniel Webster ?), and in the lower right a sketch apparently intended to represent Captain John Smith leading Pocahontas to an audience with Queen Elizabeth, who sits surrounded by three men wearing turbans, one of them seated on the ground smoking a long Indian pipe. R., no date. Academy board, 6 x 9.

New York, Richard Loeb.

28. *Plums.* Plums in a wooden fruit basket stuffed with paper toward the back of a draped table. On the edge of the table, before the fruit basket, many more plums. The table is draped with a green, fringed cloth. L., 1892. 12 x 10. Probably by L. W. Prentice. (See prefatory matter.)

New York, Kennedy Galleries. (Recognized as a forgery by the Kennedy Galleries.)

29. *Still Life.* A bare wooden table top. On it, left to right, a glass of wine, an irregularly shaped roll or small loaf of bread, an Italian wine bottle, largely full, mounted in plaits of straw, a sprig of two plums with leaves, a pear, a squat crock with two handles pointed toward the left, and four peaches. Between the plums and the first two peaches, lying on the table top, a small copper coin and a large silver one. To the right of this, a package of matches. Matches and leaves here and there; the top of the match package at extreme right. R., 1878. 16 x 24.

New Orleans, Mrs. S. R. Hudson.

30. *The Baroque Salt Cellar.* A table top draped with a figured cloth, fringed at the left. On it, at left, a bunch of green grapes hanging over the table's edge. Above this is a baroque salt cellar in the form of a sea shell fitted with goldsmith's work; a nude, bearded, male figure seated on a horse supports the sea shell, and its lid, standing half open, is surmounted by another nude, bearded figure seated in a chair in the form of a bird. To the right of this are two peaches, an empty wine glass, and a bunch of dark red grapes with their leaves. The entire composition is framed by a tray lying on its side at the back of the table. R., 1881.

* Baltimore, Israel Siegel.

31. *Watermelon.* A bare table top. On it, left to right, three peaches and two pears, an irregularly split watermelon in two pieces, the smaller of which stands to the right of the larger, and, at extreme right, dark grapes with their leaves. A small sprig of cherries hangs over the table's edge just to the right of the center. L., no date. 20⅛ x 16⅛.

* New York, Grothann H. Oertling.

32. *Fruit Piece.* An extremely elaborate picture rather difficult to describe. A marble table top. On it, in dead center, a large glass fruit dish full of grapes of various colors. From this central axis the composition moves diagonally, and with complete bilateral symmetry, to left and right. At left is a folded, fringed cloth decorated with rectilinear patterns. On this stand an apple, grapes, an orange, a banana peel, a champagne bottle without cork, and a glass of wine. Behind the banana peel and the wine glass is a pineapple with its leaves. In dead center on the bare table top, at the foot of the glass fruit dish, is a china dish full of raspberries with a silver spoon in it, seen from the back. To the right of this, a pearl-handled knife lies on the table top. Behind it are an unpeeled banana, four peaches, and a bunch of dark red grapes with leaves and tendrils. Many more grapes, mostly light green ones, scattered about. A tiny mouse sniffs the scene at extreme left, near the apple. Signed on the cloth at the left, no date. 22 x 28. At one time this picture was advertised as the FRUIT with which Harnett made his debut at the National Academy of Design in 1875, but there is no evidence whatsoever for this identification. The picture is prim, naïve, and rather folklike in style and more closely resembles the work of George Cope than that of any other artist dealt with in this book.

* New York, Berry-Hill Galleries.

A note should be added concerning two pictures with forged Harnett signatures which the author saw at different times in New York shop windows but of which he was unable to obtain photographs and about which no information could be secured. One was a reasonably competent painting of mounted butterflies on a gray background; it was approximately 18 x 24 in size. The other was a small, crude, absurd study of a candlestick on a table top.

List of Owners: Genuine Harnetts

*T*he pictures are listed by their numbers in the critical catalogue. An asterisk before a listing means that the information involved is not recent.

List of Owners: Genuine Harnetts

Pennsylvania Academy of the Fine Arts — 4.
Philadelphia Museum of Art — 20, 28, 52.
Potamkin, Mr. and Mrs. Meyer — 108.
Pugh, Mr. and Mrs. Cresson — 23.
Ramos, Paul Peralta — 118.
Reading, Pennsylvania, Public Museum and Art Gallery — 12B.
Reily, George — 39.
Reynolda House, Winston-Salem, North Carolina — 33.
Rosenberg, J. W. — 31.
Santa Barbara Museum of Art — 51.
Schmidt, Richard E. — 30.
Selnick, William — 23A.
Setze, Josephine — 76A.
Skinner, Mrs. Lemoine — 49.
Smith, Robert H. — 50, 64.
Smokler, Bert — 71B.
Snyder, Mrs. M. D. — 70.
Spiller, Mr. and Mrs. Mortimer — 97.

Springfield, Massachusetts, Museum of Fine Arts — 120.
Stralem, Mr. and Mrs. Donald — 16, 29B, 38, 47, 53, 76B.
Taper, Mr. and Mrs. Barry — 76D.
* Thomson, Mrs. Natalie — 37.
Toledo, Ohio, Museum of Art — 105.
Trupp, Mrs. Bernard — 114.
* Turner, H. — 78.
University of California Art Museum, Berkeley — 3.
Wadsworth Atheneum, Hartford, Connecticut — 122.
Wattles, Mrs. S. D. — 46.
Weiman, R. P. — 27C.
Wichita Art Museum — 13.
Williams, William — 102.
Woolworth, Mrs. Norman — 121.
Zipkin, Jerome — 17.
Zuckerman, Paul — 84, 85A.

Index

Index

Index

Index

Index

Index

Addendum

In November, 1968, just as the revised edition of this book was going to press, Harnett's rack picture for George Hulings floated to the surface in New York. It had apparently languished for many years in the shop of an obscure antique dealer in Camden, New Jersey, across the river from Philadelphia.

This painting, as described in the Philadelphia *Item* for June 11, 1895, (see page 74 above) "represents a home made card and letter rack made of tape in which has been placed a number of cards and letters from his [Hulings'] friends." Its general composition is much like that of the Harnett rack which we reproduce as plate 46. It contains six envelopes and two cards addressed to Hulings at 1300 South Fourth Street, Philadelphia, or at Fourth and Wharton Streets, the address given for him in the *Item's* story. Four of these envelopes also contain return addresses, very prominently displayed, as in no other rack painting known to me. The names and addresses of Mr. Hulings' correspondents, all in Philadelphia, are as follows:

William McCarter, 236–238 South Fifth Street.
William Macpherson, M.D., 347 Wharton Street.
J. Wesley Bowen, 1026 South Second Street.
C. W. Bickley, 1236 South Fourth Street.

In addition, the painting represents one of Harnett's own calling cards and calling cards bearing the names George W. Isard; M. A. Rowan, 322 Reed Street; and S. Creadick, 1314 South . . . Street. None of these names turns up elsewhere in the Harnett story, and since all the gentlemen in question lived in the same general neighborhood, it is obvious that the *Item's* reporter knew what he was talking about when he said they were Hulings' friends. (But I still think Hulings was romancing when he told the reporter that Harnett's *Old Violin* had been painted for him and had been stolen from Harnett's studio by officials of the Cincinnati Industrial Exposition.)

The iconographic tally of the picture is completed with two envelopes seen from the back and therefore uninscribed, the envelope of a Western Union telegram apparently addressd to Hulings, a torn-off label at the extreme upper left, a newspaper clipping at the extreme lower right, and, at the lower right of the rack, a large rectangle of folded paper inscribed ". . . ary Commandery / No. 36," with a Latin cross between the "No." and the "36."

The painting measures 30 by 25 inches, is signed and dated at the lower left in the year 1888, and on its back bears a large numeral 4, which is Harnett's typical "serial number" for that year. (See page 85, last paragraph.)

In our list of the works of Harnett, under the subheading "Undated," No. 2, is a description of a fuzzy photograph of a rack painting or the model for one. The newly discovered picture is identical with this photograph except for the large sheet inscribed ". . . ary Commandery," which was apparently added later.

On pages 11 and 12 is an analysis of the Peto rack picture with a forged Harnett signature on which is a faked inscription, ". . . lings / & Wharton St / Philadelphia / Penn", which was obviously planted in an effort to make the Peto look like the painting described in the *Item* article. (This inscription is reproduced as our plate 8.) The discovery of the real Hulings rack, and the recent uncovering of Peto's signature on the back of the painting in question (as described elsewhere in this book) should finally close the case.

The newly discovered painting should take the number 109C in our catalogue (leaving 109B open for the eventual discovery of Harnett's No. 3 of 1888) and voids our catalogue number 2. It also raises the count of recovered genuine Harnetts to 154.